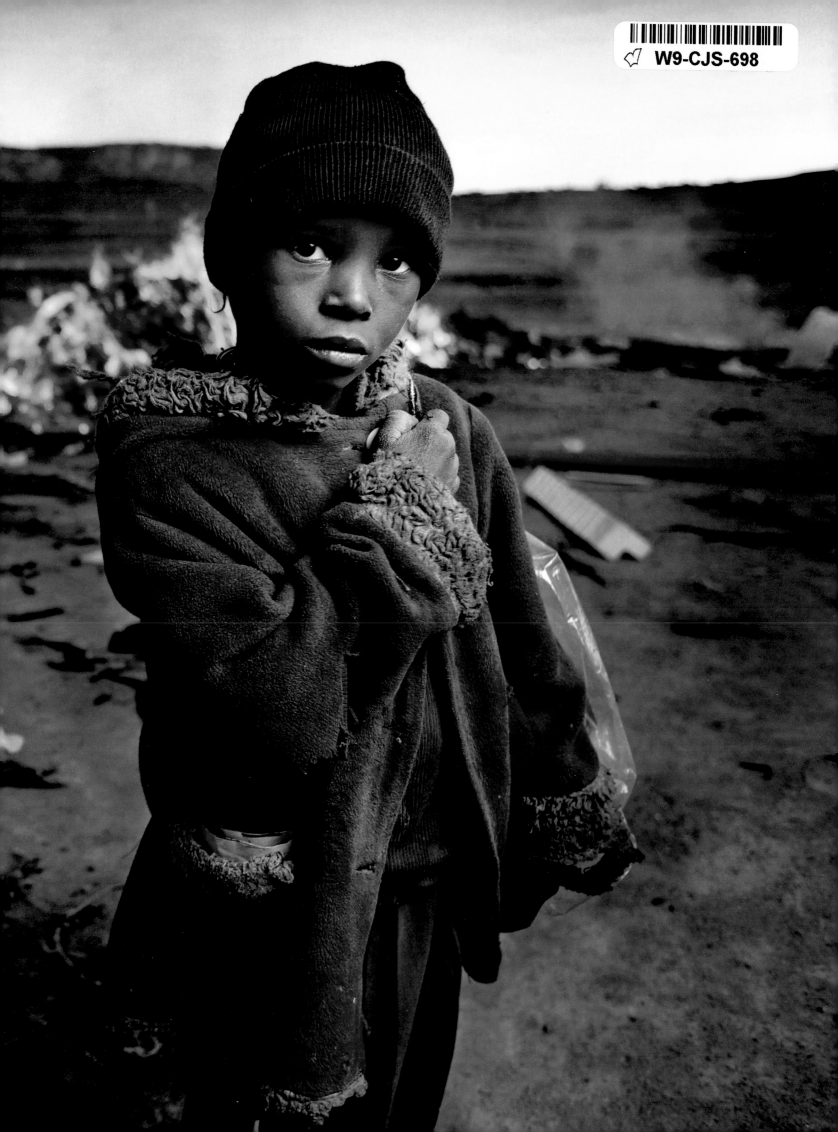

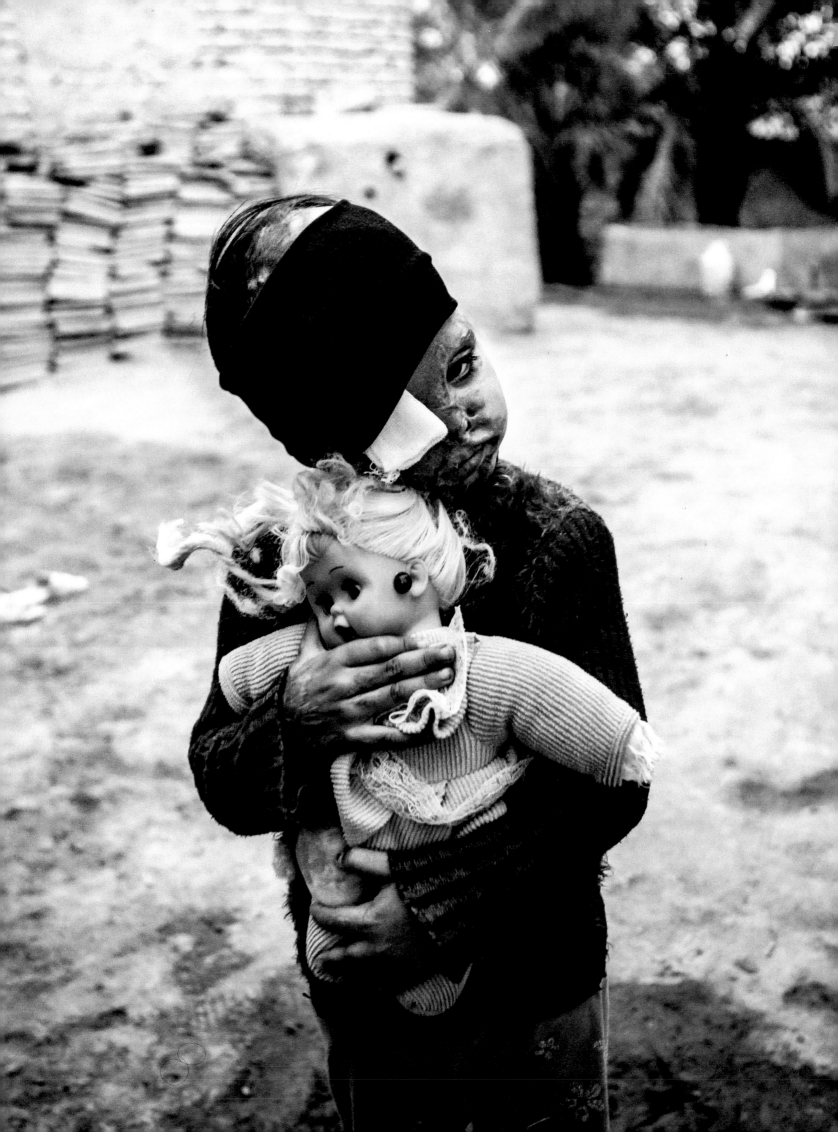

We the Children

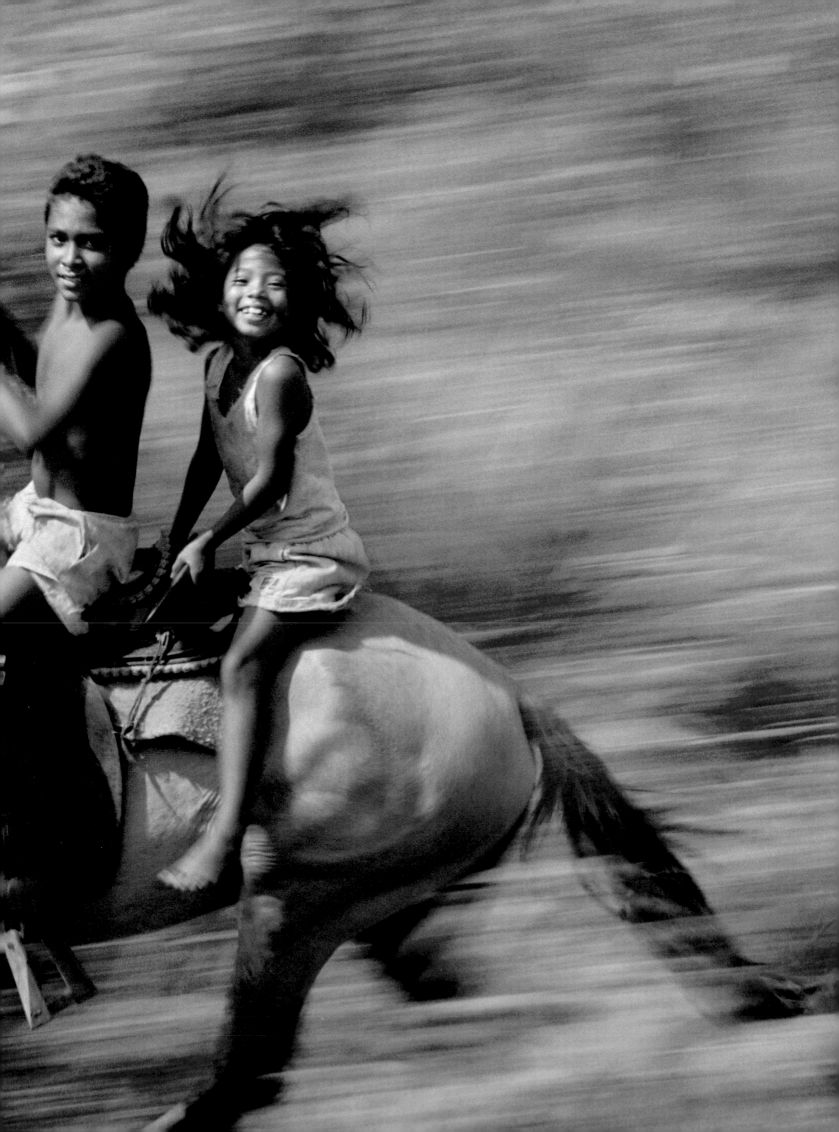

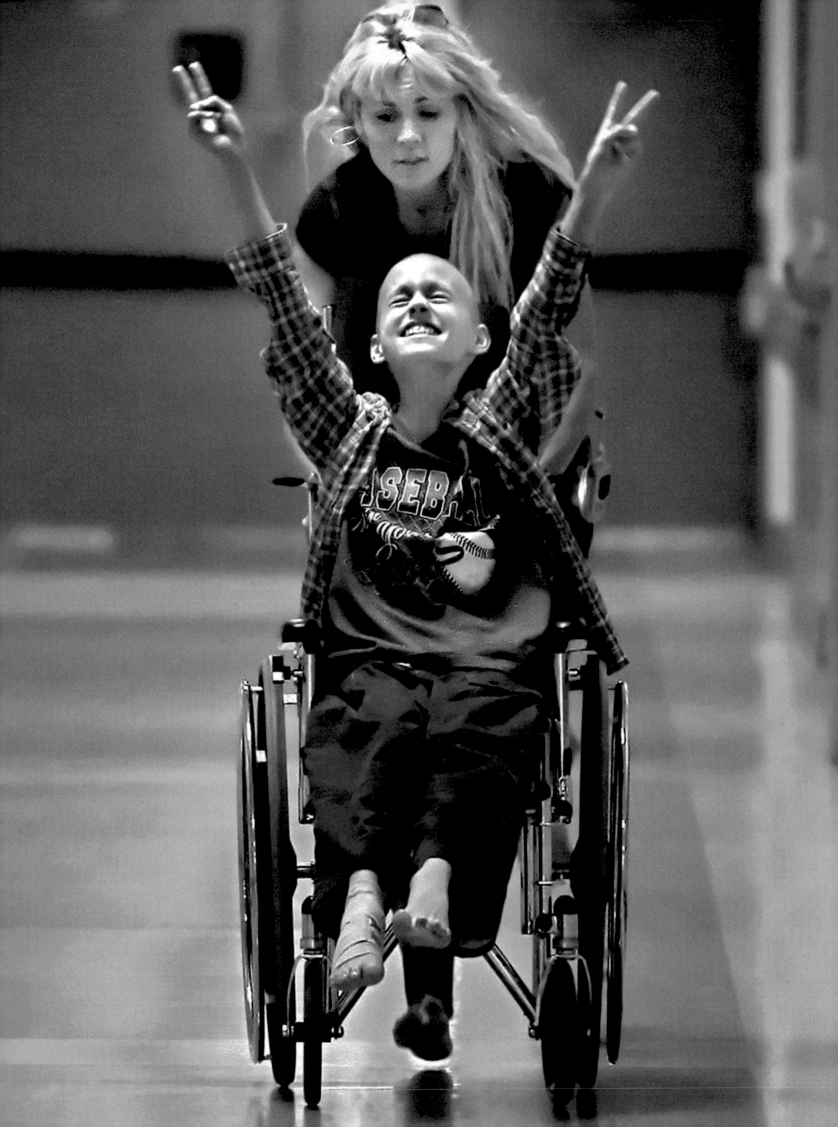

Die Menschheit hat schon immer nach nichts mehr gestrebt, als dass es unseren Kindern gut gehen soll. Es gibt keine wichtigere Aufgabe, als eine Welt zu gestalten, in der alle unsere Kinder in Gesundheit, Frieden und Würde aufwachsen und ihre Fähigkeiten entfalten können.

The desire for our children's well-being has always been the most universally cherished aspiration of mankind. There is no task more important than building a world in which all our children can grow up to realize their full potential, in health, peace and dignity.

Kofi Atta Annan

Kofi Atta Annan ist ein ghanaischer Diplomat. Er war der siebte Generalsekretär der Vereinten Nationen und bekleidete diese Position von 1997 bis 2006. „Für [seinen] Einsatz für eine besser organisierte und friedlichere Welt" wurde Annan gemeinsam mit den Vereinten Nationen im Jahr 2001 der Friedensnobelpreis verliehen.

Kofi Atta Annan is a Ghanaian diplomat. He served as the seventh Secretary-General of the United Nations from 1997 to 2006 . 'For his work towards a better organized and more peaceful world,' Annan, jointly with the United Nations, received the Nobel Peace Prize in 2001.

We the Children

25 Jahre UN-Kinderrechtskonvention
25 Years UN Convention on the Rights of the Child

Peter-Matthias Gaede
Jürgen Heraeus

Christiane Breustedt
Kerstin Bücker

Gemeinsam für Kinder GEO Edition Lammerhuber

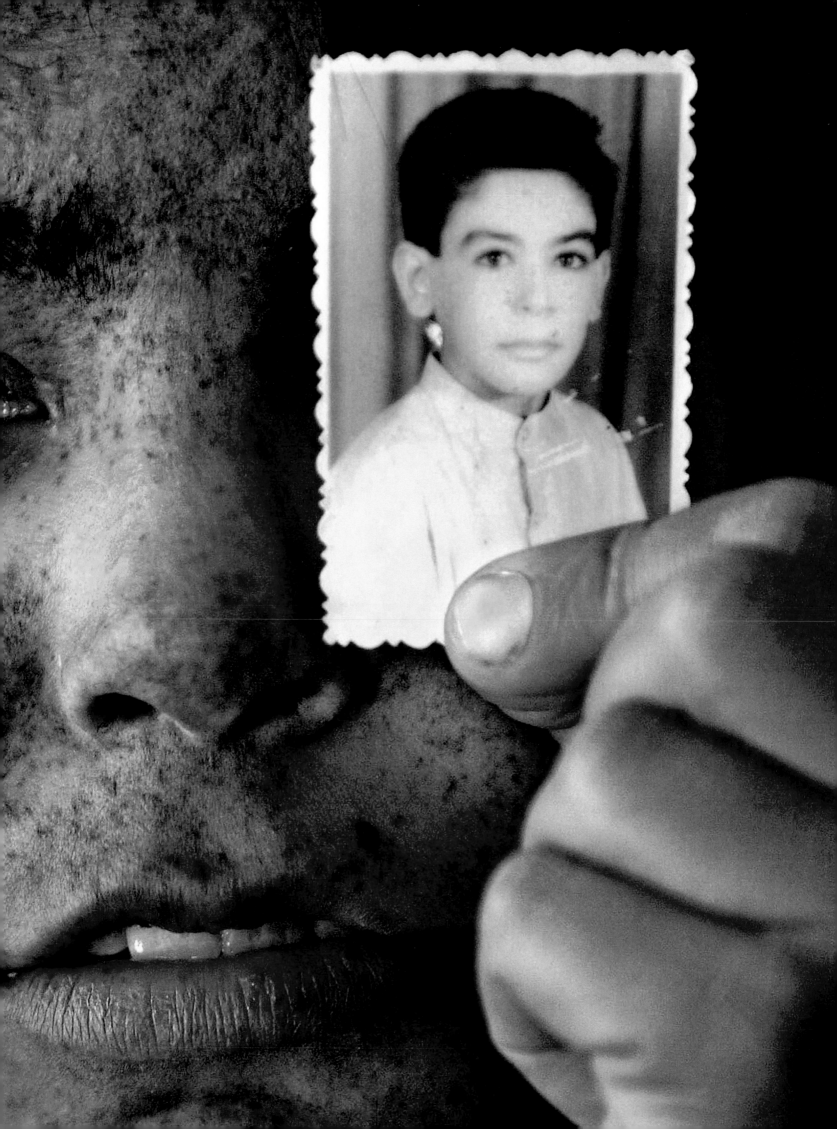

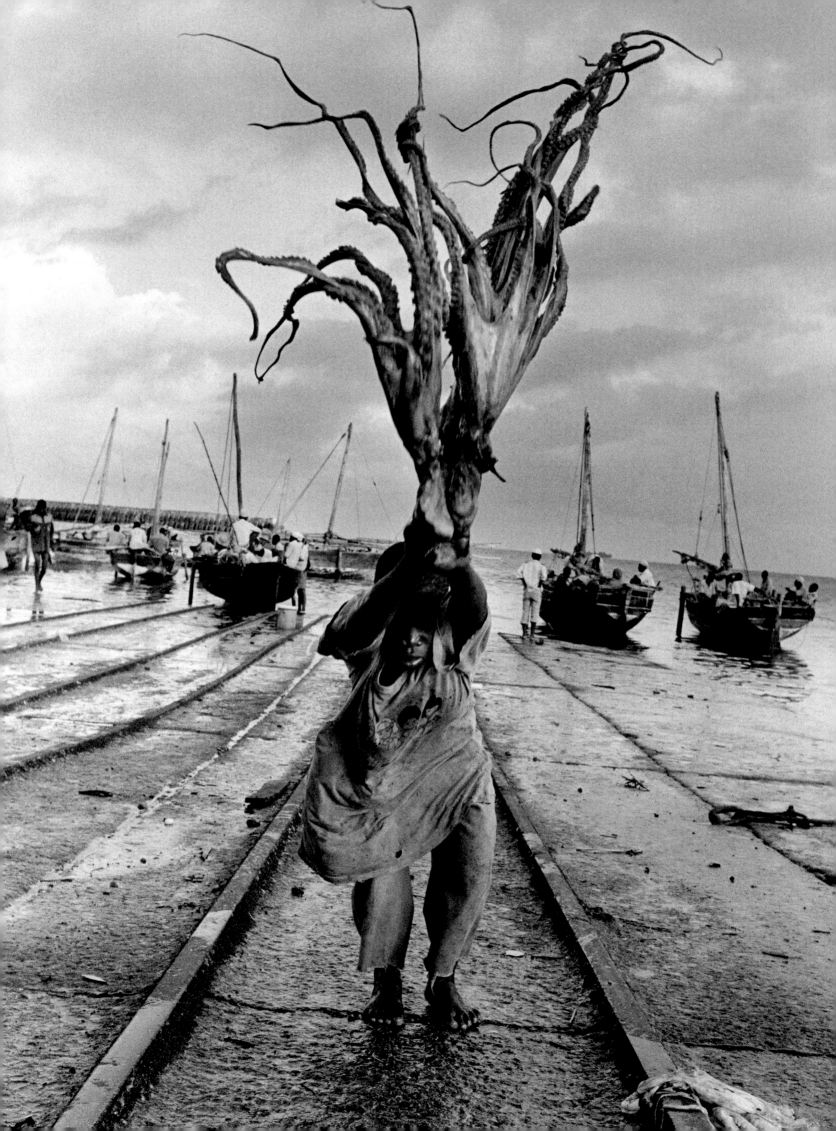

Kinderrechte — für jedes Kind
Rights of the child — for every child 12

Das Recht, gesehen zu werden
The right to be visible 34

Ich habe einen Traum
I have a dream 44

35 Fotoreportagen über die Situation der Kinder unserer Welt
35 Photo reports reflecting the situation of children in our world 68

Die UN-Kinderrechtskonvention im Wortlaut
The UN Convention on the Rights of the Child verbatim 270

Der Wettbewerb „UNICEF-Foto des Jahres"
The UNICEF Photo of the Year Award 292

Vorhergehende Bilder
Previous images
Hartmut Schwarzbach | Argus, 2006
Robin Hammond | Panos Pictures, 2009
Younes Khani | Mehr News Agency, 2013
Don Bartletti | Los Angeles Times, 2000
Renée C. Byer | The Sacramento Bee, 2004
Mauricio Lima | Agence France-Presse, 2003
Fernando Moleres | Panos Pictures/laif, 2007

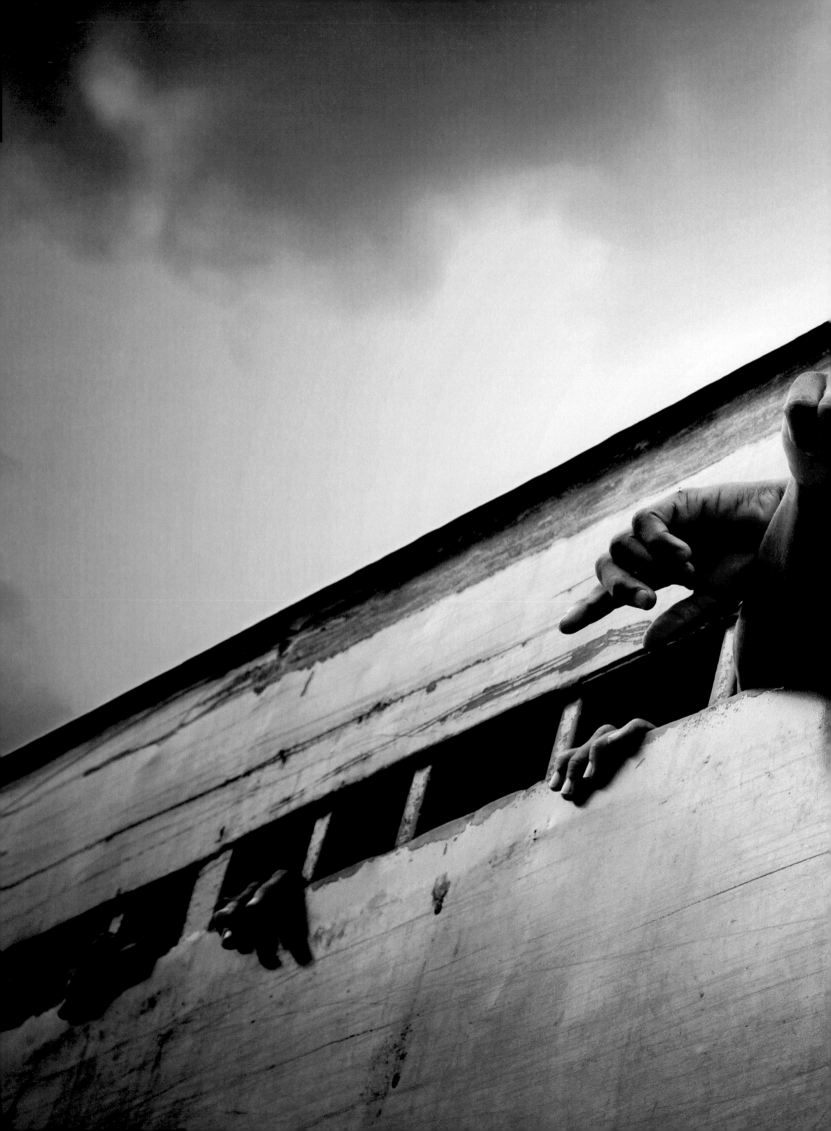

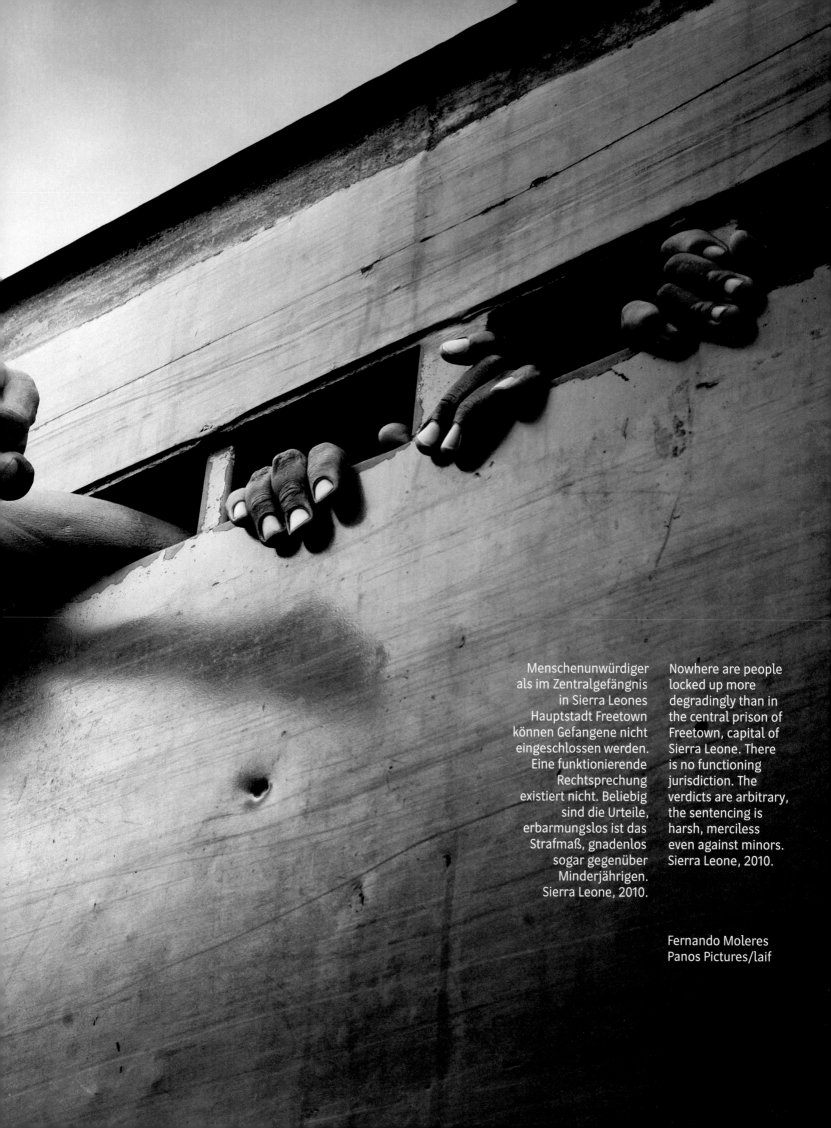

Menschenunwürdiger als im Zentralgefängnis in Sierra Leones Hauptstadt Freetown können Gefangene nicht eingeschlossen werden. Eine funktionierende Rechtsprechung existiert nicht. Beliebig sind die Urteile, erbarmungslos ist das Strafmaß, gnadenlos sogar gegenüber Minderjährigen. Sierra Leone, 2010.

Nowhere are people locked up more degradingly than in the central prison of Freetown, capital of Sierra Leone. There is no functioning jurisdiction. The verdicts are arbitrary, the sentencing is harsh, merciless even against minors. Sierra Leone, 2010.

Fernando Moleres
Panos Pictures/laif

Kinderrechte — für jedes Kind

Jürgen Heraeus
Vorstandsvorsitzender des Deutschen Komitees für UNICEF e. V.

Jedes Kind hat die gleichen Rechte, egal, wo auf der Welt es aufwächst. Es soll überleben und sich gut entwickeln können, zur Schule gehen, vor Gewalt geschützt sein, gehört werden. So steht es in der UN-Kinderrechtskonvention, die so gut wie alle Länder der Erde unterzeichnet haben. Das Wohlergehen der Kinder ist unantastbar — das ist der Kern der UNICEF-Arbeit, und wohl niemand würde dem ernstlich widersprechen. Wie kann es dann im 21. Jahrhundert sein, dass Kinder — wie in Syrien — durch Heckenschützen gezielt ins Visier genommen werden? Warum werden Millionen Kinder misshandelt, oft genau dort, wo sie am sichersten sein sollten — zu Hause oder in der Schule? Weshalb erleben mehr als sechs Millionen Mädchen und Jungen im Jahr nicht einmal ihren fünften Geburtstag? Angesichts der teils dramatischen Bilder, die dieses Buch zeigt, mag die UN-Kinderrechtskonvention mit ihren 54 Artikeln wie ein zahnloser Papiertiger wirken. Doch schaut man genauer hin, wird ihre Bedeutung deutlich: Seit die Konvention 1989 von den Vereinten Nationen verabschiedet wurde, hat sie den Umgang mit Kindern verändert und wichtige Verbesserungen ausgelöst. Erstmals wurde anerkannt: Kinder sind keine „kleinen Erwachsenen", sie haben eigene, ihrer besonderen Lebenssituation angemessene Rechte, die bisher in allgemeinen Menschenrechtsdokumenten oft vergessen wurden.

Die Konvention ist heute ein wichtiges Instrument der Zivilgesellschaft gegenüber Regierungen, Unternehmen und auch in der breiten Öffentlichkeit. Sie hat das Bewusstsein für Kinderrechtsverletzungen wie Kinderarbeit, Gewalt oder sexuelle Ausbeutung geschärft. In vielen Ländern traten entsprechende Gesetze in Kraft oder wurden verbessert. Das Bekenntnis zu den Kinderrechten ging weltweit mit Investitionen in Gesundheit und Bildung, sauberes Trinkwasser, Impfungen, medizinische Versorgung und Aufklärung einher. So ist es in den letzten 25 Jahren gelungen, die Kindersterblichkeit fast zu halbieren. Das ist ein enormer Fortschritt für die Menschlichkeit, aber auch ein Beitrag gegen das Bevölkerungswachstum. Denn wenn Eltern sicher sein können, dass ihre Töchter und Söhne überleben, bekommen sie langfristig weniger Kinder. Eine wichtige Veränderung ist aber auch, dass Kinder heute ernster genommen werden und bei vielen Themen mehr mitreden als früher. Kinder zu respektieren und ihnen zuzuhören, muss überall selbstverständlich werden — zu Hause, in den Schulen und Gemeinden. Auch in den Industrieländern hilft uns die Konvention, die schwierige Situation vieler Kinder besser zu verstehen und Verbesserungen einzufordern — damit benachteiligte Kinder nicht ausgeschlossen werden.

Mit *We the Children* will UNICEF die Augen öffnen für das Leid und die Freude, die Not und die Kraft von Kindern auf der ganzen Welt. Wir möchten erreichen, dass ihr Stellenwert in den Köpfen und den Herzen der Menschen steigt. Wir wollen, dass Erwachsene bei ihren Entscheidungen immer auch an die Kinder denken — auf allen politischen Ebenen, bis hin zur Entwicklung der neuen globalen Entwicklungsziele, die ab 2015 gelten sollen. Wenn ich in die Gesichter in diesem Buch schaue, wird mir klar: Das Schicksal der Kinder lässt niemanden gleichgültig. Der Wunsch, Kindern eine gute Zukunft zu ermöglichen, kann alle Grenzen und Unterschiede überbrücken. Deshalb bin ich zuversichtlich, dass wir gemeinsam eine bessere Welt für Kinder schaffen können. Ich danke allen, die sich zum 25. Geburtstag der Kinderrechte von diesem Buch berühren und für die Rechte der Kinder begeistern lassen. Besonders danke ich dem Auswärtigen Amt der Bundesrepublik Deutschland und allen weiteren Partnern und Unterstützern, die dies möglich gemacht haben.

Rights of the child — for every child

Jürgen Heraeus
Chairman of the German Committee for UNICEF

Every child has the same rights, no matter where in the world it grows up. It shall be able to live and develop well, attend school, be protected from violence and get heard. This is what it says in the UN Convention on the Rights of the Child, which has been signed by practically all countries in the world. The well-being of children is inviolable — this is central to the work of UNICEF and hardly anyone would disagree with that. How then can it be that in the 21st century children are targeted by snipers — as happens in Syria? Why are millions of children abused, often in the very places where they should be safest — at home and at school? Why do more than six million boys and girls every year not even live to their fifth birthday? Compared to the sometimes dramatic pictures in this book, the UN Convention on the Rights of the Child and its 54 Articles may seem like a toothless paper tiger. But look at it more closely and their significance becomes clear: From its adoption by the United Nations in 1989, the Convention has changed the way children are treated and has triggered important improvements. It recognized for the first time that children are not 'small adults'. They have their own rights, appropriate for their circumstances, which have often been overlooked in the general human rights documents.

Today the Convention is an important instrument of civil society vis-à-vis governments, businesses and also the general public. It has raised awareness of violations of children's rights, such as child labour, violence or sexual exploitation. In many countries laws have been passed or improved in this respect. The commitment to the rights of the child across the world has gone hand in hand with investment in health and education, clean drinking water, vaccinations, medical care and sex education. Within the last 25 years infant mortality has halved. This is enormous progress for humanity and a contribution to curbing population growth at the same time. Because if parents can be sure that their sons and daughters will live, they have fewer children in the longer term. Another important change is that children are being taken more seriously today and can have their say on more topics than before. Respecting children and listening to them must become a matter of course everywhere — at home, in schools and communities. In industrial countries, too, the Convention helps to better understand the difficult situation of many children and to demand improvements, so that disadvantaged children are no longer excluded.

With *We the Children* UNICEF wants to open your eyes for the pain and the joy, the hardship and the energy of children across the world. We want to make them a priority in the minds and hearts of people. We want adults to always bear the children in mind in their decisions — at all political levels, including the creation of new global development goals to come into force in 2015. When I look into the faces in this book I realize: The fate of the children leaves no one indifferent. The desire to provide children with a good future can overcome all boundaries and differences. This is why I am confident that together we can create a better world for children. I thank everyone who allows himself or herself to be touched by this book on the 25th anniversary of the Rights of the Child and to get excited about them. My special thanks go to the Foreign Office of the Federal Republic of Germany and all other partners and supporters who made this book possible.

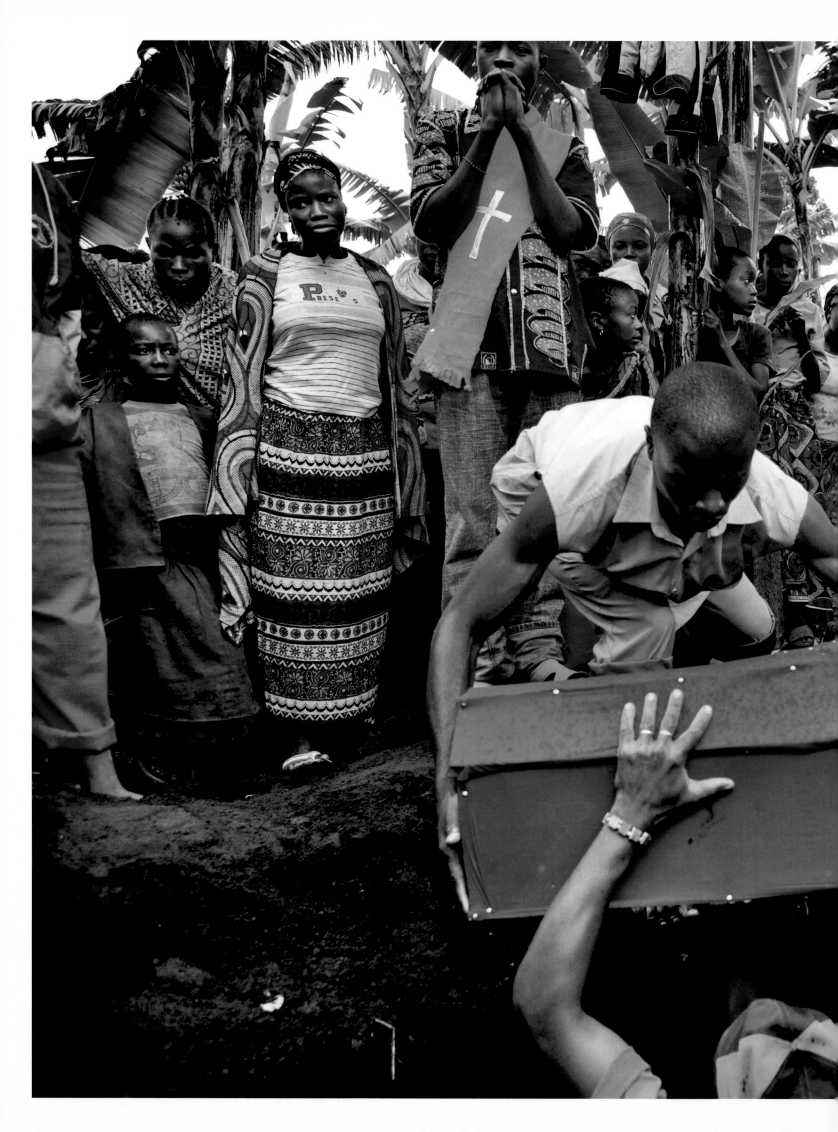

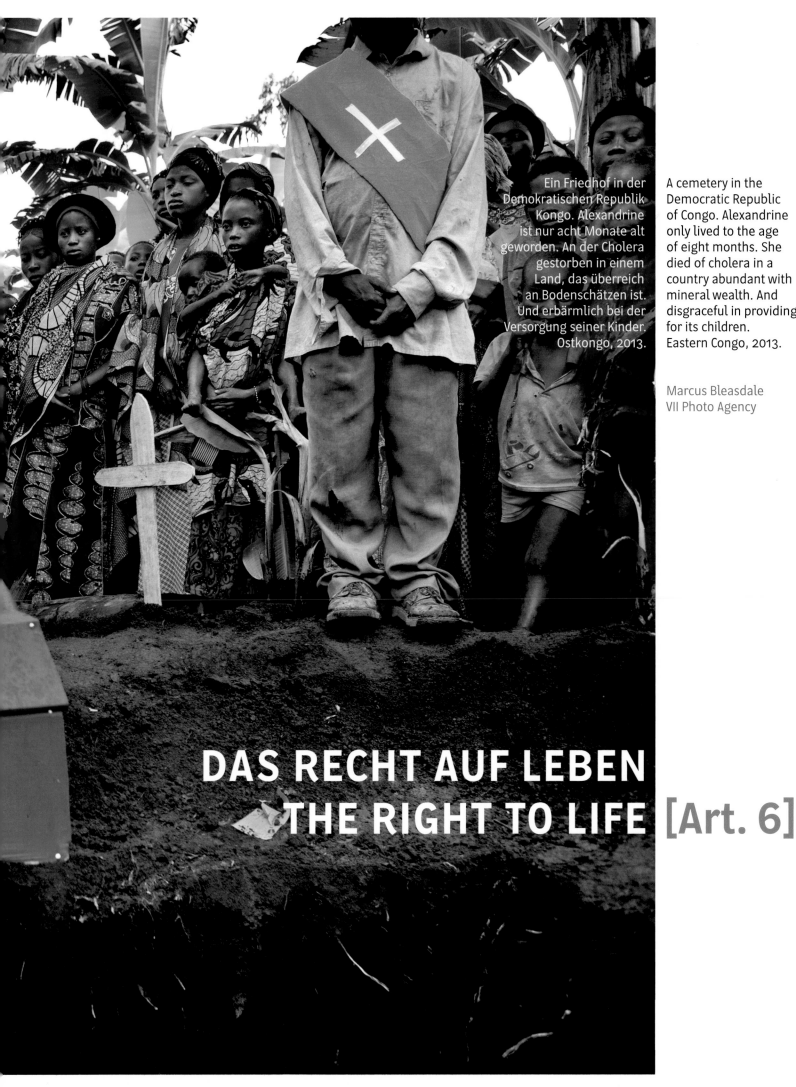

Ein Friedhof in der Demokratischen Republik Kongo. Alexandrine ist nur acht Monate alt geworden. An der Cholera gestorben in einem Land, das überreich an Bodenschätzen ist. Und erbärmlich bei der Versorgung seiner Kinder. Ostkongo, 2013.

A cemetery in the Democratic Republic of Congo. Alexandrine only lived to the age of eight months. She died of cholera in a country abundant with mineral wealth. And disgraceful in providing for its children. Eastern Congo, 2013.

Marcus Bleasdale
VII Photo Agency

DAS RECHT AUF LEBEN
THE RIGHT TO LIFE [Art. 6]

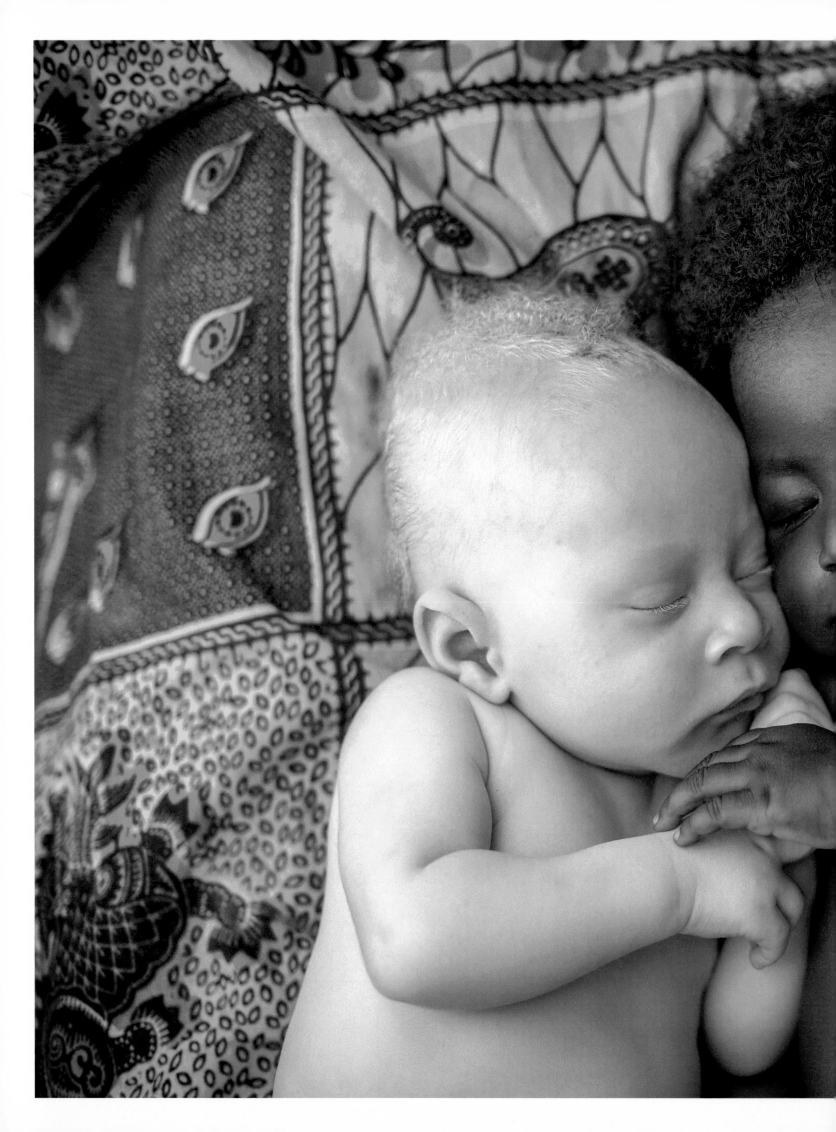

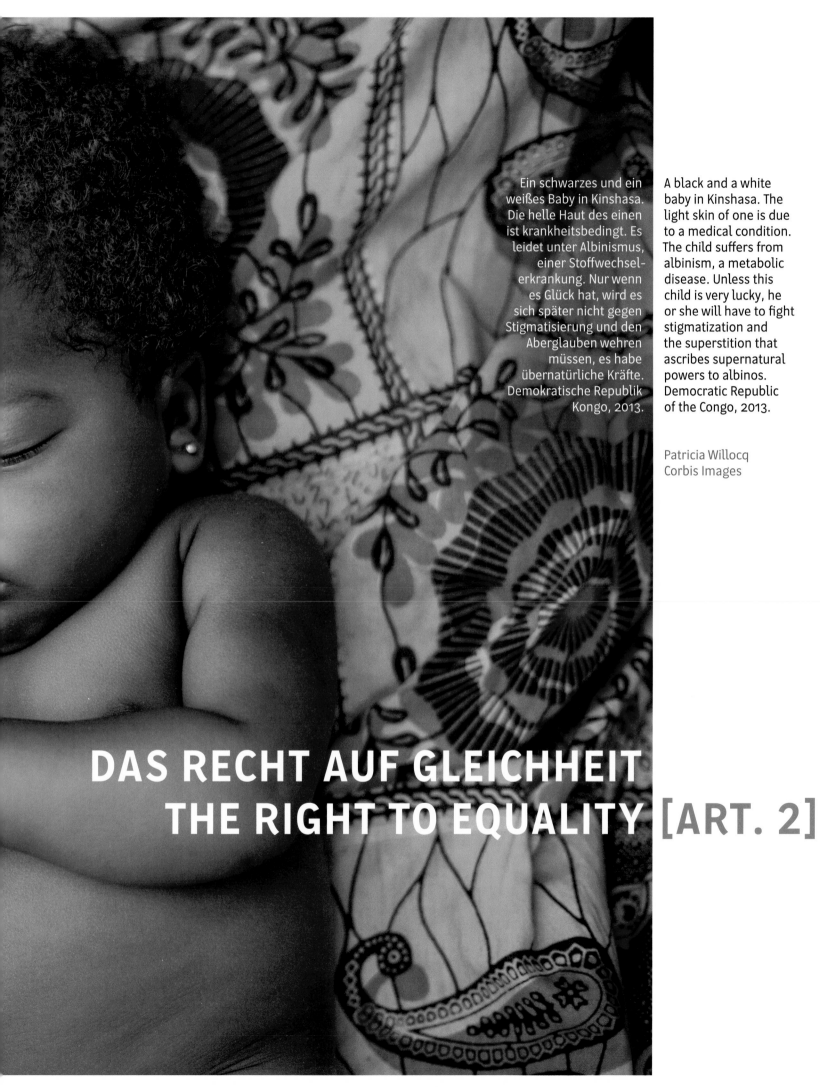

Ein schwarzes und ein weißes Baby in Kinshasa. Die helle Haut des einen ist krankheitsbedingt. Es leidet unter Albinismus, einer Stoffwechselerkrankung. Nur wenn es Glück hat, wird es sich später nicht gegen Stigmatisierung und den Aberglauben wehren müssen, es habe übernatürliche Kräfte. Demokratische Republik Kongo, 2013.

A black and a white baby in Kinshasa. The light skin of one is due to a medical condition. The child suffers from albinism, a metabolic disease. Unless this child is very lucky, he or she will have to fight stigmatization and the superstition that ascribes supernatural powers to albinos. Democratic Republic of the Congo, 2013.

Patricia Willocq
Corbis Images

DAS RECHT AUF GLEICHHEIT
THE RIGHT TO EQUALITY [ART. 2]

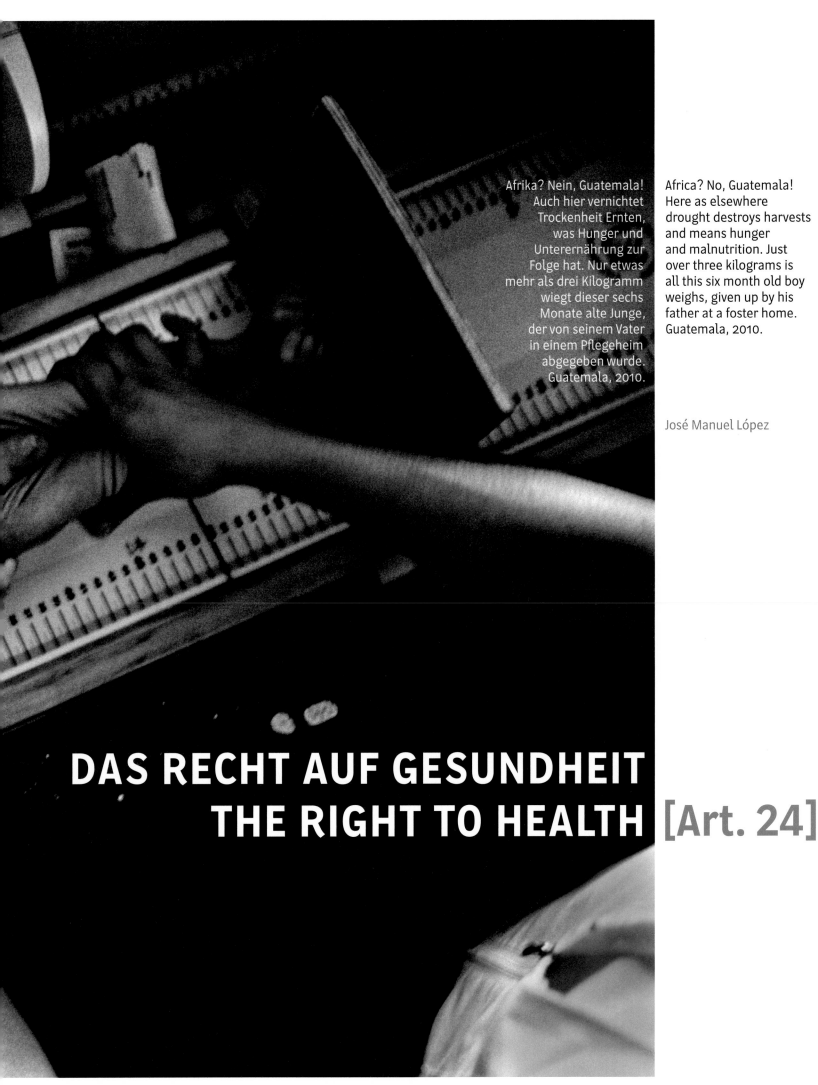

Afrika? Nein, Guatemala! Auch hier vernichtet Trockenheit Ernten, was Hunger und Unterernährung zur Folge hat. Nur etwas mehr als drei Kilogramm wiegt dieser sechs Monate alte Junge, der von seinem Vater in einem Pflegeheim abgegeben wurde. Guatemala, 2010.

Africa? No, Guatemala! Here as elsewhere drought destroys harvests and means hunger and malnutrition. Just over three kilograms is all this six month old boy weighs, given up by his father at a foster home. Guatemala, 2010.

José Manuel López

DAS RECHT AUF GESUNDHEIT
THE RIGHT TO HEALTH [Art. 24]

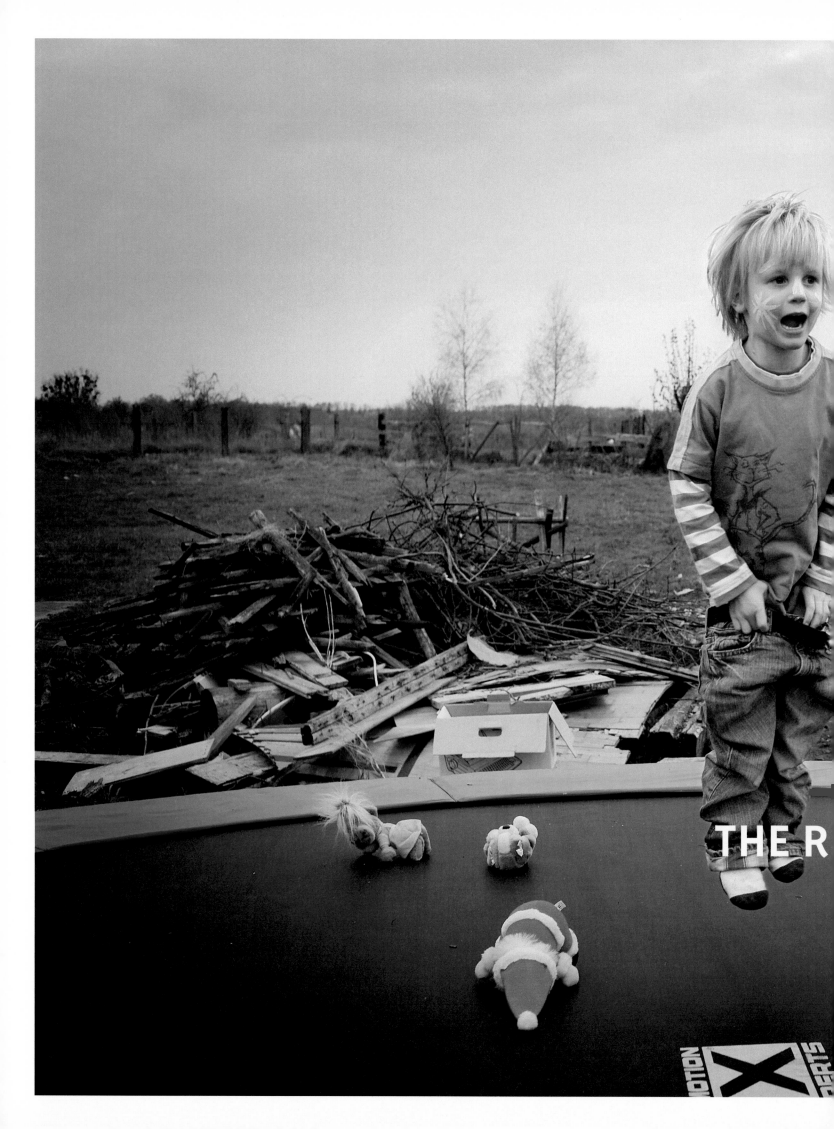

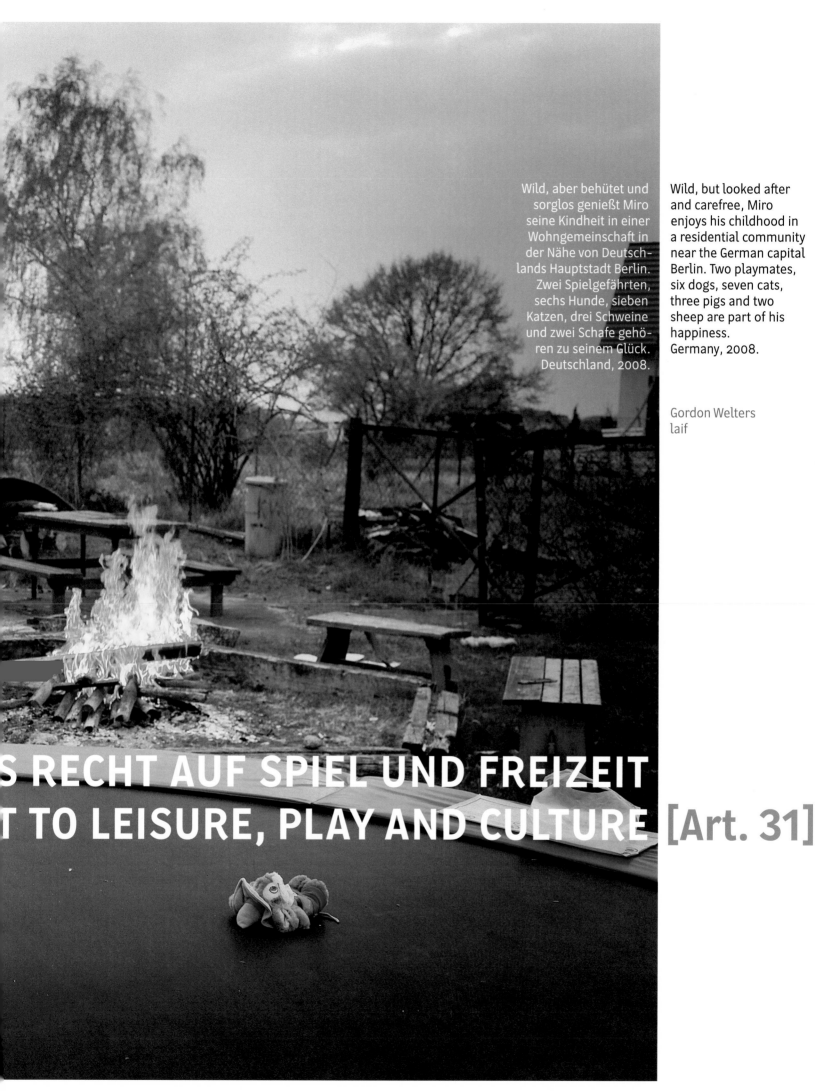

Wild, aber behütet und sorglos genießt Miro seine Kindheit in einer Wohngemeinschaft in der Nähe von Deutschlands Hauptstadt Berlin. Zwei Spielgefährten, sechs Hunde, sieben Katzen, drei Schweine und zwei Schafe gehören zu seinem Glück. Deutschland, 2008.

Wild, but looked after and carefree, Miro enjoys his childhood in a residential community near the German capital Berlin. Two playmates, six dogs, seven cats, three pigs and two sheep are part of his happiness. Germany, 2008.

Gordon Welters
laif

S RECHT AUF SPIEL UND FREIZEIT
T TO LEISURE, PLAY AND CULTURE [Art. 31]

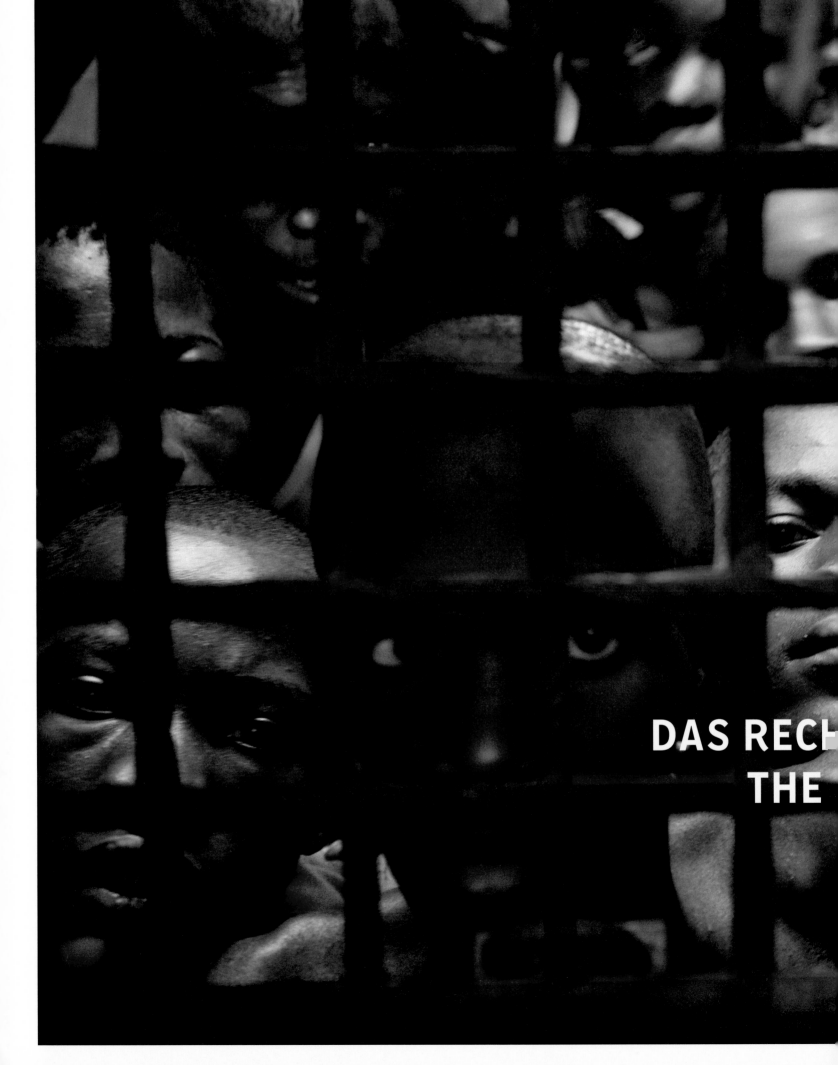

DAS RECH
THE

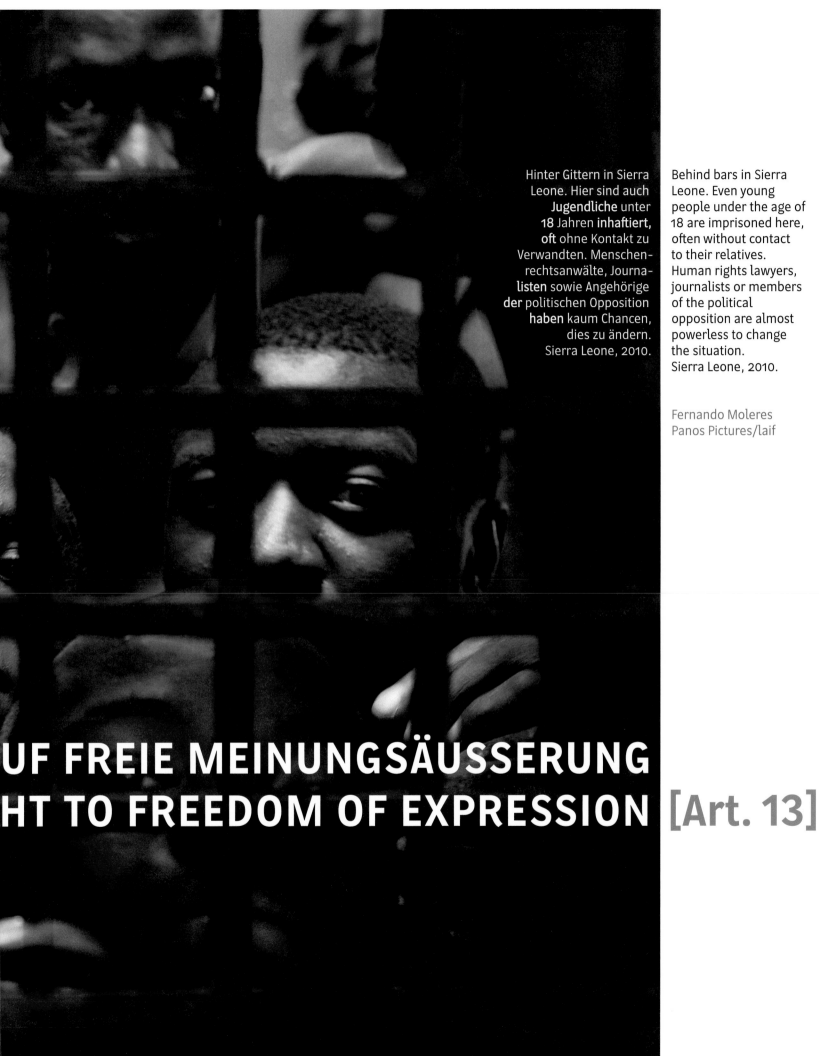

Hinter Gittern in Sierra Leone. Hier sind auch **Jugendliche** unter 18 Jahren **inhaftiert, oft** ohne Kontakt zu Verwandten. Menschenrechtsanwälte, Journa**listen** sowie Angehörige **der** politischen Opposition **haben** kaum Chancen, dies zu ändern. Sierra Leone, 2010.

Behind bars in Sierra Leone. Even young people under the age of 18 are imprisoned here, often without contact to their relatives. Human rights lawyers, journalists or members of the political opposition are almost powerless to change the situation. Sierra Leone, 2010.

Fernando Moleres
Panos Pictures/laif

UF FREIE MEINUNGSÄUSSERUNG
HT TO FREEDOM OF EXPRESSION [Art. 13]

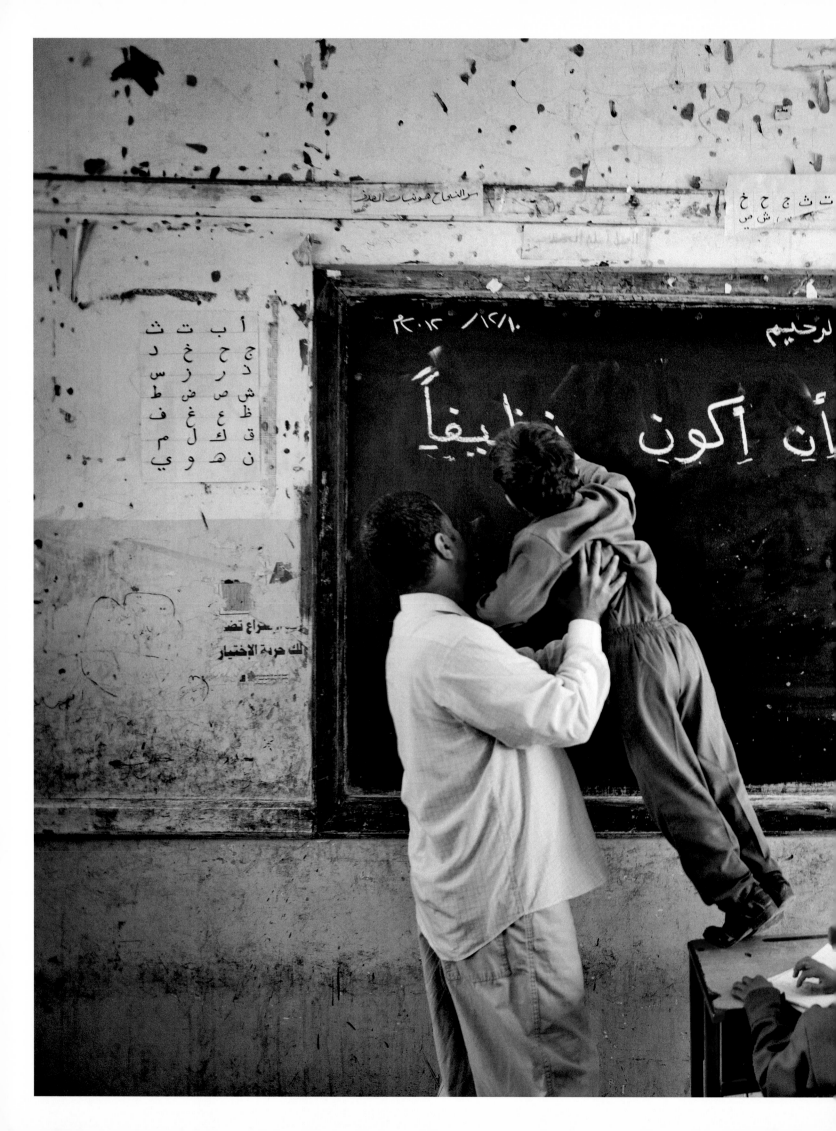

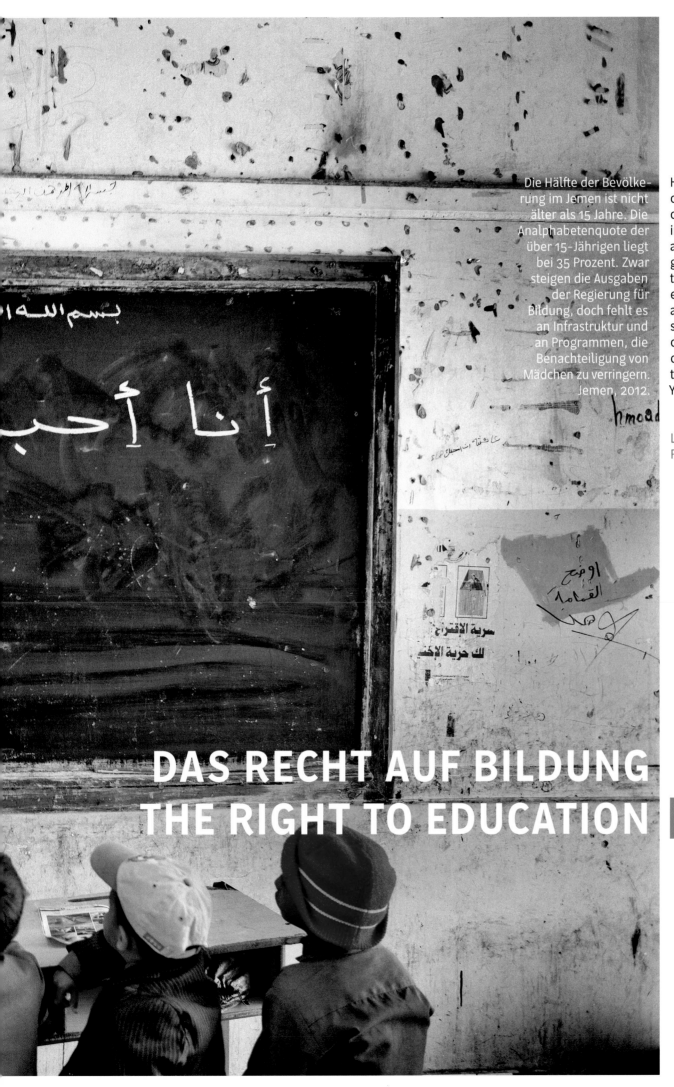

Die Hälfte der Bevölkerung im Jemen ist nicht älter als 15 Jahre. Die Analphabetenquote der über 15-Jährigen liegt bei 35 Prozent. Zwar steigen die Ausgaben der Regierung für Bildung, doch fehlt es an Infrastruktur und an Programmen, die Benachteiligung von Mädchen zu verringern. Jemen, 2012.

Half of the population of Yemen is 15 years or younger. Illiteracy in those over 15 stands at 35 percent. The government has started to spend more on education, but there is a lack of school infrastructure and especially of programmes to counter the discrimination against girls. Yemen, 2012.

Laura Boushnak
Rawiya Collective

DAS RECHT AUF BILDUNG
THE RIGHT TO EDUCATION [Art. 28]

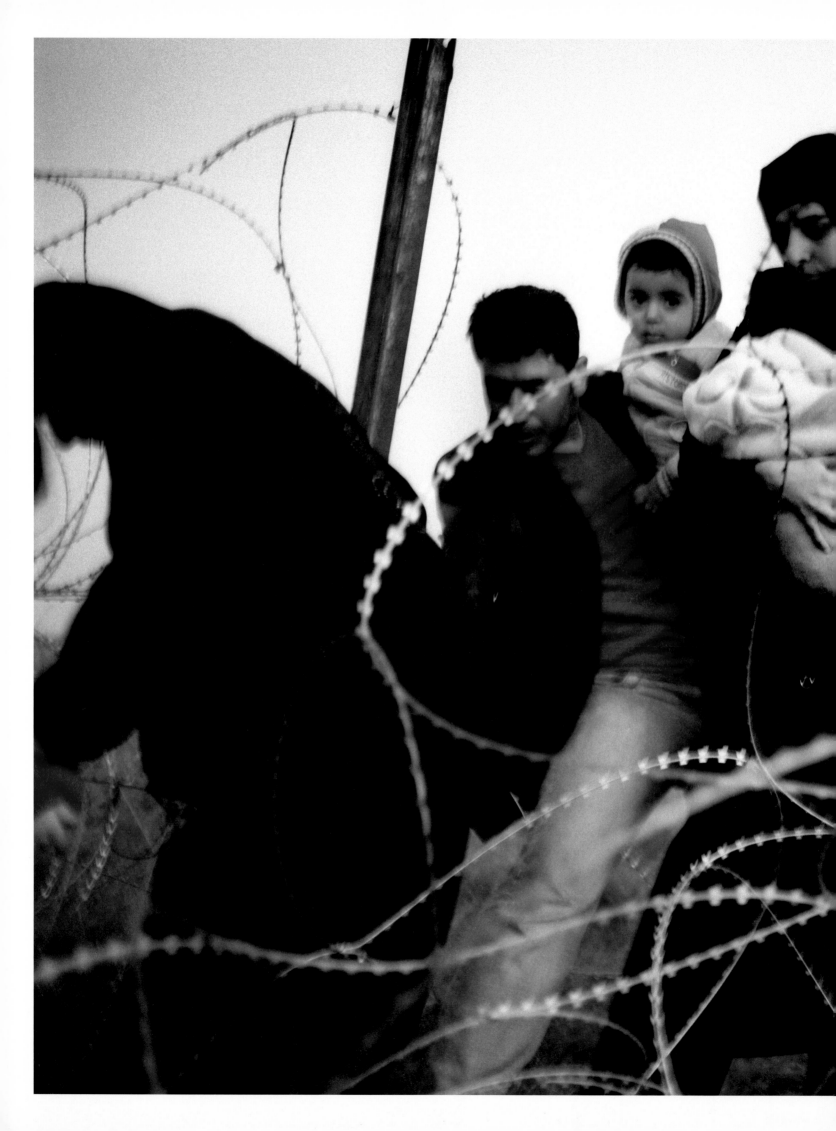

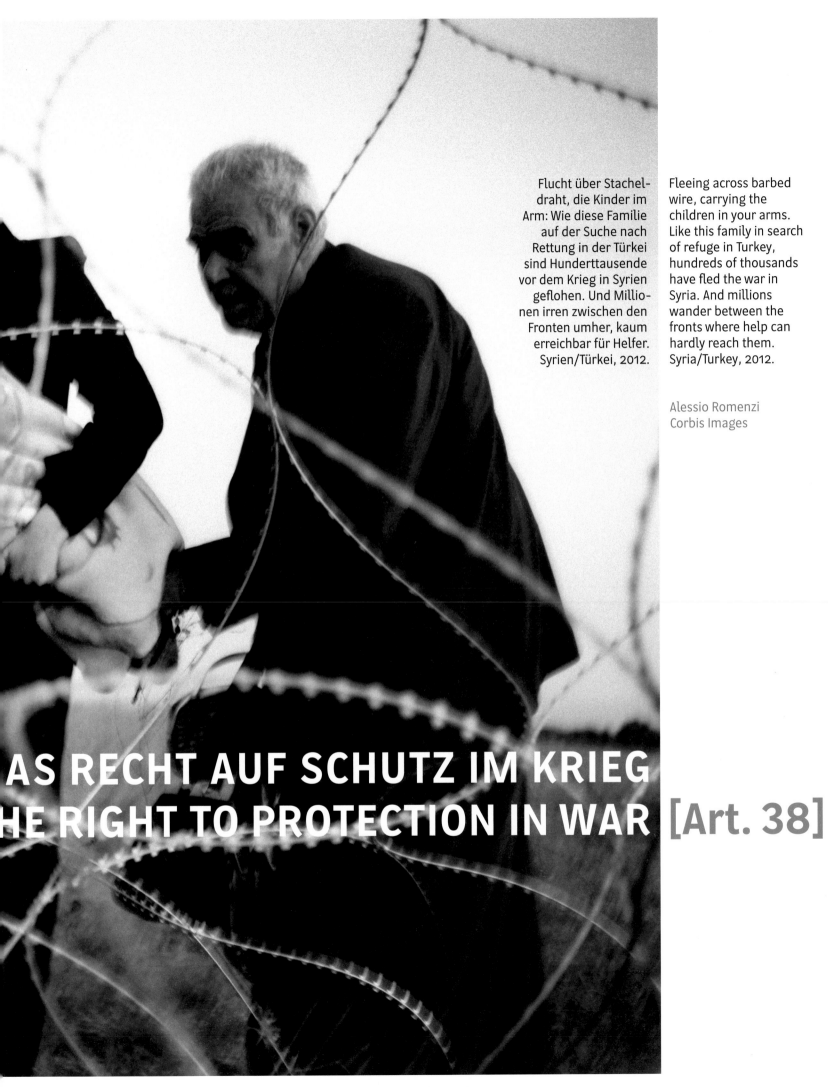

Flucht über Stachel-
draht, die Kinder im
Arm: Wie diese Familie
auf der Suche nach
Rettung in der Türkei
sind Hunderttausende
vor dem Krieg in Syrien
geflohen. Und Millio-
nen irren zwischen den
Fronten umher, kaum
erreichbar für Helfer.
Syrien/Türkei, 2012.

Fleeing across barbed
wire, carrying the
children in your arms.
Like this family in search
of refuge in Turkey,
hundreds of thousands
have fled the war in
Syria. And millions
wander between the
fronts where help can
hardly reach them.
Syria/Turkey, 2012.

Alessio Romenzi
Corbis Images

AS RECHT AUF SCHUTZ IM KRIEG
HE RIGHT TO PROTECTION IN WAR [Art. 38]

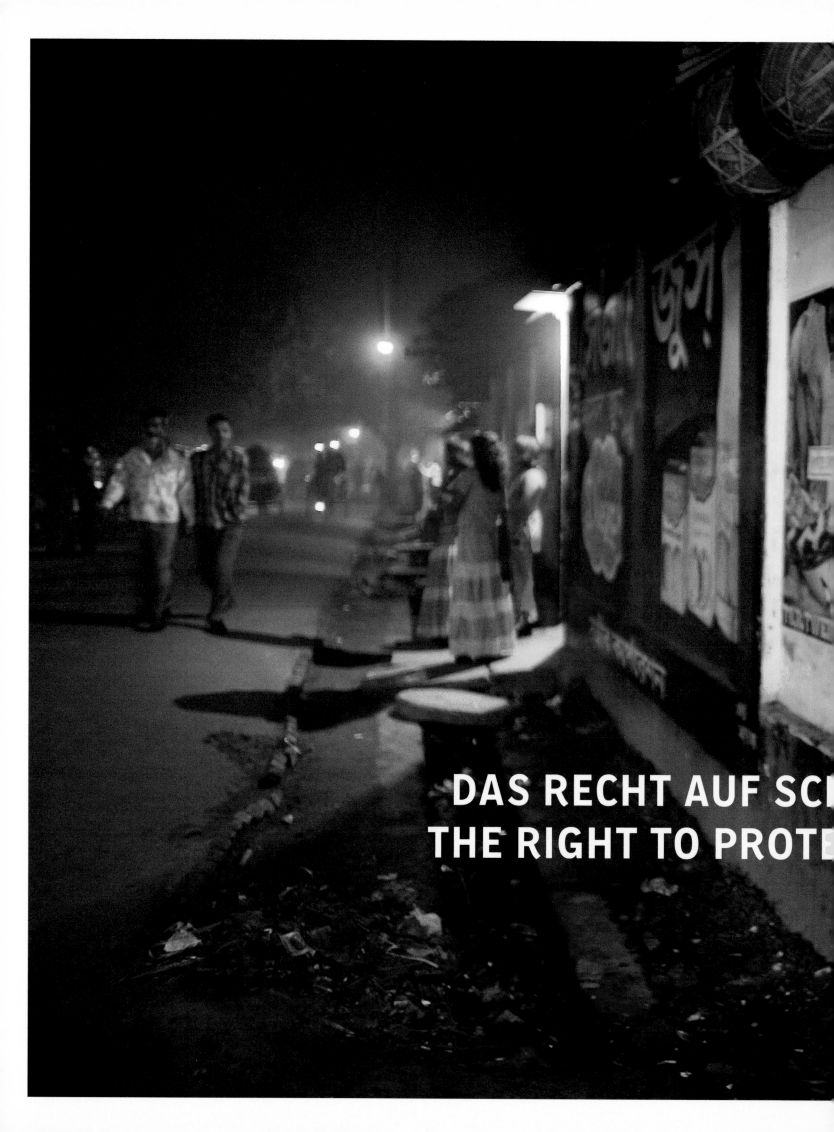

DAS RECHT AUF SCH
THE RIGHT TO PROTE

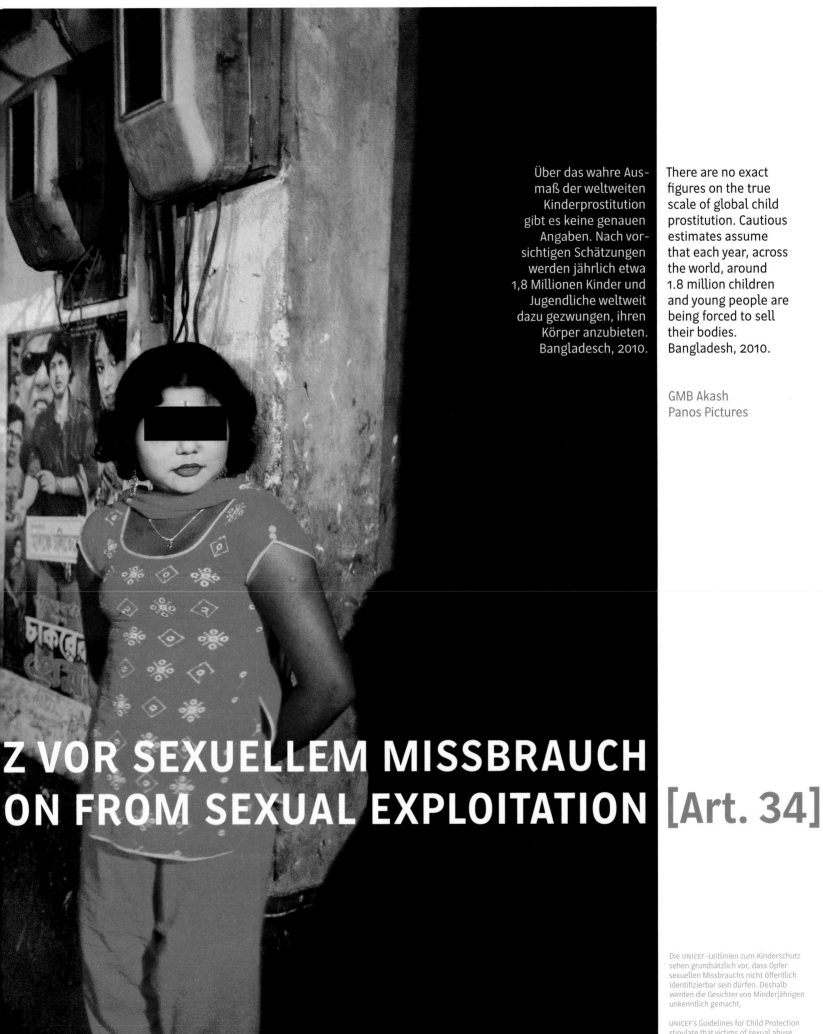

Über das wahre Ausmaß der weltweiten Kinderprostitution gibt es keine genauen Angaben. Nach vorsichtigen Schätzungen werden jährlich etwa 1,8 Millionen Kinder und Jugendliche weltweit dazu gezwungen, ihren Körper anzubieten. Bangladesch, 2010.

There are no exact figures on the true scale of global child prostitution. Cautious estimates assume that each year, across the world, around 1.8 million children and young people are being forced to sell their bodies. Bangladesh, 2010.

GMB Akash
Panos Pictures

Z VOR SEXUELLEM MISSBRAUCH
ON FROM SEXUAL EXPLOITATION [Art. 34]

Die UNICEF-Leitlinien zum Kinderschutz sehen grundsätzlich vor, dass Opfer sexuellen Missbrauchs nicht öffentlich identifizierbar sein dürfen. Deshalb werden die Gesichter von Minderjährigen unkenntlich gemacht.

UNICEF's Guidelines for Child Protection stipulate that victims of sexual abuse must be unidentifiable. For this reason, the faces of minors have been made unrecognizable.

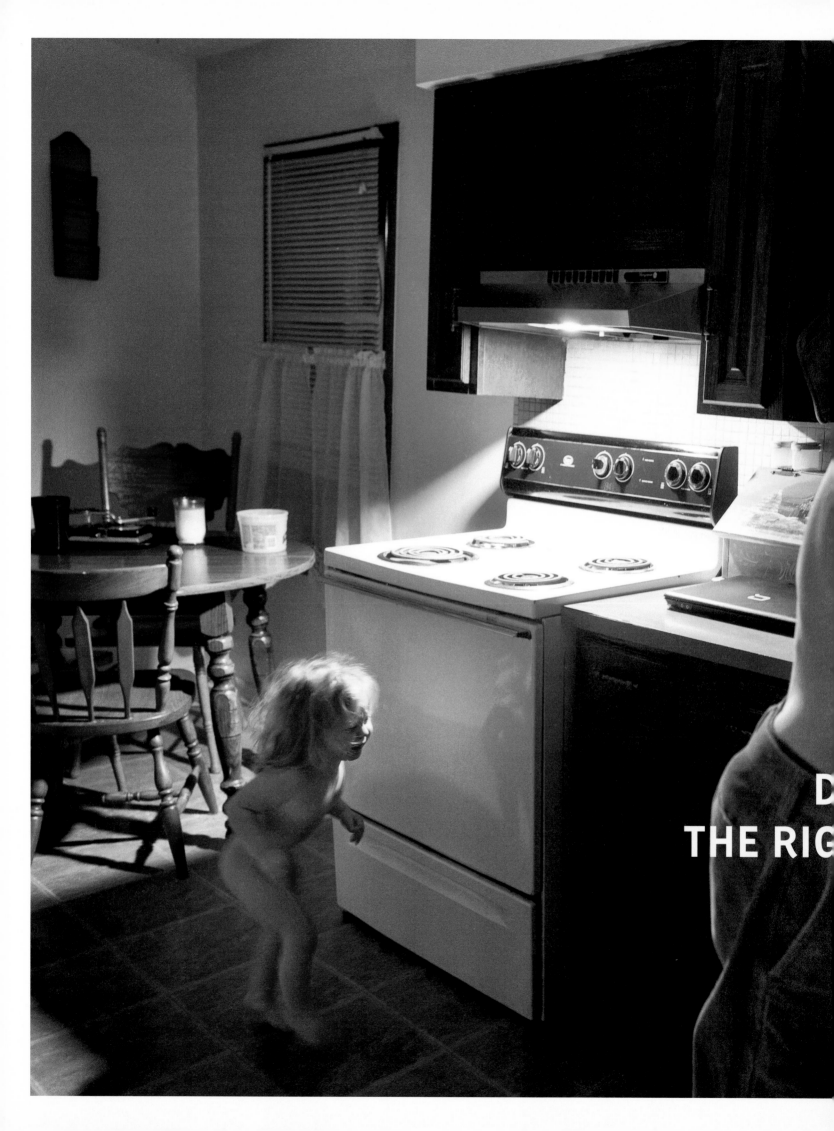

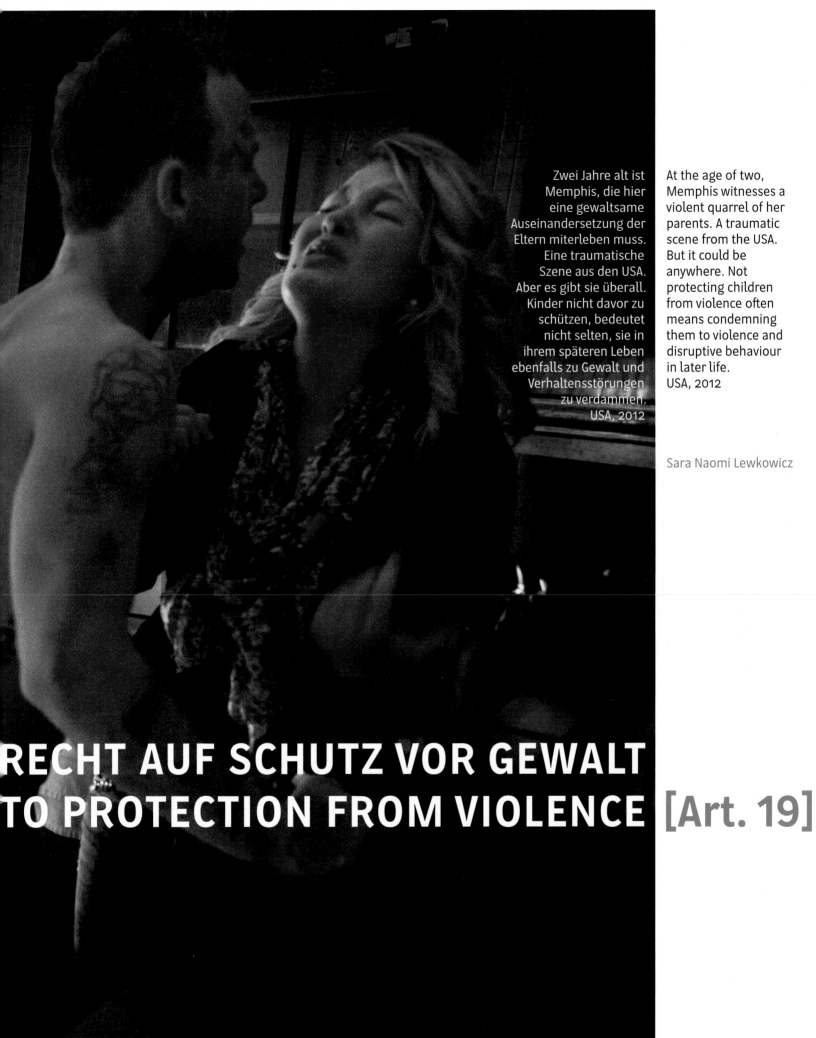

Zwei Jahre alt ist Memphis, die hier eine gewaltsame Auseinandersetzung der Eltern miterleben muss. Eine traumatische Szene aus den USA. Aber es gibt sie überall. Kinder nicht davor zu schützen, bedeutet nicht selten, sie in ihrem späteren Leben ebenfalls zu Gewalt und Verhaltensstörungen zu verdammen.
USA, 2012

At the age of two, Memphis witnesses a violent quarrel of her parents. A traumatic scene from the USA. But it could be anywhere. Not protecting children from violence often means condemning them to violence and disruptive behaviour in later life.
USA, 2012

Sara Naomi Lewkowicz

RECHT AUF SCHUTZ VOR GEWALT
TO PROTECTION FROM VIOLENCE [Art. 19]

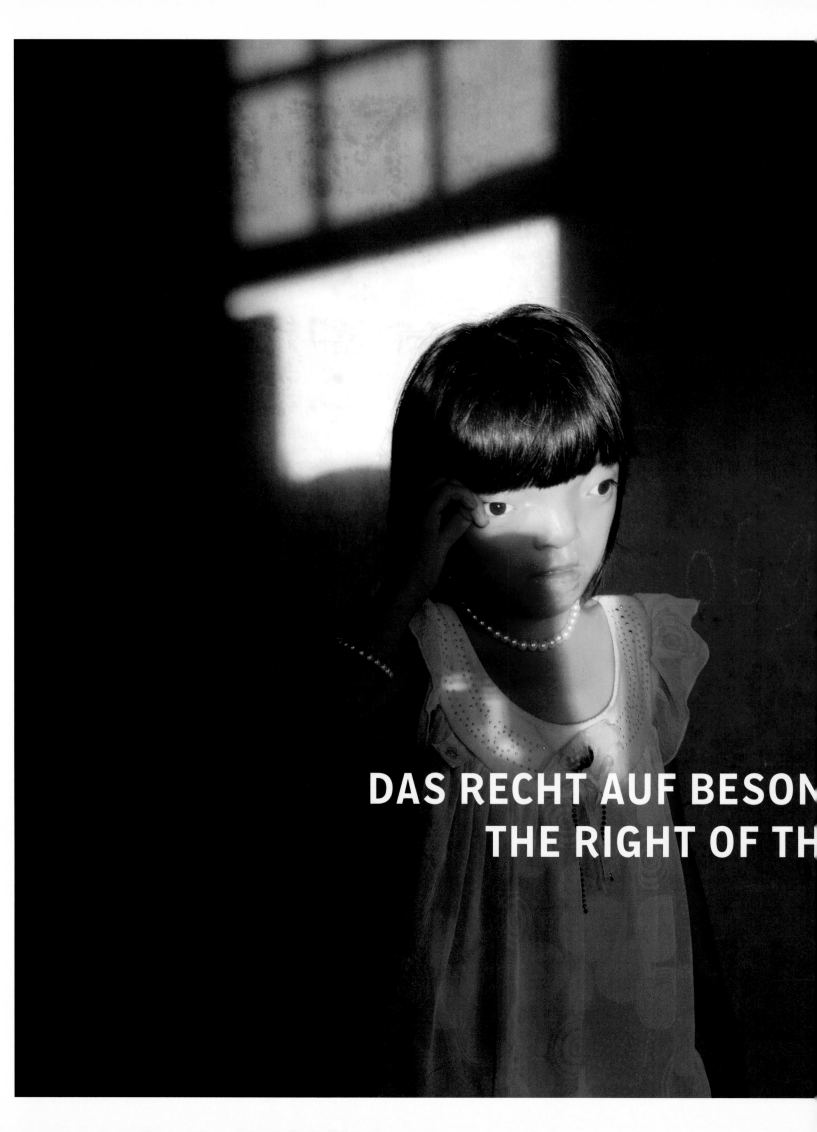

DAS RECHT AUF BESON
THE RIGHT OF TH

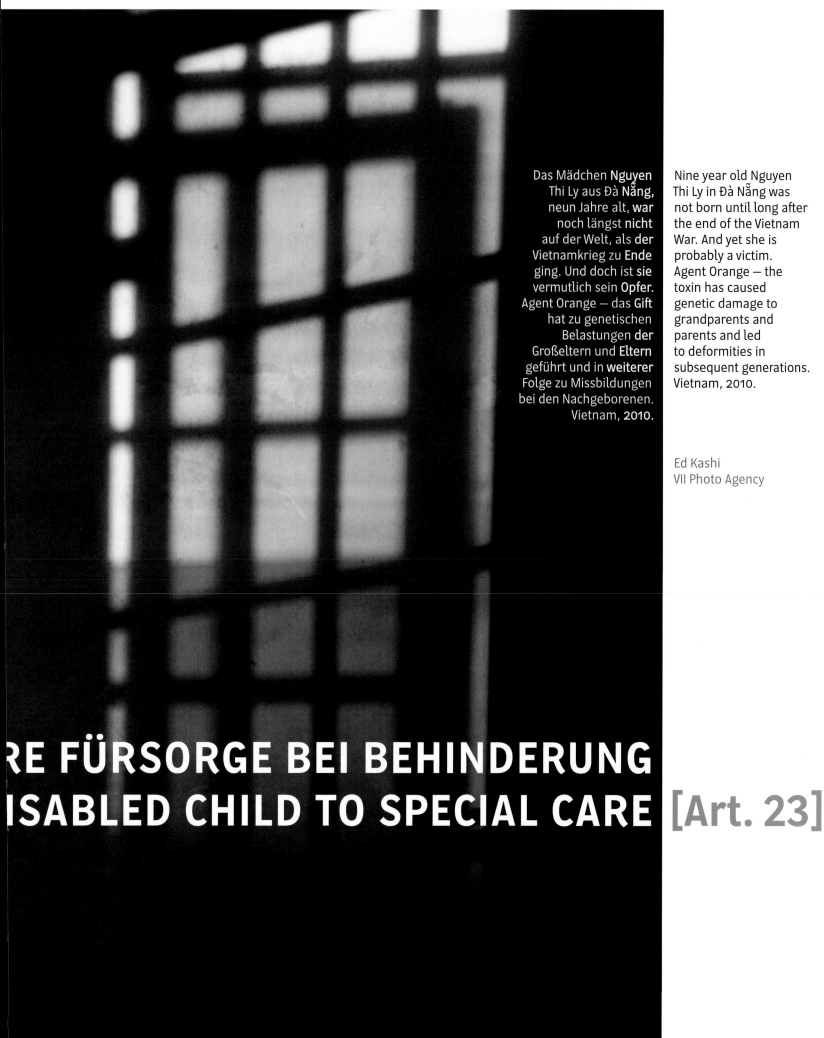

Das Mädchen **Nguyen** Thi Ly aus Đà **Nẵng,** neun Jahre alt, **war** noch längst **nicht** auf der Welt, als **der** Vietnamkrieg zu **Ende** ging. Und doch ist **sie** vermutlich sein **Opfer.** Agent Orange — das **Gift** hat zu genetischen Belastungen **der** Großeltern und **Eltern** geführt und in **weiterer** Folge zu Missbildungen bei den Nachgeborenen. Vietnam, **2010.**

Nine year old Nguyen Thi Ly in Đà Nẵng was not born until long after the end of the Vietnam War. And yet she is probably a victim. Agent Orange — the toxin has caused genetic damage to grandparents and parents and led to deformities in subsequent generations. Vietnam, 2010.

Ed Kashi
VII Photo Agency

RE FÜRSORGE BEI BEHINDERUNG
ISABLED CHILD TO SPECIAL CARE [Art. 23]

Das Recht, gesehen zu werden

Peter-Matthias Gaede
Chefredakteur GEO, 1994 bis 2014

Nicht Mehl und Grütze erbat er sich, sondern Blumen. Blumen für die 200 Kinder, die er in seinem Waisenhaus im Warschauer Ghetto behütete. Es war der Juni 1942. An Hunger, an Typhus starben die Menschen im Ghetto an jedem dieser schrecklichen Tage im dritten Jahr der deutschen Besatzung; sie starben in Massen. Und wahrscheinlich hatten auch die Kinder in Dr. Janusz Korczaks Heim nur wenig, was sie am Leben hielt. Aber „heiter, kindlich, sorglos" sollten sie doch sein, wünschte sich Korczak, „sie haben ein Recht auf den heutigen Tag".

Als sie dann in den Zug steigen sollten, der sie in das Vernichtungslager Treblinka bringen sollte, in den Tod, verließ Korczak sie nicht. Er wollte es ihnen leichter machen. Aufs Land würden sie fahren, erzählte er ihnen wohl, auf Blumenwiesen. In Wälder, wo es Beeren und Pilze geben würde. Und so traten die 200 Waisenkinder paarweise zum Abmarsch an, fröhlich; ein zwölfjähriger Junge an der Spitze des Zuges spielte auf seiner Geige, so schrieb es ein Zeuge auf. Die Kinder sangen, die zwei Kleinsten trug Korczak auf dem Arm. Und vielleicht tat er das auch, als sie in die Gaskammer mussten. Der Tag ist nicht bekannt, an dem es geschah.

So starb der polnische Kinderarzt jüdischen Glaubens, der Reformpädagoge, der Schriftsteller Janusz Korczak, eigentlich Henryk Goldszmit, der die Kinder liebte. Dieses „Proletariat auf kleinen Füßen", das ihm allgemein rechtlos und ausgebeutet vorkam. Der mahnte, ihre Bedürfnisse wahrzunehmen, so klein sie auch sein mochten. Denn: „Kinder werden nicht zu Menschen, sie sind es bereits." Und der deshalb forderte, dass sie Rechte haben sollten. Das Recht, so sein zu dürfen, wie sie sind. Unwissend zunächst. Und wissbegierig. Das Recht, weinen zu dürfen. Das Recht, ernst genommen und zu nichts verpflichtet zu werden, was ihre Kraft und ihr Alter überstiege. Das Recht auf Eigenart und Eigentum. Das Recht, vor Armut und Missbrauch, Krankheit und Gewalt geschützt zu werden. In einer „Magna Charta Libertatis", einer Verfassung für Kinder, sollte all dies festgelegt werden. Schon 1919 hatte Korczak das angestrebt. „Vielleicht ist das einmal, nach 50 Jahren, irgendjemandem von Nutzen" — so begann, geschrieben im August 1942, die letzte Tagebuchaufzeichnung von Janusz Korczak, der bereit war, mit seinen Kindern einen letzten Weg zu gehen. Denn, so schrieb er: „Nicht mich will ich retten, sondern meine Idee."

Sie wurde gerettet. Und es war gewiss ein schöner Moment, als am 20. November 1989 die große Schauspielerin Audrey Hepburn ans Rednerpult der Generalversammlung der Vereinten Nationen in New York trat, um jenen Völkerrechtsvertrag zu verlesen, mit dem 193 Staaten die UN-Kinderrechtskonvention verabschiedet hatten. Noch sollte es zwar fast ein weiteres Jahr dauern, bis sie in Kraft trat. Noch immer ist sie von einigen wenigen Staaten nicht ratifiziert, und ein Land wie Deutschland unterschrieb zunächst nur mit einigen Vorbehalten, die erst 2010, auch auf Druck von UNICEF, zurückgenommen wurden. Auch Zusatzprotokolle mussten hinzukommen: zum Mindestalter für die Teilnahme junger Soldaten an Kampfhandlungen, 18 Jahre, schlimm genug; zum Verbot von Kinderhandel, Kinderprostitution und -pornografie; zum Recht von Kindern, sich an einen Beschwerdeausschuss der Vereinten Nationen zu wenden.

Aber immerhin: Der Kinderrechtskonvention sind mehr Staaten beigetreten als sämtlichen anderen UN-Konventionen bisher. Und deutlich hinaus reicht sie über alle vorangegangenen Versuche, die Rechte von Kindern in universale Normen zu gießen. Deutlich hinaus also über die „Genfer Erklärung" des Völkerbundes von 1924, über UN-Erklärungen von 1948, 1959 und

The right to be visible

Peter-Matthias Gaede
Editor-in-chief GEO Magazine, 1994 to 2014

He did not ask for flour and gruel but for flowers. Flowers for the 200 children he cared for in his orphanage in the Warsaw ghetto. It was June 1942. On each of these terrible days in the third year of German occupation, people died of hunger, of typhoid fever; they died in great numbers. And the children in Dr. Janusz Korczak's orphanage probably had not much to keep them alive either. But Korczak wished for them to be "happy, childlike, carefree — they have a right to the present day."

Later, when they were to board the train that would take them to Treblinka extermination camp, to their death, Korczak did not leave them. He wanted to make it easier for them. They were going to the country, he may have told them, to flowering meadows. To forests, where berries and mushrooms grew. And so the 200 orphans lined up in pairs, cheerfully; a twelve year old boy at the head of the group played on his violin, a witness wrote. The children sang, Korczak carried the two smallest in his arms. And maybe he also carried them when they entered the gas chambers. The date on which it happened is not known.

This is how Janusz Korczak, real name Henryk Goldszmit, died. The Polish paediatrician of Jewish faith, reform educator, author, who loved children, this "proletariat on little feet", which seemed to him to lack rights and to be exploited. Who called for recognizing their needs, however small. Because: "Children do not grow into human beings, they already are". And who demanded that they should therefore have rights. The right to be as they are. Unknowing at first. And inquisitive. The right to cry. The right to be taken seriously and not to be made to do anything that exceeded their strength and age. The right to peculiarity and possession. The right to be protected from poverty, abuse, disease and violence. It should all be set down in a Magna Charta Libertatis, a constitution for children. Korczak strove for that as early as 1919. "Maybe one day, after 50 years, this may be useful for someone." This is how the last diary entry starts, written in August 1942, by Janusz Korczak, who was prepared to go with his children to the very end. Because, he wrote, "It is not me I want to save but my idea."

It was saved. And it must have been a beautiful moment when on 20 November 1989 the great actress Audrey Hepburn came to the lectern at the United Nations General Assembly in New York to read out the international treaty with which 193 states had adopted the UN Convention on the Rights of the Child. It did take almost a whole year for it to come into force. To this day a very few states have not ratified it, and a country like Germany at first only signed with reservations that were not taken back until 2010, not least under pressure from UNICEF. Additional protocols were also needed: on a minimum age of 18, bad enough, for young soldiers to take active part in combat; on the prohibition of child trafficking, child prostitution and child pornography; on the right of the child to address the UN Committee on the Rights of the Child.

Still, so far the Convention on the Rights of the Child has been adopted by more states than any other UN Convention. And it clearly reaches far beyond any previous attempt to express the rights of children as universal norms. Beyond the 1924 Declaration of Geneva by the League of Nations, beyond UN declarations of 1948, 1959 and 1966 and beyond the more symbolic designation of an International Year of the Child in 1976. "Children do not grow into human beings, they already are" — how truly revolutionary this statement by Janusz Korczak was, while seemingly explaining the obvious: It almost shows more clearly in the plainer

1966 und die eher symbolhafte Ausrufung eines „Internationalen Jahres des Kindes" 1976. „Kinder werden nicht zu Menschen, sie sind es bereits" – wie in Wahrheit revolutionär dieser Satz des Janusz Korczak war, der doch anmutet, als würde er nur das Selbstverständlichste der Welt erklären: Es zeigt sich fast in den unscheinbareren Passagen der 54 Artikel der UN-Kinderrechtskonvention noch mehr als dort, wo die Befreiung der Kinder von Krankheit oder Hunger oder ihr Recht auf Bildung eingefordert werden. Jedes Kind hat das Recht auf einen Namen, auf Identität, auf ein Alter! Ja, selbst das musste und muss nämlich erkämpft werden: Bis heute ist jedes dritte Kind auf dieser Welt nicht einmal offiziell registriert, hat nur einer von sieben kleinen Erdenbürgern überhaupt eine Geburtsurkunde.

Es war ein langer Weg, auf dessen Etappe der 20. November 1989 stand: Egal, ob das Kind nun, wie viele Kulturgeschichtler meinen, erst im 19. Jahrhundert und vom Bürgertum als „nachwachsende Ressource" und also schützenswertes Gut, gar als Teil einer neuen familiären Innigkeit entdeckt worden war – und davor nur eine Art minderbemittelter Erwachsener und Arbeitskraft war, schon deshalb nicht besonders in einen Kokon aus Liebe, Fürsorge und Nachsicht gehüllt, weil Sterblichkeit, elende Lebensumstände und geringe Lebenserwartung keinerlei Zeit für Zärtlichkeit ließen. Oder ob sich das „Konzept Kindheit" als Ausdruck einer speziellen Lebensphase womöglich doch schon im 16. und 17. Jahrhundert herauskristallisiert hatte und zumindest in einem religiösen Kontext eine neue Gefühlskultur gegenüber Kindern allmählich in die Gesellschaft sickerte. Weder Rousseau 1762 (*Émile oder über die Erziehung*) noch der English Factories Act, der 1833 Fabrikarbeit für Kinder unter neun Jahren verbot, hatten jedenfalls nur entfernt die Dimension dieser allgemeinen Menschenrechtserklärung für Kinder, die an einem Montag im November des Jahres 1989 am East River zu Manhattan beschlossen wurde. In memoriam Janusz Korczak. In memoriam Eglantyne Jebb, der Begründerin des Save the Children Fund, die angesichts des Elends, in das der Erste Weltkrieg die Menschen gestürzt hatte, eine Children's Charta entworfen hatte. Im Gedenken an viele andere Pioniere des Gedankens, wenigstens für die Kinder müsse doch gelten, der Mensch sei nicht des Menschen Wolf.

Und was hat uns die Kinderrechtskonvention hinterlassen? Ambivalenz. Das Glück, dass es sie gibt. Auch und gerade für UNICEF. Und Erfolge, die es ohne sie nicht gegeben hätte. Auch und gerade für UNICEF. Und auf der anderen Seite: Unzufriedenheit. Verzweiflungsanfälle angesichts all dessen, was die Buchstaben einer feierlichen Erklärung eben doch nicht, noch nicht auszurichten vermögen. Dann nicht, wenn ein Warlord Kinder an der Kalaschnikow rekrutiert, wenn eine Trockenheit Bauern und deren Kinder in den Hunger treibt, wenn Schulen in Flutwellen verschwinden, wenn eine fanatisch ausgelegte Religion die Bildungschancen von Mädchen schändet, wenn die Ware Kind auf den finsteren Hinterhöfen dieser Welt in jungem Fleisch bemessen wird, wenn Flüchtlinge ihre ausgemergelten Babys über Stacheldrähte zu Feldlagern schleppen, wenn Achtjährige den Elektroschrott unserer Konsumwelt von qualmenden Müllhalden klauben, wenn Kriege kleine Jungen ohne Arme und Beine hinterlassen und finstere Traditionen kleine Mädchen mit säurezerfressenen Gesichtern oder beschnittener Klitoris.

Ambivalenz. Was das Völkerbekenntnis zu den Rechten der Kinder an Gutem geschaffen hat, was UNICEF seither möglich war, das deutet das Vorwort dieses Buches an. Und es ist sogar noch viel mehr als das dort Aufgezählte. Es sterben gegenüber 1990 nur noch knapp halb

paragraphs of the 54 Articles of the UN Convention on the Rights of the Child than in those paragraphs that call for the children to be free of hunger and disease or for their right to education. Every child has a right to a name, to identity, to an age! Yes, even this had to be fought for and still does. To this day, one in three children in the world does not even get officially registered. Only one in seven little citizens of the world owns a birth certificate.

It was a long journey that led up to 20 November 1989. It does not matter if, as many cultural historians claim, the child was discovered as late as the 19th century by the bourgeoisie as a 'renewable resource' and thus as an asset worth protecting, or even as part of a new family intimacy. And before that a child will have been just a kind of less able adult and labour, not particularly cherished, cared for and indulged, not least because mortality, miserable living conditions and low life expectancy left no room for tenderness. Or if the idea of childhood as the expression of a special phase of life had evolved in the 16th or 17th century after all, and had, as a new culture of emotion vis-à-vis children, gradually seeped into society, at least within the context of religion. In any case, neither Rousseau in 1762 (*Émile, or On Education*) nor the English Factories Act of 1833, which prohibited factory work for children under the age of nine, came anywhere close to the dimension of this general human rights declaration for children, which was passed on a Monday in November 1989 on the East River in Manhattan. In Memoriam Janusz Korczak. In Memoriam Eglantyne Jebb, founder of the Save the Children Fund, who, in the face of the suffering heaped upon the people by the First World War, had drawn up a Children's Charta. In memory of many other pioneers of the idea that at least for children it should be true that man was not wolf to man.

And what has the Convention on the Rights of the Child bequeathed to us? Ambivalence. The good fortune that it exists. Not least and especially for UNICEF. And achievements that would have been impossible without it. Not least and especially for UNICEF. And yet: Discontent. Fits of despair in the face of all that the letters of a solemn declaration cannot not, not yet, achieve. When a warlord recruits children with Kalashnikovs, when drought drives farmers and their children into hunger, when schools disappear in a flood, when a fanatically interpreted religion violates the educational opportunities of girls, when children as a commodity are measured in young meat in the backyards of this world, when refugees drag their emaciated babies across barbed wire to field camps, when eight year olds collect the electronic scrap of our world of consumption from smouldering rubbish dumps, when wars leave small boys without arms or legs and sinister traditions leave little girls with acid-ravaged faces or circumcised clitoris.

Ambivalence. What good the commitment of the nations to the rights of the child has achieved, what UNICEF has since been enabled to do is sketched in the preface to this book. And it is much more than what is listed there. Compared to 1990 only half as many children die from avoidable diseases such as diarrhoea or pneumonia; polio has been pushed back on a large scale. And never before has such a high proportion of children attended school. Four out of five now do instead of just one in two. Far fewer children are born HIV-positive than a few years ago. More countries than before shun violence in education, in schools. Even a country like Nepal now provides child benefit. And 100 000 former child soldiers have been rescued into civil life by UNICEF. The fire that feeds these glimmers of hope is burning brighter, getting bigger.

so viele Kinder an vermeidbaren Krankheiten wie Durchfall oder Lungenentzündung; auch die Kinderlähmung ist großflächig zurückgedrängt. Und noch nie ist ein solch hoher Prozentsatz von Kindern zur Schule gegangen wie heute: Vier von fünf sind es nun, nicht mehr nur jedes zweite. Viel weniger Kinder als noch vor Jahren kommen HIV-positiv zur Welt. Mehr Länder als früher haben Gewalt in der Erziehung, in der Schule geächtet. Kindergeld gibt es nun sogar in einem Land wie Nepal. Und 100 000 ehemalige Kindersoldaten hat UNICEF in das zivile Leben hinübergerettet. Das Feuer, aus dem diese Hoffnungsfunken stieben, lodert heller, wird größer.

Aber in der Dunkelheit dahinter: Alles das, was noch immer erbärmlich ist. Noch ist jedes vierte Kind auf der Welt chronisch mangelernährt. Noch gibt es für 57 Millionen Kinder kein Klassenzimmer. Noch arbeiten 168 Millionen Kinder unter ausbeuterischen Bedingungen in Kohlegruben, Minen, Fabriken oder, vor allem Mädchen, entrechtet in Privathaushalten. Noch sind 30 Prozent der Mädchen unter 18 Jahren, manche gerade sieben, in einigen Entwicklungsländern in erzwungene Ehen eingesperrt. Und leider ließe sich auch diese Liste der Schande verlängern. Um jene Kinder und Jugendlichen etwa, Hunderttausende sind es schätzungsweise, die in Haftanstalten einsitzen, sehr häufig ohne Gerichtsurteil. Und so zwingt alles das auch die Menschen, die sich für UNICEF engagieren, in die „graue Strickjacke der Sorge", wie es ein Zyniker einmal schrieb, einer von jener Sorte vermutlich, die sich gerne über „Gutmenschen" mokieren, ohne zu merken, wie billig das ist.

Denn ja, es taugt halt nicht für Frühlingsfarben, heute davon zu hören, dass 235 000 Kinder unter fünf Jahren im Südsudan wegen akuter Mangelernährung dringend behandelt werden müssen und die Nothelfer von UNICEF und Welternährungsprogramm dort von Zuständen berichten, wie sie sie „noch nie gesehen haben". Und morgen davon lesen zu müssen, dass weltweit so viele Menschen auf der Flucht sind, über 50 Millionen, wie seit dem Zweiten Weltkrieg nicht mehr. Die Multiplikation der Krisenherde verlangt nach reichlich vielen guten Menschen, die sich nicht darum scheren, wie grau es ist, in der Zentralafrikanischen Republik eine Schule wieder aufzubauen oder in einem Auffanglager Milchrationen zu verteilen. Und es gibt kaum eine Seite in diesem Buch, die man nicht in der Hoffnung betrachten würde, es wären gute Menschen zur Stelle, die beenden würden, was dort zu sehen ist.

In diesem Sinne ist *We the Children* ein Buch, das nicht beschwichtigen kann und nur an wenigen Stellen tröstet. Eher offenbart es die To-do-Liste der internationalen Politik und vieler einzelner Länder und Gesellschaften im Jubiläumsjahr der Kinderrechtskonvention — alles das, was Papier geblieben und Realität noch nicht ist. Alles das, was Vorsatz bleiben wird, wenn Regierungen und Gesetzgebung, Verwaltung und Justiz nicht ernst machen mit dem, was 1989 unterschrieben wurde. *We the Children* ist aus anderthalb Jahrzehnten „UNICEF-Foto des Jahres" hervorgegangen. Es setzt also auf Bilder mehr als auf Text. Und das tut es im Vertrauen darauf, mit Bildern besonders bewegen zu können, auch wenn die visuelle Flut der Gegenwart schon zu Zweifeln daran führt. Wer nur alle Facebook-Fotos eines einzigen Tages ansehen wollte, benötigte dafür 40 Jahre ohne Pause, ohne Schlaf, denn es sind 400 Millionen. Und die permanente „Fernanwesenheit", wie der Mediensoziologe Andreas Schelske es nennt, das Gefühl, laufend in der gesamten Welt unterwegs zu sein, muss nicht bedeuten, an dieser Welt tatsächlich auch interessiert zu sein. Slow Photography wird schon verlangt, eine Art Heilfasten vom rasenden Bilderverzehr.

But in the darkness beyond: everything that is still disgraceful. To this day, one in four children in the world is chronically malnourished. There are still no classrooms for 57 million children. Even now 168 million children work in exploitative conditions in mines, factories or, girls especially, in private households without any rights. Thirty percent of girls under the age of 18, some of them as young as seven, are trapped in forced marriages in some developing countries. Unfortunately this list of shame is far from complete. One might add those children and young people, an estimated hundreds of thousands, who are held in prisons, often without a verdict. And so all of this forces the people who are active for UNICEF into the 'grey cardigan of concern', as a cynic once wrote, probably one of those who like to mock 'do-gooders' without realizing how cheap that is.

Indeed, there are news that do not fit spring colours, news like the fact that 235 000 children under five in the South Sudan are in urgent need of treatment for acute malnourishment and the aid workers of UNICEF and the World Food Programme report scenes from there like they "have never seen before." Or having to read tomorrow that across the world there are so many refugees, over 50 million, more than at any time since World War II. The multiplication of trouble spots needs plenty of good people who do not care how grey it is to reconstruct a school in the Central African Republic or to distribute milk rations in a detention centre. And there is hardly a page in this book that you do not look at hoping for good people to be there to end what you see.

In this sense, *We the Children* is a volume that cannot soothe and offers comfort in only a few pictures. Rather it reveals the to-do list of international politics and of many specific countries and societies in the anniversary year of the Convention on the Rights of the Child — everything that has remained paper and not become reality yet. Everything that will remain intent if governments and legislation, administration and the legal system do not take seriously what was signed in 1989. *We the Children* has evolved from a decade and a half of the UNICEF Photo of the Year competition. It thus relies more on images than on text. And it does so in the hope that pictures can move people more immediately, even though the visual flood of our time may raise doubts about that. Anyone who would want to view all Facebook photos of one single day would need 40 years to do that, without a break and without sleep, because they number 400 million. And the permanent 'remote presence', as media sociologist Andreas Schelske calls it, the feeling of being constantly out and about across the world, does not necessarily mean a real interest in that world. There is a demand for Slow Photography, a kind of therapeutic fast from manic image consumption.

So what statement do the photographs in this book make? Can pictures lie? Yes. Do images say more than a thousand words? Not necessarily. And yet, let us dream a little: Maybe sometimes images may form a protective wall by sensitizing people to what is worth protecting. Or tear down walls by leading us into unseen spaces. Activate us by breaking up inertia. Prove what is repressed, drive spikes into memory. They can trigger revulsion and disgust, fear and outrage — and may encourage empathy, facilitate compassion, anchor charity.

For all these reasons the UNICEF Photo of the Year, although not conceived as a sister to the campaign for the rights of the child, is a powerful eye opener. Even where it upsets and unsettles. And because it is more furious than the image traditionally used by children's chari-

Welche Aussage also treffen die Fotos in diesem Buch? Können Bilder lügen? Ja. Sagen Bilder mehr als tausend Worte? Nicht unbedingt. Und doch, träumen wir ein bisschen: Vielleicht können Bilder ja manchmal Schutzmauern bilden, wenn sie für das Beschützenswerte sensibilisieren. Können sie Mauern einreißen, wenn sie in ungesehene Räume führen. Können sie aktivieren, weil sie die Trägheit stören. Können sie beweisen, was verdrängt wird, können Pflöcke in die Erinnerung schlagen. Sie können Abscheu hervorrufen und Ekel, Angst und Empörung — und vielleicht auch zur Empathie befähigen, das Mitleid erleichtern, dem Mitgefühl einen Anker geben.

Aus allen diesen Gründen ist das „UNICEF-Foto des Jahres", obwohl gar nicht als Schwester der Kinderrechts-Kampagne auf die Welt gekommen, ein so eindringlicher Augenöffner. Auch wo es stört und verstört. Und weil es rabiater ist als das Bild, auf das Kinderhilfsorganisationen traditionell setzen, wenn sie um die Solidarität mit jenen werben, deren Leben auf den Schattenseiten spielt. Es sind die großen Augen eines kleinen Mädchens, es ist das niedliche Rinnsal aus der Nase, das wuschelige Haar, das noch das Müllkind in Manila gewöhnlich heimfähig macht im virtuellen Haus der Spender — und wenn es das immerhin tut, so ist es schon gut.

Aber das Müllkind aus Manila kann hässlich sein, eine Gaumenspalte haben — und verdient nicht weniger Hilfe. Und die Drogenabhängigkeit von 13-Jährigen in St. Petersburg kann zum Verzweifeln sein — und ist trotzdem nicht geeignet für Kapitulationserklärungen. Und ein Kind im Schlamm von Port-au-Prince hätte auch ohne weißes Kleidchen seine Würde; es sollte sich nicht hübsch machen müssen, auf dass wir es wahrnehmen und bewundern. Dies zu verdeutlichen, die Armut der Armut, nicht die Anmut der Armut, ist das Verdienst der Fotografen, deren Arbeit in diesem Buch versammelt ist. Für einen Moment des Hinsehens. Vielleicht des Innehaltens. Vielleicht des Schockiertseins. Vielleicht des Weinens. Das Erbärmliche ist nicht schluckfreundlich zu genießen.

Was bedeutet es auch für die Fotografen, die sich nicht mit Königshochzeiten befassen oder Fußballhelden, sondern verstümmelten Kindern begegnen, auf menschliche Gerippe sehen, auf die Arbeitsqual in einem Dreckloch im Kongo? Es bedeutet auch für sie, die Zeugen, Elendsgefühle. Freilich: Zu viel sollte auch ihnen nicht abverlangt werden. Dass der Mensch nicht alles Leid gleichermaßen betrauern kann, ist eine Überlebenskonstante, die nicht außer Kraft gesetzt ist für Fotoreporter. Und auch die selbstlosesten Ärzte ohne Grenzen, die tapfersten Delegierten vom Internationalen Komitee des Roten Kreuzes, die aufopferungsvollsten Helfer von UNICEF werden das Gewehrfeuer fliehen und die einstürzenden Dächer über sich zu meiden versuchen im letzten Moment. Aber wie alle diese Menschen gibt es, dieses Buch zeigt es, auch Journalisten mit hohem Einsatzwillen. Der Vorwurf der Sensationsgier muss sie nicht treffen. Sie berauschen sich nicht am Extrem, sie berichten. Sie führen nicht vor, sie nehmen — mitunter über Jahre — teil. Sie arbeiten nicht ab, sie arbeiten sich ein, wie viele der Geschichten im Folgenden zeigen. Sie rauben diese Geschichten nicht, sie überbringen sie. Und sie gehen nicht selten an die Grenzen, hinter denen es für sie selber ungewiss wird. Dankbarkeit also gebührt all denen, deren Bilder dieses Buch möglich gemacht haben — so sehr die auch bedrängen und bedrücken.

Es ist ein ungeschöntes Buch und soll nichts anderes sein. Auch wenn es, glücklicherweise, nicht das Ganze zeigt. Denn natürlich gibt es auch die ganz andere Kindheit, die unbe-

ties when to promote solidarity with those whose life is lived on the down side: the big eyes of a small girl, the cute runny nose, the tousled hair that makes even the rubbish dump kid in Manila invitable to the virtual home of the donator – and if it manages at least that, that is alright.

But the rubbish dump kid from Manila may be ugly, have a cleft lip – und still deserves just as much help. And the drug addiction of 13 year olds in St. Petersburg may be infuriating – but it is no reason to capitulate. And a child in the mud of Port-au-Prince would have its dignity even without a white dress; she should not have to make herself pretty to get noticed and admired by us. This is what the photographers have achieved whose work is gathered in this volume: to illustrate the poverty of poverty, not its charm. The right to be visible. Perhaps long enough to pause for reflection, perhaps to be shocked, perhaps to cry. Wretchedness cannot be taken in easily.

What does it mean for the photographers who do not portray royal families or football heroes but encounter maimed children, look at human skeletons, at the wretchedness of working in a foul hole in the Congo? They, the witnesses, also feel miserable. Not that we should ask too much of them. It is a constant of survival that humans cannot grieve equally for all suffering and it is also true for photojournalists. Just as it is for the most selfless doctors without borders, the bravest delegates of the International Committee of the Red Cross, the most devoted UNICEF aid workers, who will all flee gunfire and avoid roofs collapsing above them at the last moment. As this book shows, though, there are also highly committed journalists. They must not be accused of sensationalism. They do not get high on extremes, they report. They do not present, they get involved, sometimes for years. They do not deliver and move on, they work their way in, as many stories in this volume demonstrate. They do not steal these stories, they bring them to us. And quite often they venture into areas of uncertainty even for them. Gratitude is due to all those whose pictures have made this book possible, however much these pictures press on us and depress.

It is an uncompromising book and this is what it should be. Even though, luckily, it does not show the whole picture: there is, of course, another kind of childhood, carefree, fulfilled, secure. There is progress, change for the better. And there is the danger that alarmism and an inclination for disasters as a phenomenon of the media struggle for the limited resource of attention dull our senses and achieve the opposite of what is needed: surfeit, revulsion, overload, compassion fatigue.

It would be a mistake though to think there was nothing left but being paralysed. A children's charity, too, lives on the assumption that there is light at the end of the tunnel, even if this book makes us realize how terribly long this tunnel is, in Bangladesh and in India and in the Yemen, in Central Africa, Central America or Southeast Asia.

And in Germany? Between 2000 and 2010, nearly one in ten children here has lived through what is called 'long-term experience of poverty'. An OECD survey on child poverty in 29 states puts wealthy Germany on a middle rank only. At least war and violence are far from the world of children here – or are they? Not quite, it seems. How else to explain the answers of over 1000 girls and boys between the ages of six and 14 in the Children's Values Monitor,

schwerte, erfüllte, geborgene. Gibt es Fortschritt, gibt es Veränderungen zum Guten. Und zugleich die Gefahr, dass Alarmismus und Katastrophengeneigtheit als Erscheinung der um die knappe Ressource Aufmerksamkeit ringenden Medien abstumpfen und mithin das Gegenteil dessen bewirken, was benötigt wird: Überdruss, Abkehr, Überforderung; compassion fatigue, Mitleidsermattung.

Man sollte trotzdem nicht glauben, nicht anderes bliebe mehr, als paralysiert zu sein. Auch ein Kinderhilfswerk lebt davon, am Ende des Tunnels das Licht zu vermuten — selbst wenn das vorliegende Buch vor Augen führt, wie furchtbar lang dieser Tunnel ist, in Bangladesch und in Indien und im Jemen, in Zentralafrika, Mittelamerika oder Südostasien.

Und in Deutschland? Zwischen 2000 und 2010 hat fast jedes zehnte Kind hier erlitten, was eine „langfristige Armutserfahrung" genannt wird. Nach einer OECD-Erhebung zur Kinderarmut unter 29 Staaten liegt das reiche Deutschland nur auf einem Mittelplatz. Aber wenigstens der Krieg, die Gewalt sind doch fern in der Kinderwelt hierzulande — oder nicht? Wohl nicht ganz. Sonst hätten bei dem im September 2014 veröffentlichten Kinderwerte-Monitor, einer repräsentativen Erhebung unter mehr als 1000 Jungen und Mädchen zwischen sechs und 14 Jahren, nicht 82 Prozent gesagt, das Recht, ohne Gewalt aufzuwachsen, sei ihnen das Wichtigste. Und zugleich 35 Prozent der Befragten angegeben, dies sei wohl jenes Recht, gegen das am häufigsten verstoßen werde. Dass Kinder in Deutschland „früh lernen, die Welt jenseits ihres persönlichen Erfahrungsraumes und nationaler Grenzen zu begreifen", schließen die Verfasser der Studie daraus. Und dass nicht zuletzt der omnipräsente Krisendiskurs in den Medien auch bei Kindern in einem friedlichen Land in Mitteleuropa dazu führt, in ihrem Angstrepertoire viel mehr zu haben als Elternverlust, Dunkelheit, Spinnen oder das Halbjahreszeugnis. Syrien scheint auch in die Seele von Marie kriechen zu können, ein Nachhall der Detonationen in Afghanistan selbst bis an Johanns Ohren.

Es wäre ein Traum, wenn sich auch Marie und Johann oder Kevin und Melanie bald wieder höchstens vor Spinnen oder Dunkelheit fürchten müssten. Und der noch viel größere: Wenn jegliche Gewalt gegen Kinder auch in jenen Ländern verboten würde, in denen 95 Prozent aller Mädchen und Jungen heute leben. Das Recht der Kinder, in Würde, gesund, wohlgenährt, gewaltfrei aufzuwachsen, zur Schule gehen zu dürfen, im Krieg und auf der Flucht beschützt zu werden und, wenn sie behindert sind, besondere Fürsorge zu erhalten, ist keine Frage karitativer Gönnerhaftigkeit. Es ist völkerrechtliche Verpflichtung, vor 25 Jahren beschlossen.

Fehlt, dass sie eingelöst wird. Und so ist dieses Buch, es sei noch einmal geschrieben, eine schroffe Erinnerung an das, was auf der Agenda der Weltfamilie steht.

a representative survey published in September 2014, of whom 82 percent put the right to grow up without violence as a top priority. And 35 percent of respondents said that this was likely to be the right most often violated. The authors of the study conclude that children in Germany "learn early on to recognize the world outside their sphere of personal experience and national borders." And that the ubiquitous crisis discourse in the media means that even children in a peaceful country in Central Europe have a spectrum of fears that includes much more than losing your parents, darkness, spiders or the end of term report. Syria manages to sneak even into the soul of Marie, the detonations in Afghanistan reverberate even in Johann's ears.

It would be a dream if Marie and Johann or Kevin and Melanie soon would only have to fear spiders and the dark. And the even greater dream if any violence against children would also be prohibited in the countries in which 95 percent of all girls and boys live today. The right of the children to grow up in dignity, healthy, well-fed, without violence, to be allowed to attend school, to be protected in war and in flight and, if they are disabled, to receive special care, is not a question of charitable paternalism. It is an international commitment, agreed 25 years ago.

What is missing is its implementation. And so this book, I repeat, is a harsh reminder of the agenda of the global family.

Ich habe einen Traum. Ein Foto kann das Antlitz eines Kindes zeigen. Was aber könnten wir von seinen Gedanken, seinen Fantasien sehen, wäre niemand da, der auch die stille Sehnsucht der Kinder zu Bildern macht? Die Kinderrechtsorganisation Save the Children hat den Fotografen Chris de Bode gebeten, die Wünsche der Kinder festzuhalten: in Uganda etwa, in Jordanien oder Haiti, in Mexiko oder Liberia. Träume, wie sie Sabina hat, Tochter eines Riksha-Fahrers in Neu-Delhi. Sabina sagt: „Wo ich wohne, ist alles um mich herum schmutzig, es stinkt. Ich hätte so gern wunderschöne Kleider. Ich würde wie ein Filmstar strahlen." Träume wie dieser symbolisieren die Hoffnung und die Widerstandskraft von Kindern — und die Notwendigkeit, am Ziel der Chancengleichheit für sie alle festzuhalten. Und die Hoffnungen der Kinder so ernst zu nehmen, wie es Chris de Bode gelungen ist — voller Respekt und Mitgefühl.

I have a dream. A photograph can show the face of a child. But what would we notice of the thoughts and fantasies of that child if there was no one who could turn quiet yearnings into images? The child rights organization Save the Children asked photographer Chris de Bode to capture what children wish for: in Uganda, maybe, in Jordan or Haiti, in Mexico or Liberia. Dreams like that of Sabina, daughter of a rickshaw driver in New Delhi. Sabina says, "Where I live, everything around me is dirty and smells. I would so like to have beautiful clothes. I would like to shine like a film star." Such dreams symbolize the hopes and the resilience of children — and the need for persisting in the effort to achieve equal opportunities for all of them. And for taking the children's hopes as seriously as Chris de Bode did, with respect and empathy.

Chris de Bode | Panos Pictures/laif. Für den in den Niederlanden geborenen Fotografen sind viele Wünsche in seinem Berufsleben in Erfüllung gegangen. Als professioneller Bergführer begann er zu fotografieren. Aus dem Hobby wurde eine Passion. Seine Fotoreportagen aus Krisengebieten, oftmals in Zusammenarbeit mit Nichtregierungsorganisationen wie Save the Children, Greenpeace und verschiedenen UN-Organisationen entstanden, führten zu Veröffentlichungen in internationalen Magazinen, die mit vielen Auszeichnungen bedacht wurden. Chris de Bode hat mehrere Bücher publiziert. Inzwischen setzt er seine Projekte auch in Dokumentarfilmen um.

Chris de Bode | Panos Pictures/laif. For the photographer from the Netherlands many wishes in his professional life have come true. He began taking photographs in his capacity as professional mountain guide and climbing instructor. The hobby soon became a passion. His photo reports from crisis areas were often created in cooperation with non-governmental organizations, such as Save the Children, Greenpeace and various UN organizations. They have led to publication in international magazines and received many awards. Chris de Bode has published several books. These days he also turns his projects into film documentaries..

Fotografien auf den Seiten 44 bis 67 | All images on pages 44 to 67 **courtesy of Save the Children.**

Aniket träumt davon, in den Weltraum zu fliegen. Er ist zehn Jahre alt und lebt mit seinen Eltern und Geschwistern ebenfalls in der indischen Hauptstadt. Aufgewachsen ist er in einem Armenviertel. Die Baubehörde löste die Siedlung auf, danach musste die Familie in eine überfüllte Unterkunft an einen anderen Ort ziehen. Aniket ist ein kluger Junge, dessen Lieblingsprogramm im Fernsehen der „Discovery Channel" ist. Seit Aniket eine Sendung über Weltraumforschung gesehen hat, ist der Himmel sein Ziel. Er sagt: „Ich träume davon, zum Mond zu fliegen. Es muss so schön sein, aus dem Weltall auf die Erde hinabzusehen. Ich frage mich, ob ich von dort oben Indien erkennen kann. Mein Land ist ja ziemlich groß — nicht wahr?"

Aniket dreams of flying into space. He is ten years old and also lives in the Indian capital with his parents and siblings. He grew up in a deprived area. When the building authority razed the settlement, the family had to move into an overcrowded accommodation in a different city. Aniket is a bright boy whose favourite TV programme is the Discovery Channel. Ever since Aniket watched an episode about space research, the sky has become his destination. He says, "I dream of flying to the moon. It must be so great to look down on Earth from Space. I wonder if I would recognize India from up there. After all, my country is pretty big, isn't it?"

Wilberforce träumt von den größten Trophäen.
Er ist elf Jahre alt und lebt mit seinen Eltern und
sechs Geschwistern im Norden Ugandas. Wilber-
force sagt: „Ich will der schnellste Läufer der Welt
werden. Ich möchte, dass meine Eltern, meine
Schule und mein Land einmal stolz auf mich sein
können. Darum laufe ich jeden Tag weite Strecken.
Nur mit viel Training kann ich mein Ziel erreichen."

Wilberforce dreams of the biggest trophies. He
is eleven years old and lives with his parents and
six siblings in the north of Uganda. Wilberforce
says, "I want to become the fastest runner in the
world. I want my parents, my school and my coun-
try to be proud of me one day. This is why I run
long distances every day. Only by training like that
can I reach my goal."

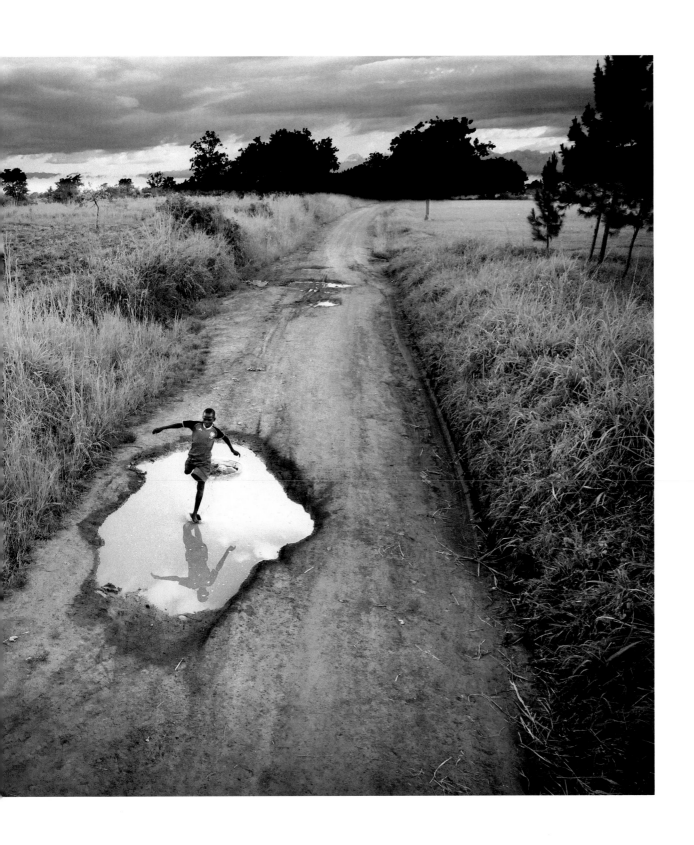

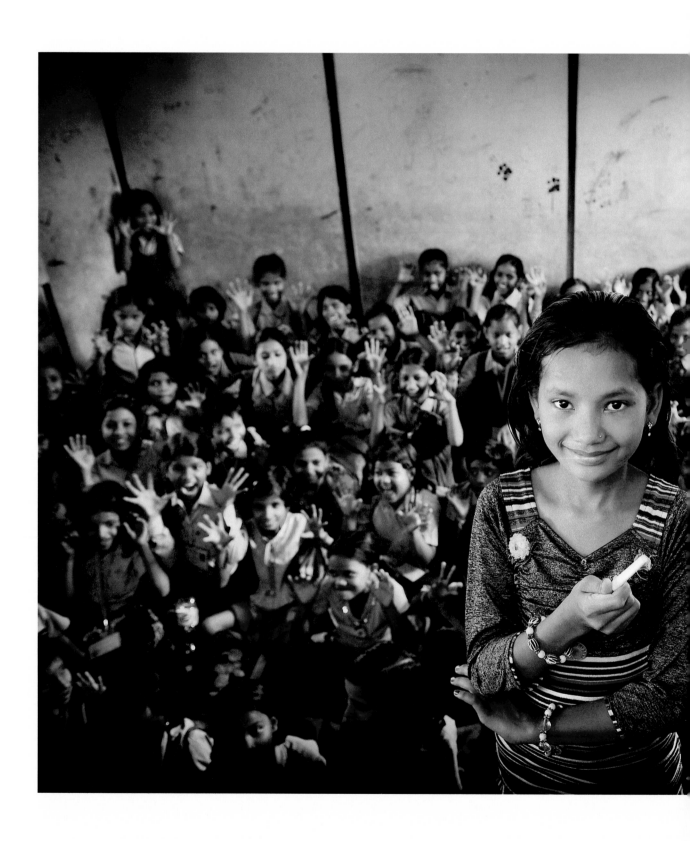

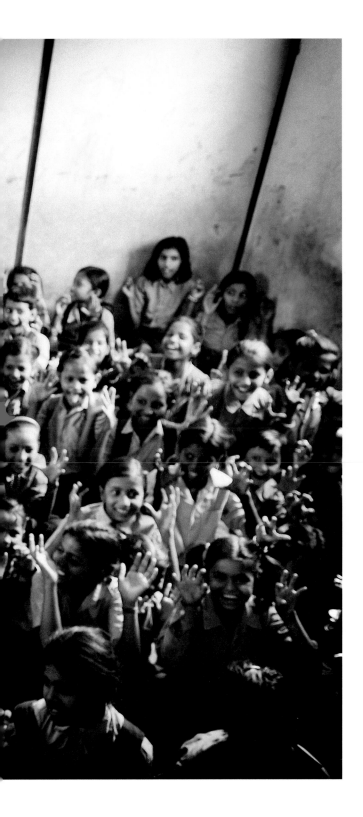

Dewi träumt davon, Lehrerin zu werden. Sie ist zwölf Jahre alt und lebt mit ihren Eltern in einem der Slums von Neu-Delhi. Dewi ist eine gute Schülerin und kann sich klar ausdrücken. Hier steht sie mit dem immer noch wichtigsten Lehrmittel an öffentlichen Schulen in Indien, einem Stück Tafelkreide, vor ihren Mitschülern. Dewi sagt: „Wenn ich groß bin, will ich unterrichten. Dann kann ich Kindern Lesen, Schreiben und Rechnen beibringen. Das ist wirklich wichtig, weil sie sonst keine Arbeit finden werden. Ich werde eine strenge Lehrerin sein, und die Kinder müssen auf mich hören."

Dewi dreams of becoming a teacher. She is twelve years old and lives with her parents in one of the many slums of New Delhi. Dewi is good at school and expresses herself concisely. Here she stands in front of her classmates with a piece of chalk in her hand, still the most important teaching aid in Indian state schools. Dewi says, "When I grow up I want to teach. Then I can get children to read, write and do sums. This is really important because they will not find work without knowing that. I will be a strict teacher and the children will have to listen to me."

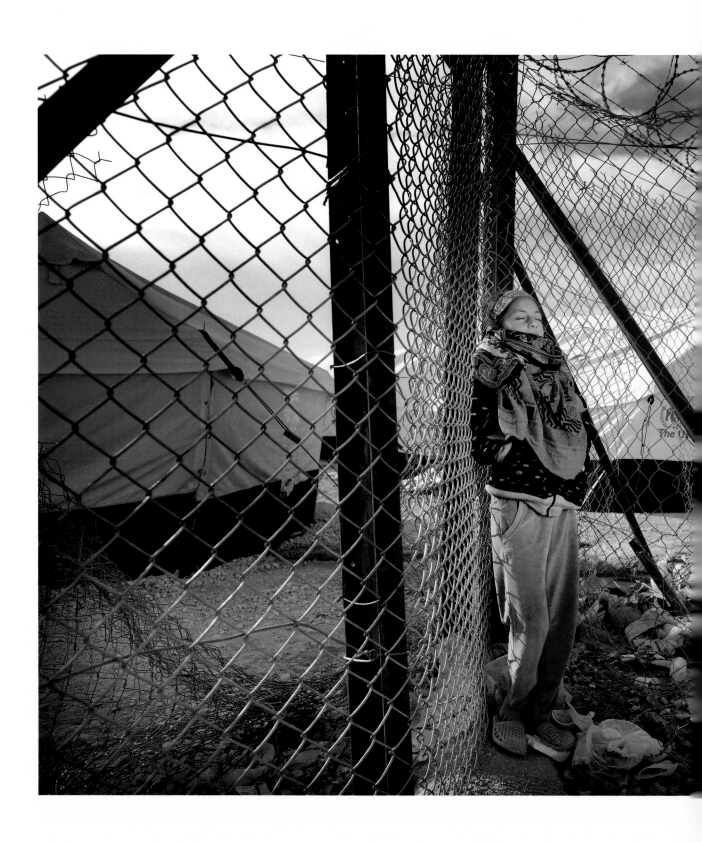

Eman träumt, durch eine grüne Wiese zu gehen.
Sie ist zehn Jahre alt und lebt im Flüchtlingslager
Za'atari in Jordanien. Sie musste mit ihren Eltern
vor dem Bürgerkrieg in Syrien fliehen. Das Lager
mit seinen fast 150 000 Menschen, die in Zelten
und Containern leben, ist eines der größten auf
der Welt. Eman sagt: „Ich möchte wieder barfuß
mit meinen Freunden durch Wiesen laufen kön-
nen. Hier ist die Erde durch die Sonne verbrannt.
Alles ist staubig. Es gibt keine Farben. Ich möchte
wieder nach Hause."

Eman dreams of walking through green grass.
She is ten years old and lives in Za'atari refugee
camp in Jordan. She and her parents had to flee
the civil war in Syria. The camp holds almost
150 000 people in tents and containers and is one
of the largest in the world. Eman says, "I want to
be able to run barefoot through the grass again
with my friends. Here the earth is parched by the
sun. Everything here is dusty. There are no colours.
I want to go back home."

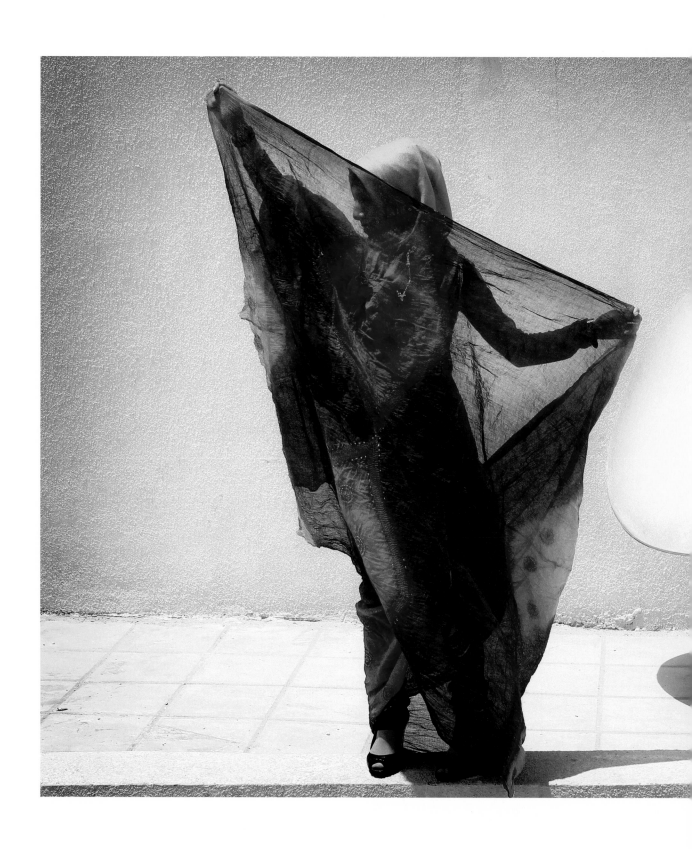

Hiba träumt davon, ein Supermodel zu werden.
Sie ist 17 Jahre alt, wie ihre Freundin Doa. Beide le-
ben in Amman, der Hauptstadt von Jordanien. Als
ihre Eltern sich trennten, sollte sie die Schule ver-
lassen und zu Hause bei ihrer Mutter bleiben. Hiba
sagt: „Ich habe meine Eltern viele Male gebeten,
wieder in die Schule gehen zu dürfen. Genauso
wie meine Schwestern. Meine Mutter aber meint,
mein Platz im Leben sei die Küche. Sie glaubt,
ich sei dumm und eine Schulbildung sei bei mir
Vergeudung. Meine Mutter ist stolz auf meine
Schwestern, aber ignoriert mich. Als Supermodel
würde ich bewundert. Ich stünde im Rampenlicht
und nicht im Schatten."

Hiba dreams of becoming a supermodel. She is
17 years old, as is her best friend Doa. Both live in
Amman, the capital of Jordan. When her parents
separated, Hiba was to leave school and stay at
home with her mother. Hiba says, "I have asked
my parents many times to let me go back to school
like my sisters. But my mother says that my place
in life is in the kitchen. She thinks I am stupid and
education at school would be wasted on me. My
mother is proud of my sisters but ignores me. As a
supermodel I would be admired. I would stand in
the light and not in the shadow."

Blaise träumt davon, wie Michael Jackson zu sein.
Er ist zwölf Jahre alt und lebt mit sieben Brüdern
und einer Schwester in Haiti. Nach dem schreck-
lichen Erdbeben 2010 plagten ihn schlimme Alp-
träume. Aber er hat die Angstzustände überwun-
den. Er möchte Mechaniker oder Chauffeur werden.
Blaise sagt: „Nun, ich träume von so vielem. Wenn
ich mich wirklich entscheiden müsste, wäre ich
unschlüssig. Wäre ich vernünftig, würde ich Chauf-
feur werden. Aber Michael Jackson zu sein, wäre
viel toller. Es ist so schwer, sich zu entscheiden."

Blaise dreams of being like Michael Jackson. He
is twelve years old and lives in Haiti with his seven
brothers and one sister. After the terrible 2010
earthquake he suffered from bad nightmares, but
he has managed to overcome his anxiety. He wants
to become a mechanic or a chauffeur. Blaise says,
"Well, I dream of so many things. If I really had to
choose, I would dither. If I were rational, I would
become a chauffeur. But to be like Michael Jackson
would be much more exciting. It is so difficult for
me to decide."

Sahid träumt davon, ein IT-Spezialist zu werden. Er ist sieben Jahre alt und lebt mit seinen Eltern und seiner Schwester in einem Armenviertel in Neu-Delhi. Auf der Hauptstraße des Viertels gibt es eine Reparaturwerkstatt für Computer. Dort hält sich Sahid gerne auf. Die Rechner faszinieren ihn. Sahid sagt: „Ich wünsche mir sehr einen eigenen Computer. Ich würde den ganzen Tag davor verbringen. Und irgendwann wäre ich ein Computerspezialist."

Sahid dreams of becoming an IT specialist. He is seven years old and lives with his parents and his sister in a deprived area of New Delhi. On the main street of that area there is a repair workshop for computers. Sahid likes to hang around there. The computers fascinate him. Sahid says, "I very much want to have my own computer. I would spend the whole day in front of it. And one day I would be a computer specialist."

Korah träumt, Krankenhausdirektorin zu werden.
Sie ist zehn Jahre alt und lebt mit ihrer Mutter
und Schwester in Haiti. Ihre Eltern sind geschie-
den. Korah kennt viele Menschen, die während
des katastrophalen Erdbebens 2010 starben oder
verletzt wurden. Das Beben und seine Auswirkun-
gen haben einen tiefen Eindruck auf sie gemacht.
Korah geht in die fünfte Klasse, und sie findet den
Schulbesuch für ihr weiteres Leben sehr wichtig.
Korah sagt: „Ich möchte ein Krankenhaus leiten.
Dort hätte ich die Möglichkeit, so viele Menschen
wie nur möglich zu behandeln. Selbst wenn sie
kein Geld hätten."

Korah dreams of becoming a hospital manager.
She is ten years old and lives with her mother and
her sister in Haiti. The parents are divorced. Korah
knows many people who died or were injured dur-
ing the terrible 2010 earthquake. The disaster and
its consequences have made a profound impres-
sion on her. Korah attends the fifth form and sees
going to school as very important for her future.
Korah says, "I want to manage a hospital. There
I could treat as many people as possible. Even if
they did not have any money."

Djarida träumt davon, Tierärztin zu werden. Sie ist acht Jahre alt und lebt mit ihrer Mutter in San Cristóbal de las Casas in Chiapas, einem Bundesstaat in Mexiko. Ihr Vater verließ die beiden schon bald nach ihrer Geburt. Djarida und alle ihre Verwandten stammen von den Mayas ab, einer noch immer diskriminierten Bevölkerungsgruppe. Ihre Mutter arbeitet hart als Haushälterin, verdient jedoch wenig Geld. Djarida, die besonders Hunde liebt, sagt: „Viele Mädchen dürfen meist nur für eine kurze Zeit zur Schule gehen. Entweder müssen sie zu Hause helfen, schlechte Jobs annehmen, oder sie werden früh verheiratet. Ich bin sehr glücklich, dass ich jeden Tag in die Schule gehen darf. Um Tierärztin zu werden, muss ich richtig gute Noten bekommen. Aber ich bin sicher, dass ich das schaffe."

Djarida dreams of becoming a vet. She is eight years old and lives with her mother in San Cristóbal de Las Casas in Chiapas, a federal state of Mexico. Her father left them soon after she was born. She and all her relatives are of Mayan ancestry, an ethnic group that is still discriminated against. Her mother works hard as a housekeeper for little pay. Djarida, who loves dogs especially, says, "Many girls are only allowed to attend school for a short time. Either they have to help at home, take on bad jobs or they are married off young. I am very happy to be allowed to go to school every day. To become a vet, I must get really good grades, but I am sure I can achieve that."

My-Taelle träumt davon, ein Clown zu werden.
Sie ist zehn Jahre alt und lebt mit ihrer Mutter, zwei
Brüdern und vier Schwestern in Haiti. Ihr Vater hat
die Familie verlassen. Nach dem desaströsen Erd-
beben 2010, das die Infrastruktur des Inselstaates
zusammenbrechen ließ, gab es für sie und so viele
andere Kinder keine Chance mehr, die Schule zu
besuchen. Inzwischen sind provisorische Klassen-
zimmer geschaffen. My-Taelle sagt: „Ich bin sehr
froh, wieder zur Schule gehen zu können. Das ist
ein bisschen wie früher. Viele Menschen waren
furchtbar traurig nach dem Erdbeben, weil sie Fa-
milienmitglieder, Freunde oder ihr Haus verloren
haben. Wenn ich den Clown spiele, bringe ich die
Menschen zum Lachen."

My-Taelle dreams of becoming a clown. She is
ten years old and lives in Haiti with her mother,
two brothers and four sisters. Her father has left
the family. After the massive 2010 earthquake,
which caused the infrastructure of the island
state to collapse, she and so many other children
could no longer attend school. By now provisional
classrooms have been created. My-Taelle says,
"I am very glad I can go to school again. It is a bit
like before. Many people were very sad after the
earthquake because they had lost members of
their family, friends or their house. When I play
the clown, I can make people laugh."

Varney träumt davon, Kapitän zu werden. Er ist 14 Jahre alt und wurde in Liberia geboren. Seine Mutter starb, als er noch klein war. Sein Vater schickte ihn zu einem Onkel in die Hauptstadt Monrovia. Dort konnte er auch zur Schule gehen. Inzwischen hat sein Vater wieder geheiratet. Varney besucht die neue Familie nicht. Varney sagt: „Die Leute im Dorf sind eifersüchtig auf mich. Und bei der neuen Familie meines Vaters fühle ich mich nicht willkommen. Erst wenn ich der Kapitän eines Schiffes bin, fahre ich nach Robertsport. Dort in der Nähe wurde ich geboren."

Varney dreams of becoming a captain. He is 14 years old and was born in Liberia. His mother died when he was little. His father sent him to stay with an uncle in the capital Monrovia. There he was able to attend school. In the meantime his father has married again. Varney does not visit the new family. Varney says, "The people in the village are jealous of me. And I do not feel welcome in my father's new family. Once I am the captain of a ship, I will sail to Robertsport. I was born near there."

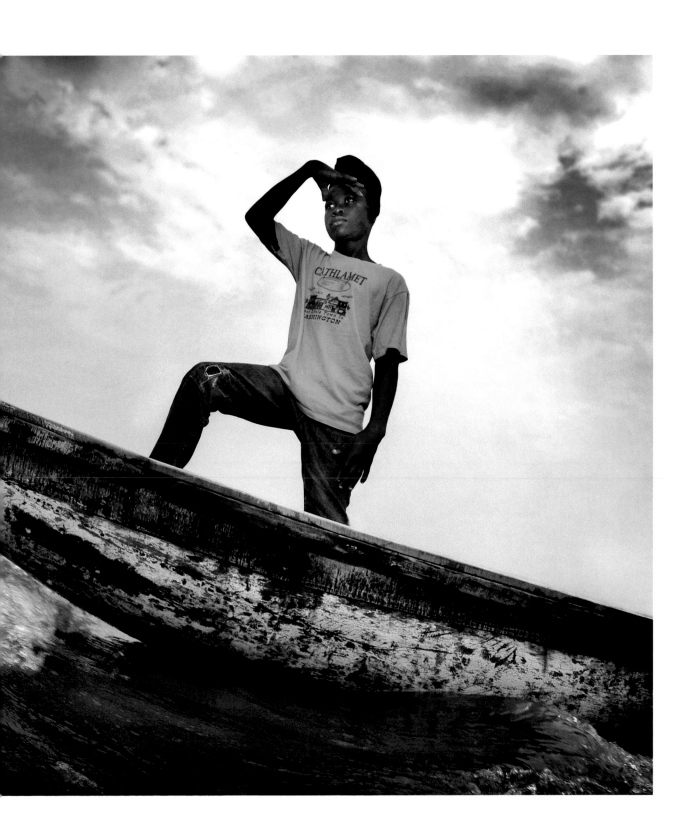

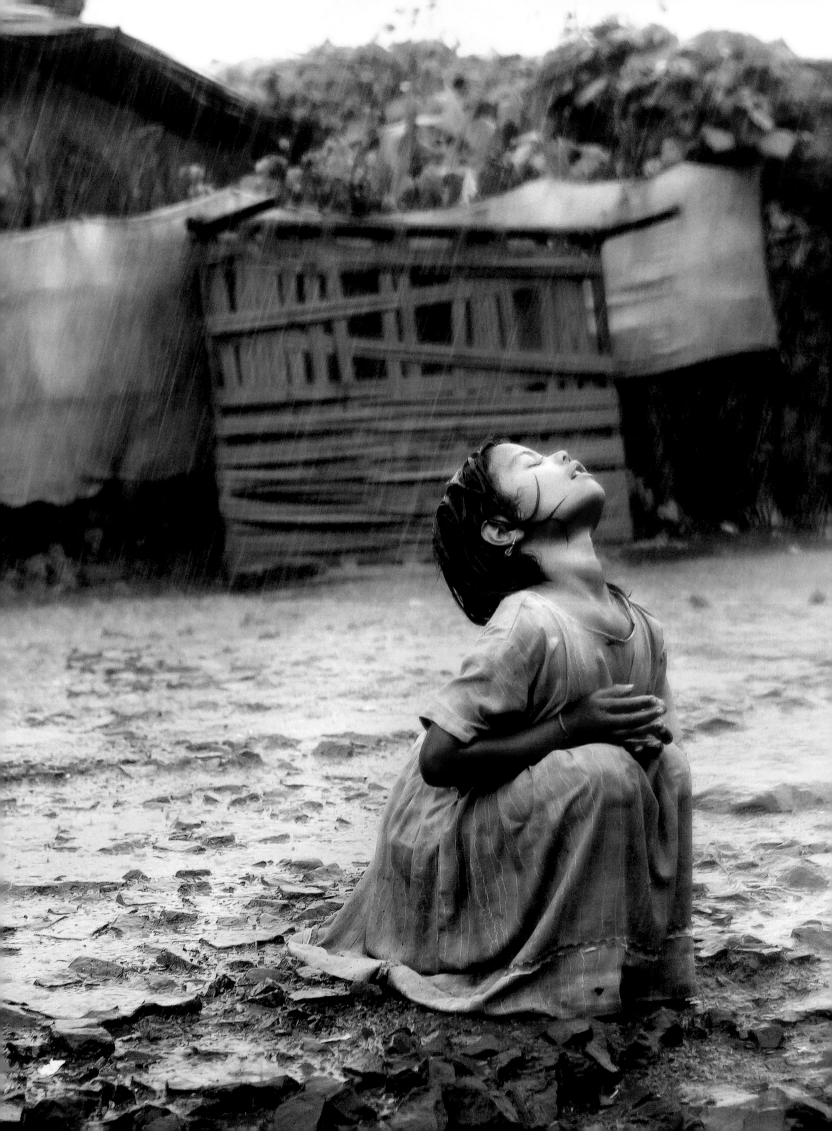

35 Fotoreportagen über die Situation der Kinder unserer Welt
Photo reports reflecting the situation of children in our world

2013 Niclas Hammarström, Marcus Bleasdale, Mugur Vărzariu, Patricia Willocq, Younes Khani **2012** Alessio Romenzi, Laura Boushnak, Alex Masi, Andrea Diefenbach **2011** Hossein Fatemi, Kai Löffelbein, Daniel Berehulak **2010** Majid Saeedi, GMB Akash, José Manuel López, Ed Kashi, Mary F. Calvert, Fernando Moleres **2009** Milan Jaroš, Robin Hammond, Thomas Lekfeldt **2008** Jacob Aue Sobol, William Daniels, Shiho Fukada **2006** Shehzad Noorani, Finbarr O'Reilly **2005** David John Gillanders, Stephanie Sinclair, Deanne Fitzmaurice **2004** Stefan Falke **2003** Felicia Webb, Yuri Kozyrev **2002** Mariella Furrer **2001** Wolfgang Müller **2000** Matías Costa

Alex Masi | Corbis Images, 2012

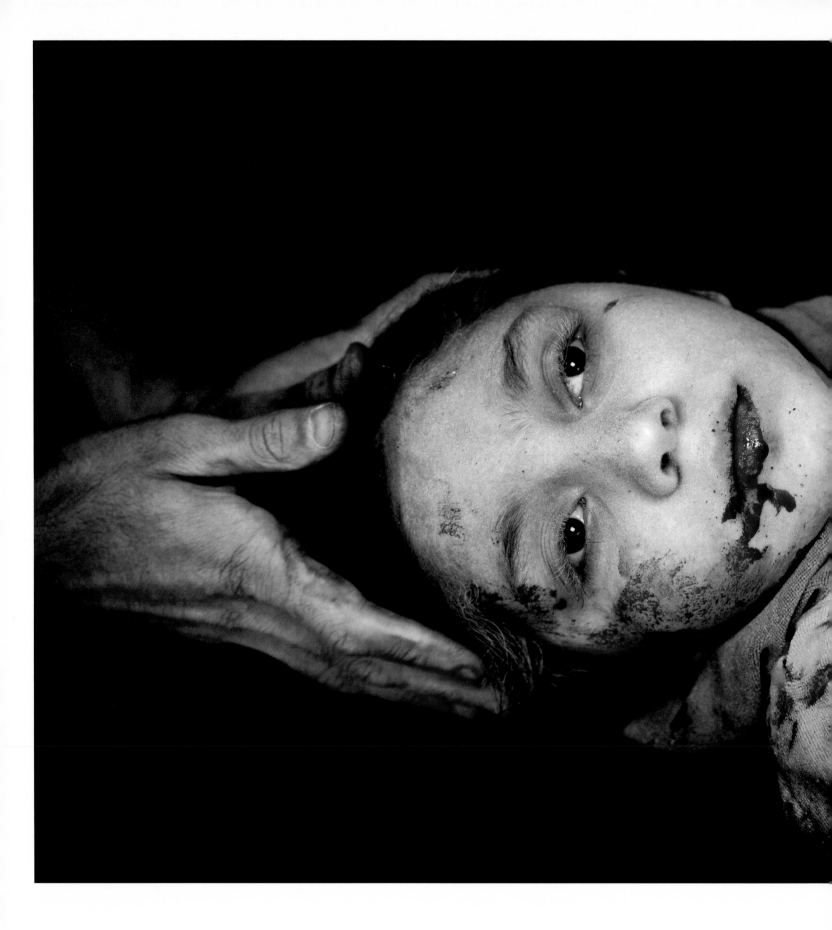

Niclas Hammarström | Kontinent Agency/laif wurde 1969 in Schweden geboren. Ab 1993 arbeitete er als Korrespondent des *Aftonbladet* in den USA. 2002 stieg er in das Unternehmen seiner Familie ein, das Hilfsmittel für Behinderte produziert. 2011 wandte sich Hammarström erneut der Fotografie zu. 2012 erhielt er einen World Press Phot Award für Bilder, die er nach dem von Anders Behring Breivik verübten Attentat auf der norwegischen Insel Utøya gemacht hatte. Als dreifacher Vater ließ ihn das Schicksa von Kindern nicht mehr los. Ihrer Situation widmete er sich besonders während seiner Aufenthalte in Syrien. Im November 2013 geriet Hammarström dort in Geiselhaft. Er nach 47 Tagen wurde er freigelassen.

Niclas Hammarström | Kontinent Agency/ laif was born in Sweden in 1969. From 1993 he worked as US correspondent for *Aftonbladet*. In 2002 he entered into his family business, a company that produces aids for disabled people. In 2011 Hammarström turned again to photography. In 2012 he received the World Press Photo Award for picture he had taken on the Norwegian island Utøya after the mass shooting by Anders Behring Breivik. A father of three, he got caught by the fate of children. It is their situation tha he focused on during his stays in Syria. In November 2013 Hammarström was taken hostage there and only released after 47 days.

Fotografen, die von Tod und Zerstörung berichten, müssen starke Nerven haben. Auch ein hartes Herz? Nein, die meisten von ihnen sind von den Kriegen, die sie erleben, angewidert. Sie wollen und können sich nicht daran gewöhnen, Gewalt als eine normale Facette der menschlichen Natur zu betrachten. Gerade deshalb gehen sie in die Gefahr. Der Fotograf Niclas Hammarström reiste mehrmals nach Syrien, ins umkämpfte Aleppo. In einem Krankenhaus erschütterte ihn der Anblick der elfjährigen Dania, die beim Spielen auf der Straße von Bombensplittern getroffen wurde. Kann man den Ausdruck auf dem Gesicht des Kindes vergessen? Und überkommt einen nicht Verzweiflung, wenn man sieht, dass ein Lehrer, der kleine Mädchen auf der Straße unterrichtet, sie mit einer Kalaschnikow beschützen muss? Wenn Jugendliche mit einer Waffe in der Hand Fußball spielen? Wenn eine Familie mit ihren letzten Habseligkeiten, gefüllt in zwei Plastiktüten, ihre zerstörte Heimat verlassen muss?

Photographers who report on death and destruction must have nerves of steel. And a heart of stone? No, most of them are disgusted by the wars they witness. They will not and cannot get used to seeing violence as a normal facet of human nature. This is precisely why they put themselves in danger. Photographer Niclas Hammarström traveled to Syria several times, to war-torn Aleppo. In a hospital he was shaken by the sight of eleven year old Dania who had been hit by shrapnel while playing in the street. Is it possible to forget the expression in the child's face? And how not to despair when you see that a teacher who teaches little girls in the street has to protect them with a Kalashnikov? When young people play football with a weapon in their hands? When a family has to leave their home with what is left of their possessions stuffed into two plastic bags and a laundry basket?

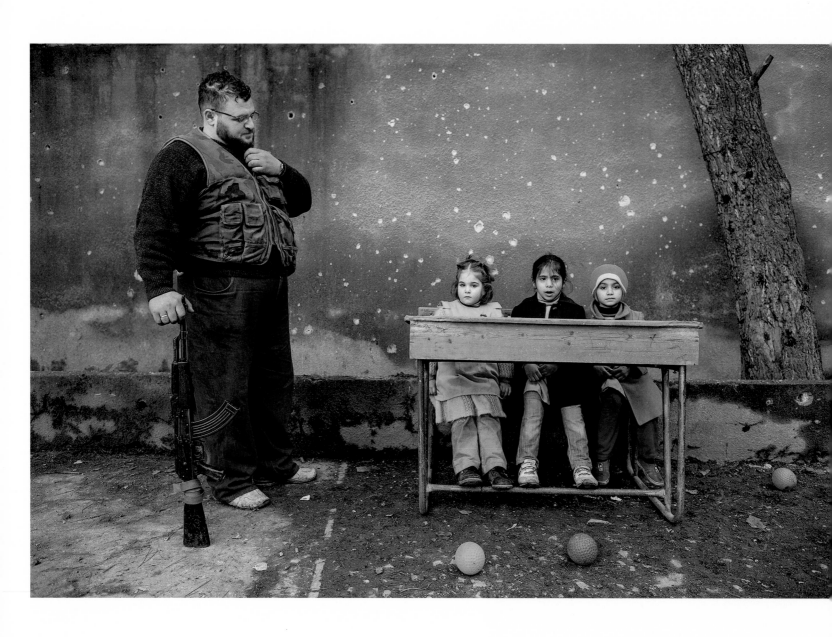

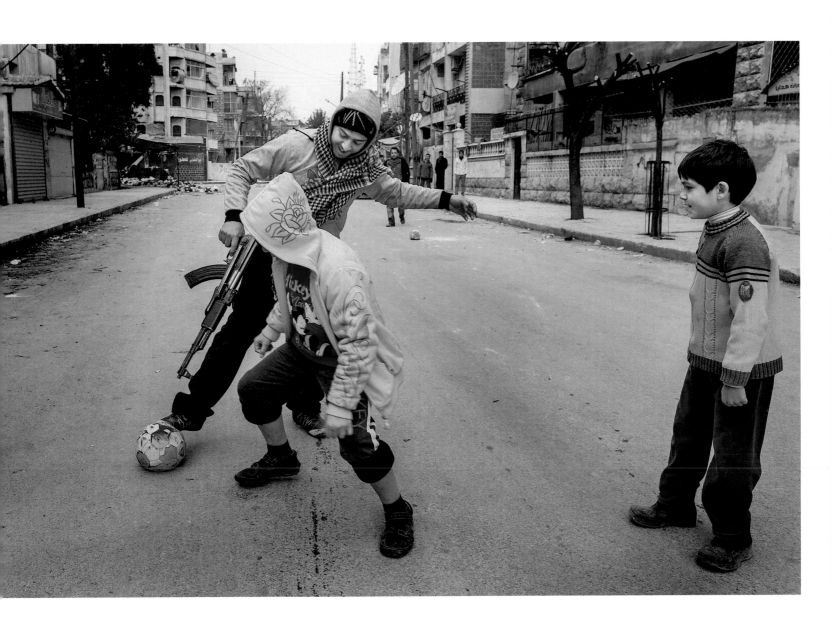

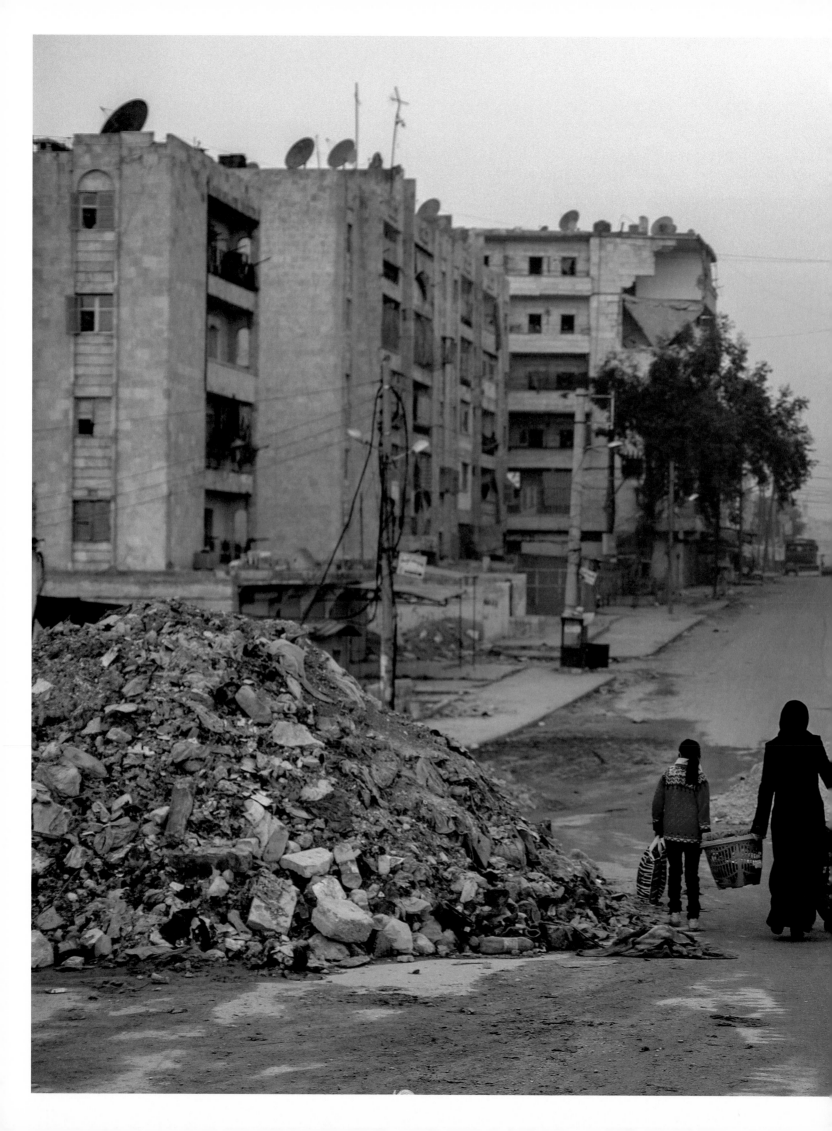

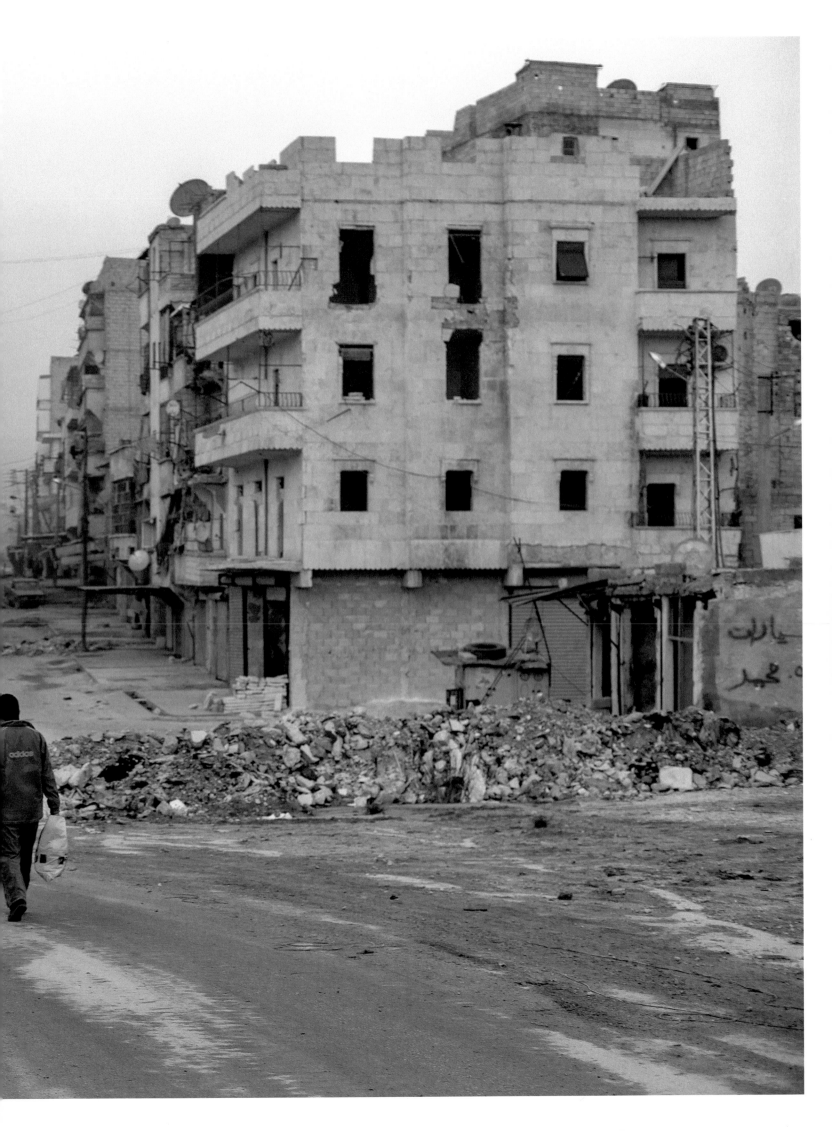

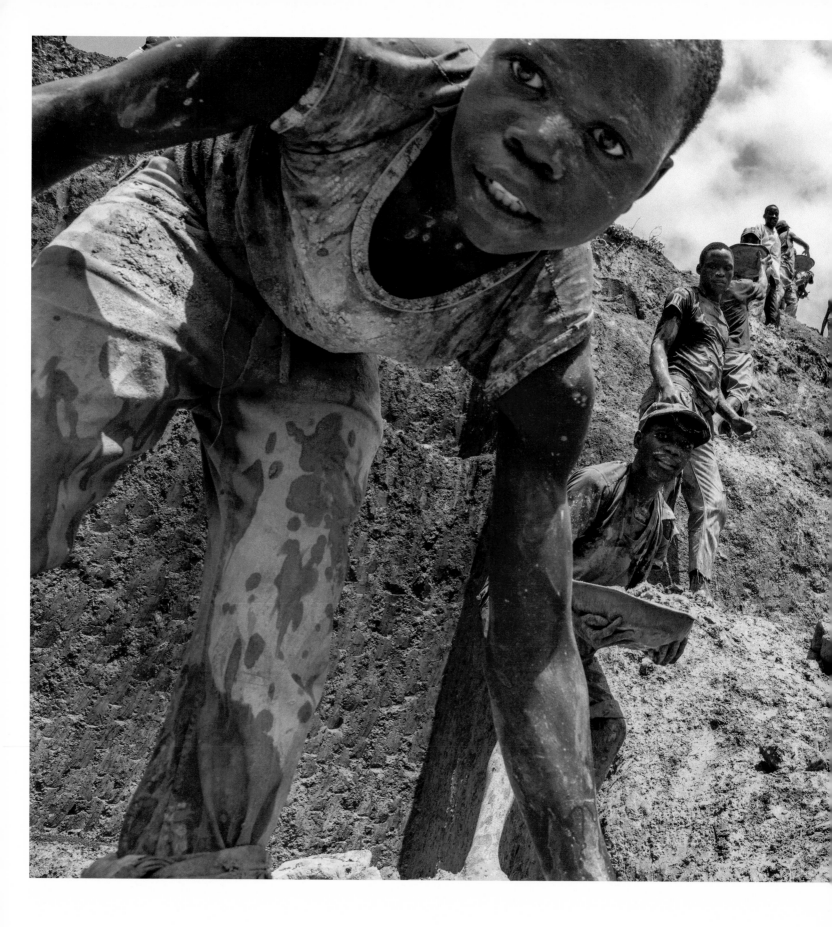

Marcus Bleasdale | VII Photo Agency wurde 1968 in England geboren, verbrachte zwölf Jahre in Afrika und lebt gegenwärtig in Oslo. Ein Universitätsstudium in den Fächern Ökonomie und Finanzen schärfte seinen Blick für wirtschaftliche Zusammenhänge und bestimmt auch die Thematik vieler seiner Fotoreportagen, die, vielfach ausgezeichnet, in großen europäischen und US-Magazinen erscheinen. Bleasdale will politisch wirken; seinen Vorträgen, unter anderem im US-Senat, in der Versammlung der Vereinten Nationen und im englischen Parlament, misst er deshalb eine ebenso große Bedeutung bei wie seiner journalistischen Arbeit.

Marcus Bleasdale | VII Photo Agency was born in England in 1968, spent twelve years in Africa and now lives in Oslo. Studying economics and finance at university sharpened his eye for economic backgrounds and shaped his choice of theme for much of his photojournalism, which won many awards and is published in major European and US magazines. Bleasdale wants to have a political impact. Which is why, for him, his talks, for instance to the US Senate, the UN Assembly and the UK Parliament, are just as important as his work as a journalist.

Mit unermüdlichem Engagement versucht Marcus Bleasdale seit 1999, auf die desaströse Situation in der Demokratischen Republik Kongo aufmerksam zu machen — einem Land, das über riesige Boden-schätze verfügt: Gold, Diamanten, Mangan, Uran. Und besonders Coltan, ein Erz, dessen metalli-sche Elemente unverzichtbar für die Elektronik in Mobiltelefonen, Computern, Digitalkameras und Spielkonsolen sind. Eine korrupte Staatsführung, käufliches Militär, einander bekämpfende Rebel-lengruppen und auch internationale Unterneh-men bereichern sich an den begehrten Rohstoffen, während die Bevölkerung zur Armut verdammt bleibt. Immer wieder aufflackernde Bürgerkriege haben vermutlich schon fünf Millionen Menschen das Leben gekostet. Um Elend und Hoffnungslo-sigkeit zu entgehen, schuften Kinder und Jugend-liche in den Abbaugebieten, oder sie schließen sich Milizen oder Schmugglern an, unter deren Kontrolle der Rohstoffabbau vielerorts steht.

With tireless dedication Marcus Bleasdale has tried to alert the world since 1999 to the disas-trous situation in the Democratic Republic of Congo — a country with enormous mineral wealth: gold, diamonds, manganese, uranium. And espe-cially coltan, a mineral whose metallic elements are indispensable for the electronics in mobile telephones, computers, digital cameras and gam-ing consoles. A very corrupt government, bribable military, infighting rebel groups and even inter-national companies exploit the coveted raw ma-terials while the population remains condemned to poverty. Now and then, civil wars flare up and have probably cost five million lives to date. In a struggle against need and hopelessness, children and young people work hard in the mines or join militias or smugglers who control the exploitation of raw materials in many places.

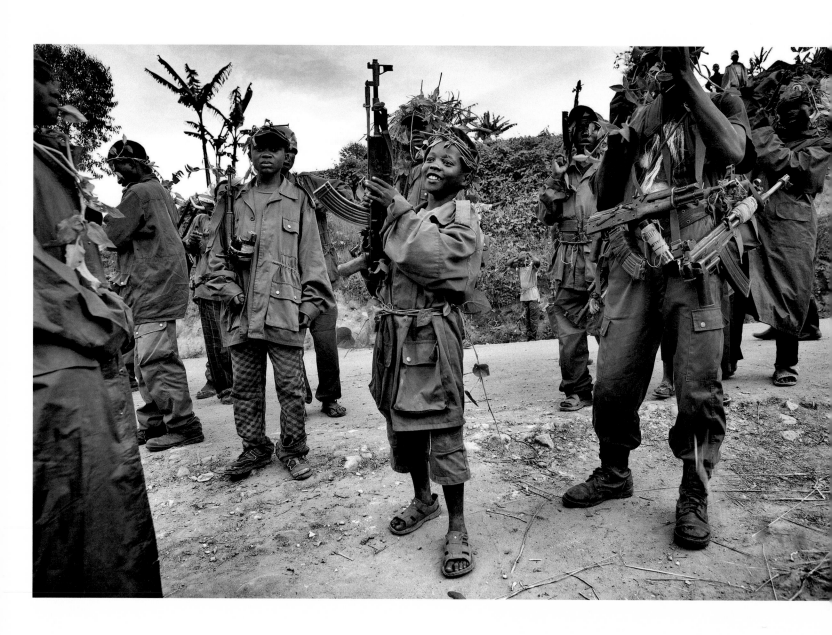

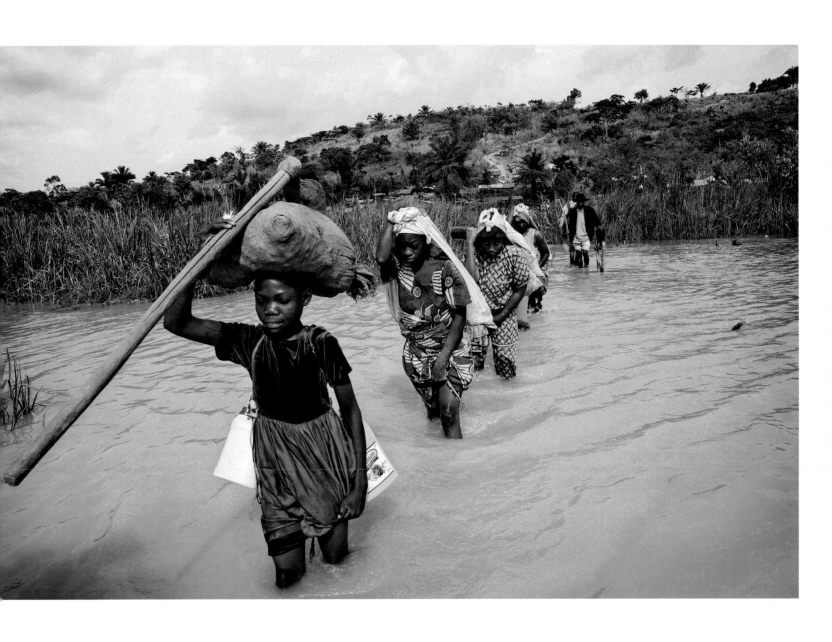

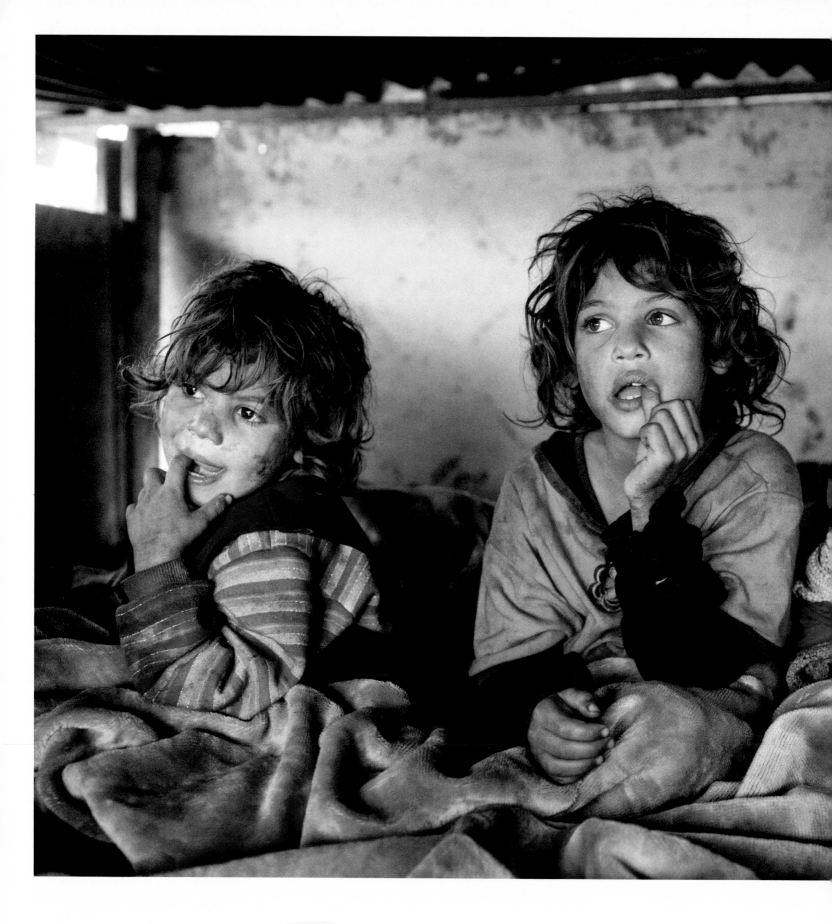

Mugur Vărzariu. Weil ihn sein Beruf als Marketing-Manager in Rumänien nicht mehr befriedigte, gab Mugur Vărzariu ihn 2010 auf. Sein Interesse an Fotografie war scho zuvor vorhanden, aber von da an wurde sie zum Dreh- und Angelpunkt seines Lebens. Durch das Auge seiner Kamera, sagt er, könne er klarer sehen; als Fotograf könn er seine Emotionen verstecken, gerade wenn ihm zum Heulen zumute sei. Die ihn bedrückenden Lebensumstände der Roma sind sein Thema. Anerkennung findet Vărzari durch Veröffentlichungen, Ausstellungen und Vorträge. Er ist Botschafter für World Vision in Rumänien.

Mugur Vărzariu. When his job as marketing manager in Romania no longer met his ambitions, Mugur Vărzariu left it in 2010. His interest in photography dated further bac than that, but now it became the pivotal element of his life. Through the eye of his camera, he says, he can see more clearly; as photographer he is able to hide his emotion particularly in situations when he feels like crying. The depressing circumstances of the Romani people are his theme. Vărzariu has gained recognition through publication exhibitions and talks. He is ambassador for World Vision in Romania.

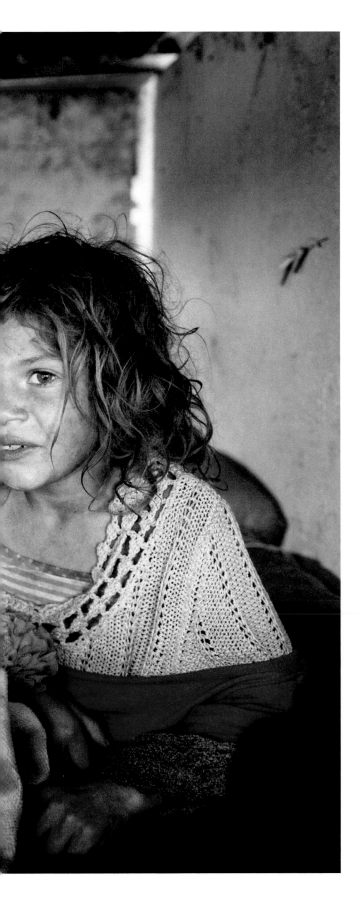

Das Schlimmste, was er sich vorstellen könne, sagt Mugur Vărzariu, sei die Gleichgültigkeit gegenüber offensichtlichem Unrecht. Mit dieser Einstellung dokumentiert er die traurigen Lebensumstände einer verfemten Minderheit in seinem Heimatland Rumänien: der Roma. Seine hier zu sehenden Bilder stammen aus Baia Mare, einer Stadt im Nordwesten Rumäniens, und sie stehen stellvertretend für andere Roma-Lager im Land. In den mühsamen Zeiten des Wechsels vom Kommunismus zur freien Marktwirtschaft suchen viele Rumänen nach Sündenböcken für eigene unerfüllte Träume. Die Minorität der Roma bietet sich für hasserfüllte Ablehnung und Ausgrenzung an. Schwere Übergriffe auf sie und ihren Besitz waren und sind an der Tagesordnung, Zwangsumsiedlungen nichts Ungewöhnliches. Vielen Roma bleibt ein Leben ohne Wasser und Strom, neben Müllhalden oder Kläranlagen, in ständiger Angst und in Unsicherheit.

The worst he can imagine, says Mugur Vărzariu, is indifference to obvious injustice. With this attitude he documents the sad circumstances of the Romani people, an ostracized minority in his home country of Romania. His pictures shown here were taken in Baia Mare, a town in the northwest of Romania, and they stand for other Romani camps across the country. In difficult times of change from communism to a free market society, many Romanians are looking for scapegoats to blame for their own unfulfilled dreams. The Romani minority lends itself to hate-filled rejection and marginalization. Violent attacks on them and their possessions have been and still are commonplace, forced resettlement is not unusual. Many Romani are left living without running water or electricity, next to rubbish dumps or sewage treatment plants, in constant fear and uncertainty.

DAS RECHT AUF SCHUTZ VOR GEWALT **[Art. 19]**
THE RIGHT TO PROTECTION FROM VIOLENCE

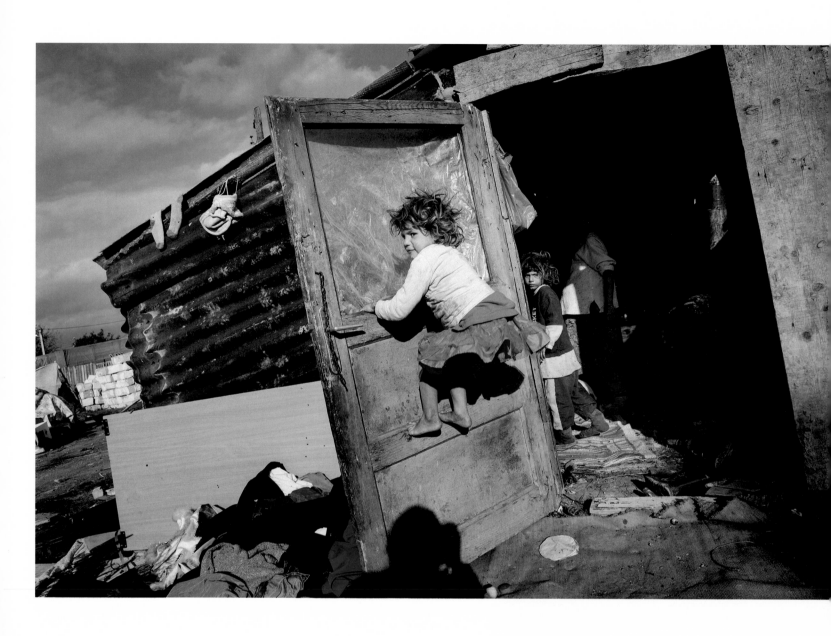

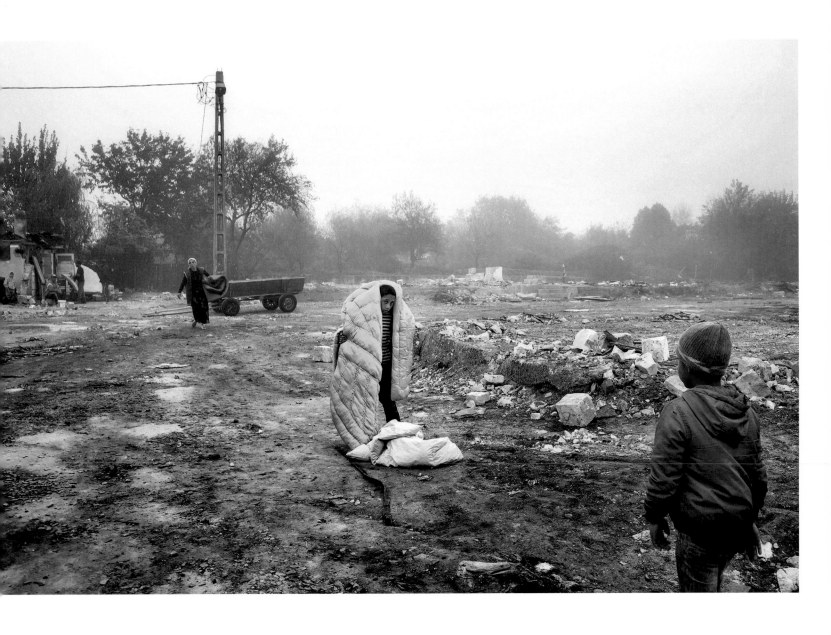

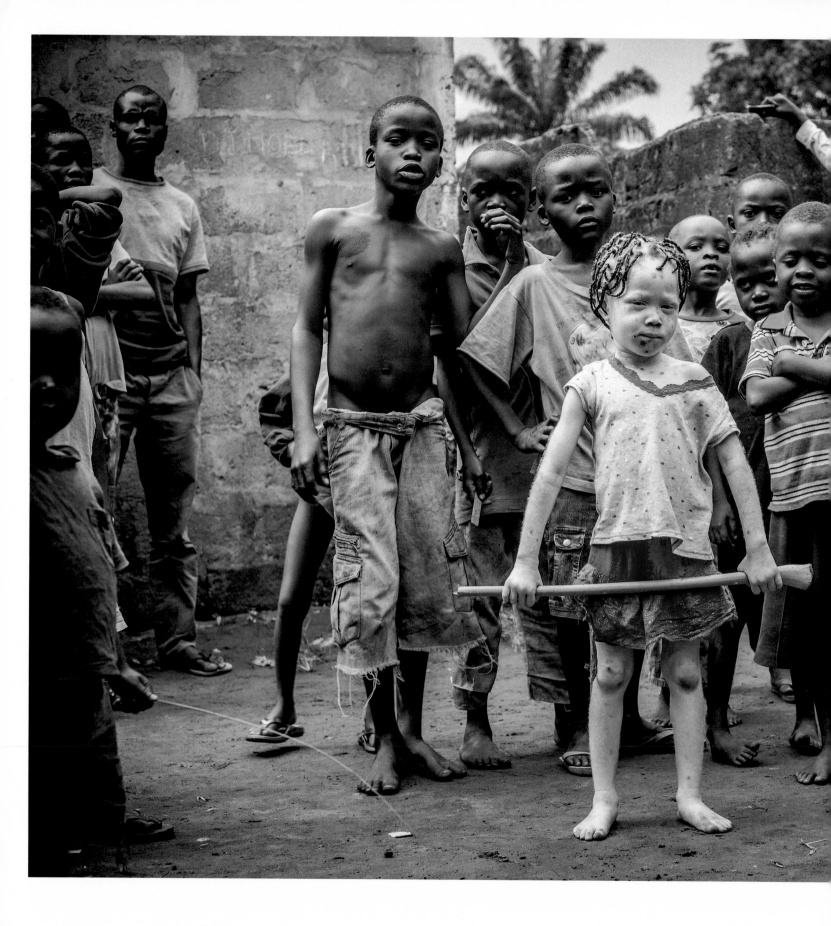

Patricia Willocq | Corbis Images wurde 1980 in Kinshasa, der Hauptstadt der Demokratischen Republik Kongo, geboren und besuchte dort das Gymnasium. Ihr Masterstudium absolvierte sie am Higher Institute of Translators and Interpreters in Belgien. Die Sprachbegabung nutzte sie bei ihren Reisen auf nahezu alle Kontinente, bei denen sie zuerst beiläufig, dann immer intensiver fotografierte, bevor ihre Arbeiten 2005 erstmals veröffentlicht wurden. Da die hellhäutigen Kinder und deren Schicksal sie schon als Mädchen berührten, ist sie ihnen auch als Fotografin treu geblieben.

Patricia Willocq | Corbis Images was born in Kinshasa, capital of the Democratic Republic of the Congo, in 1980 and attended grammar school there. She took her master's degree at the Higher Institute of Translators and Interpreters in Belgium. Her talent for languages stood her in good stead on her travels on nearly all continents, during which she began, at first casually, then ever more intensely, to take photographs, until she published her work for the first time in 2005. Light-skinned children and their fate had touched her even when she was a girl and she remained true to them as a photographer.

So wenig wie der „schwarze Kontinent" in anderer Hinsicht so monochrom wie in unseren Klischeevorstellungen ist, so wenig ist er es in den Hautfarben seiner Bewohner. Eine Ausprägung aber macht Menschen hier noch mehr als anderswo zu Sonderlingen: sehr weiße Haut, eine ungewöhnlich helle Haarfarbe, blaue oder grüne Augen. Als Albinismus wird diese angeborene Stoffwechselerkrankung bezeichnet, die zu einer Störung der Melaninbildung führt. Dadurch fehlen die dunklen Pigmente in Haut, Haaren und in der Iris. Die Betroffenen sind oft sehbehindert und brauchen besonderen Schutz vor der Sonne. Vor allem leiden sie unter gesellschaftlicher Stigmatisierung und dem Aberglauben, sie hätten übernatürliche Kräfte, seien unsterbliche Geister. Da grenzt es an ein Wunder, mit welchem Mut und Selbstbewusstsein die jungen Albinos in Kinshasa versuchen, ihrer Außenseiterrolle zu trotzen. Patricia Willocq versucht, mit ihren Fotos zum Selbstvertrauen der betroffenen Kinder beizutragen.

Just as the 'black continent' is nothing like as monochrome as our stereotyped ideas of it, so neither are the skin tones of its inhabitants. One variant, however, here more than elsewhere, marks people out as misfits: very white skin, unusually light hair colour, blue or green eyes. This congenital metabolic disease is called albinism. It disrupts the production of melanin and means that dark pigmentation in skin, hair and iris is missing. Sufferers often are visually impaired and need special protection from the sun. Most of all they suffer from social stigmatization, from the superstitious belief that they might have supernatural powers and might be immortal spirits. So it is little short of a miracle how courageously and confidently the young albinos in Kinshasa try to overcome their role as outsiders. In her photographs Patricia Willocq helps to boost the self-assurance of the affected children.

DAS RECHT AUF GLEICHHEIT **[Art. 2]**
THE RIGHT TO EQUALITY

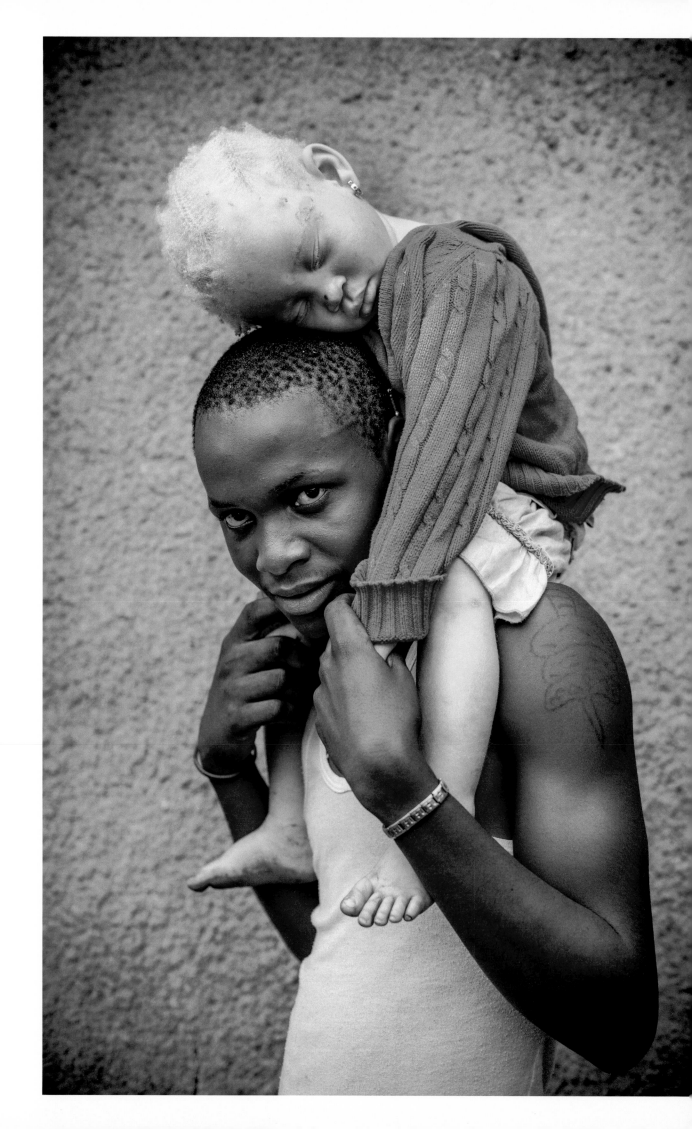

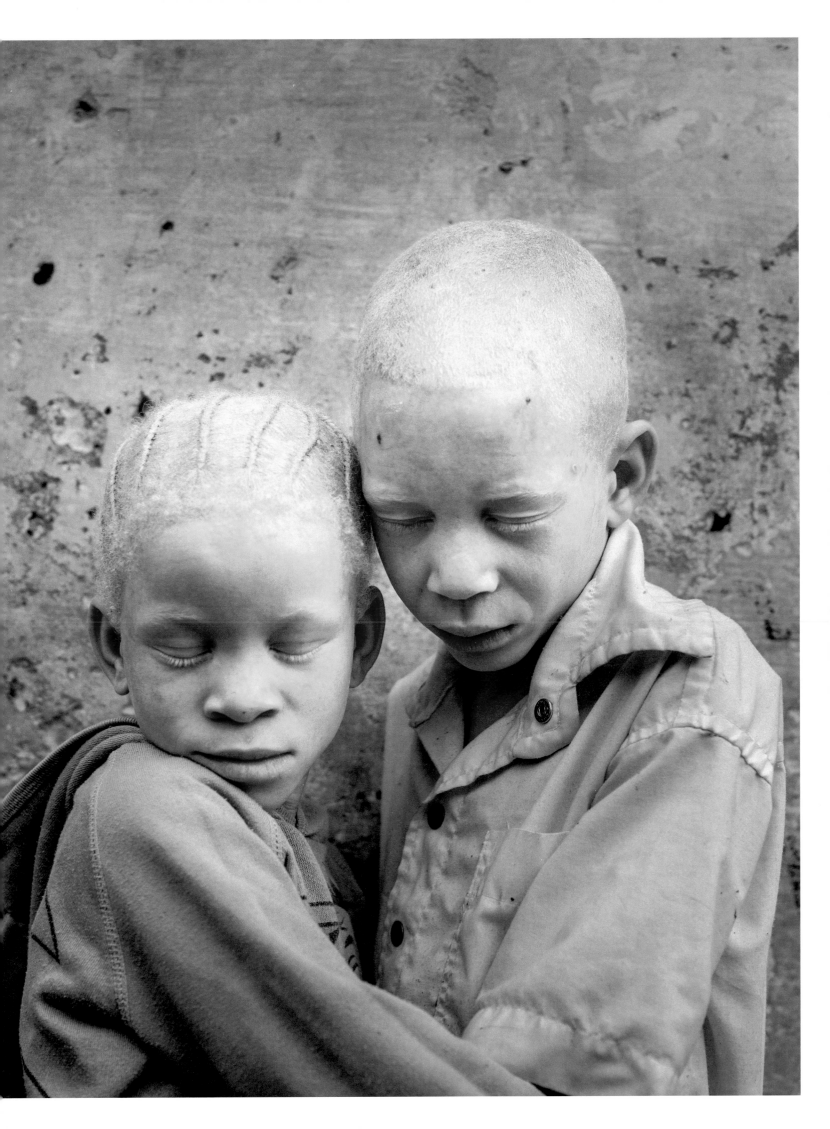

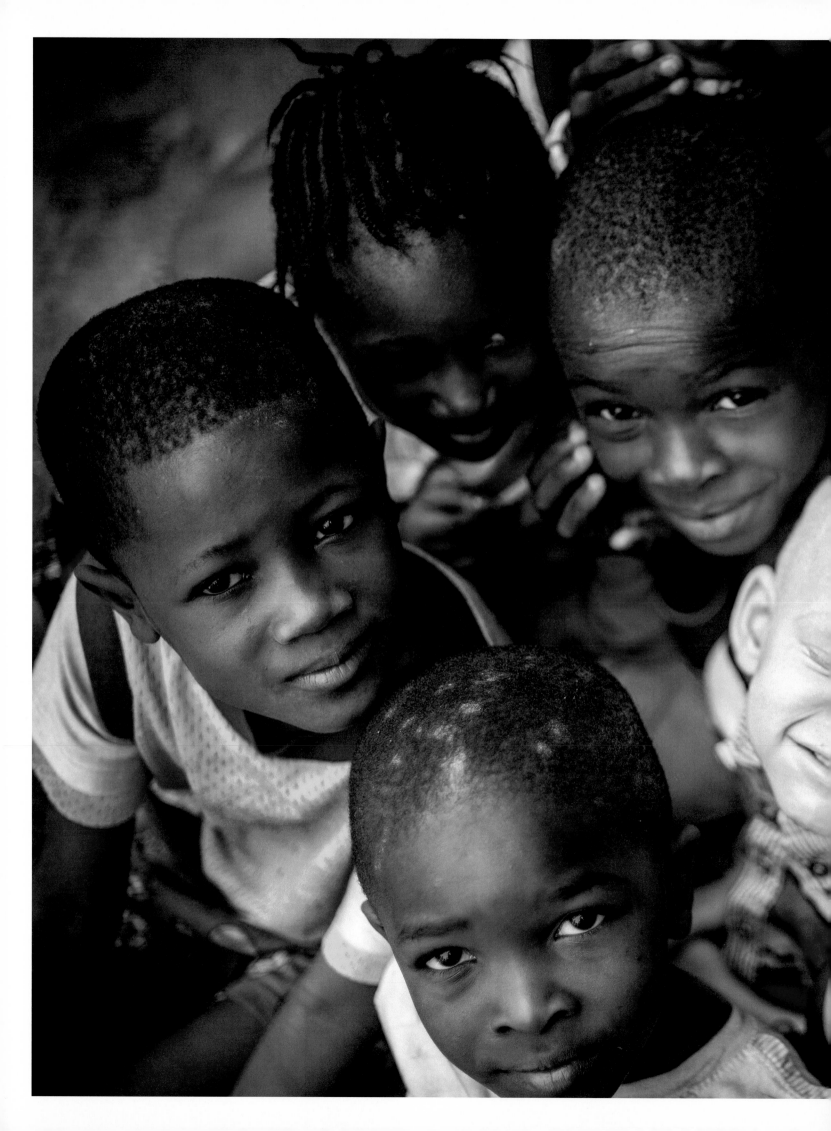

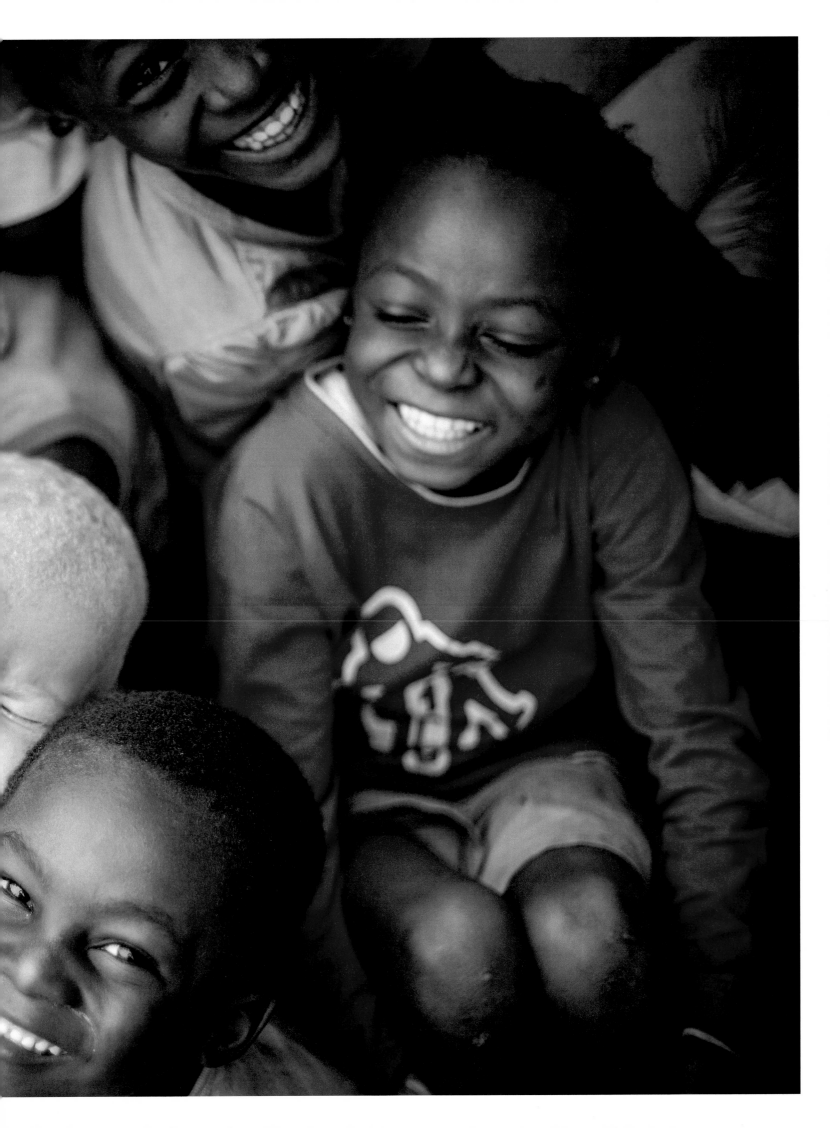

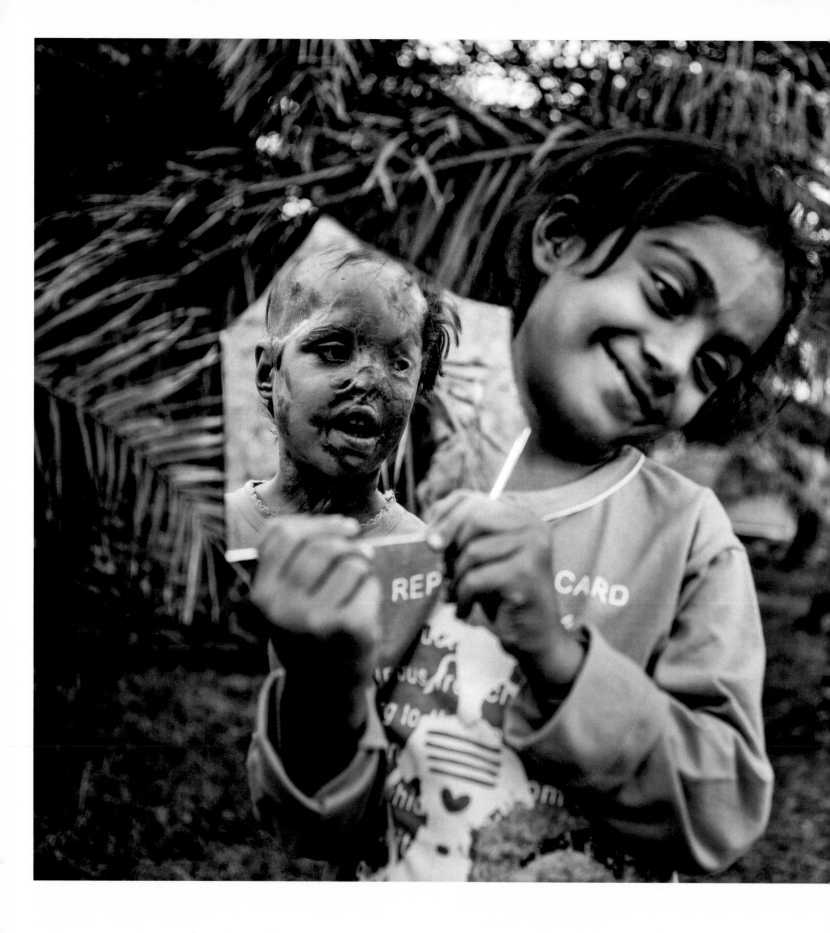

Younes Khani | Mehr News Agency wurde 1987 in Teheran geboren. Professionell fotografiert er seit 2004, seit 2006 für die halbamtliche iranische Nachrichtenagentur Mel
und für internationale Auftraggeber. Sein fotografischer Schwerpunkt liegt auf Kultur und gesellschaftlichen Veränderungen im Iran. Persönlich sucht er sich meist Theme
aus, die das Miteinander von Männern, Frauen und Kindern zeigen. Und seit über zwei Jahren hält er engen Kontakt zu Somayeh und ihrer Tochter Rama.

Younes Khani | Mehr News Agency was born in Teheran in 1987. He has worked as a professional photographer since 2004, and since 2006 for the semi-official Iranian new
agency Mehr as well as for international clients. His photography focuses on culture and social change in Iran. In his personal choice of themes he goes for those that includ
an interaction of men, women and children. And for more than two years now he has been in close contact with Somayeh and her daughter Rama.

Es gibt Fotografien, die eine so grausame Wirklichkeit zeigen, dass der Betrachter am liebsten wegschauen würde. Von solcher Art sind die Bilder des Iraners Younes Khani. Was er dokumentierte, ist ein Exzess der Gewalt an Frauen; Ausdruck jener Tradition, in der eine Frau nicht mehr als das Besitzgut des Mannes ist. Khani fotografierte die immer wieder eingesperrte und geschlagene Iranerin Somayeh, die, als sie keinen anderen Ausweg mehr sah, als sich zu trennen, mitsamt ihrer vierjährigen Tochter Rama vom Ehemann mit Säure übergossen wurde. Somayeh ist seither erblindet, Rama verlor ein Auge; beide haben schwere Verätzungen an Gesichtern und Körpern. Der Vater von Somayeh verkaufte sein Farmland, um eine medizinische Behandlung für Tochter und Enkelin zu ermöglichen. Was den Fotografen an diesem Schicksal zusätzlich bewegt, ist der große Wunsch der Mutter, dass ihre Tochter trotz des verlorenen Auges und ihrer anderen schweren Verletzungen eines Tages zur Schule gehen kann.

There are photographs that show a reality so cruel the viewer would like to look away. Iranian Younes Khani takes such pictures. What he has documented is massive violence towards women; remnant of a tradition in which a woman is just part of a man's belongings. Khani photographed the Iranian woman Somayeh, who was repeatedly locked away and beaten. When she saw no way out other than to separate from her husband, he attacked her and her four year old daughter with acid. Somayeh lost her sight, Rama one eye; both have severe burns in face and body. Somayeh's father sold his farmland to procure medical treatment for his daughter and granddaughter. What moved the photographer in addition to this stark fate is the mother's dearest wish that her daughter, despite her severe injuries and having lost one eye, should one day be able to attend school.

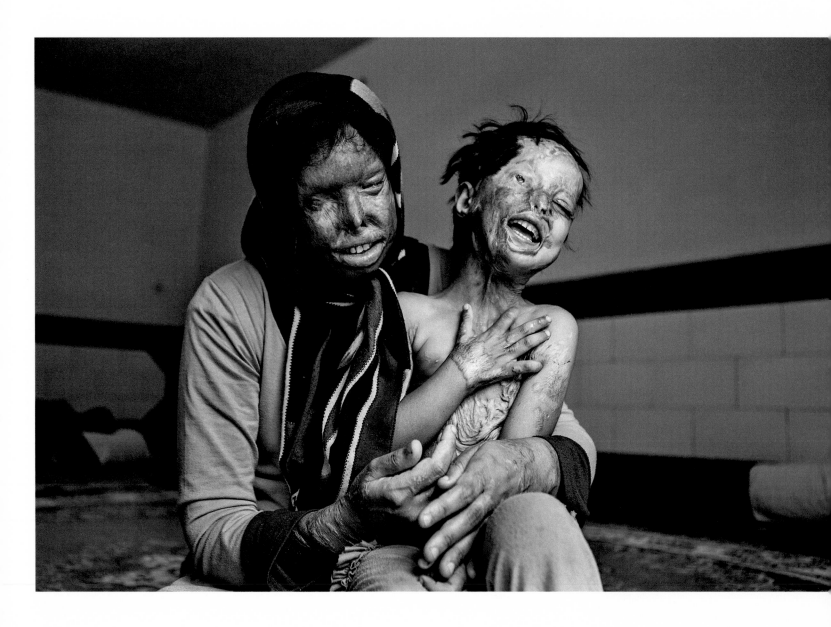

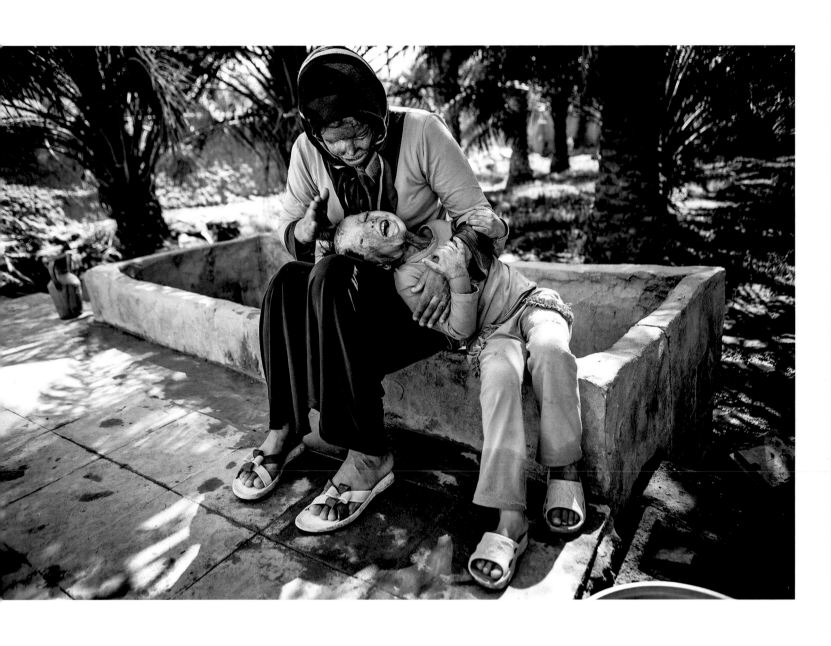

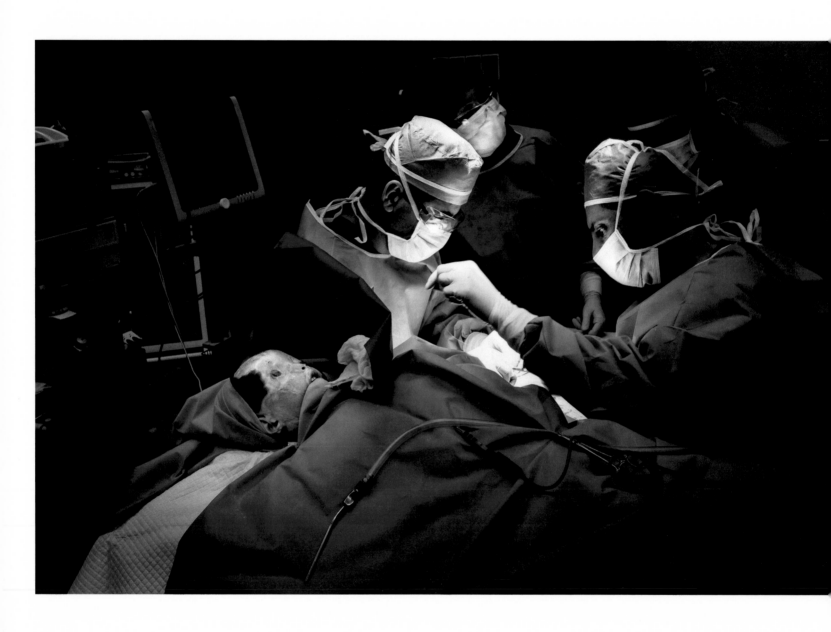

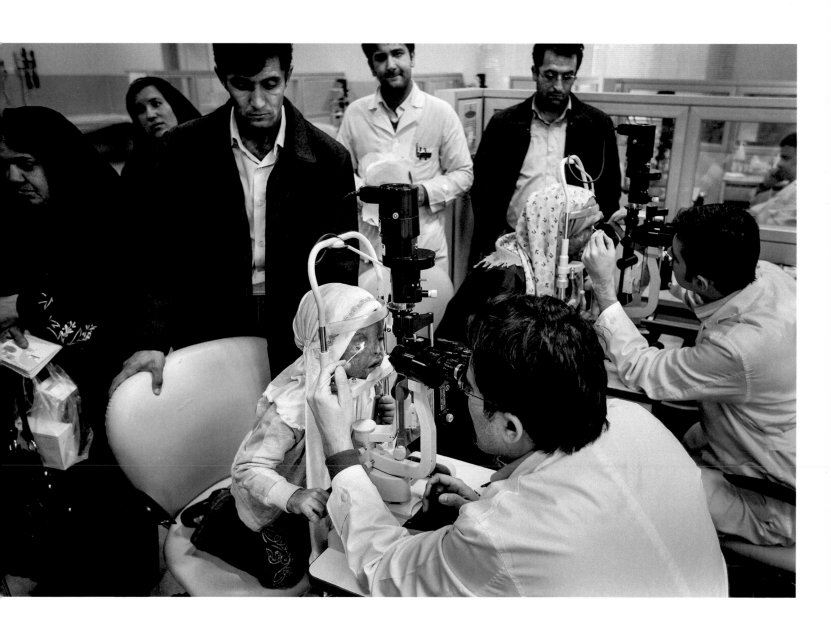

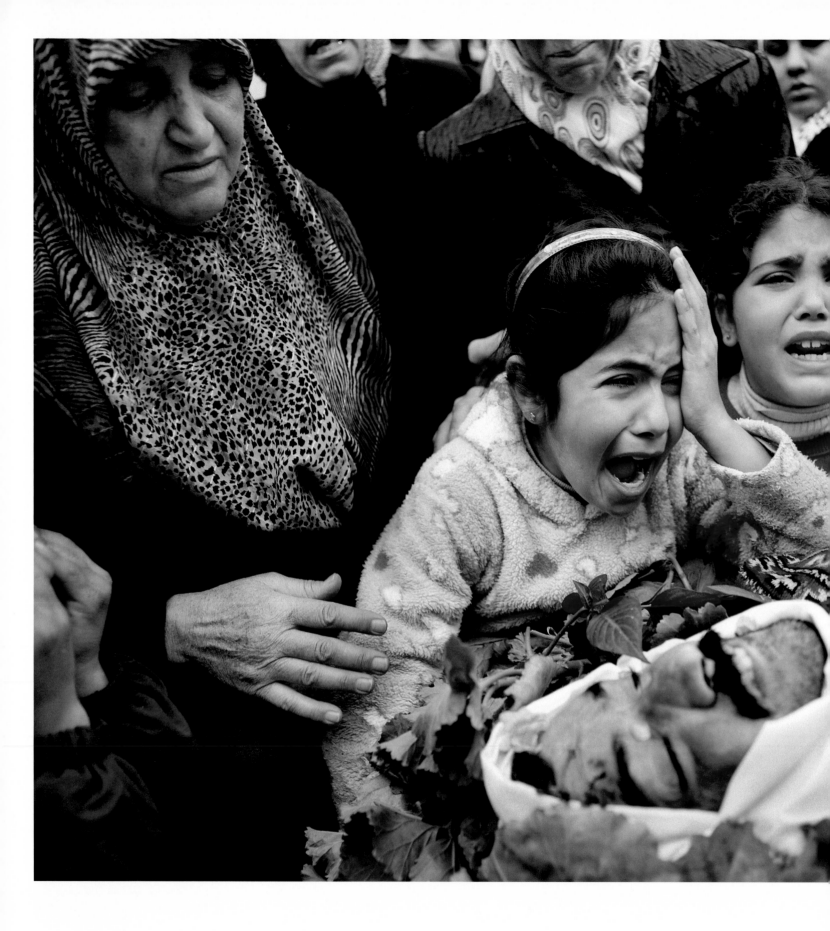

Alessio Romenzi | Corbis Images wurde 1974 in Italien geboren. Schon als Jugendlicher hat er leidenschaftlich fotografiert, und nach einer Lehre als Zimmermann zog er nach Rom, um dort 2009 ein Studium in Fotografie abzuschließen. Er verlegte seinen Wohnort in den Nahen Osten, um für internationale Magazine und Organisationen wie Amnesty International, das Internationale Komitee des Roten Kreuzes und die Vereinten Nationen zu fotografieren. Romenzi war einer der ersten Reporter, der sich in umkämpfte Gebiete in Syrien einschmuggeln ließ. Er hofft, dass seine Bilder jene Menschen, die in Frieden leben, dazu animieren, Hilfsorganisationen bei deren Arbeit zu unterstützen.

Alessio Romenzi | Corbis Images was born in Italy in 1974. Even as a youngster he was passionate about photography. After an apprenticeship as a joiner he went to Rome to study photography, which he completed in 2009. He moved to the Middle East to photograph for international magazines and for organizations such as Amnesty International, the International Committee of the Red Cross and the United Nations. Romenzi was one of the first reporters to be smuggled in to the embattled areas in Syria. He hopes that his pictures will encourage those who live in peace to support relief agencies in their work.

Die Kämpfe zwischen den verschiedenen Gegnern und Verteidigern der Regierung Baschar al-Assad verwandeln Syrien seit 2011 in ein ständig neu ausbrechendes Inferno. In seinen Bildern fängt Alessio Romenzi den Irrsinn von Verwüstungen, Verletzungen und Tod ein: Jeden Tag bricht Kindern das Herz bei Beerdigungen ihrer Väter, Mütter und Geschwister; jeden Tag stehen kleine Mädchen mit verstörtem Blick auf blutigen Fußböden eines Hospitals, umgeben von Männern mit Kalaschnikows und Verwundeten; jeden Tag suchen Frauen und Kinder Deckung in Kellerräumen, wenn oben die Granaten einschlagen. Mindestens 160 000 Menschen, Stand Sommer 2014, sind bisher getötet worden. Fast drei Millionen Syrer sind aus ihrem Land geflohen, und mehr als sechs Millionen sollen innerhalb Syriens auf der Flucht sein. Menschen, die mit einem Trauma werden leben müssen, wenn sie denn leben werden.

Clashes between the various opponents and the defenders of the government of Bashar al-Assad have turned Syria into an inferno that has kept re-igniting since 2011. In his pictures Alessio Romenzi captures the madness of destruction, injury and death: Every day the hearts of children break when they bury their fathers, mothers, siblings; every day distraught little girls stand on the bloody floor of a hospital, surrounded by men with Kalashnikovs and by the injured; every day women and children seek shelter in cellars while shells hit upstairs. At least 160 000 people, as of summer 2014, have been killed so far. Nearly three million Syrians have fled their country and more than six million are estimated to be refugees inside Syria. People who will have to live with a trauma, if they do survive.

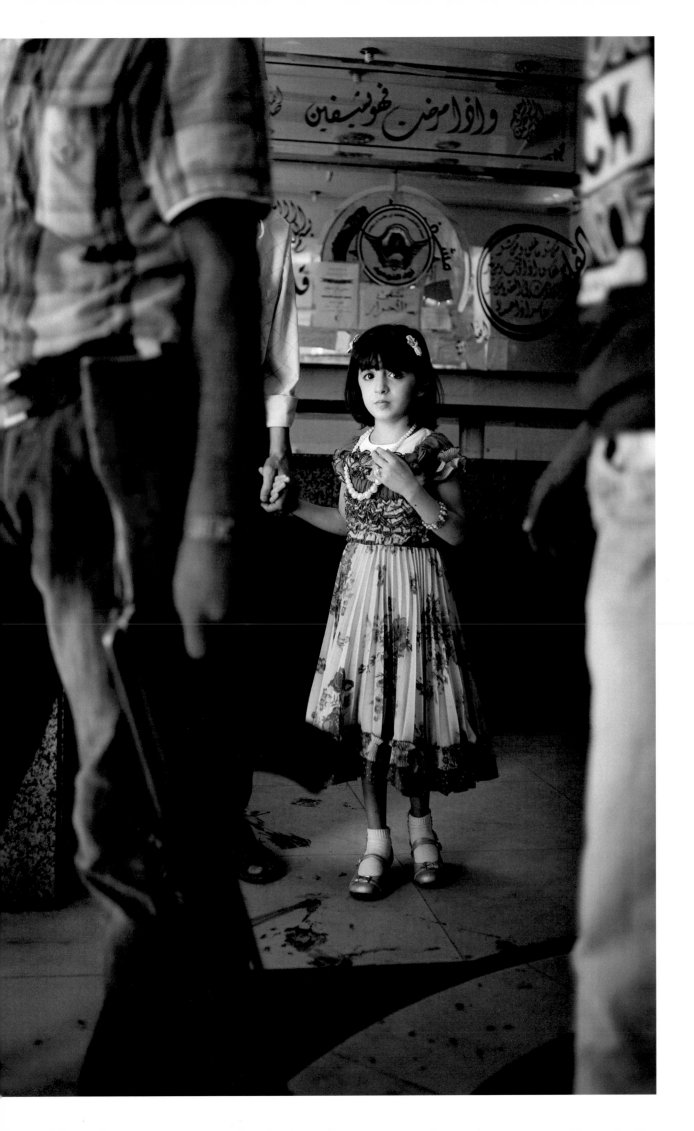

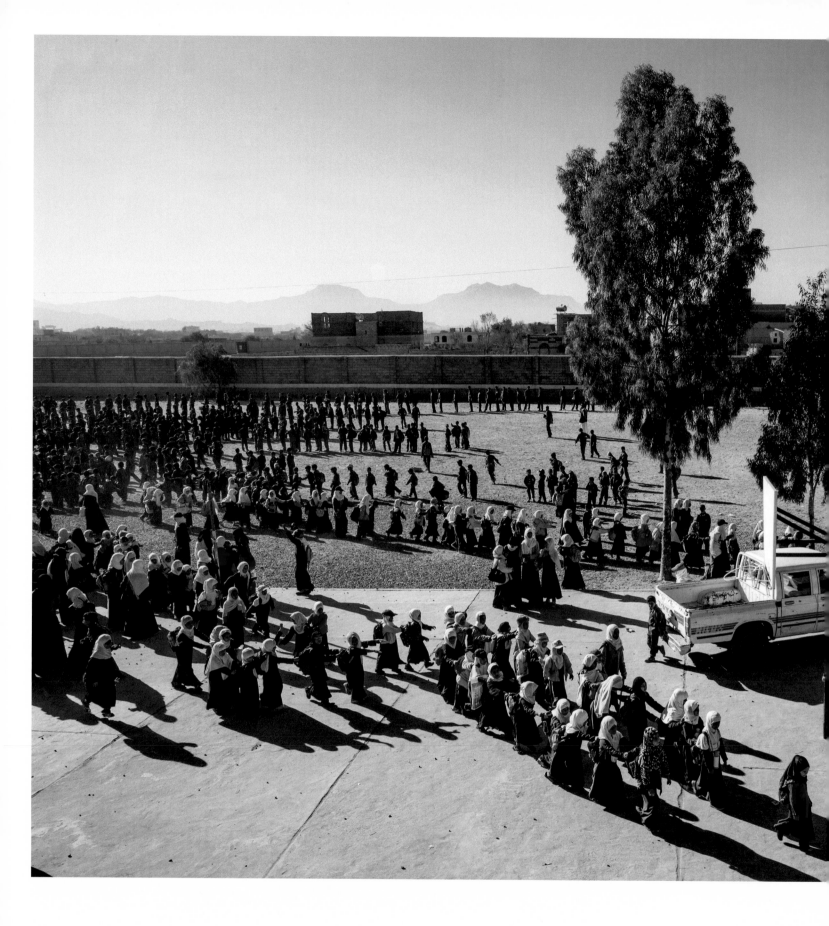

Laura Boushnak | Rawiya Collective ist Palästinenserin, in Kuwait geboren. Im Libanon studierte sie Soziologie. Um Aspekte des sozialen Zusammenlebens zu visualisiere[n] begann sie mit der Fotografie, arbeitete für AP und AFP über die Konflikte im Nahen Osten. Die von ihr mitbegründete Agentur Rawiya ist das erste weibliche Foto-Kollektiv de[r] Region. In Ländern der muslimischen Welt dokumentiert Laura Boushnak die sozialen und kulturellen Veränderungen im Leben von Mädchen und Frauen und die Bedeutun[g] der Lese- und Schreibfähigkeit als Voraussetzung eines Wandels zum Besseren. Ihre Fotos werden international veröffentlicht und von den USA bis nach China ausgestellt.

Laura Boushnak | Rawiya Collective is a Palestinian, born in Kuwait. She studied sociology in Lebanon. She started to take photographs in an attempt at visualizin[g] aspects of social coexistence. She has worked for AP and AFP on the conflicts in the Middle East. The Rawiya Collective that she helped to establish is the first femal[e] photo agency in the region. In countries of the Muslim world Laura Boushnak documents the social and cultural changes in the lives of girls and women and the role o[f] literacy as a precondition for a change for the better. Her photographs have been published internationally and been exhibited across the world, from the USA to Chin[a].

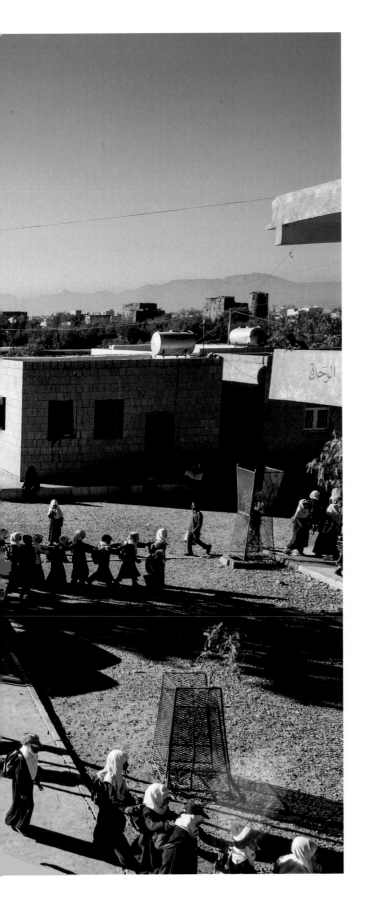

Ein jemenitisches Sprichwort sagt: Ein Mädchen verlässt sein Haus nur zwei Mal: Wenn es heiratet, und wenn es stirbt. Im Jemen als Frau geboren zu werden, bedeutet: Die Chancen, eine öffentliche Schule zu besuchen, dort Lesen und Schreiben zu lernen, sind gering. Laut UNICEF wird jedes dritte Mädchen im Jemen vor seinem 18. Geburtstag verheiratet. Dabei spielen auch Stammestraditionen eine Rolle. Etwa die Auffassung, dass eine sehr junge Braut leichter zu einer gefügigen Ehefrau geformt werden kann. Diese Haltung gegenüber der Rolle der Frau kommt ebenso aus tradiertem Geschlechterverständnis wie aus armutsbedingter Unbildung — besonders auf dem Lande. 18 Prozent der jemenitischen Bevölkerung leben in absoluter Armut. So müssen Mädchen auf dem Weg zu mehr Bildung und Selbstbestimmung viele Hürden innerhalb ihrer Familie überwinden. Laura Boushnak zeigt die ersten kleinen Freiheiten — und die Freude darüber bei jungen jemenitischen Schülerinnen.

A Yemeni saying goes: A girl only leaves the house twice: when she marries and when she dies. To be born a woman in Yemen means hardly any chance of attending a public school, of learning to read and write there. According to UNICEF every third girl in Yemen is married off before she turns 18. Tribal traditions also play a role in this, like the assumption that a very young bride will be easier to mould into a submissive wife. These mindsets about the role of women that stem from traditional concepts of gender as much as from poverty-driven lack of education, especially in rural areas. 18 percent of the population live in absolute poverty. In this situation girls must take many hurdles within their families on the path towards education and self-determination. Laura Boushnak shows the first small liberties — and the joy about them in the young Yemenite pupils.

**DAS RECHT AUF BILDUNG
THE RIGHT TO EDUCATION [Art. 28]**

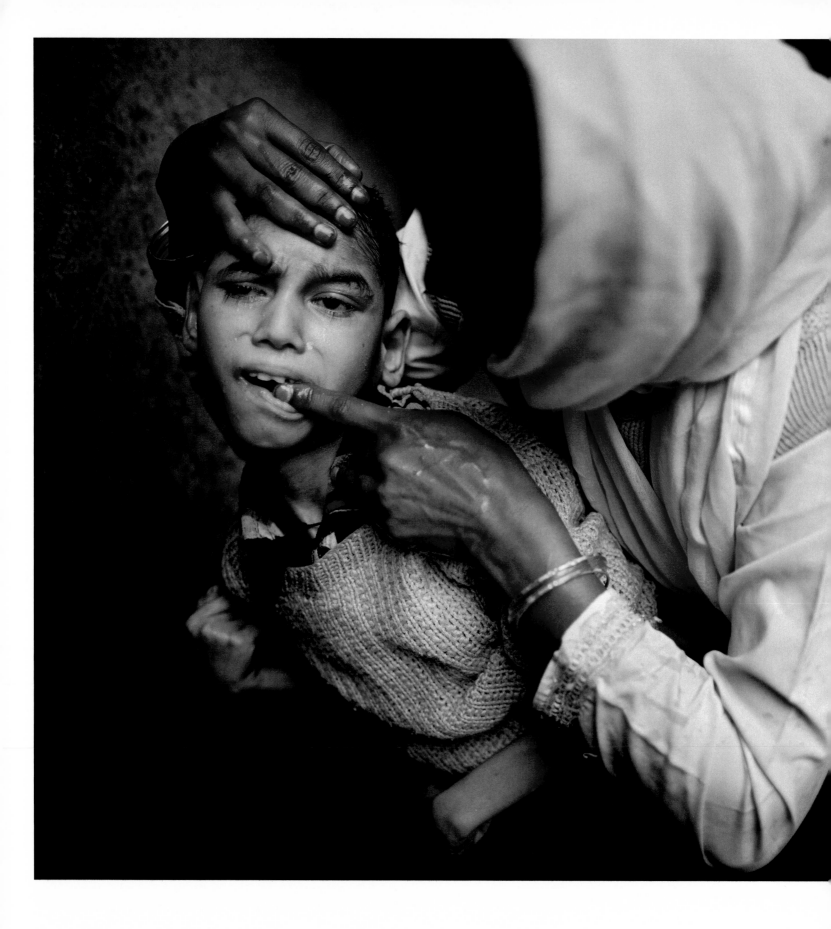

Alex Masi | Corbis Images wurde in Italien geboren, schloss 2006 ein Studium des Fotojournalismus am London College of Communication ab und widmet sich bei seine Recherchen sozialen und ökologischen Themen sowie den Menschenrechtsverletzungen in Ländern wie Indien, Afghanistan, Nigeria und dem Irak. Immer wieder ist Masi nac Bhopal gereist, um auf die Folgen eines heute fast vergessenen Umweltdesasters hinzuweisen. Er ist überzeugt, dass Fotos in der Lage sind, durch die von ihnen erzeug öffentliche Aufmerksamkeit zu Änderungen im Handeln politischer Akteure und in der Rechtsprechung beizutragen. Empathie will Masi erzeugen, Respekt und Brüderlichke

Alex Masi | Corbis Images born in Italy, completed a degree in photojournalism at the London College of Communication in 2006 and focuses in his investigations on soci and ecological themes, as well as on human rights violations in countries such as India, Afghanistan, Nigeria and Iraq. Masi has returned to Bhopal repeatedly to point o the aftermath of an environmental disaster that is almost forgotten today. He is convinced that photographs, through the public attention generated by them, are capable encouraging change in the actions of political and legislative actors. What Masi wants to generate is empathy, respect and fraternity.

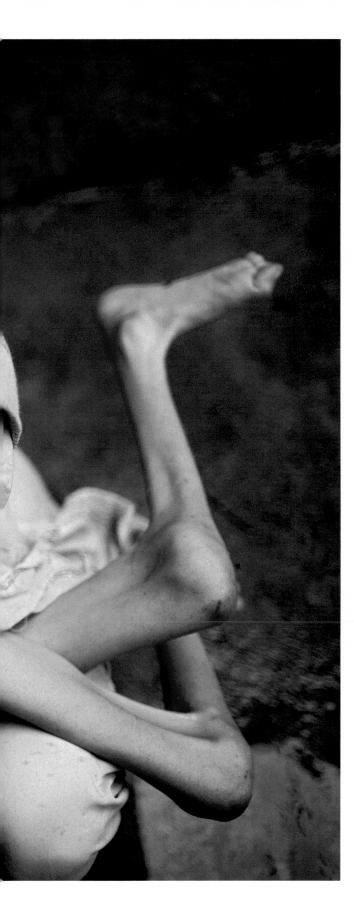

Im Dezember 1984 traten aus einem Werk des US-Chemiekonzerns Union Carbide im indischen Bhopal aufgrund technischer Pannen, nicht zuletzt verursacht durch Sparmaßnahmen, mehrere Tonnen giftiger Stoffe in die Atmosphäre. Tausende Menschen starben an den unmittelbaren Folgen. Unzählige erblindeten, erlitten Hirnschäden, Lähmungen, Lungenödeme, Herz-, Magen- und Lebererkrankungen. Fehlbildungen bei Neugeborenen und Wachstumsstörungen bei heranwachsenden Kindern sind eine weitere Langzeitfolge, weil sich nach wie vor hochgiftige Überreste aus der Explosion in Boden und Grundwasser befinden. Doch niemand fühlt sich für die Sanierung des Industriegeländes zuständig. Genauso wenig wie für die Geschädigten. Alex Masi hat es auf sich genommen, mit seinen Bildern immer wieder an die Opfer der verdrängten Katastrophe und das bis heute nicht gelöste Problem der Giftmüllentsorgung zu erinnern.

In December 1984, several tons of toxic material were released into the atmosphere in a factory of US chemical corporation Union Carbide in Bhopal, India. The accident was caused by technical faults, some of them the result of cost-cutting measures. Thousands died from the immediate effects. Countless people went blind, suffered brain damage, paralysis, lung oedemas, damage to heart, stomach or liver. Longer-term effects include congenital malformations in babies and growth disorders in children, because highly toxic residuals of the explosion are still contained in the soil and the groundwater. And yet nobody is taking responsibility for cleaning up the industrial site or for helping the sufferers. Alex Masi has taken on the task of reminding the world again and again in his pictures of the repressed disaster and the still unresolved problem of decontamination.

DAS RECHT AUF GESUNDHEIT [Art. 24]
THE RIGHT TO HEALTH

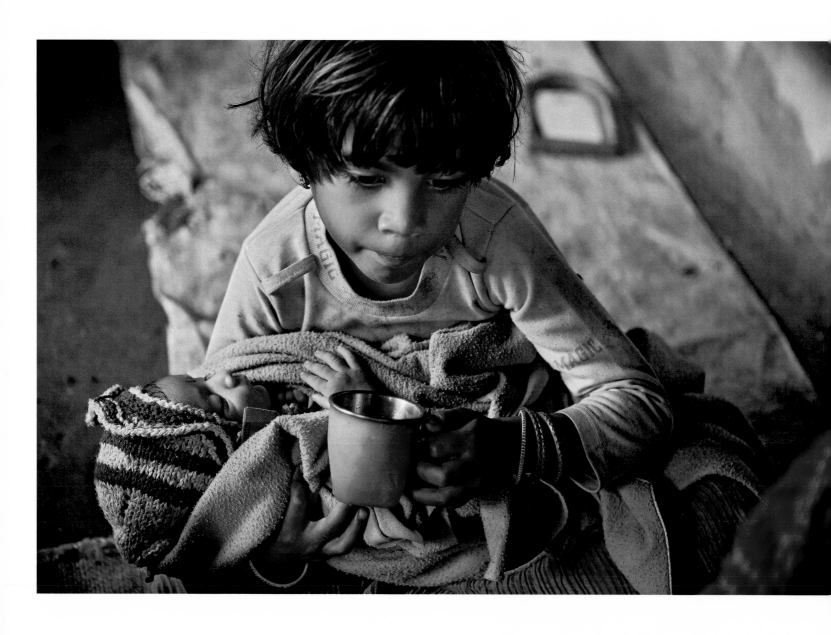

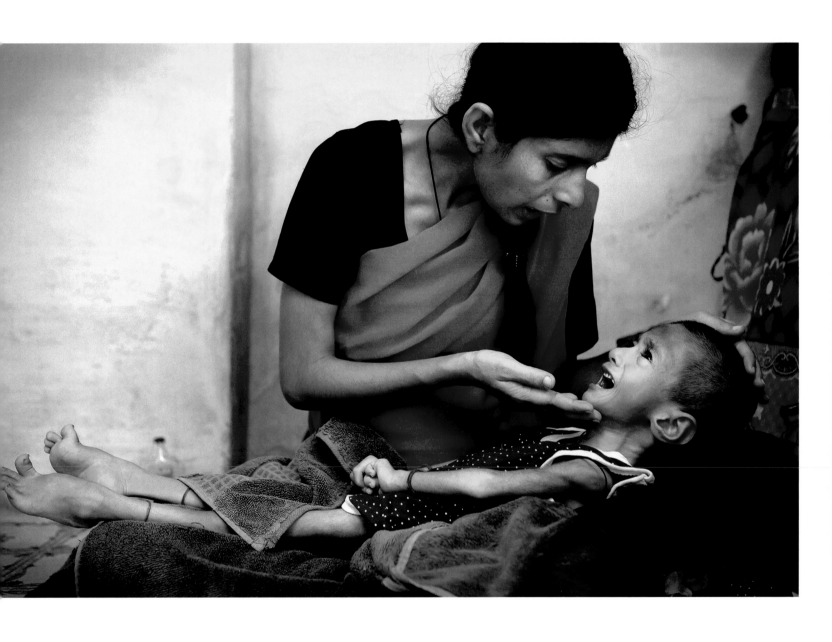

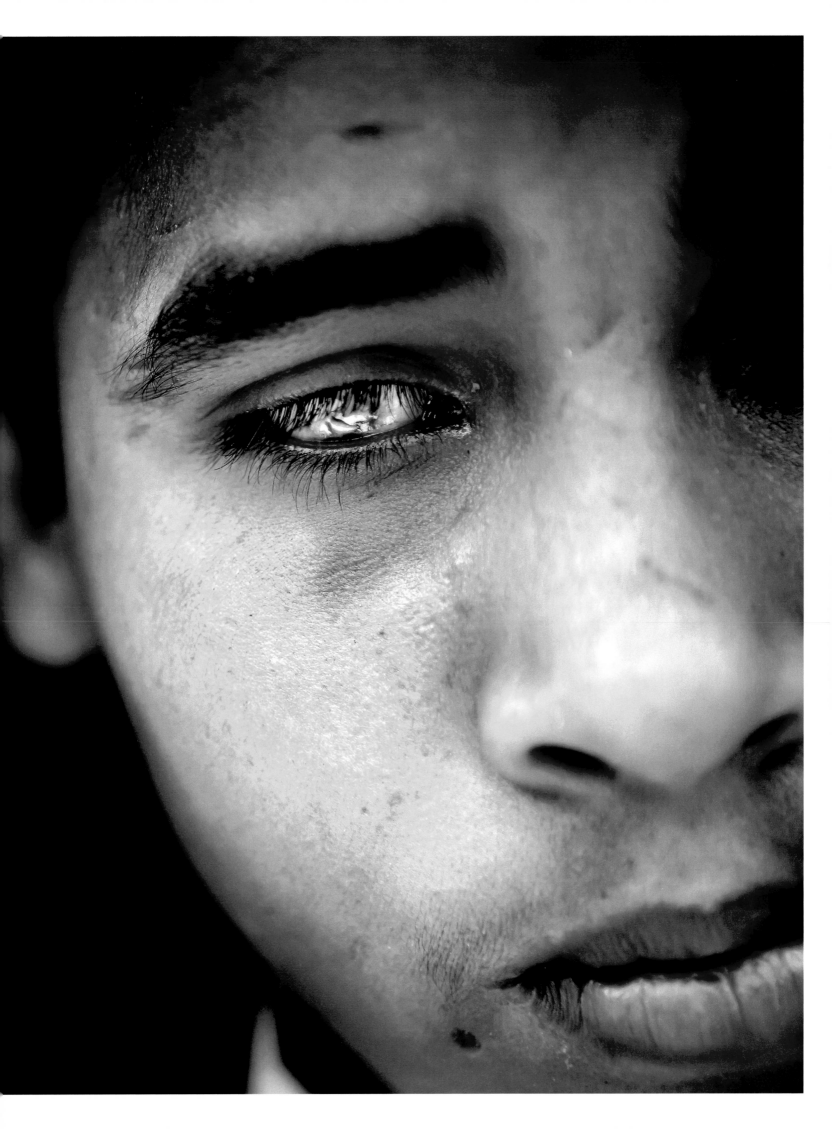

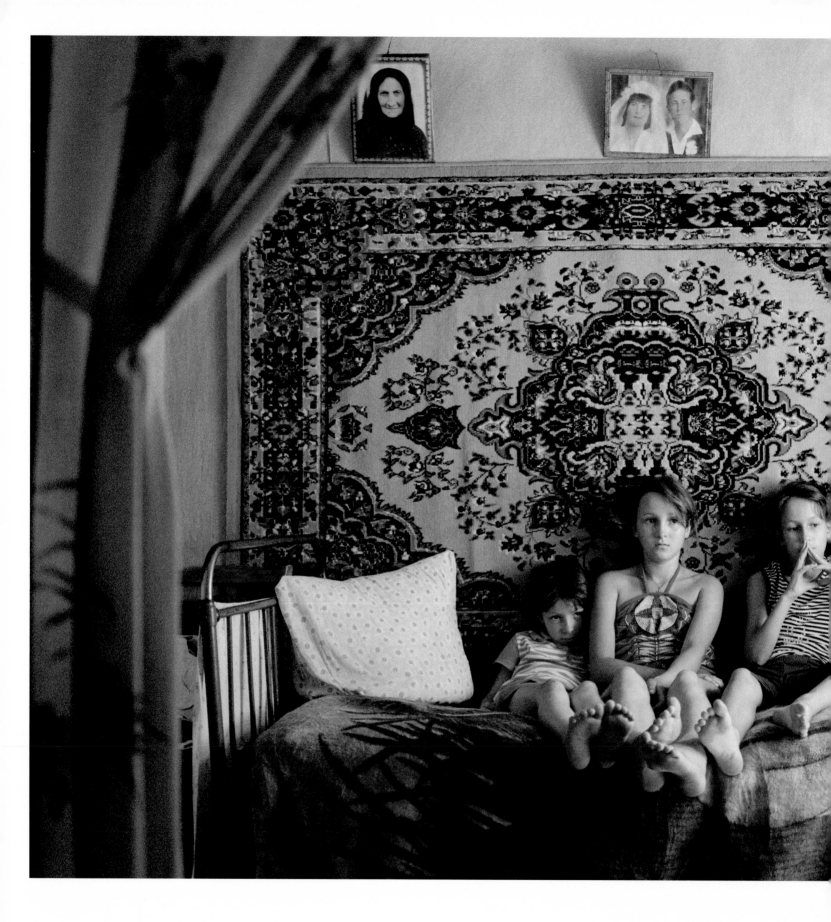

Andrea Diefenbach | Agentur Focus wurde 1974 in Deutschland geboren. Seit ihrem Studium an der Fachhochschule Bielefeld arbeitet sie als freie Fotografin. Ihre in Magazinen und Büchern veröffentlichten Reportagen zeichnen sich durch soziales Engagement und großes Einfühlungsvermögen aus. Andrea Diefenbachs Themen, etwa *Aids in Odessa, Atemwege. Porträts über das Leben mit Mukoviszidose, Jüdisches. Fotografische Betrachtungen der Gegenwart* und *Land ohne Eltern,* wurden zu Büchern und waren in Ausstellungen zu sehen.

Andrea Diefenbach | Agentur Focus was born in Germany in 1974. After completing her degree at the University of Applied Sciences in Bielefeld she started working as a freelance photographer. Her photojournalism has been published in magazines and books and is characterized by social commitment and great empathy. Andrea Diefenbach's themes, which have been presented as books and exhibitions, include *AIDS in Odessa; Atemwege. Porträts über das Leben mit Mukoviszidose* (muscoviscidosis); *Jüdisches. Fotografische Betrachtungen der Gegenwart* (Jewish home for the elderly) and *Land ohne Eltern* (country without parents).

In der Republik Moldau wächst fast jedes dritte Kind ohne Vater oder Mutter auf. Sie sind auf sich allein gestellt; manche haben das Glück, wenigstens von den Großeltern betreut zu werden. Viele der Zurückgelassenen sehen ihre Eltern Monate oder auch Jahre nicht. Für Besuche reicht das Geld nicht, das die Mutter als Altenpflegerin oder der Vater als Erntehelfer im Ausland verdienen. So bleiben für lange Zeit nur die Stimmen am Telefon oder das Gesicht beim Skypen. Und das sehnsüchtige Warten der Kinder auf Post oder Pakete mit Geschenken. Doch die sind kein Ersatz für Nähe und Zuneigung. Es bleibt für beide Seiten Traurigkeit und Einsamkeit. Eine von UNICEF geförderte Studie zeigte bereits 2006, dass Kinder, die von ihren Eltern in der Heimat zurückgelassen wurden, oft extrem unter der Trennung leiden: Sie distanzieren sich mit der Zeit emotional und tun sich schwer, soziale Kontakte zu entwickeln.

In the Republic of Moldova nearly one in three children grows up without mother or father. They are left to their own devices; some of them are lucky to be cared for by grandparents at least. Many of the children left behind do not see their parents for months or even years. The money the mother earns abroad as a geriatric nurse or the father as harvest hand is not enough to cover a visit. For long periods of time all they have are voices on the telephone or a face on Skype. And the desperate wait of the children for mail or parcels with presents. But these are no substitute for closeness and affection. Both sides are left with sadness and loneliness. A survey supported by UNICEF in 2006 pointed out how much children, who had been left behind by their parents, suffered from the separation. Over time they become emotionally distant and have difficulty forming social contacts.

Seit dem Sturz des Präsidenten Siad Barre 1991 herrscht Chaos in Somalia. Staatliche Strukturen existieren nicht mehr, lokale Clanführer oder islamistische Gruppen herrschen, die mit extremistischen Ideologien und Gewalt Angst und Schrecken verbreiten. Die UN sowie die USA und ihre Verbündeten engagierten sich vor Ort, um den Bürgerkrieg zu beenden. Doch alle Versuche endeten im Desaster, alle Friedensinitiativen scheiterten. Nur diejenigen haben das Sagen, die Geld und Waffen besitzen. Die traurigen Bilder von Hossein Fatemi zeigen, wie es der beklagenswerten Zivilbevölkerung ergeht. Es leiden die unterernährten und kranken Kinder; es leiden die Mütter, die hilflos sind, weil sie keine medizinische Unterstützung finden; es leiden die vertriebenen Familien, die ohne eine Zukunftsperspektive in Flüchtlingslagern ausharren.

Since the fall of president Siad Barre in 1991 chaos has reigned in Somalia. There are no state structures left, local clan chiefs rule or Islamist groups, who spread fear and terror with extremist ideologies. The UN and the US, with their allies, got involved locally to end the civil war. But all attempts ended in disaster, all peace initiatives failed. The only ones who have a say are those who own money or weapons. The sad images by Hossein Fatemi show what it is like for the unfortunate civilians. Malnourished and sick children suffer, helpless mothers suffer who find no medical support. Displaced families suffer, waiting in refugee camps without any outlook for the future.

[Art. 38] DAS RECHT AUF SCHUTZ IM KRIEG
THE RIGHT TO PROTECTION IN WAR

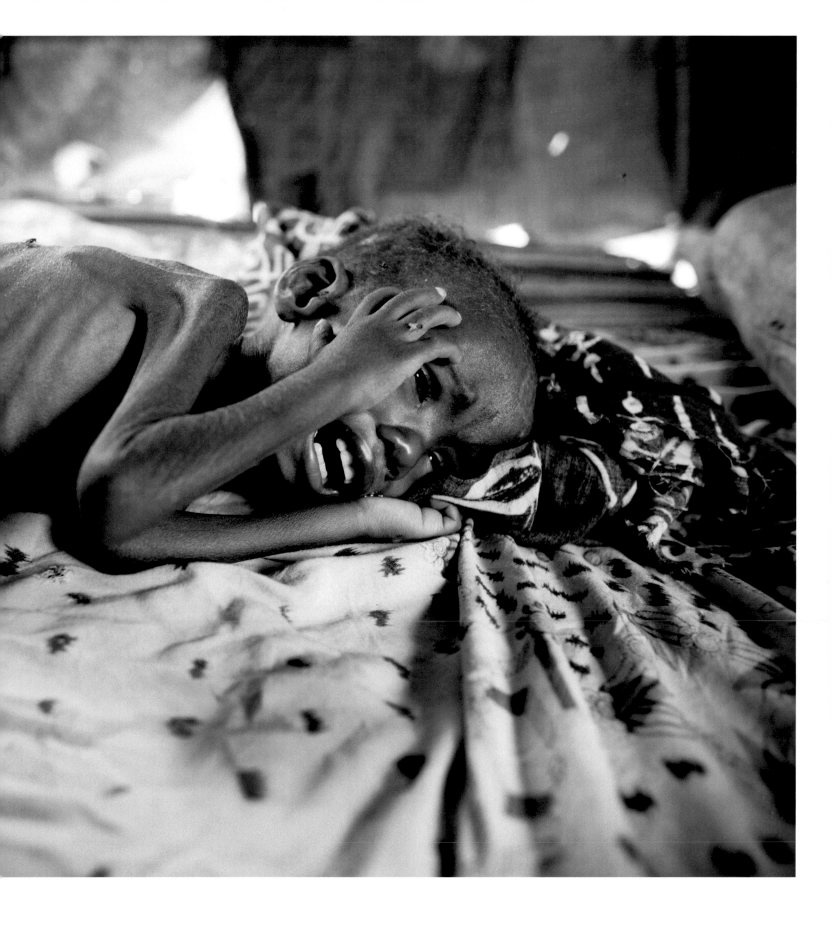

ossein Fatemi | Panos Pictures wurde 1980 im Iran geboren und begann 1997, als Fotograf zu arbeiten. Seine Bilder aus Krisengebieten wie Pakistan, Afghanistan, der Türkei, ussland, Indien, Georgien, Kenia und Somalia werden in internationalen Zeitungen und Magazinen veröffentlicht. Wichtig sind Hossein Fatemi aber auch die Reisen durch in eigenes Land. Seine Gespräche mit und seine Fotos von Iranern aus allen Gesellschaftsschichten zeigen die komplexe Wirklichkeit des Landes: die offizielle, sichtbare rsion, die von den Autoritäten proklamiert wird, und die nach außen nicht unbedingt wahrnehmbare Gegenwelt, die von der jungen Generation gelebt wird.

ossein Fatemi | Panos Pictures was born in Iran in 1980 and started to work as a photographer in 1997. His pictures from areas of conflict, such as Pakistan, Afghanistan, rkey, Russia, India, Georgia, Kenia and Somalia, are published in international newspapers and magazines. Hossein Fatemi also travels through his own country. His con- rsations with and photographs of Iranians from all walks of life display the complex reality of the country: the official, visible version, proclaimed by the authorities, and an ternative life, not necessarily visible from outside, lived by the young generation.

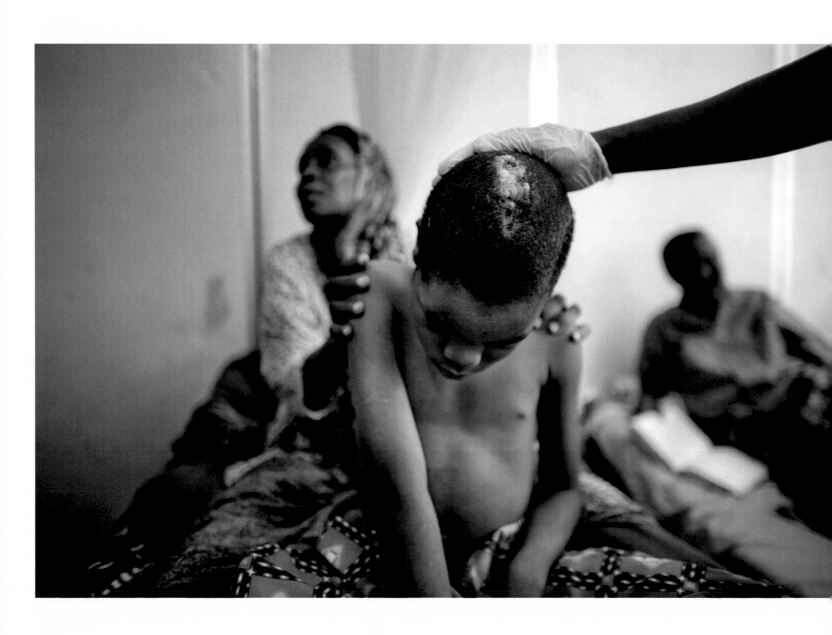

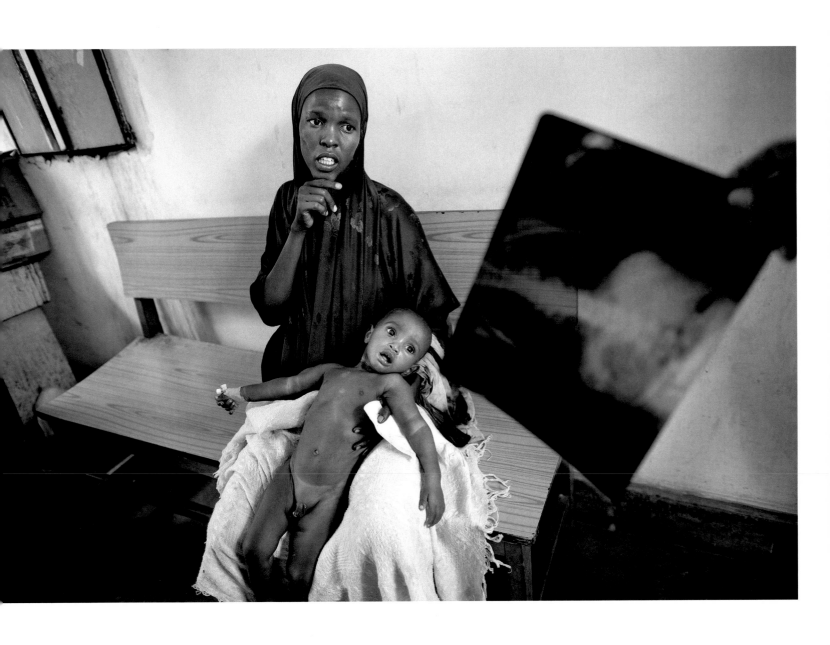

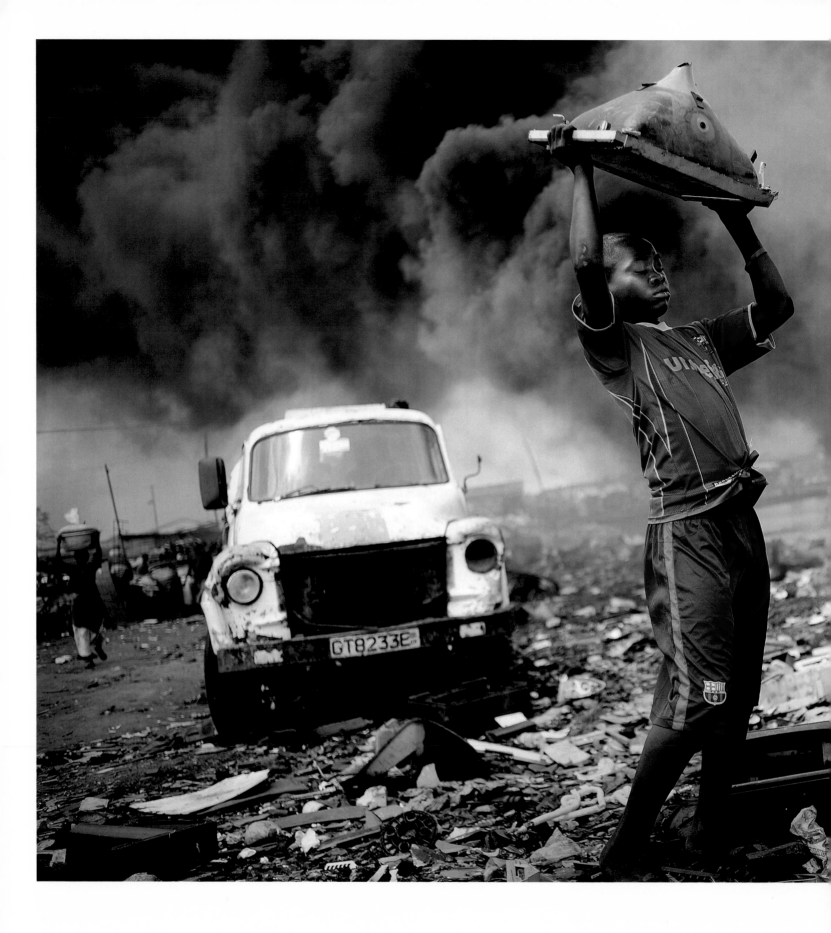

Kai Löffelbein | laif wurde 1981 in Deutschland geboren. Er studierte Politikwissenschaft, Fotojournalismus und Dokumentarfotografie. Die Wissenschaft förderte sein Verstännis für die Ursachen- und Wirkungsmechanismen des menschlichen Zusammenlebens, das Kunststudium schärfte seine visuelle Wahrnehmungsfähigkeit. Bei der Auswa seiner Themen reflektiert Löffelbein die Verantwortung des Einzelnen für Ungerechtigkeiten und Missstände in immer stärker globalisierten Märkten.

Kai Löffelbein | laif was born in Germany in 1981. He studied political science, photojournalism and documentary photography. The academic studies deepened his insight in the mechanisms of cause and effect in human coexistence, the artistic studies sharpened his visual perception. In his choice of themes Löffelbein reflects on the responsibil of the individual for the injustices and abuses in ever more closely globalized markets.

Menschen, die ihren Müll trennen und alte oder defekte Elektrogeräte zu Recycling-Höfen bringen, haben das Gefühl, mit Wertstoffen vernünftig umzugehen. Undurchsichtig sind aber – trotz gesetzlicher Normen – die Wege, die der Müll nimmt. Es wird geschätzt, dass 50 bis 80 Prozent des Elektronikschrotts aus Industrieländern in Schwellen- oder Entwicklungsländer exportiert werden. Kai Löffelbein begab sich in Afrika, Indien und China auf die Spur der entsorgten Industrie- und Konsumgüter. „Sodom und Gomorrha" nennen die Einheimischen die Giftmüllhalde in Accra. Um Geld zu verdienen, zertrümmern dort Minderjährige verschiedenste Geräte, weiden sie aus, legen dann Feuer, in dem alles außer den wertvollen Metallen schmilzt. Jugendliche in Neu-Delhi zerlegen Prozessoren; in Guiyu wachsen Kleinkinder inmitten gesundheitsgefährdender Monitorteile auf. Die Menschen leben von, in und mit dem Müll der Wohlstandsgesellschaften.

People who separate waste paper and bottles in containers or take old or broken electric appliances to recycling centres feel they are dealing sensibly with recyclables. Despite legal guidelines, however, it remains unclear where the waste ends up next. An estimated 50 to 80 percent of electronic scrap from industrial countries is being exported to emerging and developing countries. Kai Löffelbein went to Africa, India and China on the path of the recycled industrial and consumer goods. 'Sodom and Gomorrah' is the name the locals have given to the toxic waste dump in Accra. To earn some money, young people there break up all kinds of devices, gut them, then burn off anything that surrounds the precious metals. Youths in New Delhi dismantle processors; in Guiyu small children grow up in the middle of hazardous monitor parts. The people live off, in and with the waste of affluent societies.

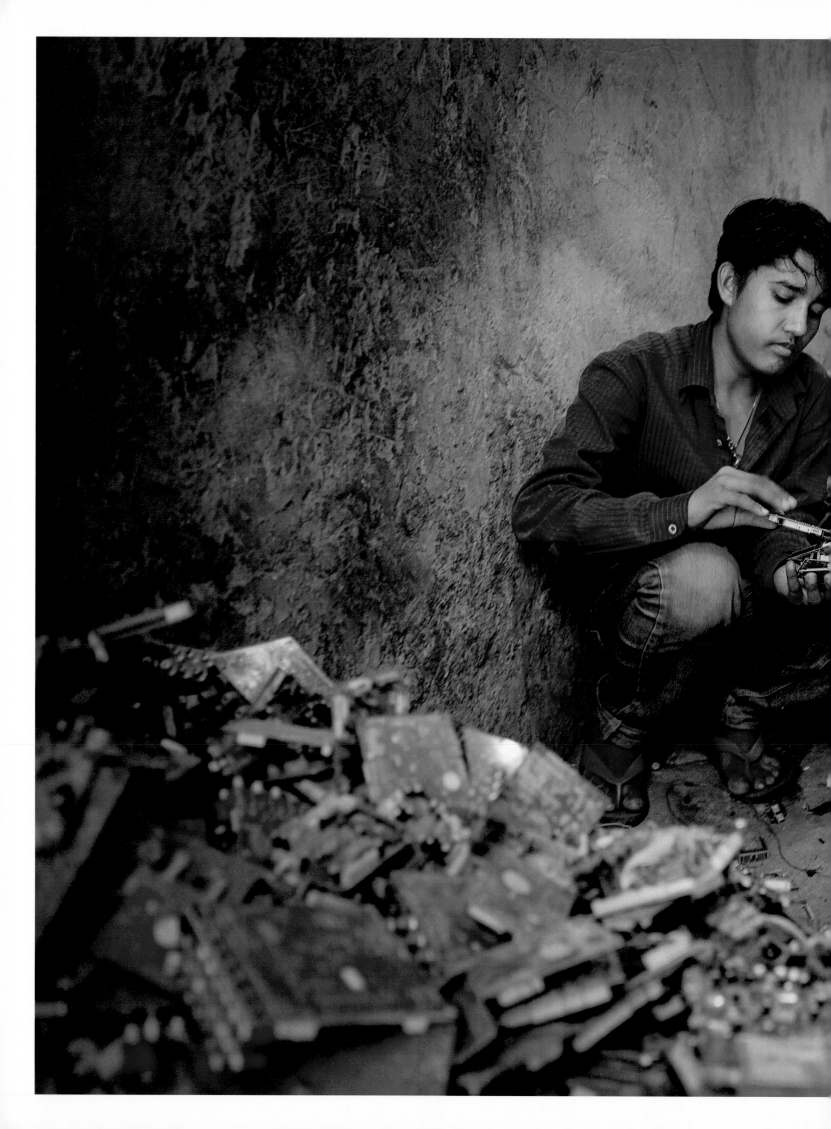

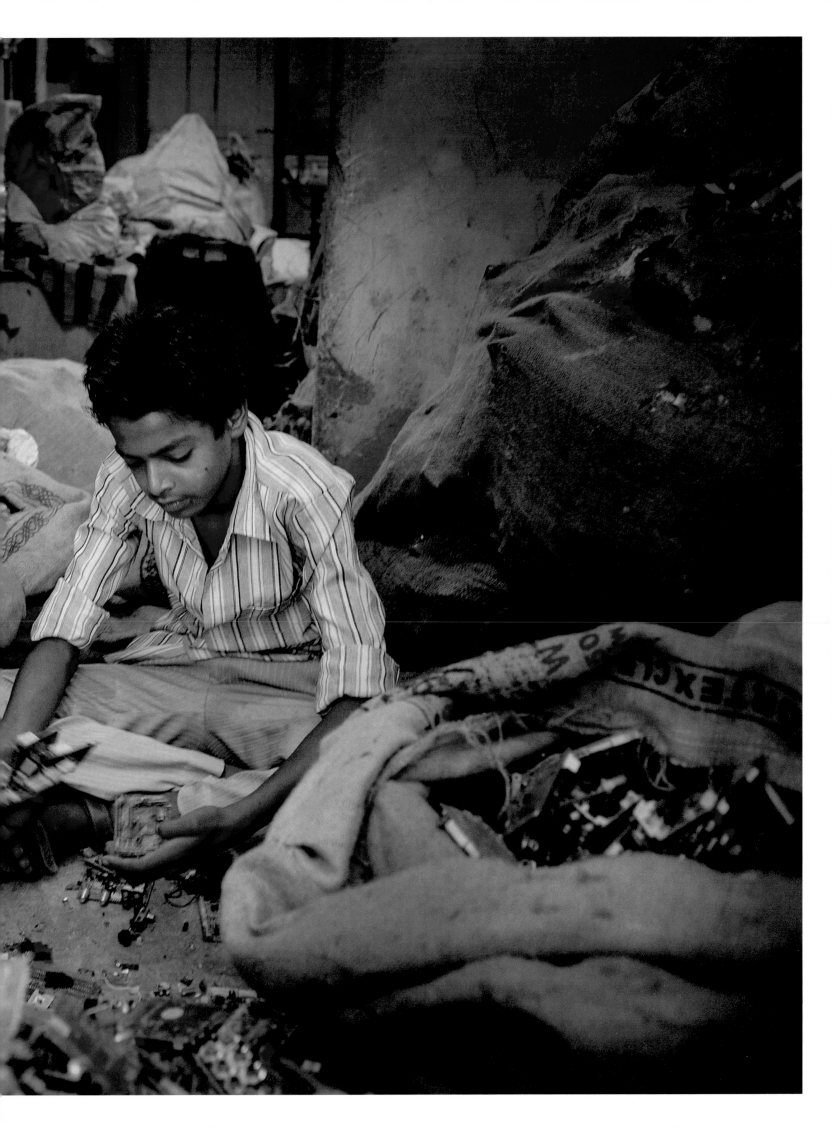

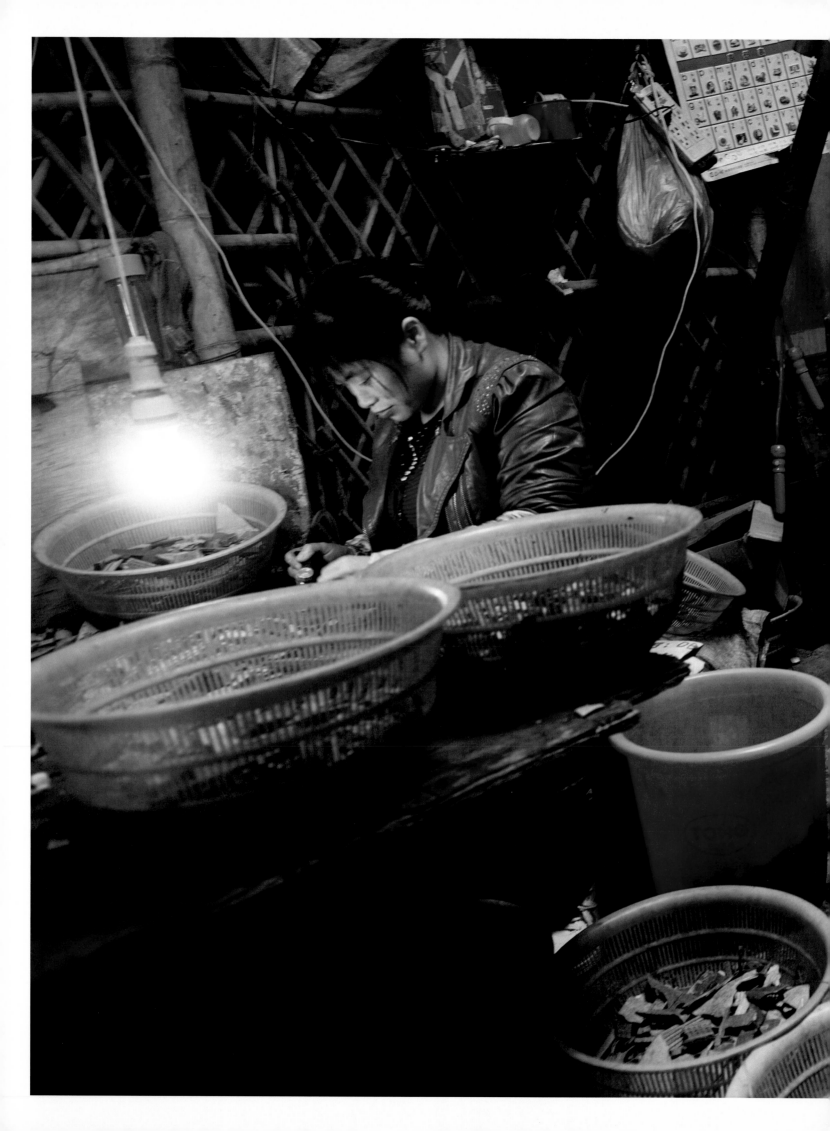

Daniel Berehulak | Getty Images wurde als Kind ukrainischer Emigranten in Sydney geboren, studierte an der University of New South Wales und wählte gegen die elterliche Erwartungen auf eine Wirtschaftskarriere die Fotografie zu seinem Lebensinhalt. Von der Sportfotografie kam er zur politischen Fotografie, von Australien über London nach Neu-Delhi. Berehulak hat in über 40 Ländern fotografiert, im Irak-Krieg wie bei afghanischen Wahlen, in Tschernobyl wie bei den Tsunami-Opfern in Japan; er wurde unter anderem für den Pulitzer-Preis nominiert und hat große internationale Auszeichnungen erhalten. Kinderarbeit in Indien ist eines seiner großen Themen.

Daniel Berehulak | Getty Images was born in Sydney to Ukrainian immigrants, studied at the University of New South Wales and chose photography as his life's work again the hopes of his parents for a business career. From sports photography he went on to political photography, from Australia via London to New Delhi. Berehulak has worked in more than 40 countries, in the war in Iraq as well as in Afghan elections, in Chernobyl and with the victims of the tsunami in Japan. He has been nominated for the Pulitzer Prize and other awards and has received major international accolades. Child labour in India is one of his main themes.

Die wichtigste Ursache für Kinderarbeit ist die Armut der Eltern. Die meisten Eltern würden ihre Kinder niemals zur Arbeit schicken, würde sie nicht äußerste Not dazu zwingen. Kinderarbeit bedeutet zugleich ein erhöhtes Angebot an billigen Arbeitskräften zu niedrigsten Löhnen — und bleibt so wiederum eine Ursache für die Elternarmut. Ein Teufelskreis. Die Fotos von Daniel Berehulak vom Kohlebergbau in den Jaintia-Bergen im indischen Bundesstaat Meghalaya vermitteln einen Eindruck von den jammervollen Bedingungen, die für Kinderarbeiter gelten. Wie viele Minderjährige hier schuften, ist umstritten — die indische Kinderrechtsorganisation Impulse NGO Network schätzt deren Zahl auf bis zu 70 000, obwohl seit 1952 in Indien die Beschäftigung von unter 18-Jährigen im Bergbau verboten ist. Doch dieses Verbot nützt den kleinen Arbeitern nichts. Sie haben keine Wahl, wenn sie und ihre Familien überleben wollen.

The most important cause of child labour is the poverty of the parents. Most parents would never send out their children to work, if dire need did not force them to do so. Child labour also means a higher supply of cheap labour for lowest wages — thus perpetuating the poverty of the parents. A vicious circle. The photographs by Daniel Berehulak of coal mining in the Jaintia Hills in the Indian state of Meghalaya tell of the miserable conditions that apply to child labourers. How many minors toil away here is a matter of controversy. Estimates of the Indian children's rights organization Impulse NGO Network put their number at up to 70 000, even though employing anyone under 18 in mining has been prohibited in India since 1952. But the ban does nothing for the little workers. They have no choice if they and their families are to survive.

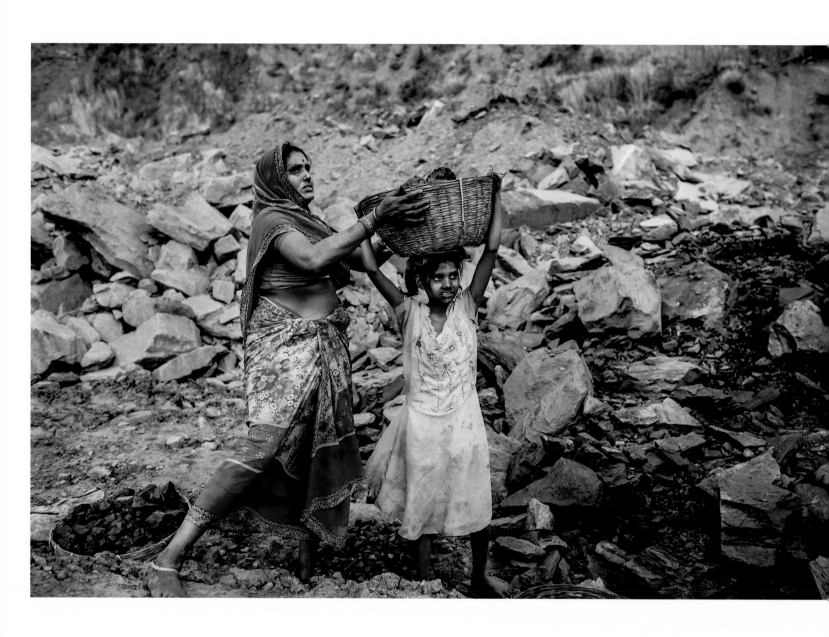

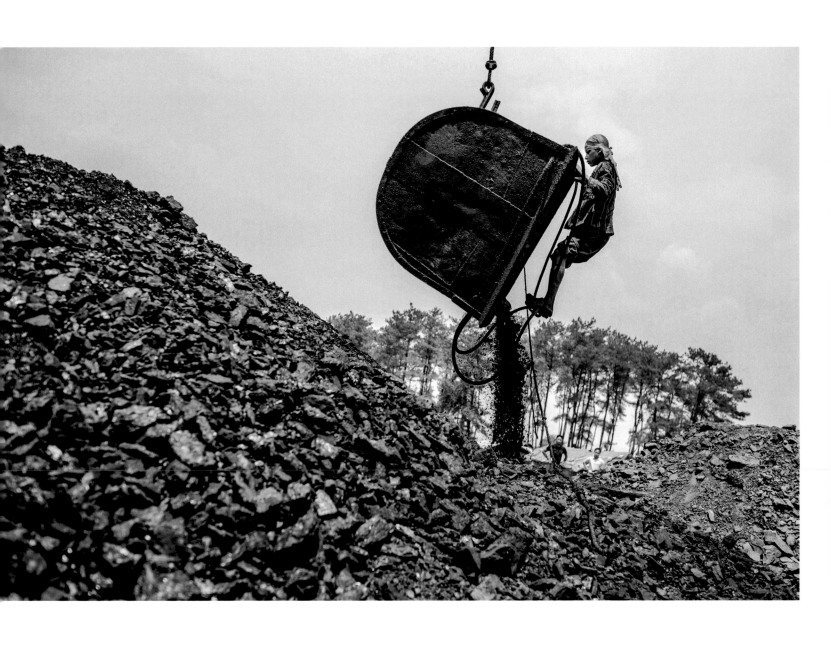

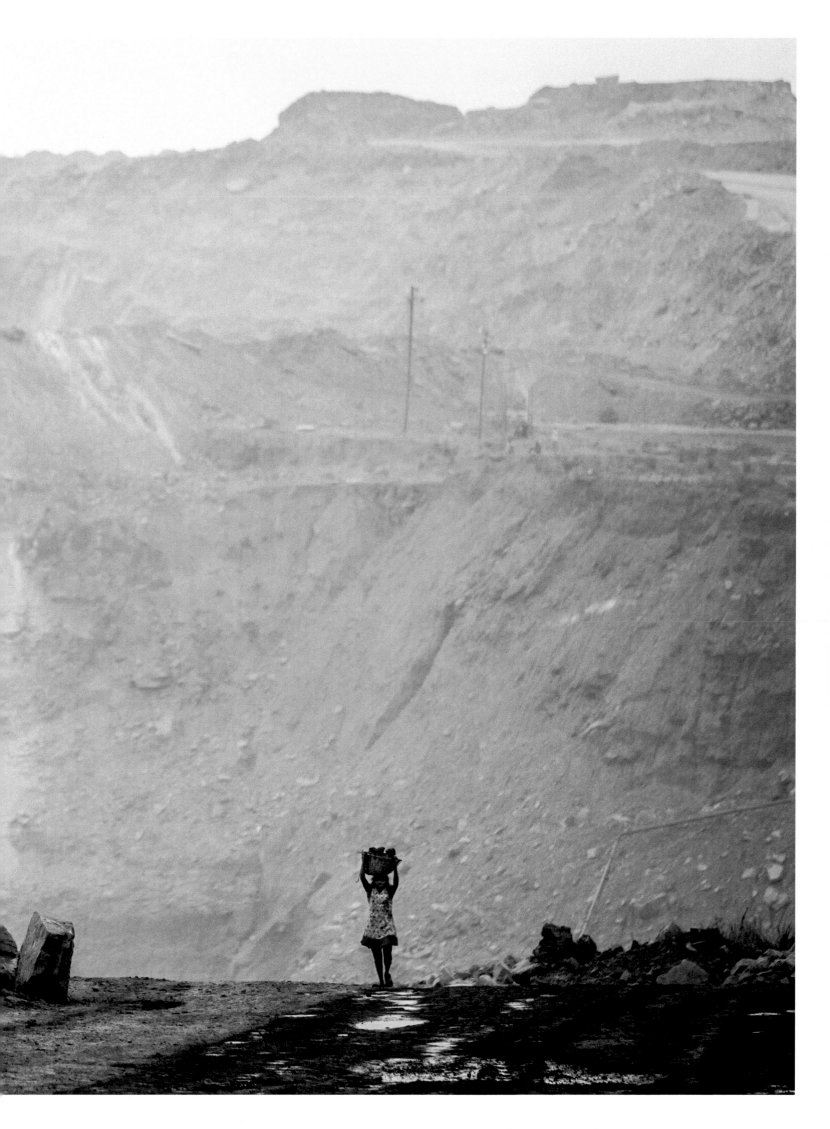

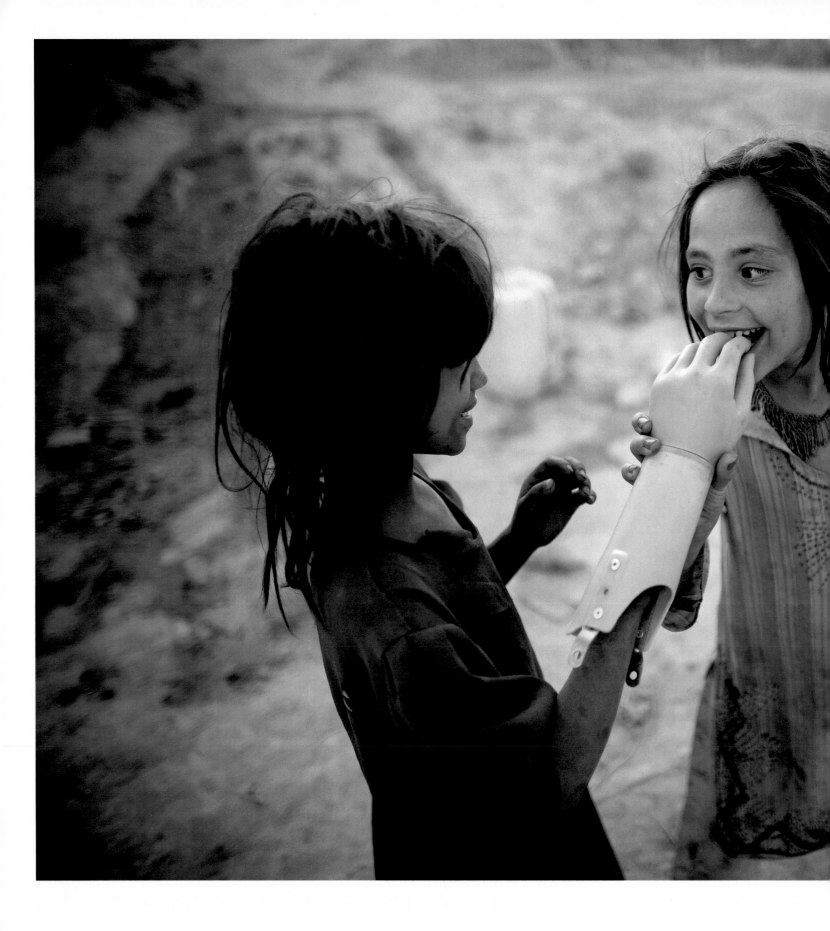

Majid Saeedi | Getty Images wurde 1974 im Iran geboren. Im Alter von 16 Jahren begann er zu fotografieren. Sein Spezialgebiet ist der Nahe Osten geworden. Für Fotorep tagen aus dieser Region erhielt er viele Ehrungen. Saeedi leitete die Bildabteilungen verschiedener Nachrichtenredaktionen und unterrichtet junge Fotografen. Zugleich ist nach wie vor im Iran unterwegs; auf der Suche nach Geschichten, die der Weltöffentlichkeit noch unbekannt sind.

Majid Saeedi | Getty Images was born in Iran in 1974. He began to take photographs at the age of 16. The Middle East has become his special area. His photojournalism abo this region has won many accolades. Saeedi has headed the image departments of various news services and teaches photography. He also still travels through Iran, looki for stories that are unknown to the global public.

Nach dem 11. September 2001, als das Taliban-Regime in Afghanistan durch ein Militärbündnis unter Führung der USA vertrieben wurde, aber ein erneuter Bürgerkrieg ausbrach, suchte die Familie des achtjährigen Akram Schutz im pakistanischen Peschawar. Akram mühte sich dort, mit dem Sammeln von Schrott ein bisschen Geld zu verdienen. Im Abfall fasste er ein undichtes Stromkabel an und erlitt dabei derart schwere Verbrennungen an Händen und Armen, dass sie amputiert werden mussten. Inzwischen ist seine Familie nach Kabul zurückgekehrt, wo der Junge durch die Hilfe des Roten Kreuzes Armprothesen erhielt. Majid Saeedi staunte, während er fotografierte, über das Mitgefühl von Akrams Freunden. Und war zugleich ergriffen angesichts der fröhlichen Leichtigkeit, mit der sie mit dem Hand-Ersatz spielten.

After 11 September 2001, when the Taliban regime in Afghanistan was driven out by a military alliance led by the US, but a new civil war broke out, the family of eight year old Akram sought security in Pakistani Peshawar. There Akram tried to earn a bit of money by collecting scrap metal. In among the rubbish he touched an unshielded electric cable and suffered such severe burns on his hands and arms that they had to be amputated. By now Akram's family has returned to Kabul, where the boy received prostheses through the Red Cross. When taking the photographs, Majid Saeedi was astonished about the empathy of Akram's friends. And he was touched at the same time by the serenity of their playing with the replacement hands.

DAS RECHT AUF BESONDERE FÜRSORGE BEI BEHINDERUNG [Art. 23]
THE RIGHT OF THE DISABLED CHILD TO SPECIAL CARE

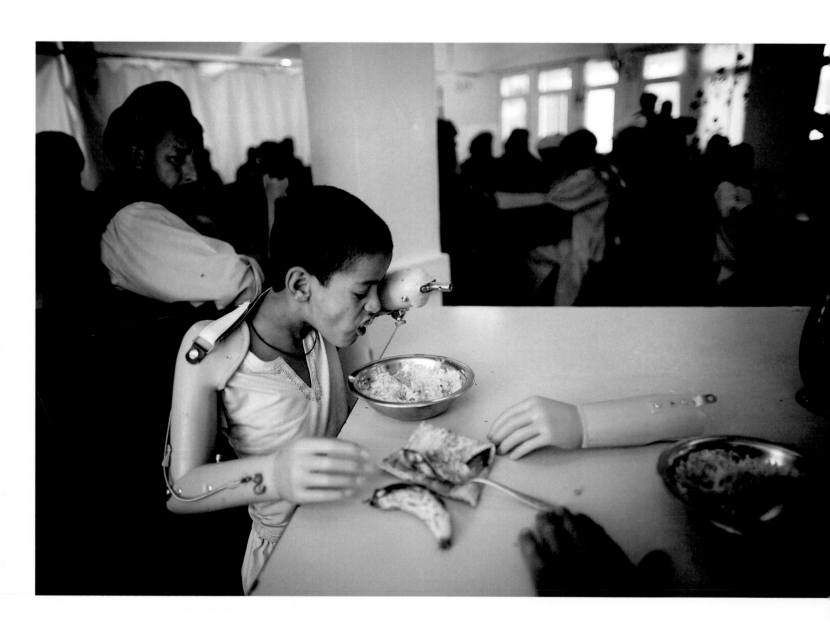

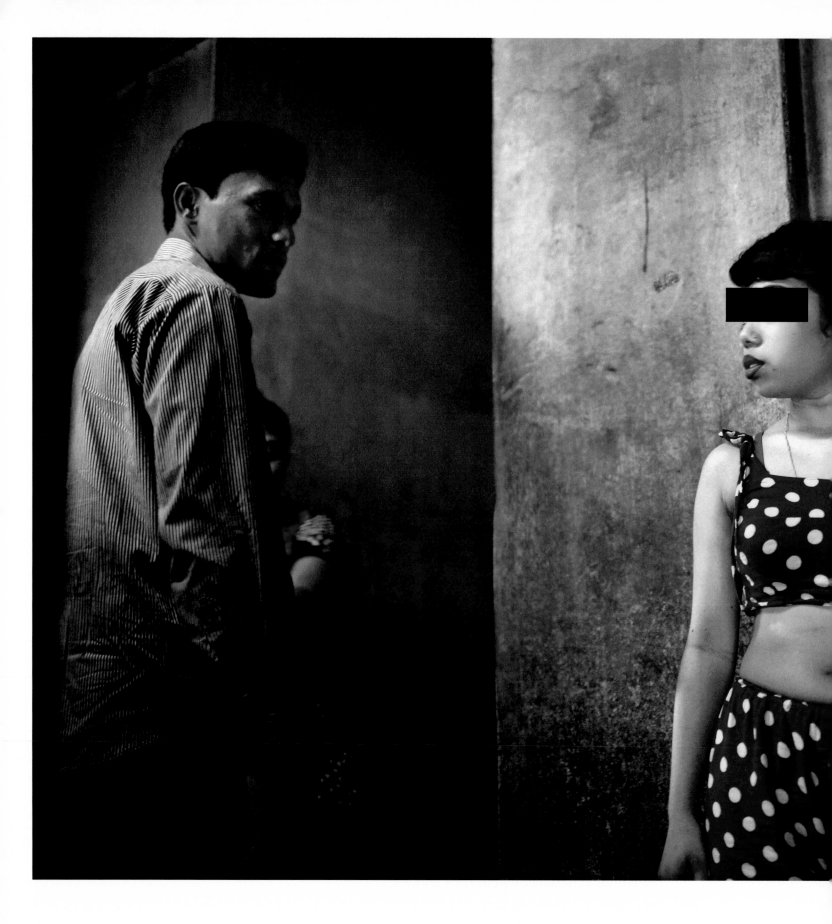

GMB Akash | Panos Pictures wurde 1977 in Bangladesch geboren. 1996 nahm er in der Hauptstadt Dhaka an einem „World Press Photo"-Seminar teil, das, wie er sagt, zu eine Art „Erweckungserlebnis" für ihn wurde. Er absolvierte daraufhin ein Fotografie-Multimedia-Studium und kommuniziert seitdem mit seiner Kamera mit jenen Menschen, die selten gehört und meistens übersehen werden. Aus seinen Begegnungen mit den Ärmsten der Armen entstand das Buch *Survivors*, dessen Gewinn Akash an die Protagoniste seiner Reportagen weitergibt — als Anschubhilfe für ein besseres Leben. GMB Akashs Engagement wird international wahrgenommen und vielfach ausgezeichnet.

GMB Akash | Panos Pictures was born in Bangladesh in 1977. In 1996 he took part in a World Press Photo Seminar in the capital Dhaka, which he recalls as a kind of revelation He went on to study photography and multimedia and has since used his camera to communicate with those people who are rarely heard and mostly overlooked. His boo *Survivors* evolved from his encounters with the poorest of the poor. Akash passes on the proceeds of the book to its protagonists — as start-up support for a better life. Akash commitment has been internationally recognized and has received many accolades.

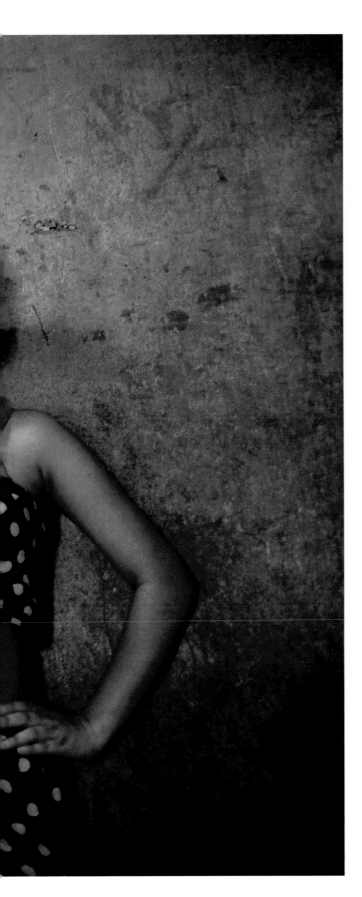

Von der Notlage oft blutjunger Prostituierter berichtet der in Bangladesch lebende Fotograf GMB Akash. Sein Erschrecken über die ausweglose Not dieser Mädchen in den Bordellen des Distrikts Faridpur wuchs noch, als er erfuhr, was die Mädchen ihren Körpern antun müssen, um älter und attraktiver zu erscheinen. Oft täglich und über Jahre hinweg nehmen sie ein Steroid ein, das in Ländern wie Bangladesch auch Rindern eingeflößt wird, um sie wohlgenährt erscheinen zu lassen. Vor allem aber ist es für Schwerkranke gedacht, die unter Arthritis, Asthma oder Allergien leiden. Oradexon, so der Name des Mittels, ist billig und unkompliziert zu beschaffen. Es führt zu Wasserablagerungen im Gewebe, was die Körper der jungen Mädchen üppiger und fülliger wirken lässt. Dass sie ihre Gesundheit damit schwer schädigen, müssen sie in Kauf nehmen. GMB Akash hofft, dass seine Fotos zu verstärkten Anstrengungen führen, Kinder vor allen Formen sexueller Ausbeutung zu schützen.

The dire situation of very young prostitutes is the subject of photographer GMB Akash, who lives in Bangladesh. His horror about the desperate plight of these girls in the brothels of Faridpur District deepened when he found out what they have to do to their bodies to appear older and more attractive. Often daily and for years they take a steroid that in countries like Bangladesh is also used in cattle to make it look more well-fed. It is mainly meant for people who suffer from severe arthritis, asthma or allergies. It is called Oradexon and it is cheap and easy to come by. It causes water deposits in the tissue, which makes the bodies of the young girls look more voluptuous. That it also severely damages their health is something they have to live with. Akash hopes that his pictures will encourage stronger efforts at protecting children from all forms of sexual exploitation.

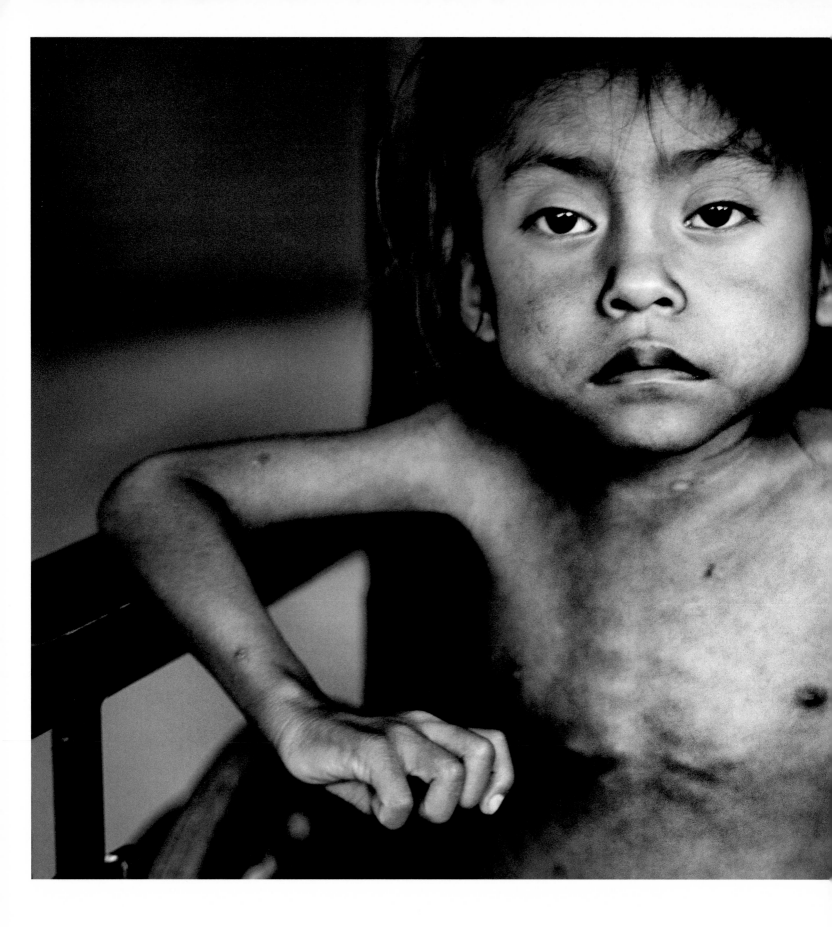

José Manuel López wurde in Spanien geboren. Er studierte Fotografie in Oviedo und arbeitete bis 2009 elf Jahre lang als Fotograf der Tageszeitung *La Crónica de León*. Inzwischen ist er weltweit unterwegs, recherchiert und fotografiert soziale und politische Themen im Mittleren und Nahen Osten, in Zentralamerika und in Afrika. Mit seinen Guatemala-Bildern machte er auf 50 000 Familien aufmerksam, die allein im Corredor Seco in chronische Not geraten sind. In ganz Guatemala sind nicht weniger als eine Million Kinder von Hunger betroffen.

José Manuel López was born in Spain. He studied photography in Oviedo and until 2009 worked for the daily paper *La Crónica de León*. These days he travels all over the world researching and photographing social and political issues in the Middle East, in Central America and in Africa. With his pictures from Guatemala he drew attention to 50 000 families in chronic need in the Corredor Seco. Across Guatemala no fewer than one million children are affected by hunger.

Corredor Seco, „Trockener Korridor", nennen die Bewohner die bergige Region in Guatemalas Südwesten. Dort vernichten Dürren immer wieder große Teile der Ernte. Dann herrscht Hunger in den Bauernfamilien, selbst wenn die Familienväter, tageweise, Arbeit auf größeren Höfen ergattern. Kinder wie das Mädchen Marisela sind hier keine Seltenheit: Es ist sechseinhalb Jahre alt und wiegt nur neun Kilo. Jedes zweite Kind unter fünf Jahren in Guatemala ist unterernährt. Die daraus resultierenden geistigen und körperlichen Schäden sind irreversibel und lassen auch die Mütter verzweifeln. Der Fotograf José Manuel López war mit Hilfsorganisationen im Land, um das Elend zu dokumentieren. Ein Elend, das nicht nur aus dem Klimawandel resultiert, sondern Folge verfehlter Agrarpolitik, fehlender Bildungsprogramme und der Ausgrenzung und Marginalisierung der Campesinos ist.

Corredor Seco, 'dry corridor', is what the locals call the mountain region in Guatemala's southwest. Recurring drought repeatedly destroys large parts of the harvest there. Then the farming families go hungry, even if the fathers manage to work as day labourers on larger farms. Children like Marisela are quite common in this region. She is six and a half years old and only weighs nine kilograms. One in two children under five in Guatemala is malnourished. The mental and physical damages resulting from malnutrition are irreversible and make the mothers despair. Photographer José Manuel López went through the country with a charity to document their plight. A plight that is not just the result of climate change but also of failed agrarian policies, lack of education programmes, and the exclusion and marginalization of the campesinos.

DAS RECHT AUF GESUNDHEIT [Art. 24]
THE RIGHT TO HEALTH

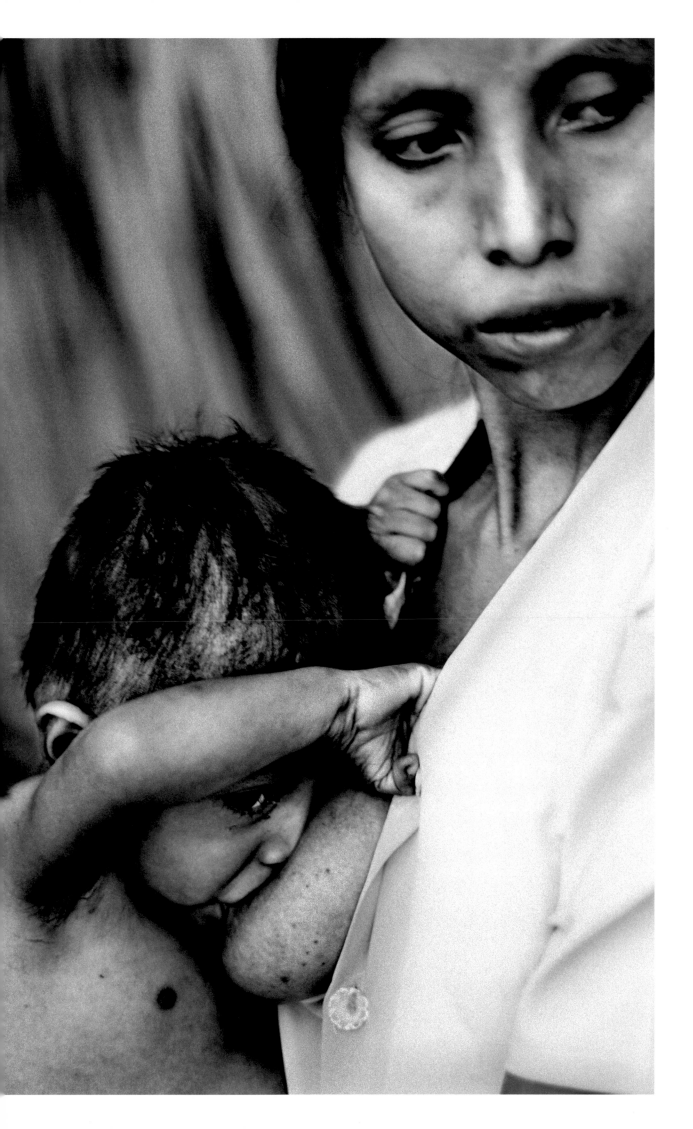

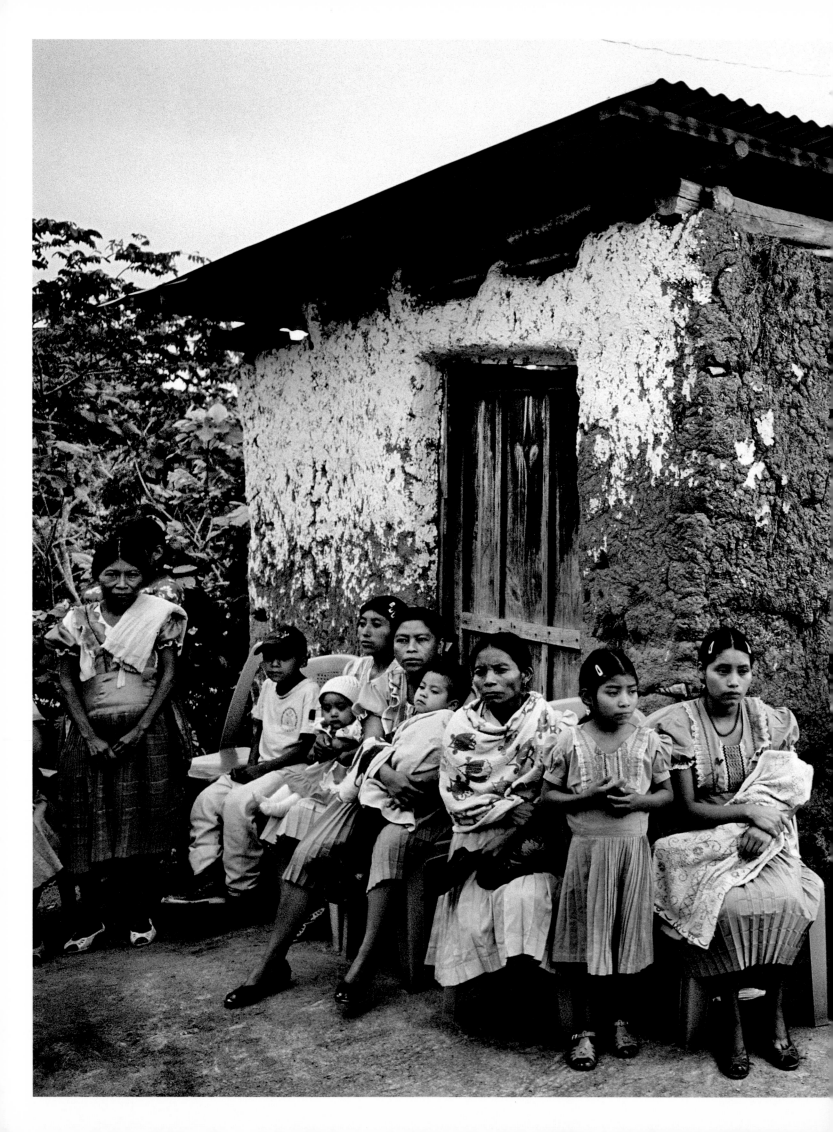

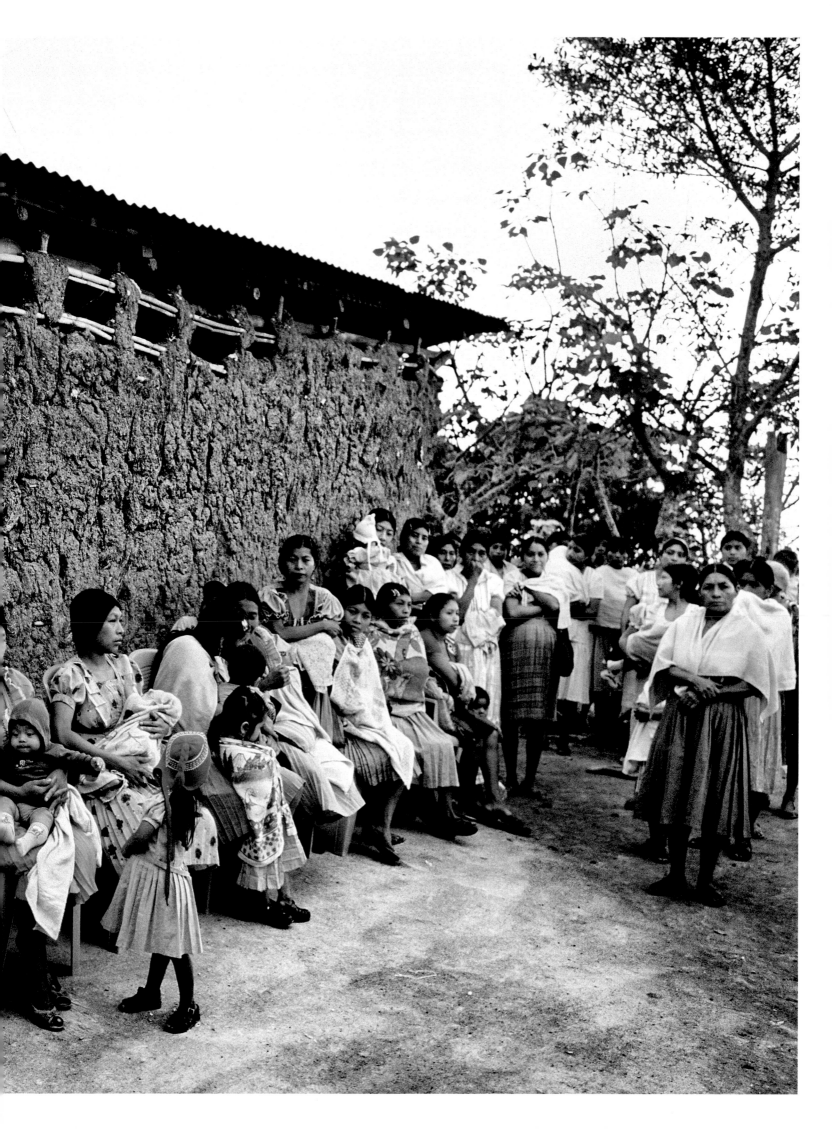

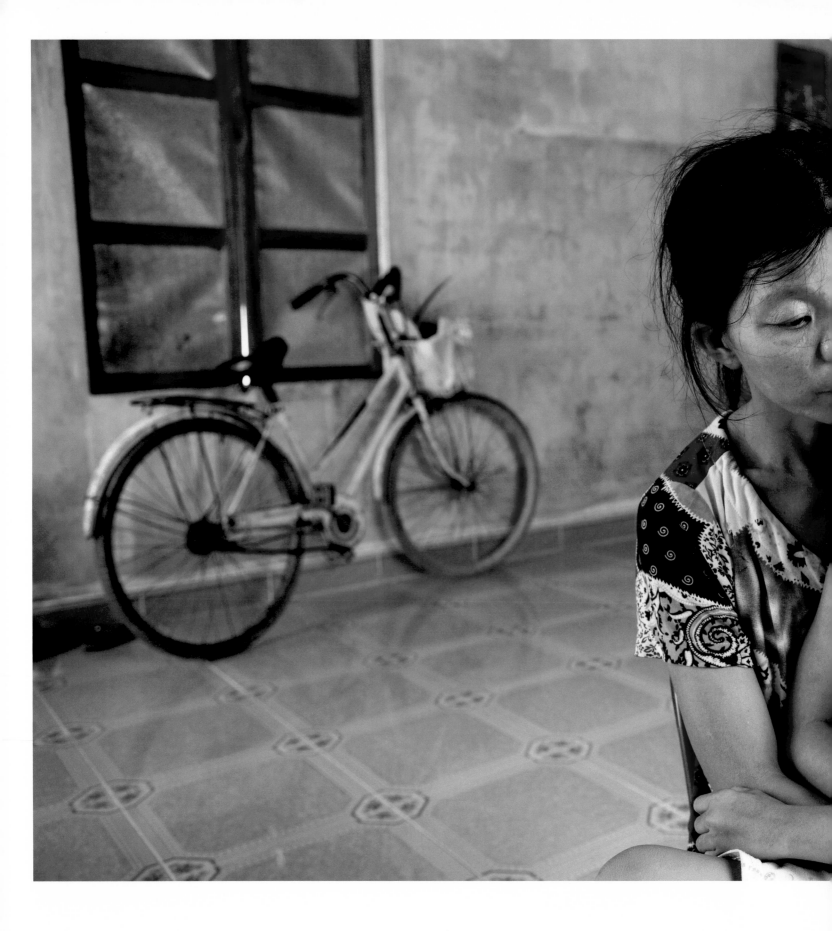

Ed Kashi | VII Photo Agency wurde 1957 in den USA geboren. Für große internationale Magazine, darunter *National Geographic* und *GEO*, hat er unter anderem über Kurdistan, Nordirland, den Irak, die Westbank, die Konflikte im Niger-Delta und die Veränderungen in der amerikanischen Gesellschaft berichtet. Als Fotoreporter und Filmemacher befasst sich Kashi mit soziopolitischen Themen und den neuen Erzählformen des Multimedia-Zeitalters. Seine Arbeiten werden bei Filmfestivals, Symposien und vor Studenten gezeigt; seine Geschichten macht er über eine eigene Non-Profit-Einrichtung kostenlos auch einem breiteren Publikum zugänglich.

Ed Kashi | VII Photo Agency was born in the USA in 1957. He has been reporting for large, international magazines, including *National Geographic* and *GEO* magazine, on places like Kurdistan, Northern Ireland, Iraq, the West Bank, the conflicts in the Niger Delta and about changes in American society. As photojournalist and film maker, Kashi focuses on sociopolitical themes and on new narrative forms of the multimedia era. His work has been shown at film festivals, symposia and workshops. He also disseminates his stories for free to a wider public via a dedicated non-profit organization.

Kein Krieg ist wirklich vorbei, wenn er für beendet erklärt wird. Auch der Vietnamkrieg sorgte über den Mai 1975 hinaus für ein schreckliches Erbe: Agent Orange, jenes Entlaubungsmittel, mit dem die USA ihrem nordvietnamesischen Gegner die Deckung im Dschungel nehmen wollten. Wirksam, so erklärten sie, sei das Herbizid nur für eine Wachstumsperiode, doch die Dioxine, die es enthält, haben Langzeitfolgen für die Menschen: Krebs, Immunschwächen und schwerste Missbildungen. Nach offiziellen Schätzungen litten oder leiden noch etwa eine Million Vietnamesen an den Effekten des Agent-Orange-Einsatzes. Wie das behindert geborene Mädchen Nguyen Thi Ly. Wie die mit Defekten auf die Welt gekommenen Jungen Tán Tri und Tán Hâu. Ed Kashi zeigt in seinen Fotos und in einem Film, mit welcher Hingabe diese Kinder seit vielen Jahren von ihren Familien betreut werden.

No war is really over at the time when its end is declared. The Vietnam War, too, has a terrible legacy beyond May 1975: Agent Orange, the defoliant the US used to strip their North-Vietnamese opponents of the jungle cover. They explained that the herbicide would only be active for one vegetation period, but the dioxins that it contained have long-term effects on humans: cancer, immunodeficiencies and severe malformations. Official estimates put the number of Vietnamese who suffered or still suffer from the effects of the Agent Orange application at one million. Like the girl Nguyen Thi Ly, or the boys Tán Tri and Tán Hâu, who were born with congenital malformations. In his photographs and in a film, Ed Kashi shows the dedication of the families in caring for these children year after year.

DAS RECHT AUF BESONDERE FÜRSORGE BEI BEHINDERUNG
THE RIGHT OF THE DISABLED CHILD TO SPECIAL CARE **[Art. 23]**

Mary F. Calvert | Zuma Press ist Amerikanerin und arbeitete bis 2010 als Fotoreporterin für die *Washington Times*. Inzwischen konzentriert sich die vielfach ausgezeichne[te] Journalistin auf frei gewählte Themen. Ihre Reportagen sieht sie als Sensibilisierungsversuche vor allem für die Situation der Frauen: Sie will zeigen, welche Auswirkunge[n] extremistisch-religiöses Denken auf das Leben von Kindern hat. Welche Folgen für Körper und Seele der sexuelle Missbrauch hat. Was es für eine Gesellschaft bedeutet, wen[n] massenweise weibliche Embryos abgetrieben werden. Und mit welchen Konsequenzen ein Land zu leben hat, in dem nur wenige Frauen lesen und schreiben können.

Mary F. Calvert | Zuma Press is an American and worked as a photojournalist for the *Washington Times* until 2010. Now the multi-award winning journalist focuses on them[es] freely chosen by her. She sees her reports as attempts at sensitizing people for the situation of women and girls in particular. She wants to show the effects of extrem[e] religious thinking on the lives of children. Or the effects of sexual abuse on body and soul. What it means for a society if female foetuses are aborted on a massive scale. A[nd] the consequences for a country if only few women there can read or write.

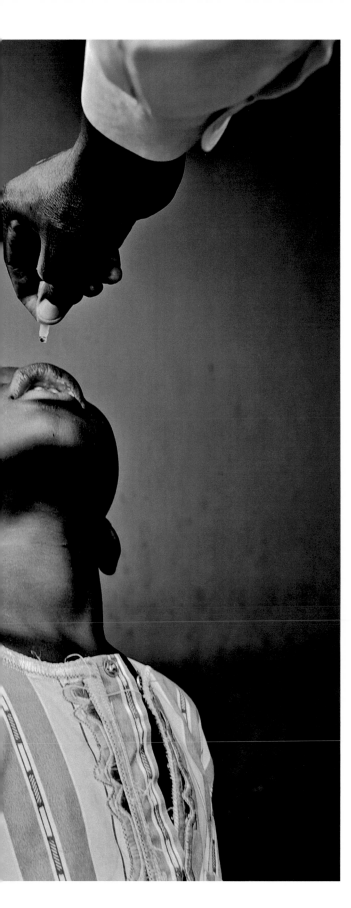

Kinderlähmung, in den meisten Ländern erfolgreich bekämpft, ist noch immer nicht vollständig besiegt. Nicht zum Beispiel im Norden Nigerias, der Operationszone der islamistischen Terror-Sekte Boko Haram. 2002 führte dort eine Kombination aus Glaubenseifer, Unwissenheit und einer Hass-Kampagne gegen westliche Einflüsse zur Unterdrückung der für dieses Jahr geplanten Immunisierung der Bevölkerung. Islamische Ideologen propagierten, Ziel des Westens sei es, Frauen unfruchtbar zu machen oder gar Aids zu verbreiten. Das fatale Ergebnis: Vier Jahre nach dieser Desinformations-Kampagne waren über 3 000 Jungen und Mädchen mit dem Poliovirus infiziert. Erst die große Zahl der sichtbar für immer schwer geschädigten Kinder hat zu einem Umdenken geführt. Prophylaxe durch ausreichend verabreichten Impfstoff wird inzwischen, wenngleich zögerlich, auch wieder von islamistischen Extremisten befürwortet. Zu spät allerdings für die von Kinderlähmung Betroffenen.

Polio, successfully overcome in many countries, is still not completely conquered. Not in northern Nigeria, for instance, where the Islamist terror sect Boko Haram operate. In 2002 a combination of religious fervour, ignorance and a hate campaign against Western influences meant that the immunization of the population planned for that year was suppressed. Islamist ideologists claimed that the West aimed to make women infertile or even to spread AIDS. The fatal result was that, four years after this disinformation campaign, more than 3 000 girls and boys had become infected with polio. Only the large number of children with visible permanent severe damage has led to a rethink. By now even the Islamist extremists support, albeit hesitantly, prevention through vaccination. Too late, though, for the children who caught polio.

DAS RECHT AUF GESUNDHEIT **[Art. 24]**
THE RIGHT TO HEALTH

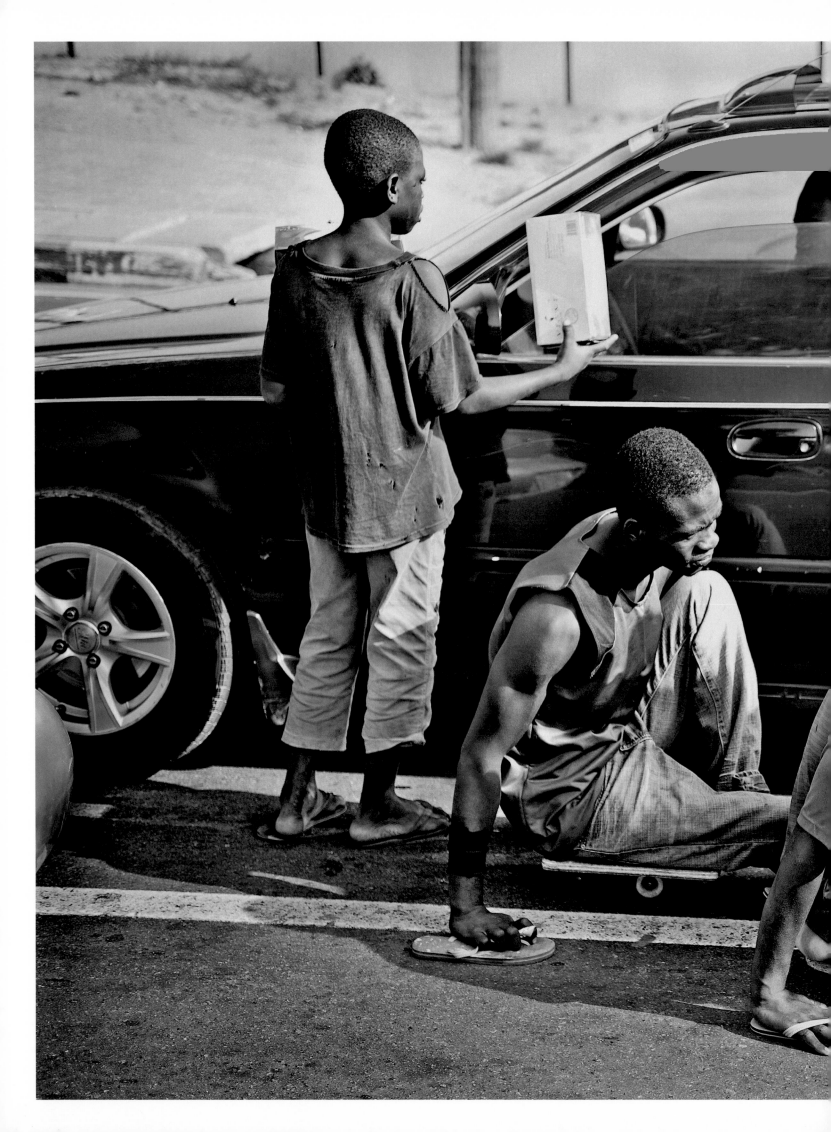

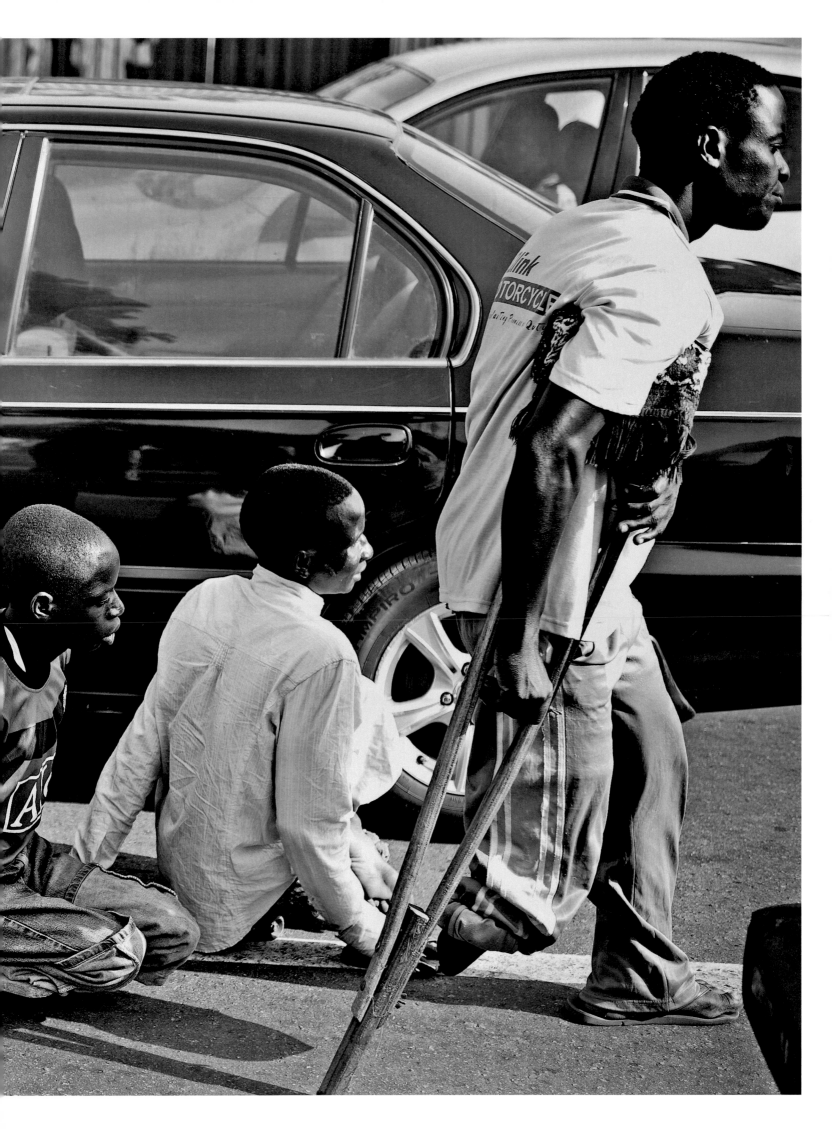

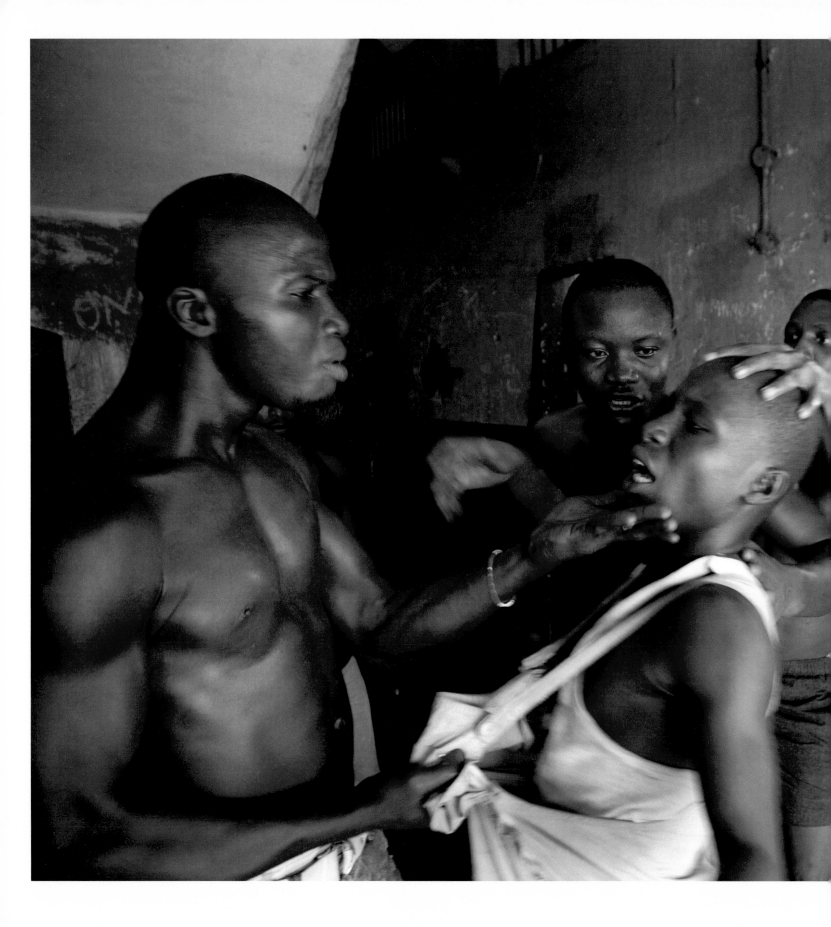

Fernando Moleres | Panos Pictures/laif wurde 1963 im spanischen Bilbao geboren. Seit über 20 Jahren beschäftigen ihn die Internationale Menschenrechts-Charta und Verstöße dagegen — und immer wieder auch das miserable Leben von Kindern, die in Ziegeleien und Gerbereien, auf Feldern und in Schiffsabwrackwerften, auf Müllhalden und in Minen arbeiten müssen. Moleres' Werk ist mit über einem Dutzend renommierter Preise ausgezeichnet worden und wird in vielen Galerien in Europa und Übersee ausgestellt sowie in Zeitschriften und Zeitungen wie *The New Yorker, Le Monde, El País* und *The Economist* publiziert.

Fernando Moleres | Panos Pictures/laif was born in Bilbao, Spain, in 1963. For more than 20 years he has looked closely at the International Human Rights Charta and violations thereof — and he has repeatedly focused on the miserable life of children who have to work in brickworks and tanneries, in fields and ship breaking yards, on rubbish dumps and in mines. Moleres has received more than a dozen prestigious awards for his work, which is being shown in many galleries in Europe and further afield and published in magazines and newspapers like *The New Yorker, Le Monde, El País* or *The Economist.*

Das Zentralgefängnis in Freetown wurde für 342 Gefangene gebaut, hinter Gittern befinden sich dort aber mehr als 1100 Inhaftierte, viele davon minderjährig. Jugendliche wie Lebbise, 16 Jahre alt, verurteilt ohne Prozess zu drei Jahren Gefängnis, weil er 100 000 Leones (25 Euro) gestohlen haben soll. Hilmani, 17 Jahre alt, verurteilt ohne Prozess, nachdem sein Onkel behauptete, er habe dessen Motorroller gestohlen. Für den Fotografen Fernando Moleres war es ein Schock, jugendlichen Gefangenen unter 18 in einem Gefängnis zu begegnen, in dem sie nach der auch von Sierra Leone unterzeichneten UN-Kinderrechtskonvention gar nicht sein dürften: Brutale Schlägereien, Massenlager, grundlos verhängte Einzelhaft in winzigen Zellen sind dort die Regel, es gibt keine sanitären Einrichtungen, keine Strom- oder Wasserversorgung. Kaum Nahrung. Und vielfach wissen die Verwandten nichts über den Verbleib ihrer verurteilten Angehörigen.

The central prison in Freetown was built for 342 inmates. It currently holds more than 1100 inmates, many of them minors. Youths like Lebbise, aged 16, who was sentenced without a trial to three years in prison because he is supposed to have stolen 100 000 Leones (25 euros). Hilmani, aged 17, sentenced without a trial, after his uncle claimed that he had stolen his motorbike. Photographer Fernando Moleres was shocked to find minors in a prison where they are not supposed to be according to the UN Convention on the Rights of the Child, which has also been signed by Sierra Leone. Brutal fighting, tightly packed dormitories, solitary confinement in tiny cells handed out without a reason are commonplace there. No sanitation, electricity or water, little food. And often the families know nothing of the whereabouts of those sentenced.

DAS RECHT AUF FREIE MEINUNGSÄUSSERUNG [Art. 13]
THE RIGHT TO FREEDOM OF EXPRESSION

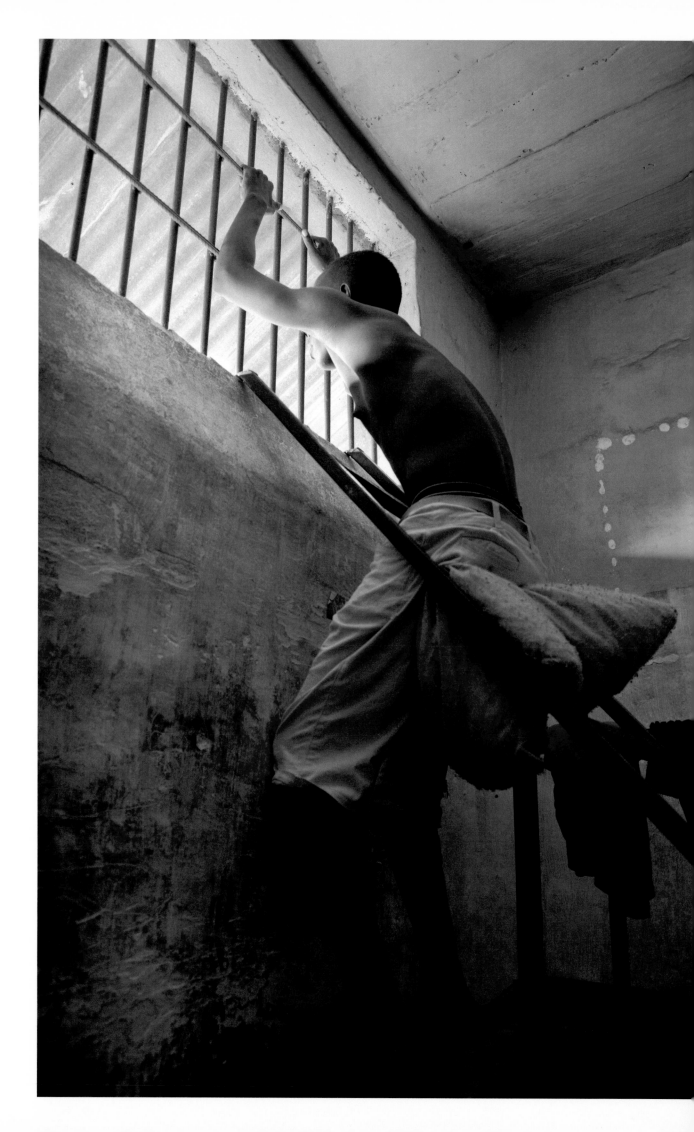

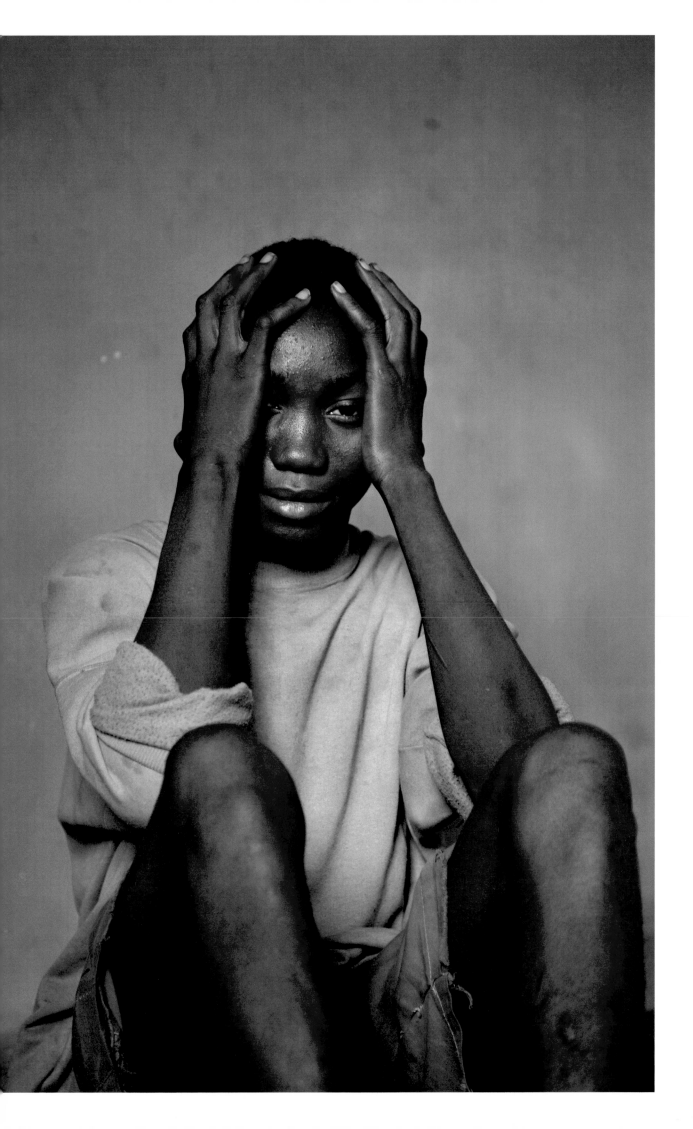

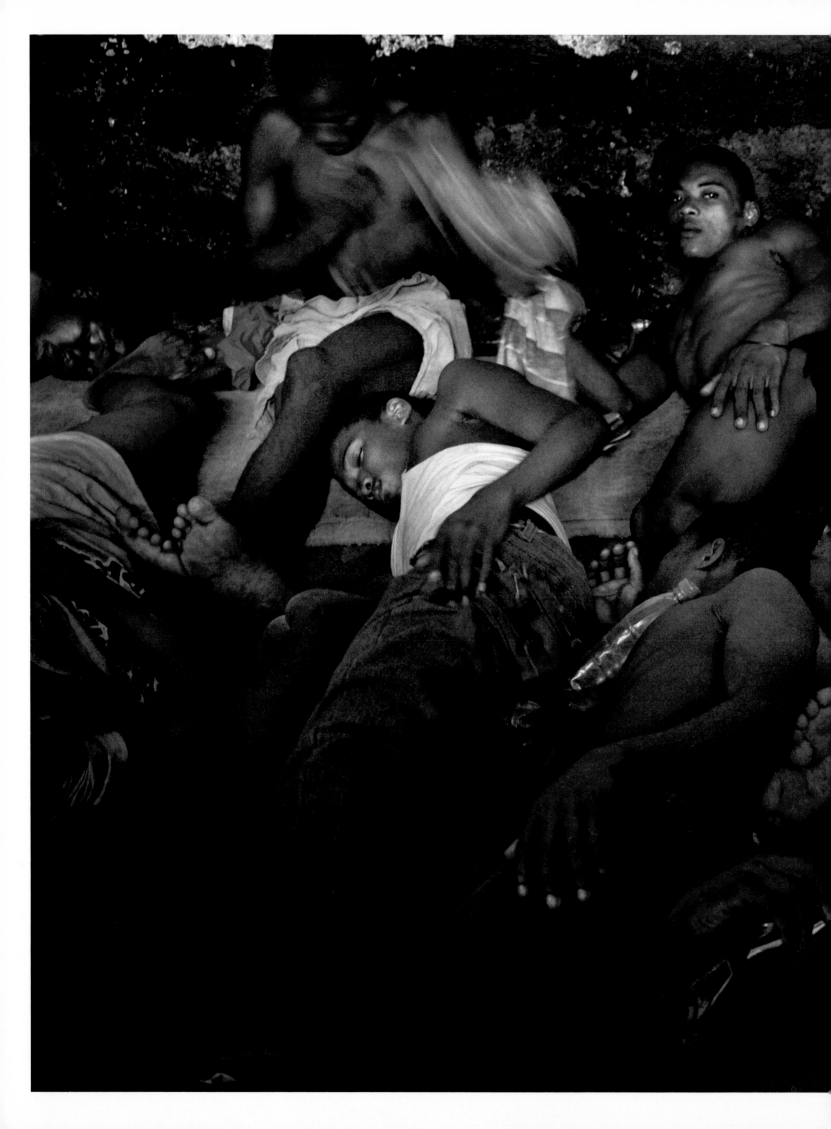

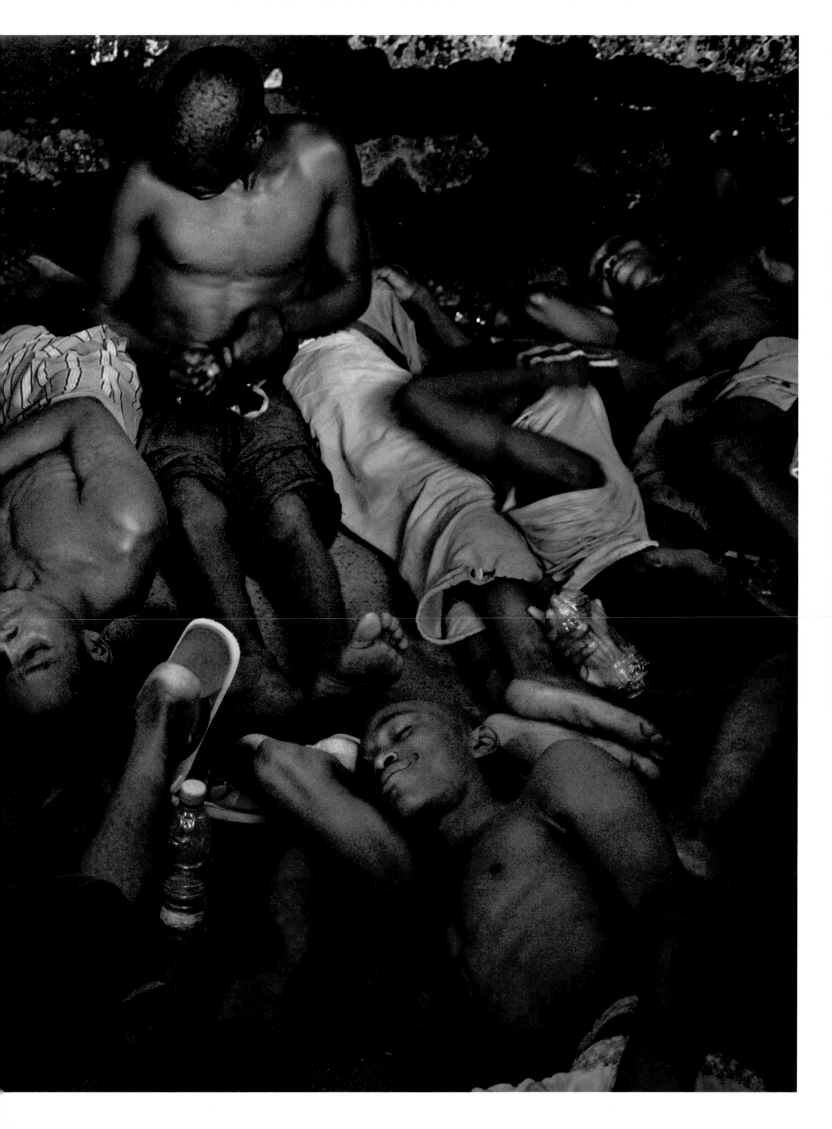

DER RÜCKZUG AUS DER WELT
A RETREAT FROM THE WORLD
Tschechien | Czech Republic
2009

Autismus, jene Entwicklungsstörung, die oft in der frühen Kindheit beginnt, äußert sich in Problemen etwa bei der Kommunikation und Beherrschung anderer sozialer Fähigkeiten. Der Fotograf Milan Jaroš hat in Prag mehrere autistische Kinder im Alltag begleitet. Der neun Jahre alte Ondřej leidet am Asperger-Syndrom, einer leichteren Form von Autismus. Er besucht die dritte Klasse einer integrativen Grundschule, in der behinderte und gesunde Schüler gemeinsam unterrichtet werden. Mathematikaufgaben zu lösen und Englisch zu sprechen, fällt Ondřej leicht. Doch scheinbar einfache Aufgaben, wie das Packen des Schulranzens, werfen ihn aus der Bahn. Dann schreit er, wirft sich auf den Boden, strampelt mit den Beinen und fuchtelt mit den Armen. Fühlt er sich vom Leben überfordert, verkriecht sich Ondřej unter seinem Bett. Kinder mit schweren Wahrnehmungs- und Informationsverarbeitungsstörungen erhalten in einem Prager Kindergarten besondere Zuwendung.

Autism is a developmental disorder that often starts in early childhood and manifests itself in problems with communication and with mastering other social skills. Photographer Milan Jaroš spent some time in Prague with several autistic children in their everyday life. Ondřej — nine years old — suffers from Asperger syndrome, a milder form of autism. He attends the third class of an integrative elementary school, where disabled and healthy pupils are taught together. Solving maths problems and speaking English are easy for Ondřej. Seemingly simple tasks, however, like packing his school bag, floor him. Then he starts shouting, throws himself on the ground, kicks his legs and waves his arms. If he feels that life is getting on top of him, Ondřej crawls under his bed. Children with severe deficits in perception and information processing receive special care and support in a Prague kindergarten.

[Art. 23] DAS RECHT AUF BESONDERE FÜRSORGE BEI BEHINDERUNG
THE RIGHT OF THE DISABLED CHILD TO SPECIAL CARE

Milan Jaroš | Respekt magazine wurde 1979 in der damaligen Tschechoslowakei geboren. 2004 beendete er ein Filmstudium an der Akademie der angewandten Künste ... Prag. Trotz der vielfältigen medialen Qualifikationen, die er sich während seiner Ausbildung erwarb, wählte er am Ende die Fotografie. Mit ihr, so sagt er, könne er seine ...urnalistischen Fähigkeiten, sein Gespür und seinen Zugang zu Menschen am besten verwirklichen. Jaroš, in seinem Heimatland, dem heutigen Tschechien, mehrfach als ...tograf des Jahres ausgezeichnet, arbeitet für die Wochenzeitung *Respekt* und veröffentlicht unter anderem in der *New York Times*, in der *International Herald Tribune und* ... *Wall Street Journal*.

Milan Jaroš | Respekt magazine was born in 1979 in what was then Czechoslovakia. In 2004 he completed his film studies at the Academy of Applied Arts in Prague. Even ...ough he holds qualifications in various media from his studies, he ended up choosing photography. In this medium, he says, he can best realize his journalist skills, his ... tuition and his way of approaching people. Jaroš has been voted photographer of the year several times in his home country, today's Czech Republic. He works for the ...eekly *Respekt* and also publishes in *The New York Times*, the *International Herald Tribune* and *The Wall Street Journal*.

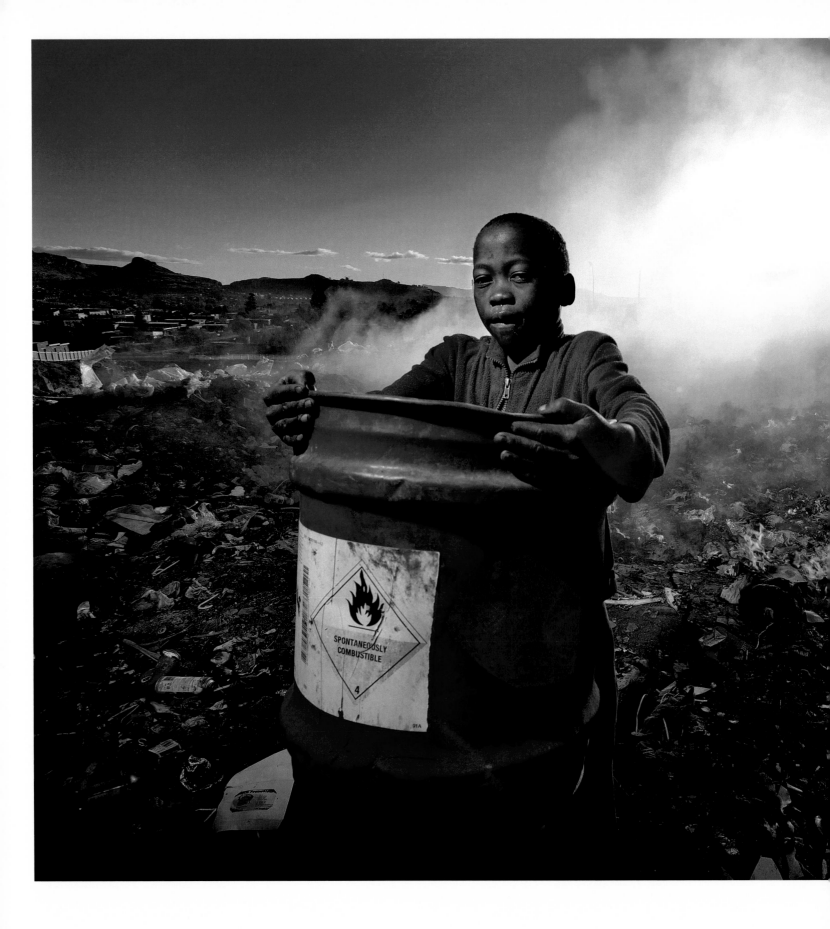

Robin Hammond | Panos Pictures wurde 1975 in Neuseeland geboren. In London begann er eine Karriere als freier Fotograf, die ihm unter anderem ein W.-Eugene-Smit Stipendium für „Humanistic Photography" und den von Amnesty International vergebenen Preis für „Human Rights Journalism" einbrachte. Für „Zimbabwe unter Mugab erhielt Hammond, der eine Zeit lang auch in Südafrika lebte, den hochdotierten „Carmignac Gestion Photojournalism Award". Seine Reportage über geistig Behinderte, e gesperrt in afrikanischen Gefängnissen, wurde zu einem preisgekrönten Buch. Seine Serie über die Jeans-Produktion erregte international Aufsehen.

Robin Hammond | Panos Pictures was born in New Zealand in 1975. In London he started his career as freelance photographer. Grants and awards that he has gaine include the W. Eugene Smith grant for Humanistic Photography and the Amnesty International Award for Human Rights Journalism. For his project Zimbabwe under Mugab Hammond, who had also lived for some time in South Africa, was awarded the valuable Carmignac Gestion Photojournalism Award. His report on mentally ill people lock away in African prisons was turned into an award-winning book. His photo series on jeans production caught international attention.

Blue Jeans, jene einst für Goldgräber geschneiderten robusten Arbeitshosen, sind im Laufe der Zeit zu einer Goldgrube für die Hersteller geworden. Doch was ihnen den Namen gab, Indigo, ist zugleich die Farbe eines dunklen Kapitels der Textilherstellung. Es handelt von Fabriken mit prekären Produktionsbedingungen und fehlenden Standards für Umweltverträglichkeit, zu finden vor allem in Südostasien, China oder in Ländern wie dem afrikanischen Königreich Lesotho. In dessen Hauptstadt Maseru verwandelt das Farbbad-Abwasser den Fluss Caledon in eine blaue, mit Chemikalien verschmutzte Brühe. Reste der Jeans-Produktion werden auf Müllhalden gekippt. Auf den qualmenden Halden sind Kinder wie der achtjährige Motselisi unterwegs, auf der Suche nach Stoffresten, die sie als Brennmaterial verkaufen können. Es ist kein Stoff, aus dem Träume sind.

Blue jeans, originally created as robust working trousers for gold diggers, have over time become a gold mine for the producers. Indigo, which gave them the name, is also the colour of a dark chapter in textile production. It tells of factories with precarious production conditions and missing standards of environmental compatibility, mainly found in Southeast Asia, China or in countries like the African Kingdom of Lesotho. In its capital Maseru the wastewater from the dye dip turns the Caledon River into a blue swill polluted by chemicals. Remnants of the jeans production are dumped on rubbish tips. On the smouldering dumps children like eight year old Motselisi are busy looking for stuff they can sell as fuel, certainly not 'the stuff that dreams are made of.'

DAS RECHT AUF SCHUTZ VOR AUSBEUTUNG **[Art. 32]**
THE RIGHT TO PROTECTION FROM EXPLOITATION

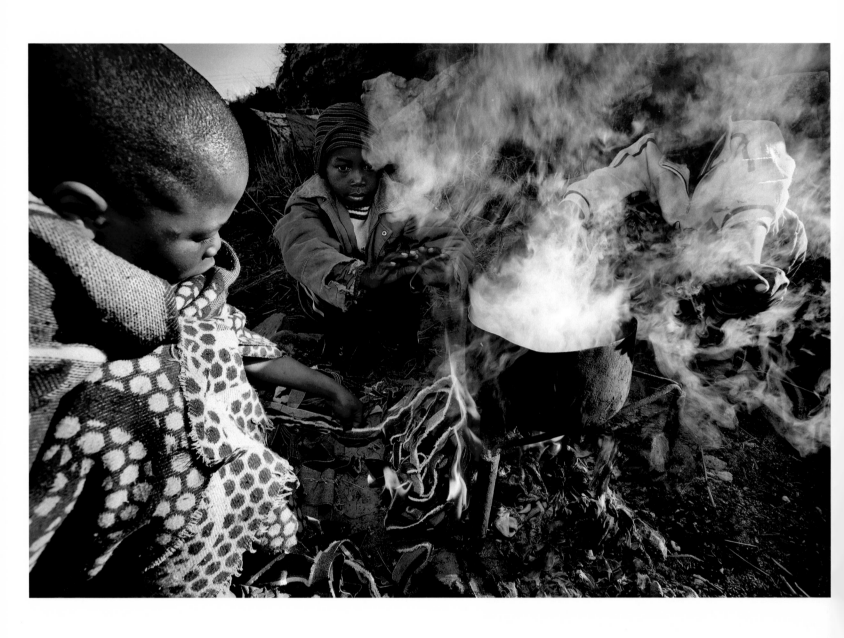

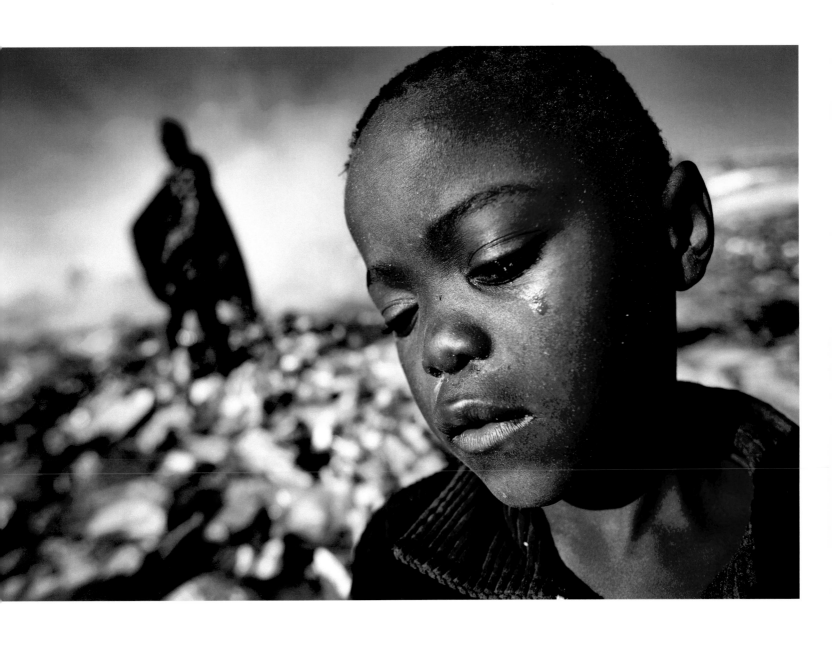

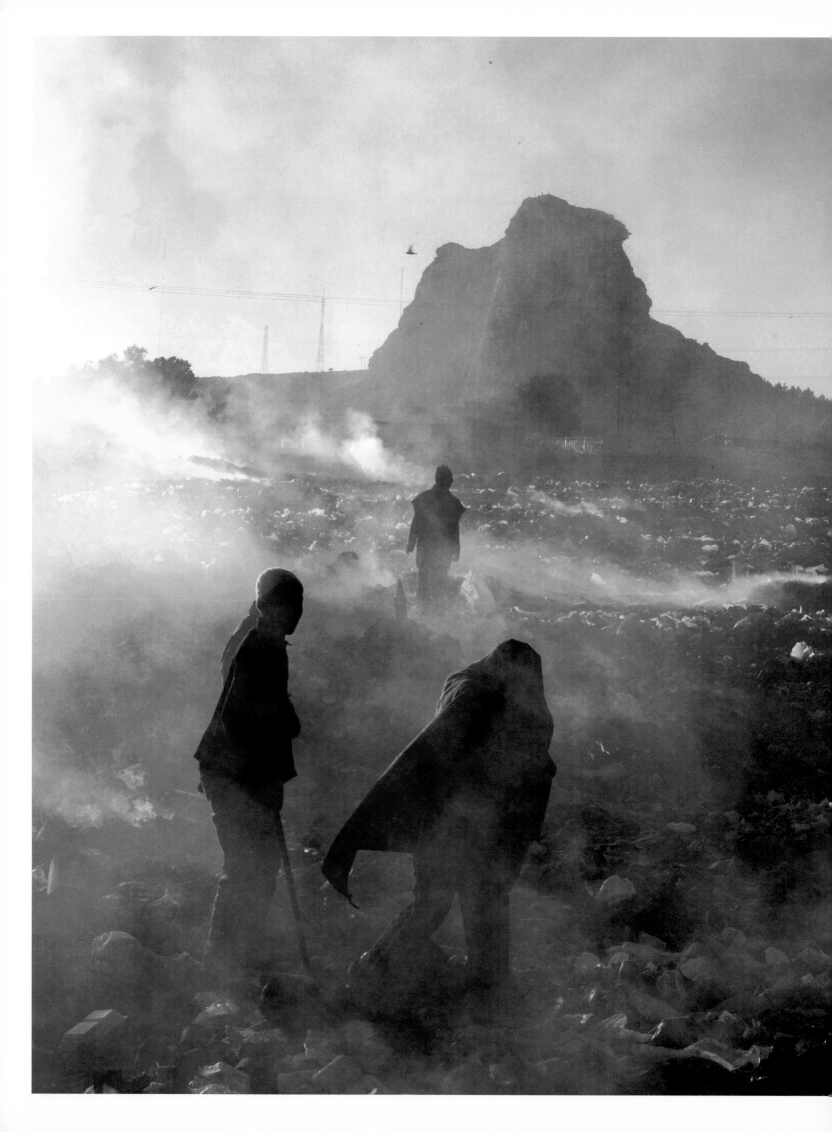

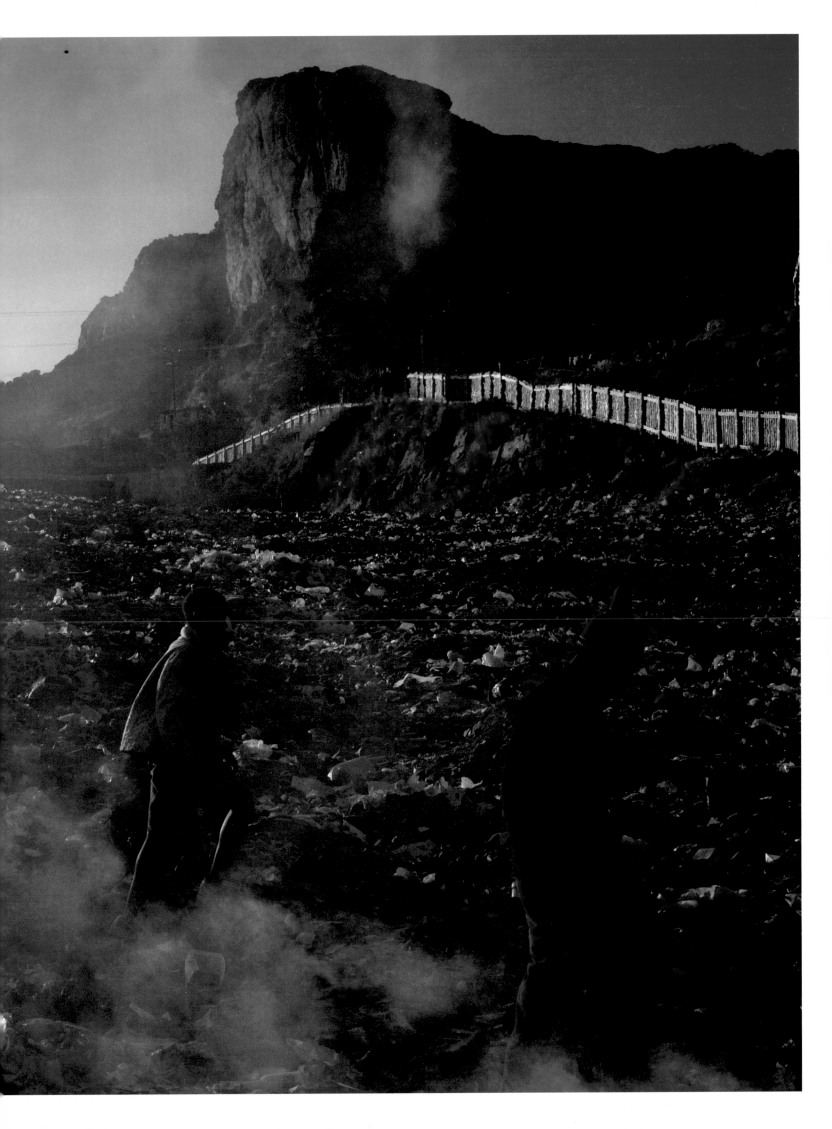

Thomas Lekfeldt | Berlingske/laif wurde 1977 in Dänemark geboren. Nach vielen Auslandsaufenthalten studierte er Anthropologie und verließ 2007 mit einem Bachelor Abschluss die Danish School of Media and Journalism, die weltweit zu den besten Ausbildungsstätten für angehende Fotojournalisten zählt. Immer wieder gewinnen ihre Absolventen international bedeutende Auszeichnungen. So auch Lekfeldt, etwa für seine Bilder von einem mit Gerbereiabwässern zur Kloake verkommenen Fluss in Dhaka, für eine Reportage über die grauenvolle Tradition der Klitorisbeschneidung in Äthiopien — und auch für seinen einfühlsamen Bericht über den Krebstod des dänischer Mädchens Vibe.

Thomas Lekfeldt | Berlingske/laif was born in Denmark in 1977. After many trips abroad he studied anthropology and in 2007 completed his bachelor at the Danish School of Media and Journalism, one of the best schools in the world for photojournalists. Its graduates repeatedly win internationally acclaimed awards. As did Lekfeldt, for instance for his pictures of a river in Dhaka which had been turned into a swill of effluent from a tannery, for his photojournalism on the cruel tradition of female circumcision in Ethiopia — and for his sensitive recording of the Danish girl Vibe's death of cancer.

Diagnose Krebs. Es gibt kaum Schlimmeres für eine Familie als die lebensgefährliche Erkrankung eines Kindes. Und kaum etwas Sensibleres für einen Fotografen, als eine betroffene Familie in einer solchen Lebenssituation zu begleiten: die Zerstörung von Unbeschwertheit und Zukunftsträumen, die Verzweiflung, die Angst. Als bei dem Mädchen Vibe ein Hirntumor diagnostiziert wird, verändert sich die ihr vertraute alltägliche Welt. Sie fürchtet sich vor den medizinischen Eingriffen. Die Haare fallen ihr aus, die vielen Medikamente verändern ihren Körper. Manchmal noch ist sie fröhlich wie früher. Wenn sie vergnügt unter der Dusche steht, mit ihren Eltern und ihrer Zwillingsschwester nach Mallorca reist. Aber die Hoffnung auf Genesung schwindet. Vibes Abwehrkräfte werden schwächer, ständig muss sie ins Krankenhaus. Ihre Eltern holen sie nach Hause, pflegen sie dort. Im Alter von nur sieben Jahren, zwei Jahre nach dem Befund, stirbt Vibe.

Diagnosis: cancer. There are few fates worse for a family than a life-threatening illness befalling a child. And few more sensitive areas for a photographer than staying with a family thus hit: serenity and dreams of the future destroyed, replaced by despair, fear. When little Vibe is diagnosed with a brain tumour, her familiar everyday world changes. She is afraid of the medical interventions. Her hair is falling out, the many medications change her body. Occasionally she is happy as before. When she is enjoying a shower, or when she travels to Mallorca with her parents and her twin sister. But hope for a recovery is waning. Vibe's body's defences are weakening, she has to return to hospital repeatedly. Her parents take her home, care for her there. At the age of only seven, two years after the first diagnosis, Vibe dies.

DAS RECHT AUF ELTERLICHE FÜRSORGE
THE RIGHT TO PARENTAL GUIDANCE **[Art. 5]**

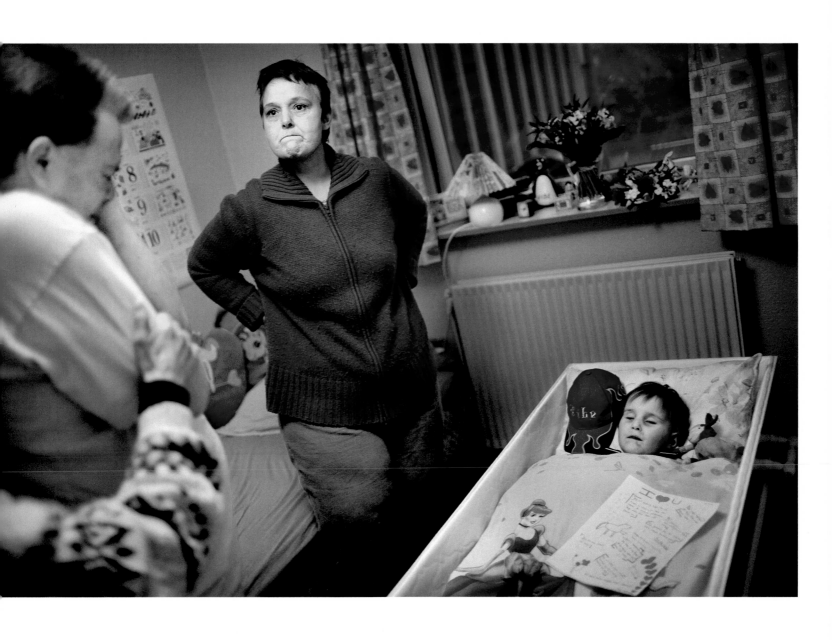

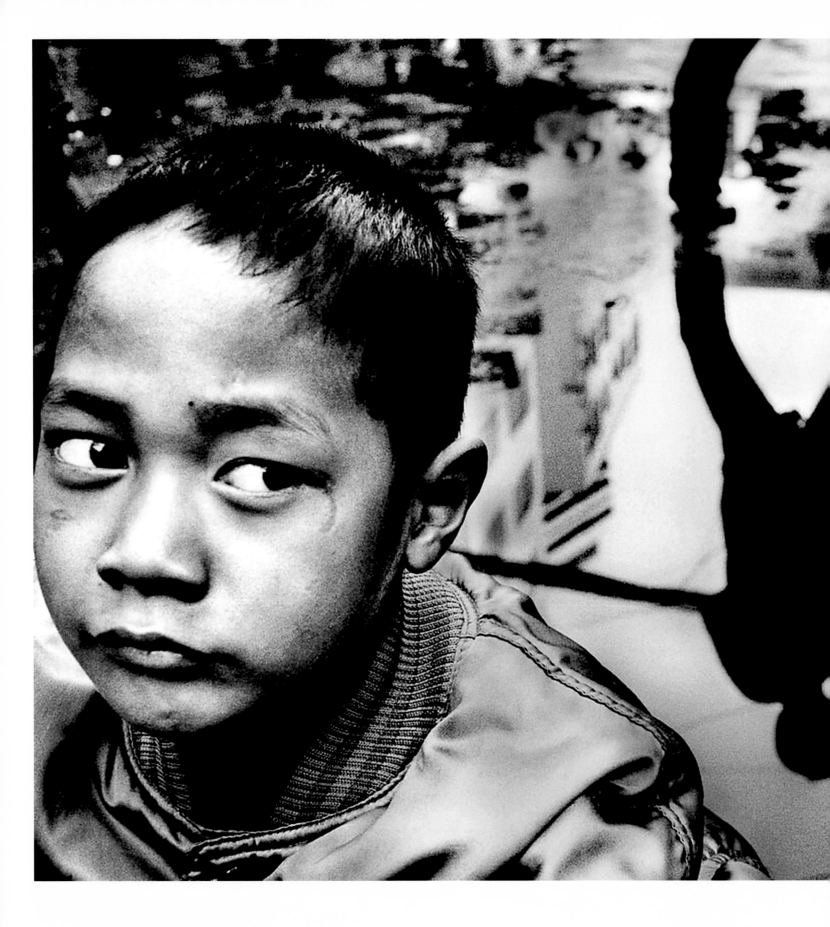

Jacob Aue Sobol | Magnum Photos wurde 1976 in Dänemark geboren. Nach einer Zeit in Kanada begann er ein Studium am European Film College, ab 1998 an der Danis School of Art Photography, die den Beinamen „Fatamorgana" trägt. So wie Luftspiegelungen durch Ablenkung des Lichts einen optischen Effekt erzeugen, der verwirren aber keine Wahrnehmungstäuschung ist, lassen sich die Fotos von Jacob Aue Sobol betrachten. Wie kalte und warme Lichtstrahlen, wie expressive Mehrfachspiegelunge wirken die Lebenswelten in Sobols Schwarz-Weiß-Fotos. Seine intimen, häufig verstörenden Fotos — auch in Grönland und Zentralamerika entstanden — werden mit Verö fentlichungen, Büchern und Preisen belohnt.

Jacob Aue Sobol | Magnum Photos was born in Denmark in 1976. After spending some time in Canada he studied at the European Film College, and from 1998 at the Danis School of Art Photography, which is also called Fatamorgana. Jacob Aue Sobol's photographs, too can be viewed like reflections in the air from deflected light, creating a optical effect that is confusing but not an illusion. The circumstances caught in his black-and-white photographs come across like cold and warm rays of light, expressiv multireflections. His intimate, often disturbing, pictures, some of which were taken in Greenland and in Central America, have been widely published and won many award

In der Sukhumvit Road in Bangkok zeigt sich die wirtschaftliche Entwicklung Thailands: Bürohochhäuser, Einkaufszentren und Luxushotels, teure Restaurants, Bars und Clubs. Eine Flanierzone für die Menschen, die im Lichte stehen. Doch daneben ein anderes Bild: Armut und soziale Misere in den Nebenstraßen, von Jacob Aue Sobol in schwermütigen Fotos dokumentiert. Die Kinder hier müssen schon früh Strategien entwickeln, um einige Baht zu verdienen, sei es als Bettler oder Blumenverkäufer, als Handlanger bei Hahnenkämpfen oder Taschendieb. Die Not hält die Kinder zusammen, führt aber auch zu Überlebenskämpfen innerhalb der Gruppen.

Sukhumvit Road in Bangkok manifests Thailand's economic development. Office blocks have sprung up here, luxury hotels, shopping centres, expensive restaurants, bars and clubs. A zone for people on the sunny side of life to stroll around in. The side streets present a different picture. Poverty and social ills, caught by Jacob Aue Sobol in melancholy photographs. Children here must start early to form strategies for earning a few baht, by begging or by selling flowers, as helpers at cock fights or as pickpockets. Hardship binds the children together but also leads to fights for survival within the groups.

DAS RECHT AUF ELTERLICHE FÜRSORGE **[Art. 5]**
THE RIGHT TO PARENTAL GUIDANCE

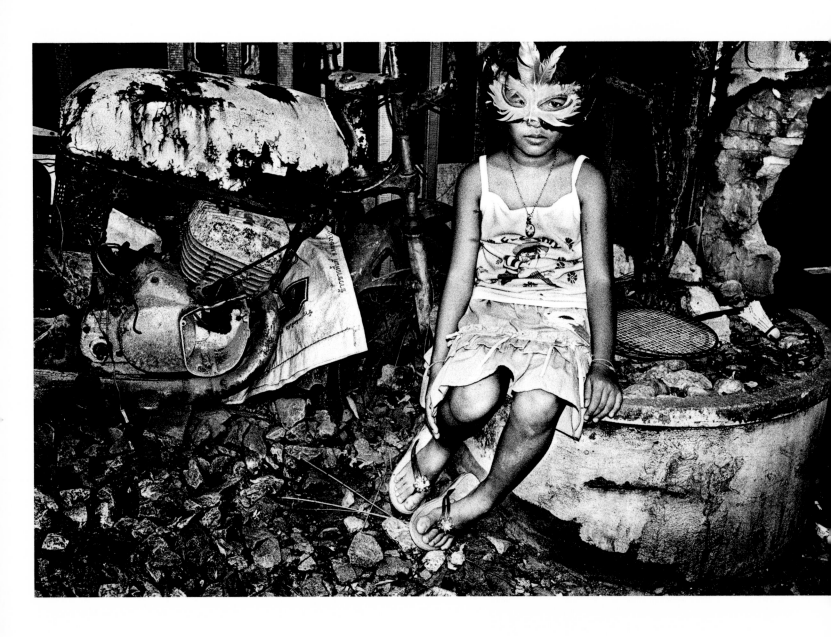

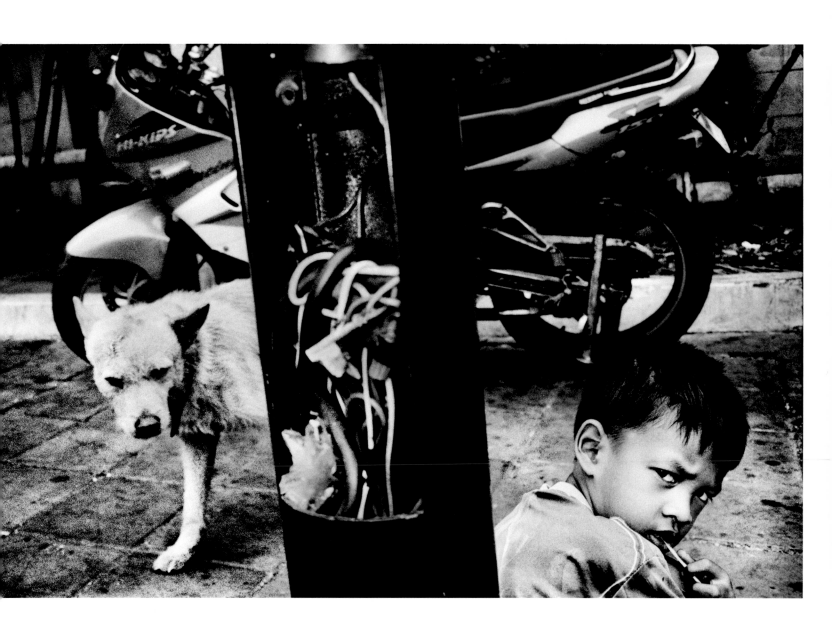

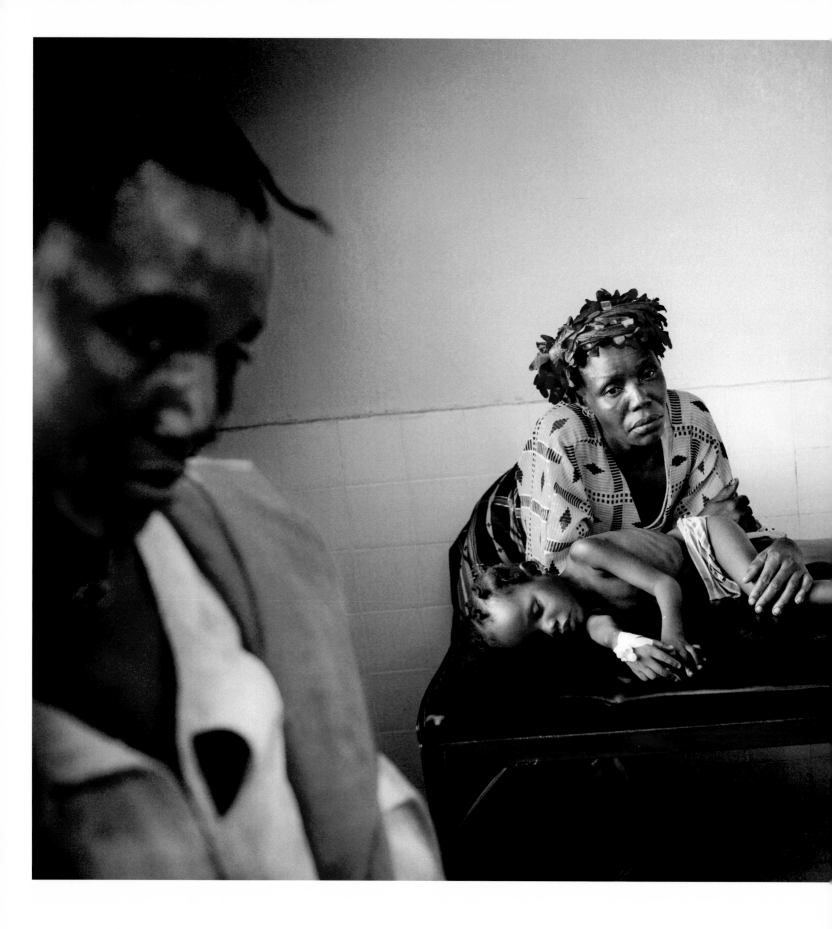

William Daniels | Panos Pictures wurde 1977 in Frankreich geboren. Seit seinem Studium am renommierten Centre Iris in Paris konzentriert er sich in seiner Arbeit als Foto reporter auf das Leben der Mühseligen, Beladenen, Besiegten: in Paris, Haiti, Libyen, Syrien, der Zentralafrikanischen Republik. Seine Bilder von Straßenkindern auf de Philippinen wurden 2004 ausgezeichnet, 2007 erhielt er finanzielle Unterstützung von der Lagardère Foundation für seinen Langzeit-Lagebericht der politischen Entwicklun in Kirgisien. Seit zwei Jahren beschäftigt sich Daniels mit den Auswirkungen der Malaria-Epidemie in Afrika, Südostasien und Lateinamerika.

William Daniels | Panos Pictures was born in France in 1977. After completing his studies at the renowned Centre Iris in Paris, he focused as a photojournalist on the lives o the weary, the burdened, the defeated: in Paris, Haiti, Libya, Syria, in the Central African Republic. In 2004 he won an award for pictures of street children in the Philippine in 2007 he received a grant from the Lagadere Foundation for his long-term report on the political developments in the Kyrgyz Republic. In the last two years Daniels ha followed up the effects of the malaria epidemic in Africa, Southeast Asia and Latin America.

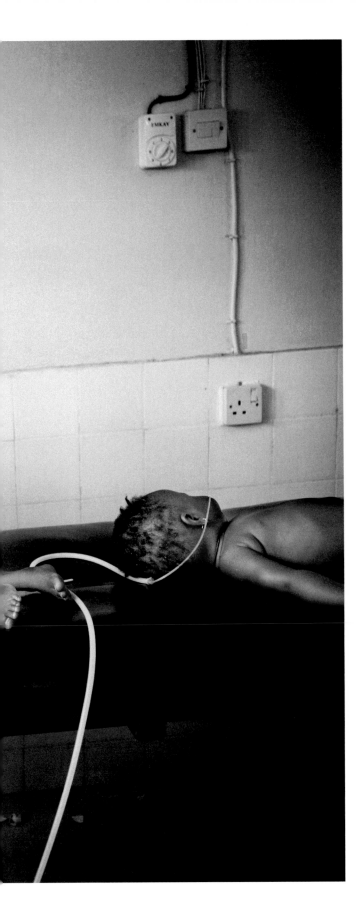

Es passiert in einem Land wie Sierra Leone häufig, dass kleine Kinder am Abend noch gesund einschlafen, ihnen am Morgen aber übel ist und ihre Glieder schmerzen. Kommt Fieber hinzu, müssen Mütter und Väter davon ausgehen, dass eine Anopheles-Mücke zugestochen und den Erreger der Malaria tropica übertragen hat. Kinder unter fünf Jahren sind besonders gefährdet; ihre Abwehrkräfte sind schwach, das Risiko ist groß, dass sie an der Infektion sterben. Es würde helfen, wenn alle Familien Moskitonetze hätten. Aber die kosten Geld. Es würde helfen, wenn weniger Brutplätze für Mücken existierten. Aber alle Feuchtgebiete — auch jene in städtischen Ballungsräumen — trockenzulegen, ist nicht zu bewältigen. Es würde helfen, wenn es ein einigermaßen funktionierendes Gesundheitssystem gäbe. All das ist Wunschdenken. Es waren dennoch die Wünsche auch von William Daniels, als er die tieftraurigen Mütter und Väter in Sierra Leone mit ihren todkranken Kindern fotografierte.

In a country like Sierra Leone it can often happen that small children are fine when the go to sleep of an evening, but the next morning they are feeling sick and their limbs hurt. If they are feverish as well, their mothers and fathers must assume that they have been bitten by an Anopheles mosquito which has transmitted malaria tropica. Children under the age of five are particularly vulnerable. Their body defences are weak, they run a high risk of dying from the infection. It would help if all families had mosquito nets — but these cost money. It would help if there were fewer breeding places for mosquitoes — but it is impossible to drain all wetlands in the urban agglomerations. It would help if there was a halfway functioning health system — but all that is wishful thinking. And yet it was what William Daniels wished for when he photographed the desperately sad mothers and fathers in Sierra Leone with their mortally ill children.

DAS RECHT AUF GESUNDHEIT **[Art. 24]**
THE RIGHT TO HEALTH

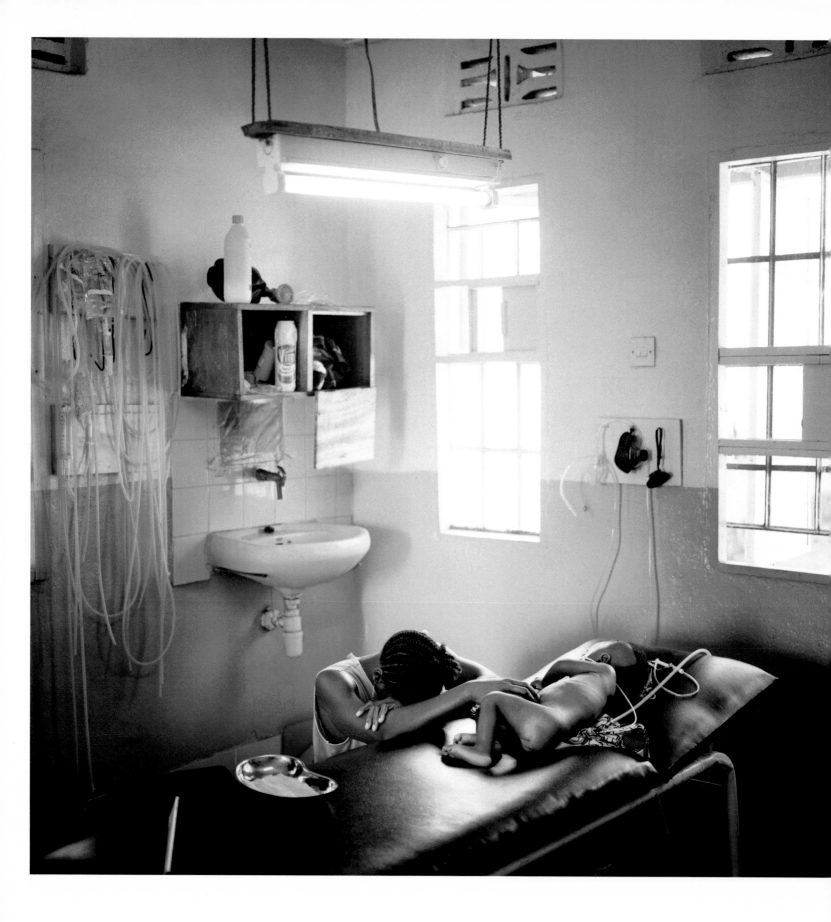

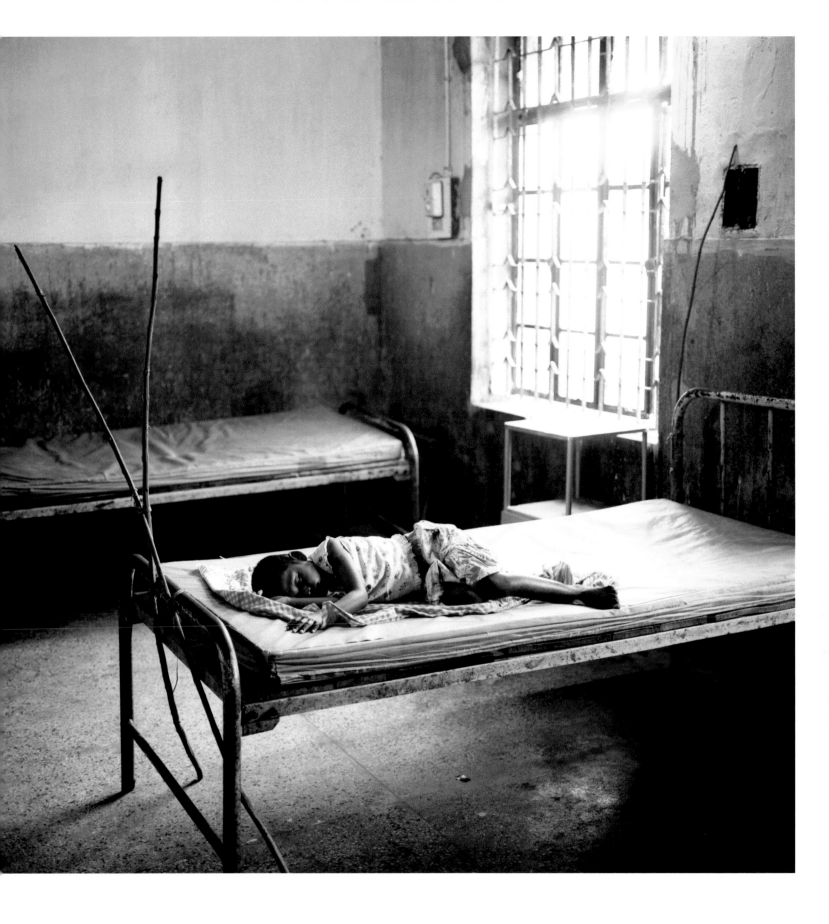

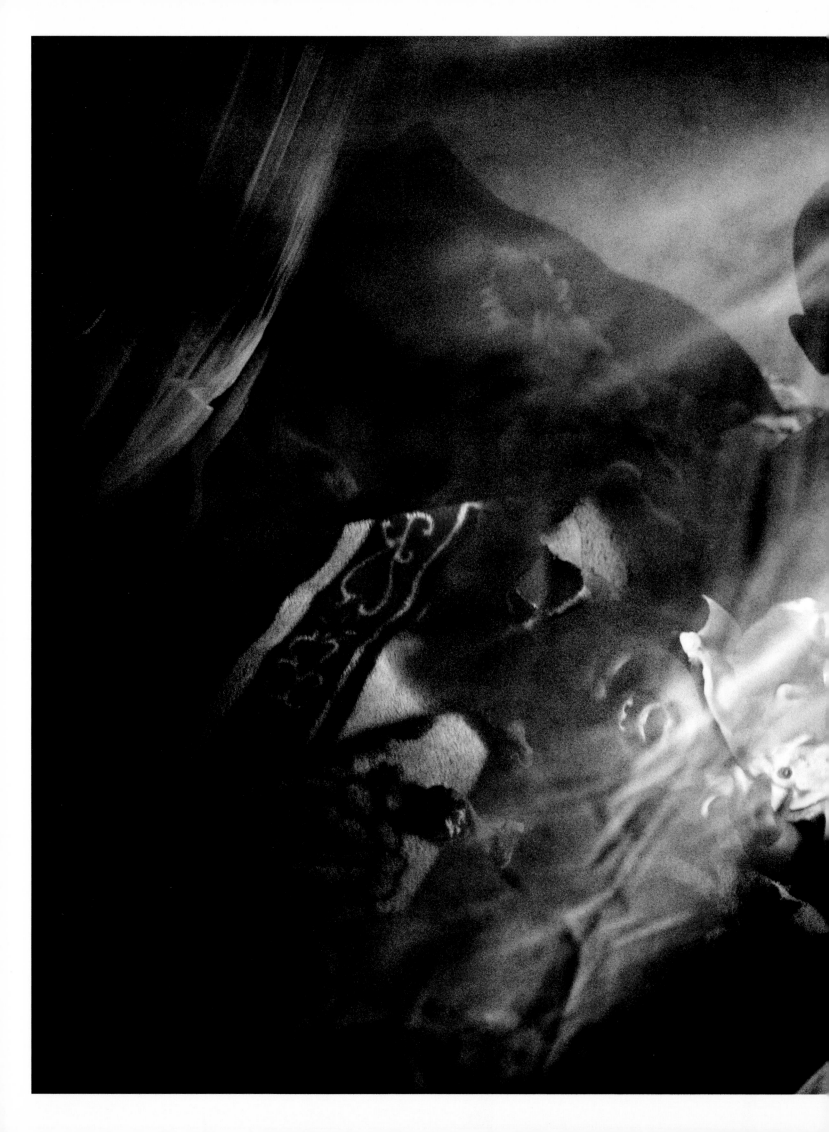

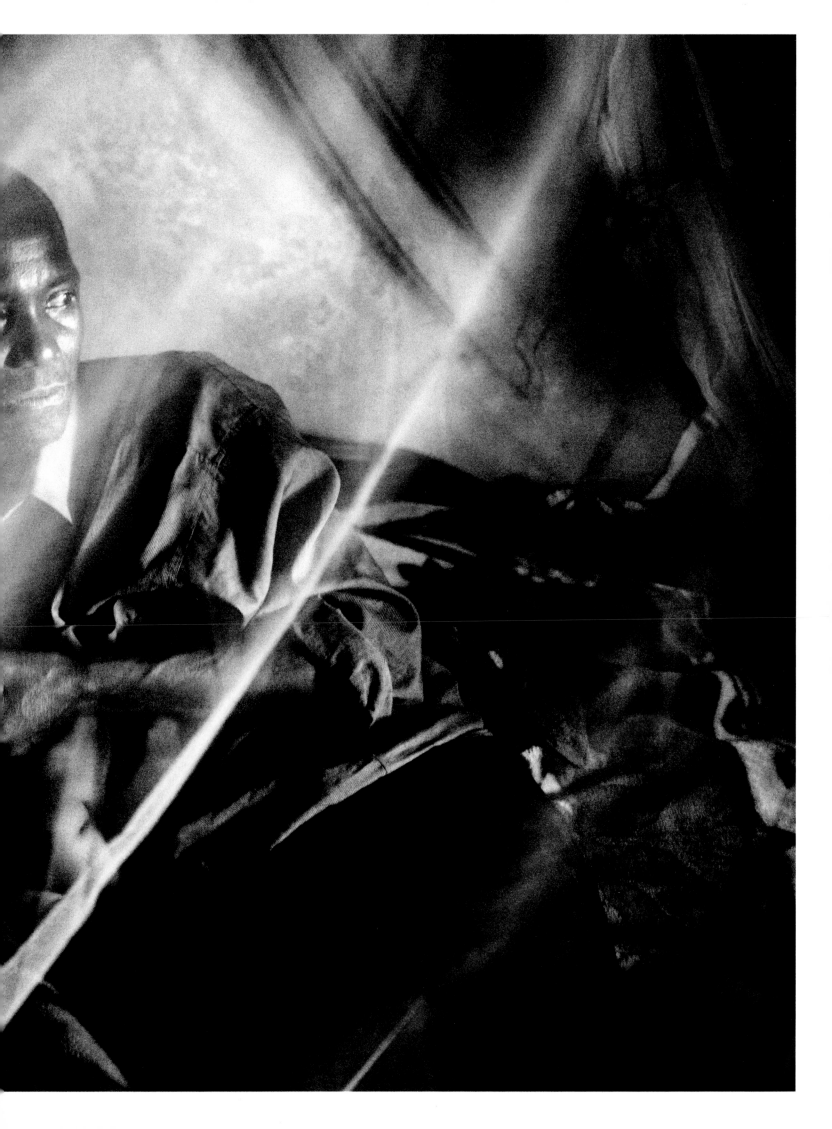

Shiho Fukada | Panos Pictures wurde in Tokio geboren. Nach einem Abschluss in Englischer Literatur wechselte sie das Metier und arbeitete in der Modeindustrie und Werbeagenturen in New York. In dieser Zeit entwickelte sie ein Gespür für gute Fotografie und begann 2004, als Fotografin zu arbeiten: Wahlkämpfer in den USA porträtier sie ebenso wie die Verlierer der japanischen Wirtschaftskrise, Bagdad bei Nacht ebenso wie Kämpfer der PKK, Kinderarbeiter und die Opfer von Naturkatastrophen. Fukad Features erscheinen in internationalen Magazinen. Finanzielle Unterstützung erhielt sie durch das Alicia-Patterson-Journalism-Fellowship-Programm und das Pulitzer Cent on Crisis Reporting.

Shiho Fukada | Panos Pictures was born in Tokyo. After completing a degree in English literature she changed to working in fashion and advertising in New York. During th time she developed a sense of good photography and in 2004 she started to work as a photographer. She portrayed electioneers in the US, those left behind by the econom crisis in Japan, Bagdad at night, PKK fighters, child labourers and the victims of natural disasters. Fukada's photojournalism is published in international magazines. She h received an Alicia Patterson Journalism Fellowship as well as a grant from the Pulitzer Center on Crisis Reporting.

Das Erdbeben vom Mai 2008 in Sichuan, bei dem Dörfer und Stadtteile einstürzten, Straßenzüge, Fabriken und Schulen in sich zusammenbrachen und mindestens 80 000 Menschen den Tod fanden, ist längst aus unserem Bewusstsein verschwunden. Die Überlebenden hingegen haben bis ans Ende ihrer Tage mit seinen Folgen zu kämpfen. Wie schaffen es Kinder, die unter den Trümmern verschüttet lagen, von herabstürzenden Steinmassen verletzt wurden, mit dem Verlust ihrer Gliedmaßen zu leben; woher schöpfen sie die Kraft, in ihren malträtierten Körpern weiterzuleben? Helfen mag ihnen jene liebevolle Zuwendung, wie sie der Vater Li Qingsong seinem Sohn Li Yaohua schenkt, wenn er ihn für eine Existenz ohne Beine trainiert. Die japanische Fotografin Shiho Fukada reiste 2008 aus Peking in ein medizinisches Zentrum in Chengdu, um dort festzuhalten, wie Mädchen und Jungen sich quälen, um mit ihren Handicaps leben zu lernen.

The earthquake of May 2008 in Sichuan, when villages and districts collapsed, whole streets, factories and schools fell in on themselves and at least 80 000 people died, has long disappeared from our consciousness. But the survivors must struggle with its consequences till the end of their days. How do children who were trapped under rubble, who were badly injured by falling debris, learn to live with the loss of a limb? From where do they draw the strength to carry on living in their maltreated bodies? What may help them is loving care like that spent by father Li Qingsong on his son Li Yaohua, when he trains him for an existence without legs. In 2008 Japanese photographer Shiho Fukada traveled from Beijing to a medical centre in Chengdu to capture the painful struggle of girls and boys learning to live with their disabilities.

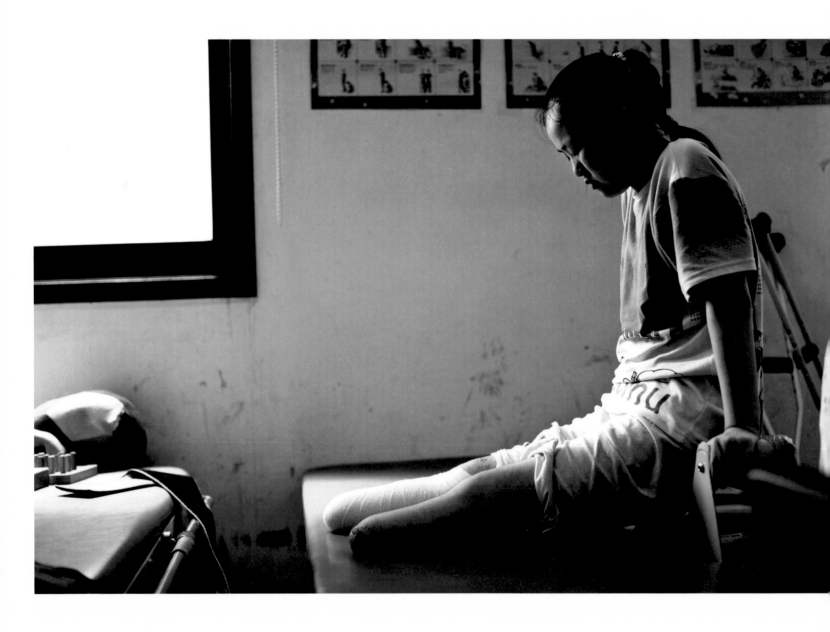

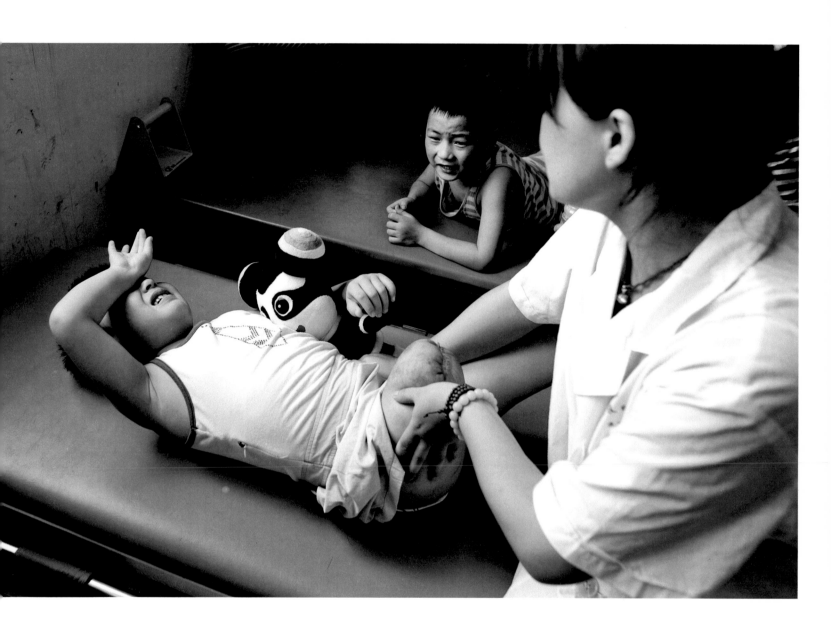

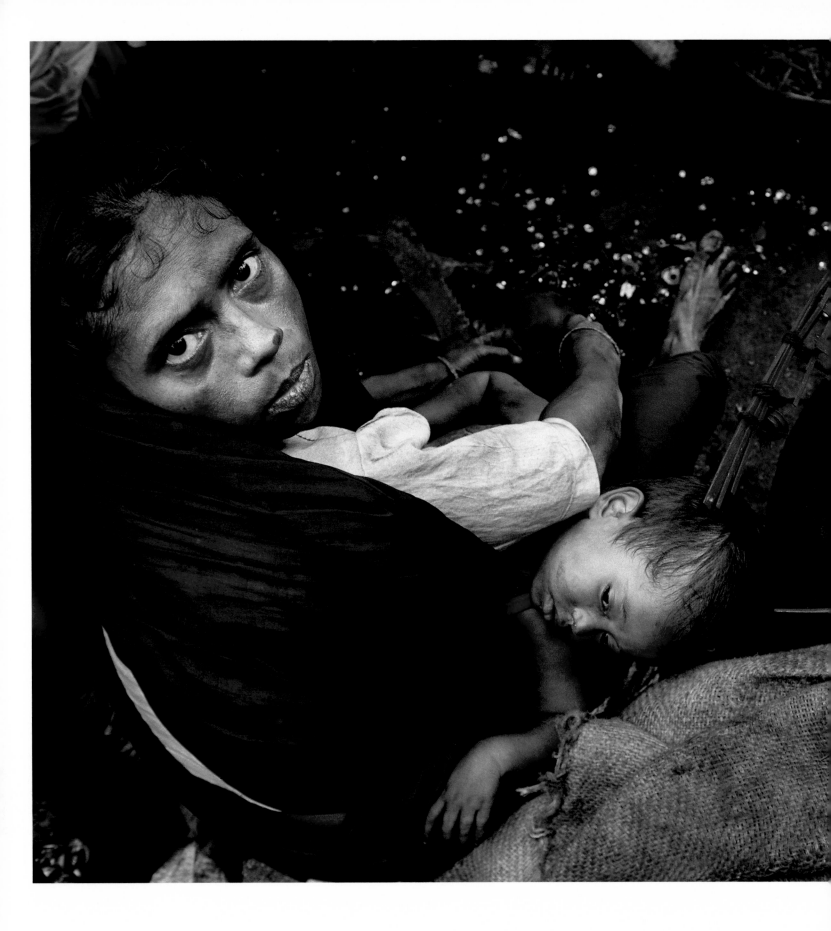

Shehzad Noorani wurde 1966 in Bangladesch geboren und lebt inzwischen in Kanada. In seiner Kindheit musste er selbst zum Unterhalt seiner Eltern beitragen. Aus eigene Erfahrung unterscheidet er zwischen erträglichen Tätigkeiten und ausbeuterischen Arbeitsumständen. Sein Engagement als vielfach ausgezeichneter Fotograf, dessen Bilde international veröffentlicht werden und der für UNICEF auch in Asien, Afrika und dem Nahen Osten unterwegs ist, bewies Noorani unter anderem mit seiner Dokumentatio über junge Prostituierte in Südostasien, für die er den Mother Jones International Award erhielt. In über 60 Ländern hat sich Noorani immer wieder mit der Situation marg nalisierter Kinder befasst.

Shehzad Noorani was born in Bangladesh in 1966 and today lives in Canada. As a child he also had to contribute to his family's income. From his own experience he disti guishes between manageable activities and exploitative working conditions. Noorani demonstrated his commitment as multi-award-winning and internationally publishe photographer, for UNICEF also in Asia, Africa and the Middle East, for instance in his documentary about young prostitutes in Southeast Asia, which earned him the Mothe Jones International Award. In more than 60 countries Noorani has repeatedly reported on the situation of marginalized children.

In Dhakas Außenbezirken haben sich Werkstätten auf das Recycling von Müll spezialisiert. Einige verwerten die Bestandteile von gebrauchten Zink-Kohle-Batterien. In den Baracken arbeiten Frauen und Kinder; Tag für Tag brechen sie Abertausende Batterien auf, säubern Kohlestäbe und separieren Metallteile. Die Luft ist von giftigem Kohlenstaub verseucht: Er verklebt die Atemwege und schwächt das gesamte Immunsystem. Mütter wie Marjina bringen ihre Babys mit in die Fabrik; die achtjährige Hajira passt während ihrer Arbeit dort auf ihre kleinen Schwestern Mumtaz und Yasmin auf. Die unsäglich elende Arbeit in fürchterlichen Lebensumständen wird mit sechs bis 15 Taka am Tag entlohnt, was etwa sechs bis 15 Cent entspricht.

In the outer districts of Dhaka, workshops have sprung up that specialize in recycling various materials from the scrap heaps. Some use the components of used zinc-carbon batteries. Women and children work in the sheds. Every day they break up thousands of batteries, clean carbon rods and separate metal parts. The air is polluted by toxic coal dust, it clogs up the respiratory system and weakens the whole immune system. Mothers like Marjina take their babies with them to the factory; eight year old Hajira is looking after her little sisters Mumtaz and Yasmin while she works. The terribly wretched work in appalling circumstances is rewarded with six to 15 taka per day, equivalent to six to 15 euro cents.

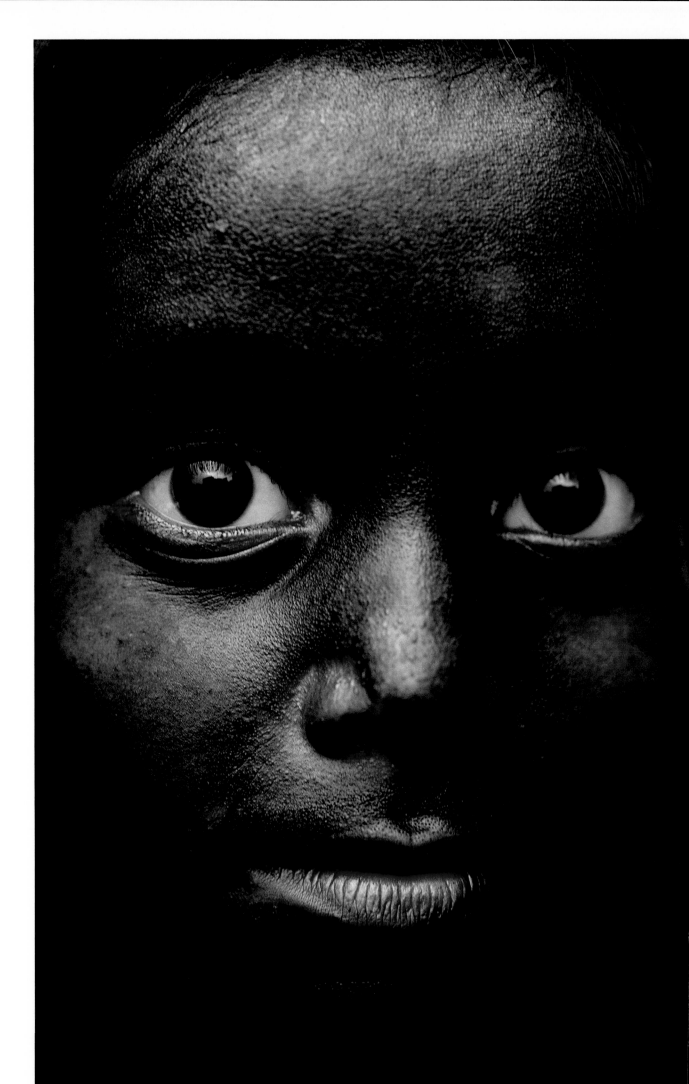

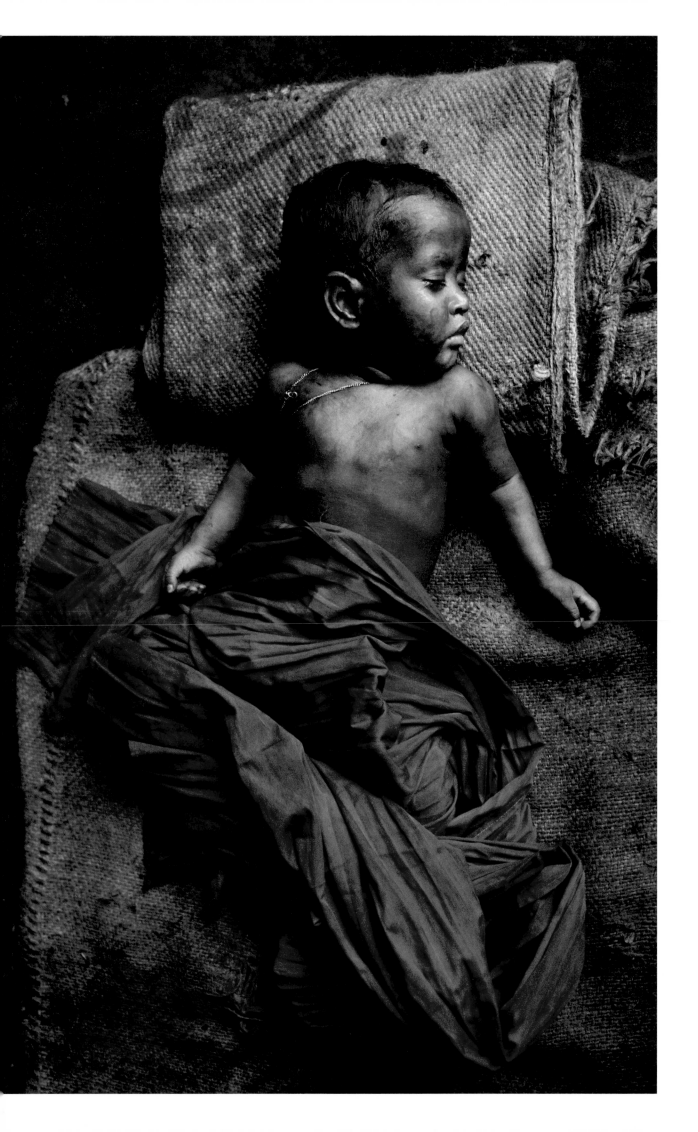

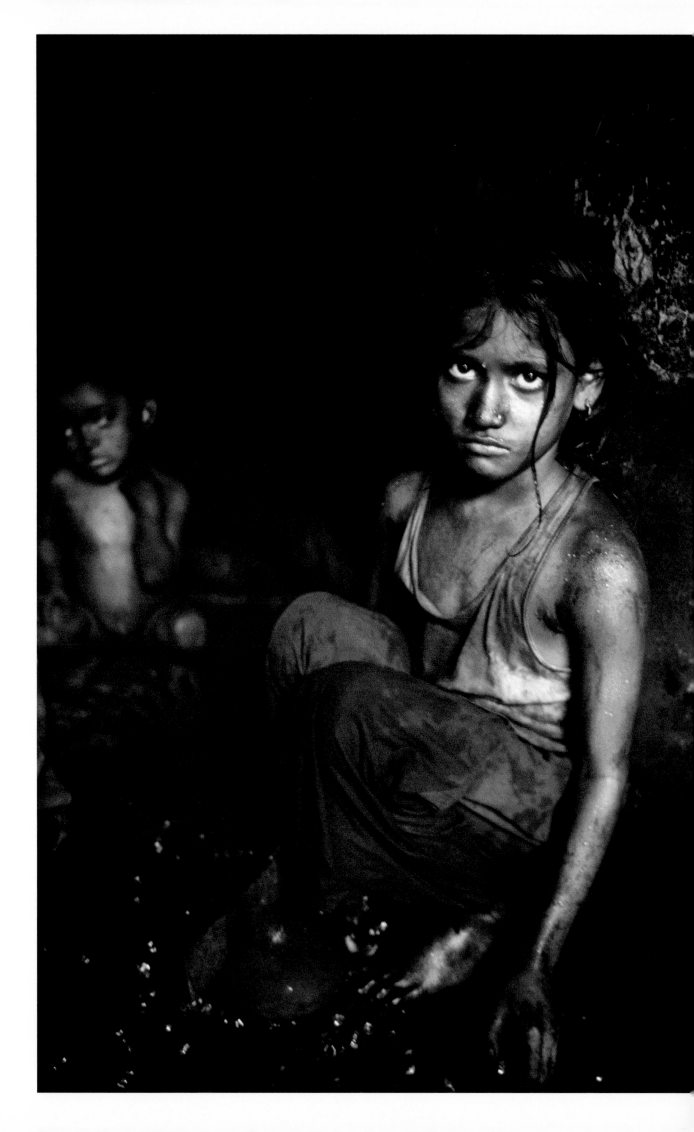

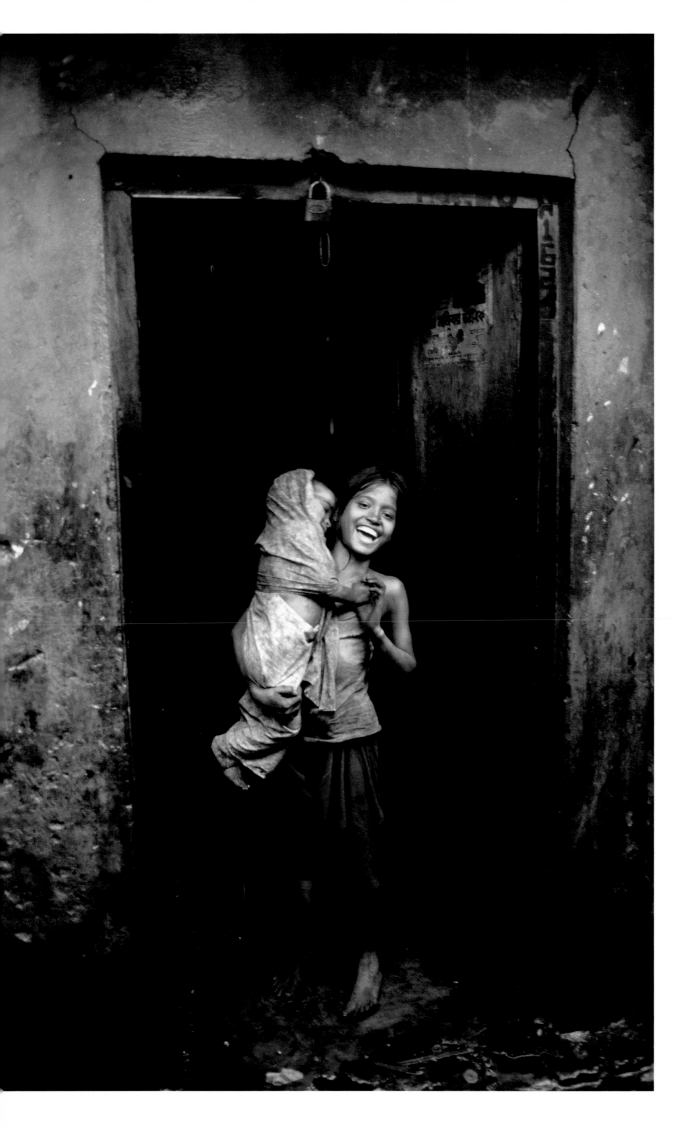

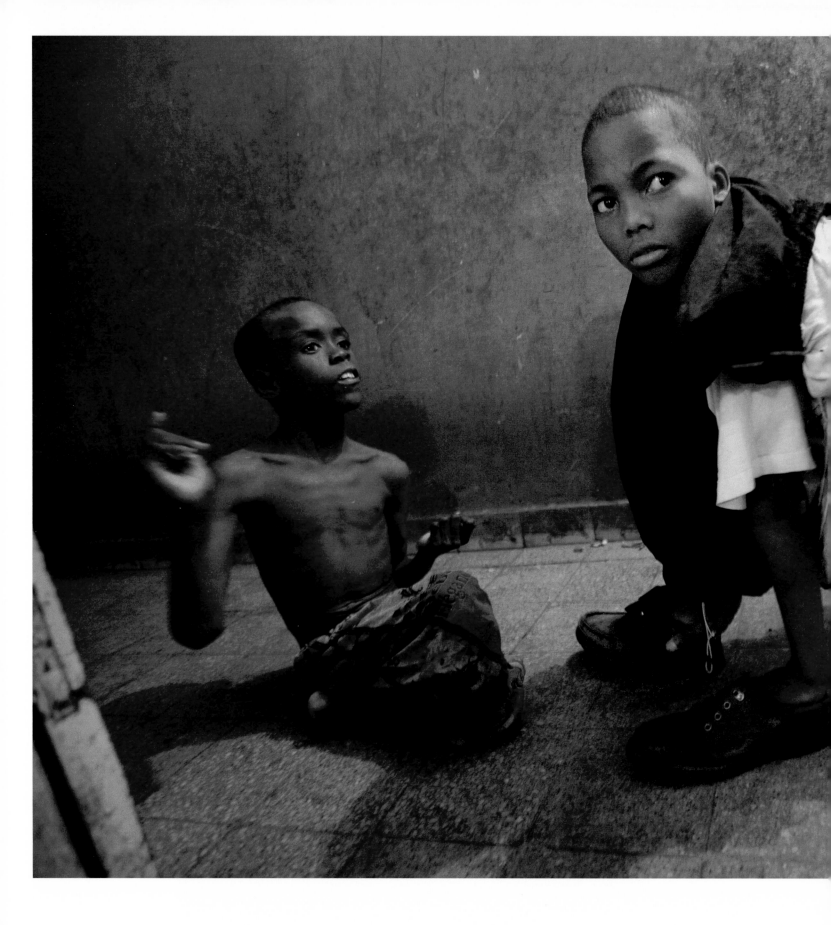

Finbarr O'Reilly | Reuters wurde 1971 in Wales geboren, wuchs in Irland und Vancouver auf und ist kanadischer Staatsbürger. Seine Journalistenkarriere begann er als Autor für Tageszeitungen. Ein Film über das Aussterben der Bonobo-Affen, den er 2003 mitproduzierte, wurde ausschlaggebend für sein Interesse am „Schwarzen Kontinent" und an der Fotografie. Als wichtigster Reuters-Fotograf für Afrika ist O'Reilly seither in Gefahrenzonen wie Sierra Leone, dem Kongo, Libyen, aber auch in Afghanistan unterwegs. 20?? und 2014 ermöglichten es ihm zwei Stipendien, die traumatischen Effekte für die Psyche des Menschen, verursacht durch Kriege und andere Konflikte, in Harvard zu studieren.

Finbarr O'Reilly | Reuters was born in Wales in 1971, grew up in Ireland and Vancouver and is a Canadian citizen. He started his career as a journalist writing for daily newspapers. Coproducing a film in 2003 about the bonobo apes dying out awakened his interest in the 'black continent' and in photography. Since then O'Reilly has become the main photographer for Reuters in Africa, traveling through dangerous territories, such as Sierra Leone, Congo, Libya, as well as Afghanistan. In 2013 and 2014 two grants allowed him to study in Harvard the traumatic psychological effects of wars and other conflicts on people.

Zu einem außerordentlichen Ereignis erklärte die Weltgesundheitsorganisation im Jahr 2014 das wieder verstärkte Auftreten von Kinderlähmung. Die Ursache: In vielen Krisenregionen hat keine konsequente Immunisierung mehr gegen das Poliovirus stattgefunden, auch in einigen gegenwärtigen Bürgerkriegsländern fällt sie aus. Was das bedeutet, sah der Fotograf Finbarr O'Reilly schon 2007 im Milizenkrieg in der Demokratischen Republik Kongo, als er in Kinshasa auf ein Heim für Jungen und Mädchen stieß, deren Rückgrate und Glieder durch die Erkrankung schwer geschädigt waren. Die Organisation StandProud bemüht sich in Kooperation mit einer lokalen Institution um Hilfestellungen, damit die betroffenen Kinder im Wortsinn wieder auf die Beine kommen. Ihnen wird, im Rahmen des Möglichen, medizinische Behandlung zuteil; Stützapparate für die Beine und Krücken zum Gehen sollen es ihnen im günstigsten Fall sogar ermöglichen, sich am Fußballspielen zu versuchen.

In 2014 the World Health Organization declared the rise in polio infections an extraordinary event. The cause: in many crisis regions no coherent immunization against the polio virus has been carried out and it is also missing in some countries where civil war is currently raging. Photographer Finbarr O'Reilly saw what that means as early as 2007 in the militia conflict in the Democratic Republic of the Congo, when he came across a home in Kinshasa for girls and boys whose spines and limbs had been severely damaged by the disease. The organization StandProud, in cooperation with a local institution, endeavours to help the children get back on their feet. As far as possible they receive medical treatment. In the most hopeful cases the leg supports and crutches for walking should even allow them to try kicking a ball.

DAS RECHT AUF GESUNDHEIT [Art. 24]
THE RIGHT TO HEALTH

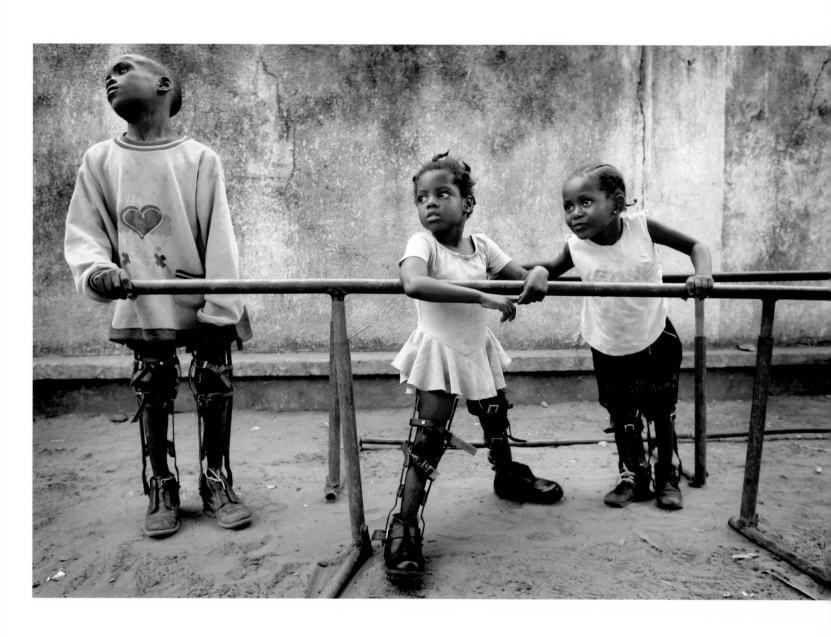

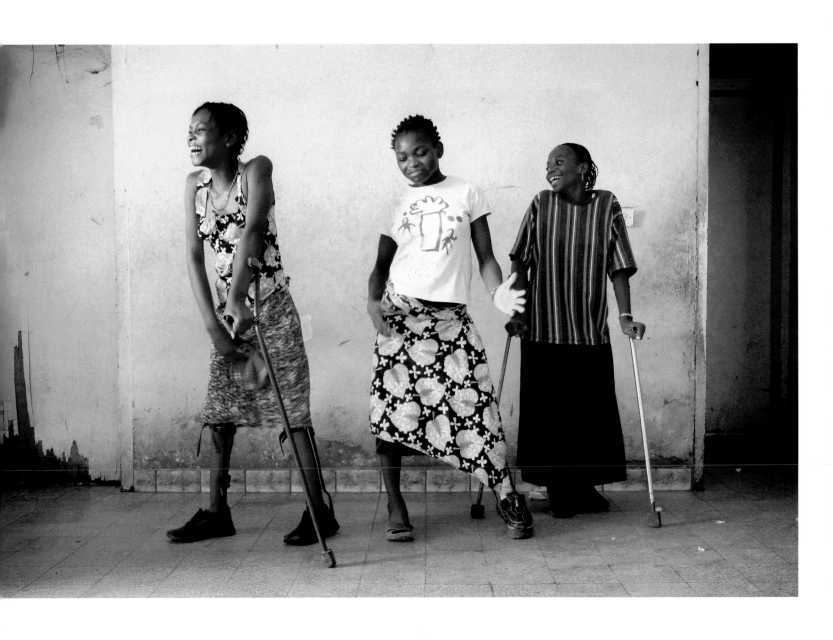

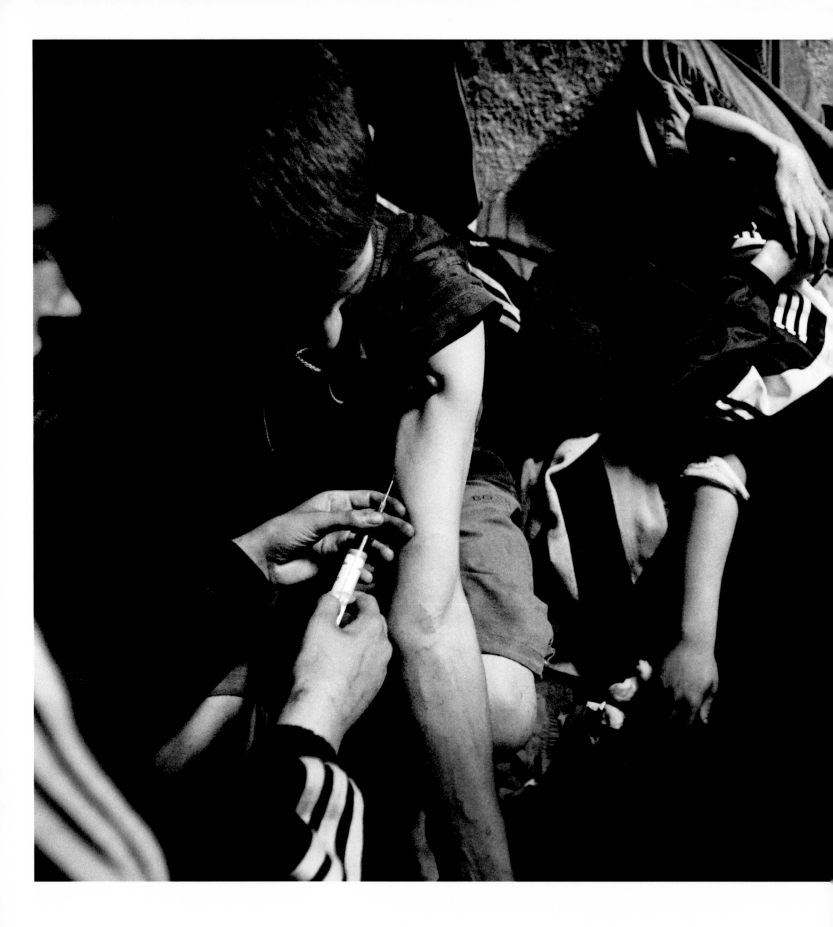

David John Gillanders wurde in Glasgow geboren. Schwarz-Weiß-Fotos in seinem Box-Club regten ihn ab seinem 14. Lebensjahr an, sich selber in der Fotografie zu versuchen. Nach der Schule arbeitete er als Schreiner, aber wie besessen fotografierte er in seiner Freizeit. In den späten 1990er Jahren gewann Gillanders etliche lokale Fotowettbewerbe. Zu seiner Verblüffung wurden Schottlands führende Printmedien auf ihn aufmerksam. 1999 riskierte er es schließlich, sich professionell der Fotografie zu widmen. Mit Erfolg. Er ist, unter anderem, der Gewinner eines Hansel-Mieth-Preises, erhielt einen Getty Grant for Editorial Photographers und den UK Picture Editor Award.

David John Gillanders was born in Glasgow. Black-and-white photographs in his boxing club inspired him to try his hand at photography when he was 14. On leaving school he worked as a joiner but carried on photographing in every spare moment. In the late 1990s Gillanders won several local photo competitions. To his surprise Scotland's leading print media noticed him. In 1999 he finally took the plunge and turned to photography professionally. And it took off. His awards include a Hansel Mieth Prize, a Getty Grant for Editorial Photographers and the UK Picture Editor Award.

Seit der Auflösung der Sowjetunion 1991 liegt Odessa in der Ukraine, die seither mit schweren politischen, wirtschaftlichen und sozialen Problemen zu kämpfen hat. Es ist ein zerrissenes Land, in dem viele Menschen auch jenseits der aktuellen Schlagzeilen ums Überleben kämpfen. So wächst eine verlorene Generation auf der Straße heran. Bindungslos, lieblos, heimatlos, besitzlos. Es ist, als wäre bei vielen Kindern und Jugendlichen das seelische und körperliche Immunsystem zusammengebrochen. Der Hoffnungslosigkeit ihres Daseins entkommen sie mit der Flucht in Drogen. Bei ihren Gleitflügen können sie Bewusstsein und Schmerzempfindungen ausschalten. So klickte sich auch Jana aus der Realität immer wieder aus. Mit 13 Jahren starb sie an HIV, übertragen durch eine nicht sterile Spritze. In Europa verzeichnet die Ukraine die meisten HIV-Infektionen.

With the dissolution of the Soviet Union in 1991 Odessa was located in Ukraine, a country that has faced grave political, economic and social problems since. It is a torn country, where many people fight for their survival beyond current headlines. A lost generation is growing up on the streets. Without ties, without love, without a home, without possessions. It seems as if the immune system of both mind and body has broken down in many children. They try to escape the hopelessness of their existence with the help of drugs. On their narcotic flights they can switch off consciousness and any sense of pain. Jana was one of those who repeatedly left reality behind in this way. At the age of 13 she died of HIV, caught through a dirty needle. Within Europe, Ukraine registers the most HIV infections.

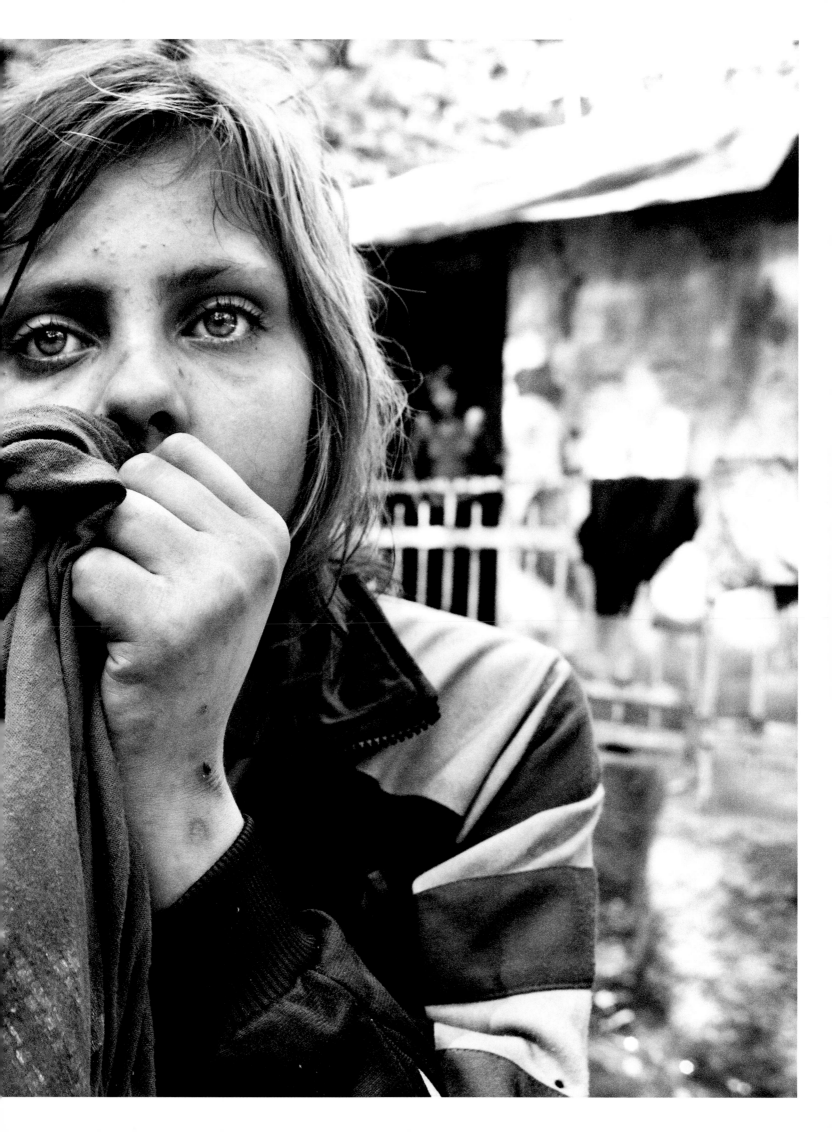

DER FLUCH DER ZWANGSEHEN
THE CURSE OF FORCED MARRIAGES
Afghanistan
2005

In die Ehe gezwungen: das Schicksal von Millionen Mädchen im Kindesalter. Nach Erhebungen von UNICEF sind in Entwicklungsländern 30 Prozent der Mädchen unter 18 Jahren von frühen und erzwungenen Eheschließungen betroffen. Und dies ist, entgegen dem Klischee, kein Phänomen nur der islamischen Welt, es geschieht auch in christlichen und buddhistischen Ländern und im Hinduismus. Besonders häufig sind Zwangsehen und Kinderhochzeiten in Ländern südlich der Sahara und in Südasien, besonders drastisch ist der Altersunterschied bei solchen Ehen in einem Land wie Afghanistan: elf Jahre alt das Mädchen, 40 der Mann — keine Seltenheit, obwohl es gesetzlich verboten ist, Mädchen unter 16 zu verheiraten. Bitterarme Familien verkaufen ihre Töchter etwa gegen das Versprechen des Bräutigams, ihnen den Schulbesuch zu ermöglichen. In Wahrheit stehen solche Kinder unter dem Zwang, möglichst schnell ihre Fruchtbarkeit unter Beweis zu stellen und werden wie Sklavinnen gehalten.

Forced into marriage: the fate of millions of girls in childhood. According to surveys by UNICEF, 30 percent of girls under 18 in developing countries are involved in early and forced marriages. And, contrary to cliché, this is not just a phenomenon of the Islamic world, it also happens in Christian and Buddhist countries and in Hinduism. Most common are forced marriages and marriages of children in sub-Saharan countries and in South Asia. The most dramatic age difference in such marriages is found in a country like Afghanistan: the girl is eleven, the man is 40 — not uncommon, even though the law forbids marrying girls off under the age of 16. Very poor families sell their daughters for the groom's promise of enabling her to go to school. In reality such children are under pressure to demonstrate their fertility as soon as possible and are kept like slaves.

[Art. 5] DAS RECHT AUF ELTERLICHE FÜRSORGE
THE RIGHT TO PARENTAL GUIDANCE

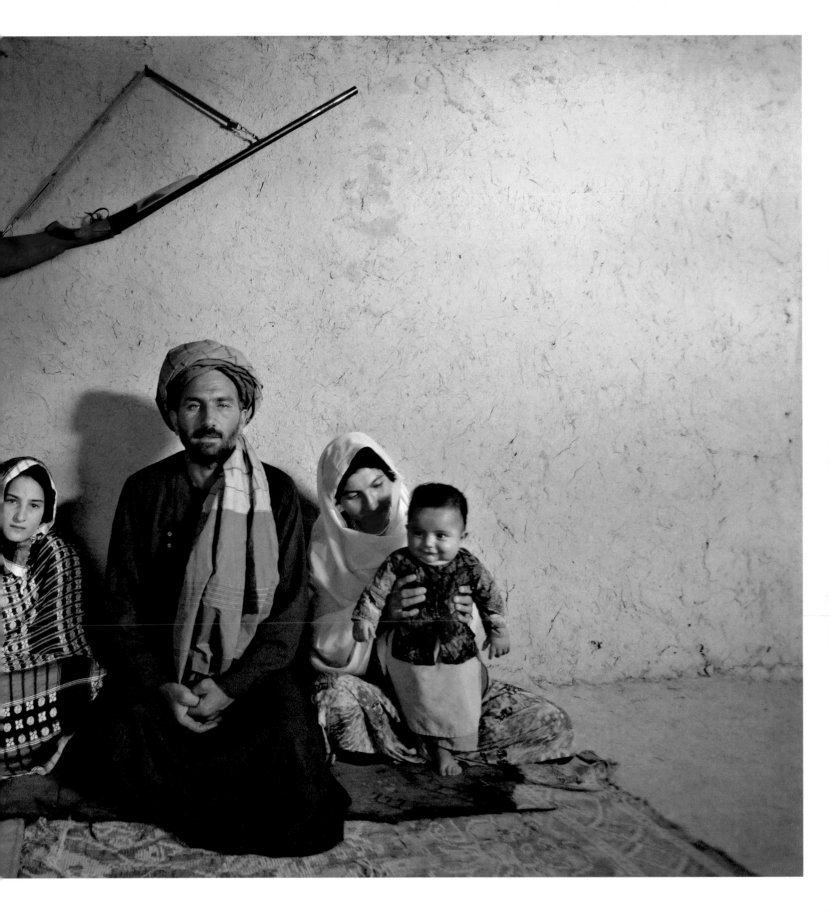

Stephanie Sinclair | VII Photo Agency wurde 1973 in den USA geboren. Nach dem Studium fotografierte sie für die *Chicago Tribune*, für die sie aus dem Irak berichtete. Als freie Fotografin arbeitete sie sechs Jahre im Mittleren Osten. Menschenrechte und das Geschlechterverhältnis in rückständigen Ländern sind ihr großes Thema, für das sie unter anderem einen Pulitzer-Preis, drei World Press Photo Awards und zwei Visa d'Or gewann. Sinclairs Bilder von zwangsverheirateten Mädchen in verschiedenen Ländern und afghanischen Frauen, die aus Verzweiflung versuchen, sich selbst zu verbrennen, sind in *GEO* und vielen anderen großen Zeitschriften rund um den Globus erschienen.

Stephanie Sinclair | VII Photo Agency was born in the USA in 1973. After completing her studies she photographed for the *Chicago Tribune* and reported for them from Iraq. She worked for six years as freelance photographer in the Middle East. Human rights and the relations of the sexes in backward countries are her main theme, which has earned her a Pulitzer Prize, three World Press Photo Awards and two Visa d'Or, among other accolades. Sinclair's images of girls forced into marriage in various countries and of Afghan women who in their desperation tried to self-immolate have been published in *GEO* and many other major magazines around the world.

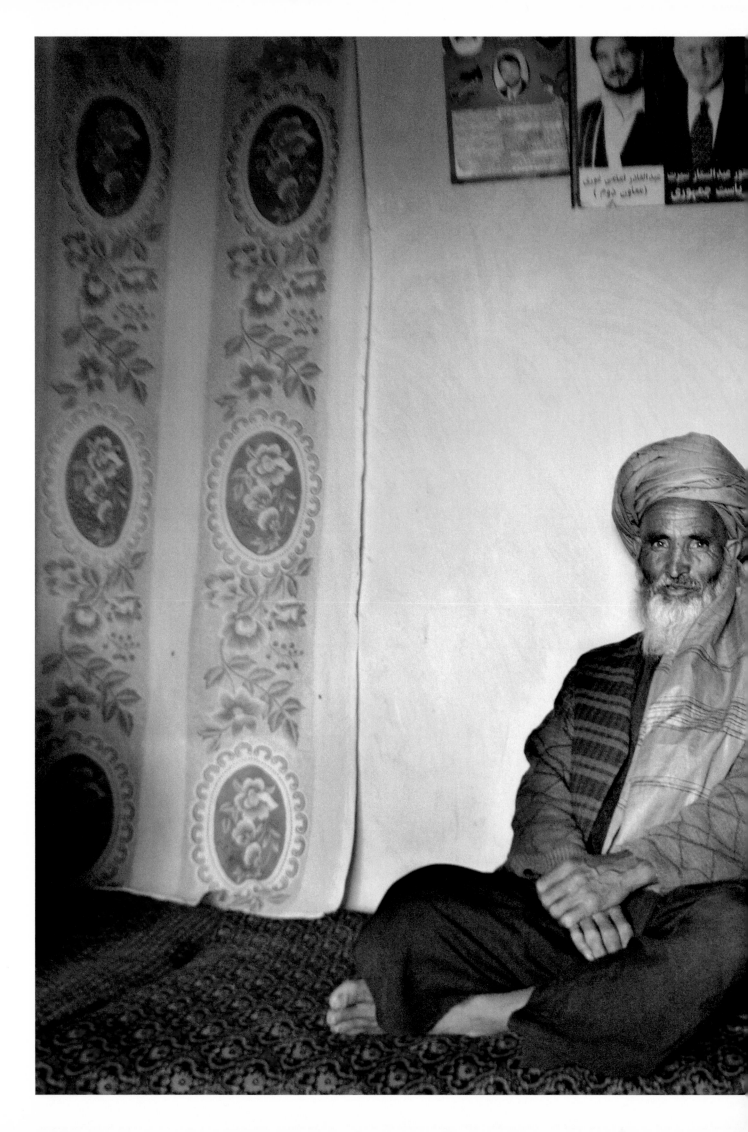

EIN TÖDLICHES SPIELZEUG
A DEADLY TOY
Irak | Iraq
2003–2005

Wie der Krieg die Kinder trifft: 2003 ist der neunjährige Saleh Khalaf mit seinem älteren Bruder Dia in der irakischen Stadt Nasiriya von der Schule auf dem Weg nach Hause. Am Straßenrand sieht er einen Gegenstand, der wie Spielzeug aussieht. Er bückt sich. Sein Bruder schreit: „Nicht aufheben!" und stürzt auf ihn zu. Zu spät. Die Granate explodiert. Dia stirbt sofort. Saleh reißt sie den Bauchraum auf, seine rechte Hand und einen Teil seiner linken ab. Auch ein Auge verliert er. Saleh wird zur nahe gelegenen Tallil Air Base geschafft. Der dort diensthabende Chirurg ist so beeindruckt vom Lebensmut des Jungen, dass er trotz seiner Zweifel, dass das Kind überleben wird, zu operieren beginnt. Von diesem Moment an beginnt eine ungewöhnliche Hilfsaktion, die Saleh bis in ein Kinderkrankenhaus ins kalifornische Oakland bringt. In gut zwei Jahren übersteht Saleh über 30 Operationen — und lebt jetzt in den USA.

How war hits children: in 2003, nine year old Saleh Khalaf is on his way home from school with his older brother Dia in the Iraqi town of Nasiriya. At the side of the road he sees an object that looks like a toy. He bends down. His brother cries, "Don't pick it up!" and runs towards him. Too late. The grenade explodes. Dia dies instantly. The explosion rips open Saleh's belly, rips off his right hand and part of his left hand. He also loses an eye. Saleh is carried to the nearby Tallil Air Base. The surgeon on duty there is so impressed with the boy's will to live that he starts operating on him despite his doubts that the child will survive. This is the start of an unusual aid campaign that will move Saleh all the way to a children's hospital in Oakland, California. Within two years Saleh survives more than 30 operations and now lives in the USA.

[Art. 38] DAS RECHT AUF SCHUTZ IM KRIEG
THE RIGHT TO PROTECTION IN WAR

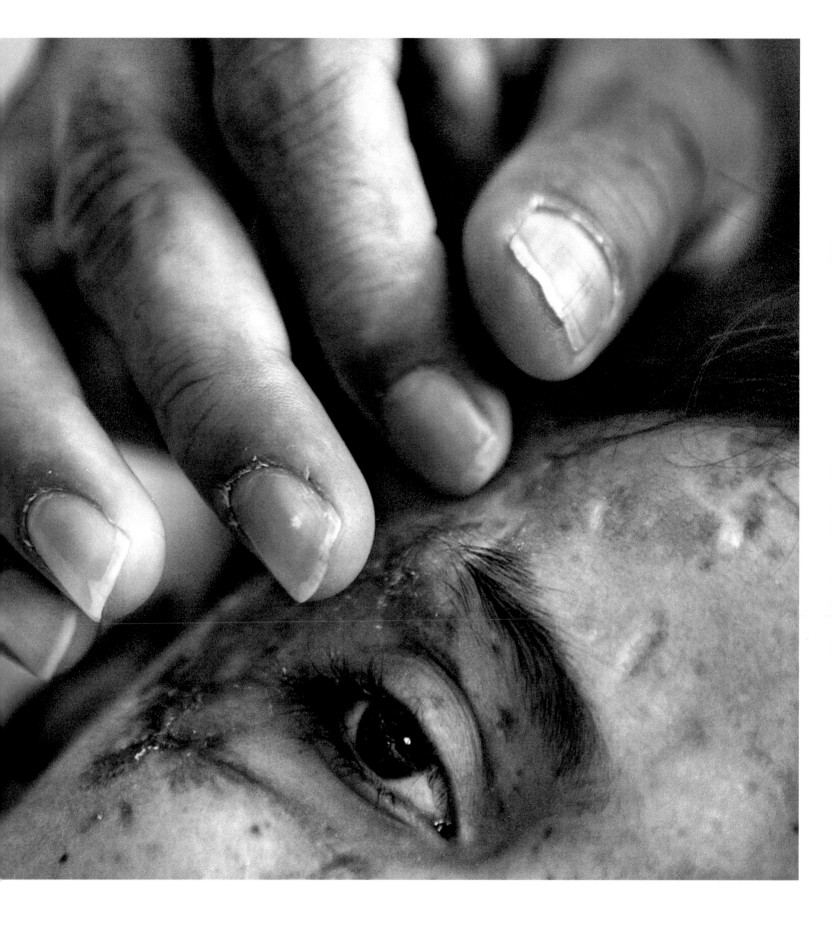

Deanne Fitzmaurice wurde 1957 in den USA geboren und studierte Fotografie an der Academy of Art in San Francisco, bevor sie bis 2008 als festangestellte Fotoreporterin bei der Tageszeitung *San Francisco Chronicle* arbeitete und in dieser Zeit unter anderem den Mark Twain Award erhielt. Inzwischen ist sie weltweit als freie Fotografin für angesehene in- und ausländische Magazine sowie für Stiftungen unterwegs. Auf Saleh Khalaf traf Deanne Fitzmaurice kurz nachdem er zur Behandlung in den USA eingetroffen war. Seither begleitet sie seine Genesung. Für diese Fotoarbeit wurde sie 2005 mit einem Pulitzer-Preis geehrt.

Deanne Fitzmaurice was born in the USA in 1957, studied photography at the Academy of Art in San Francisco and worked as a photojournalist at the daily *San Francisco Chronicle* until 2008. During this time she received several accolades, including the Mark Twain Award. Today she travels the world as a freelance photographer working for renowned national and international magazines and foundations. Deanne Fitzmaurice came across Saleh Khalaf shortly after he had arrived in the USA for treatment and has accompanied his recovery ever since. In 2005 she received a Pulitzer Prize for this photographic work.

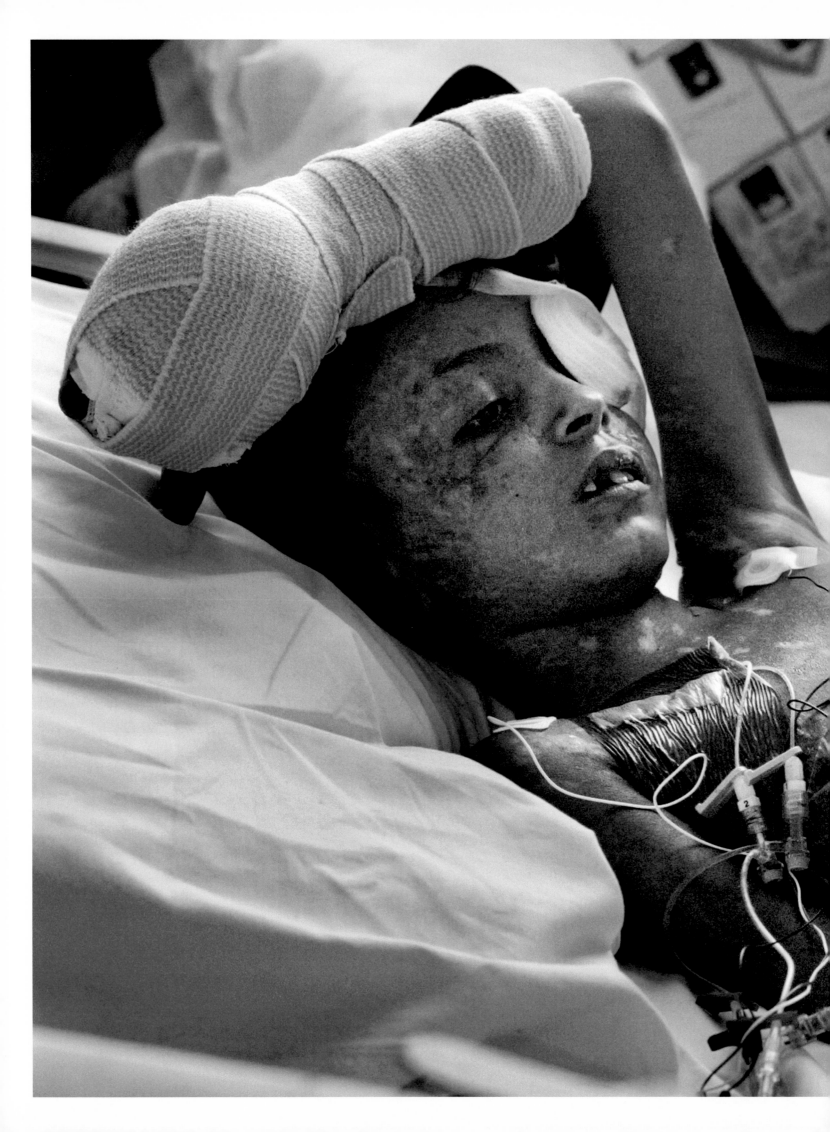

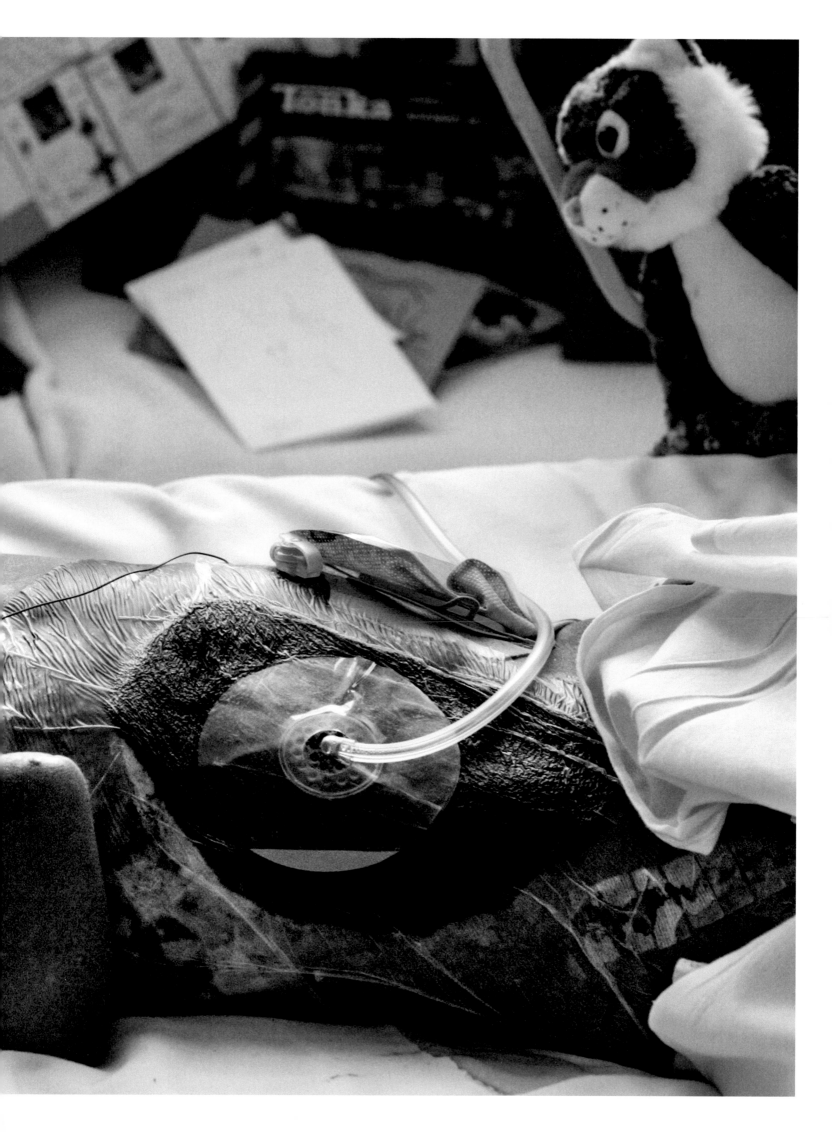

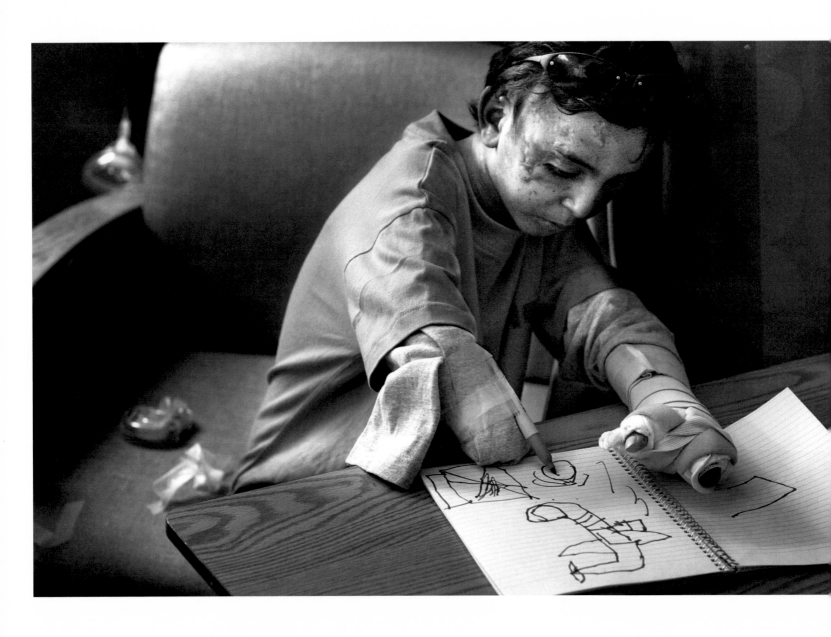

WIE DIE KLEINEN GRÖSSER WERDEN
HOW THE SMALL ONES GET TALLER
Trinidad
2004

So wie sich der friedliche Breakdance von Jugendlichen zur Alternative zu aggressiven Schlägereien zwischen Straßengangs entwickelte, könnte das Tanzen auf Stelzen auf der Insel Trinidad einen ähnlichen Effekt erzeugen. Das waren die Gedanken zweier Männer, die sich entschlossen, die um 1950 vergessene Tradition von „Moko Jumbi" wiederzubeleben. Der Name „Moko" ist vermutlich die Referenz an einen afrikanischen Gott, „Jumbi" oder „Zumbi" die Bezeichnung eines schwebenden Geistes. Auf diese Symbolik, so wird angenommen, haben sich die Sklaven aus Afrika bei ihren Stelzengängen in der Neuen Welt bezogen. Seit 1986 knüpfen Kinder und Teenager auf Trinidad in friedlicher Konkurrenz an diese Tradition an, lernen die Kunst des Stelzentanzes, die Gestaltung von Kostümen, das Trommeln und selbst das Feuerspucken während der Karnevalstage.

Just as peaceful breakdance of young people developed as an alternative to aggressive fights between street gangs, dancing on stilts could have a similar effect on the island of Trinidad. This was the thinking of two men who decided to revive the Moko Jumbi tradition that had fallen into oblivion around 1950. The name Moko probably refers to an African God, Jumbi or Zumbi describes a hovering spirit. It is assumed that the African slaves symbolized this hovering in their stilts walks in the New World. Since 1986 children and teenagers on Trinidad relate to this tradition in peaceful competition. They learn the art of dancing on stilts, of creating costumes, drumming and even breathing fire during carnival.

[Art. 31] DAS RECHT AUF SPIEL UND FREIZEIT
THE RIGHT TO LEISURE, PLAY AND CULTURE

efan Falke | laif wurde 1956 in Deutschland geboren. Er studierte Ingenieurwissenschaften, seine Leidenschaft aber galt der Fotografie und dem Film. Als Standfotograf
achte er sich einen Namen bei wichtigen Filmproduktionen. 1985 zog er nach New York. Sein Projekt über den Stelzenlauf in der Karibik wurde als Buch veröffentlicht und
eim Festival in Perpignan gezeigt. So wie die Mauer in Berlin früh sein Interesse geweckt hatte, wandte er sich später einer anderen Weltentrennung zu: der mexikanisch-us-
nerikanischen Grenze. Falke hat sie seit 2008 immer wieder bereist, von Tijuana bis ins texanische Brownsville. „La Frontera" ist sein zweites Langzeitprojekt.

efan Falke | laif was born in Germany in 1956. He studied engineering, but photography and film were his passion. He made himself a name as stills photographer for major
m productions. In 1985 he moved to New York. His project on stilts running in the Caribbean was published in book form and shown at the festival in Perpignan. Just as the
rlin Wall had caught his attention early on, he later turned to another separation of worlds, the border between Mexico and the USA. Since 2008 Falke has travelled repeat-
ly along that border, from Tijuana to Brownsville, Texas. La Frontera is his second long-term project.

Felicia Webb schrieb ihre Bachelorarbeit über Englische Literatur, reiste als Journalistin durch Südamerika und schloss 1998 ein Studium am London College of Communication mit dem Postgraduiertendiplom ab. Drei Jahre lang begleitete sie junge Mädchen, die an Anorexia und Bulimia nervosa leiden. Ihre Langzeitbeobachtung über Magersucht fand große Beachtung, ihre Fotos wurden weltweit veröffentlicht und brachten ihr Auszeichnungen und Stipendien ein. Die Folgen von Essstörungen der entgegengesetzten Art beobachtete sie an übergewichtigen Kindern in den USA. Mit Unterstützung des Winston Churchill Memorial Trust verfolgt sie dieses Thema inzwischen weltweit.

Felicia Webb wrote her bachelor thesis on English literature, travelled through South America as a journalist and completed her studies at the London College of Communication in 1998 with a postgraduate diploma. For three years she followed young girls who suffered from anorexia or bulimia nervosa. Her long-term observation of anorexia and bulimia drew much attention, her photographs were published across the world and earned her awards and grants. In the USA she studied eating disorders of the opposite type on obese children. On a grant from the Winston Churchill Memorial Trust she now follows this topic up across the world.

Während Millionen Kinder hungern, wächst in den Industrieländern eine neue stille Katastrophe heran: Fettleibigkeit. Jonathan aus Houston ist erst 14 Jahre alt. Seine Leber ist entzündet, er leidet an Steatohepatitis. Das Gewicht seiner Fettablagerungen am Hals und auf seinem Oberkörper erschwert ihm das Atmen, Sauerstoffmangel ist die Folge. Herz und Lunge werden unterversorgt; beim Schlafen muss er eine Sauerstoffmaske tragen. Jonathans Mutter ist mit der Situation völlig überfordert. Sie erzieht Jonathan und seine Schwester allein, der Vater ist im Gefängnis. Dass sich Kinder wie Jonathan ausgegrenzt fühlen, Depressionen und Probleme in der Schule haben, kommt zu ihrer physischen Not hinzu. Dramatischer Konsumüberfluss, mangelndes Bewusstsein von richtiger Ernährung, fehlende körperliche Betätigung — ein Phänomen, das mittlerweile auch schon in Schwellenländern zu beobachten ist.

While millions of children are acutely hungry, a new, quiet disaster is evolving in the industrial countries — obesity. Jonathan in Houston is only 14. His liver is inflamed, he suffers from Steatohepatitis. The weight of the fat deposits on his throat and upper body makes it difficult for him to breathe, causing a lack of oxygen supply to heart and lungs. He has to wear an oxygen mask when he is sleeping. Jonathan's mother is unable to cope with the situation. She is a lone parent for Jonathan and his sister, his father is in prison. In addition to their physical misery, children like Jonathan feel excluded, depressed and have problems at school. Excess consumption, a lack of awareness of proper nutrition, lack of exercise — phenomena that are also beginning to be known in emerging countries.

DAS RECHT AUF GESUNDHEIT **[Art. 24]**
THE RIGHT TO HEALTH

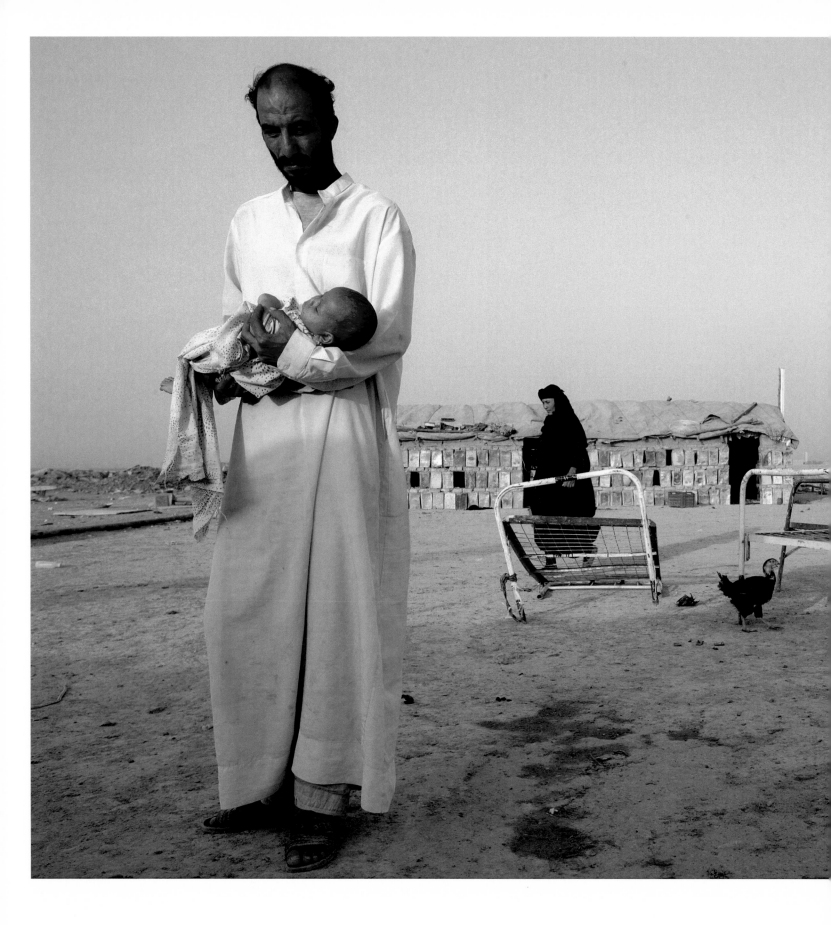

Yuri Kozyrev | Noor/laif wurde 1963 in der Sowjetunion geboren. Als Fotoreporter arbeitet er seit 25 Jahren. Er hielt die Umbrüche in der früheren Sowjetunion fest, di‹ Kämpfe in Tschetschenien und war nach dem Anschlag auf das World Trade Center einer der ersten Fotografen in Afghanistan. Von 2003 bis 2009 verfolgte er für *Time* di‹ politische Entwicklung im Irak, seit Anfang 2011 die Unruhen in Tunesien, Libyen, Ägypten, Bahrain und im Jemen. Mit Ali Ismail Abbas hält Kozyrev Kontakt über Freunde i‹ London. Mehrere World Press Photo Awards, der ICP Infinity Award und der Frontline Award sind nur einige wenige der Auszeichnungen, die Kozyrev für seine mutige Arbe‹ erhalten hat.

Yuri Kozyrev | Noor/laif was born in the Soviet Union in 1963. He has been working as a photojournalist for 25 years. He documented the transitions in the former Soviet Unio‹ the fighting in Chechnya, was one of the first photographers in Afghanistan after the attack on the World Trade Center. From 2003 to 2009 he followed the political develop ments in Iraq for *Time* magazine, since early 2011 he has been observing the upheavals in Tunisia, Libya, Egypt, Bahrain and in Yemen. Through friends in London Kozyre‹ stays in contact with Ali Ismail Abbas. The recognition of Kozyrev's courageous work includes several World Press Photo Awards, the ICP Infinity Award and the Frontline Awar‹

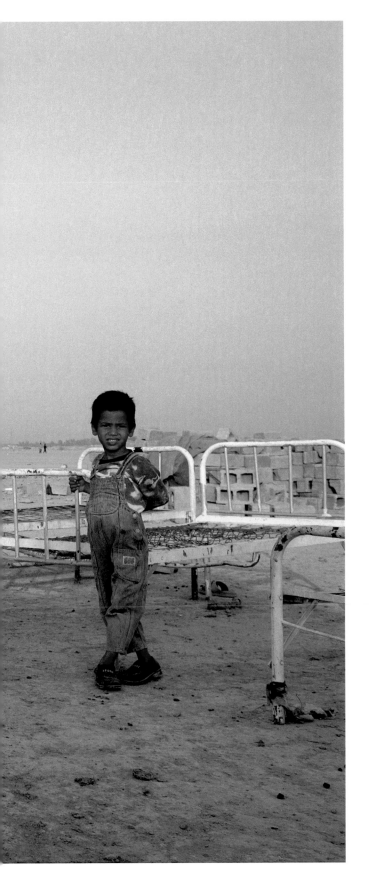

Was bleibt, wenn die Bomben gefallen sind. 2003, nach Beginn der Irak-Invasion durch US-Streitkräfte und ihre Verbündeten — Saddam Hussein war noch an der Macht —, erhielt der Fotograf Yuri Kozyrev mit wenigen anderen Kollegen die Erlaubnis, in einem Hospital in Bagdad zu fotografieren. Ein Arzt nahm Kozyrev beiseite, öffnete ein Zimmer. Da lag der schwerverwundete zwölfjährige Ali Ismail Abbas, anwesend war nur seine Tante. Kozyrev konnte kurz mit ihr sprechen. Am Tag darauf fuhr er heimlich in Alis Heimatdorf, traf Alis Onkel, fand das zerstörte Haus der Familie. Alis Vater, Alis schwangere Mutter und 13 weitere Mitglieder der Familie waren tot. Das Foto des Jungen, dem beide Arme amputiert werden mussten und der schwere Brandwunden am Körper erlitten hatte, wurde zu einer Ikone des unschuldigen Leidens, ging um die Welt, rief eine Welle von Hilfsangeboten hervor. Behandelt wurde Ali in Kuwait und in London. Und 2010 erhielt er einen britischen Pass.

What remains once the bombs have fallen. In 2003, after the start of the invasion of the US armed forces and their allies in Iraq — Saddam Hussein was still in power, photographer Yuri Kozyrev and a few colleagues were allowed to take pictures in a hospital in Bagdad. A doctor took Kozyrev aside and into another room. There lay badly injured twelve year old Ali Ismail Abbas, only his aunt was present. Kozyrev was only able to talk briefly with her. The next day he secretly drove to Ali's home village, met Ali's uncle, found the destroyed family home. Ali's father, Ali's pregnant mother and 13 other members of the family were dead. The photograph of the boy, who had to have both arms amputated and who had suffered severe burns on his body, became an icon of innocent suffering, went round the world, triggered a wave of offers of help. Ali was treated in Kuwait and in London. And in 2010 he was given a British passport.

DAS RECHT AUF SCHUTZ IM KRIEG **[Art. 38]**
THE RIGHT TO PROTECTION IN WAR

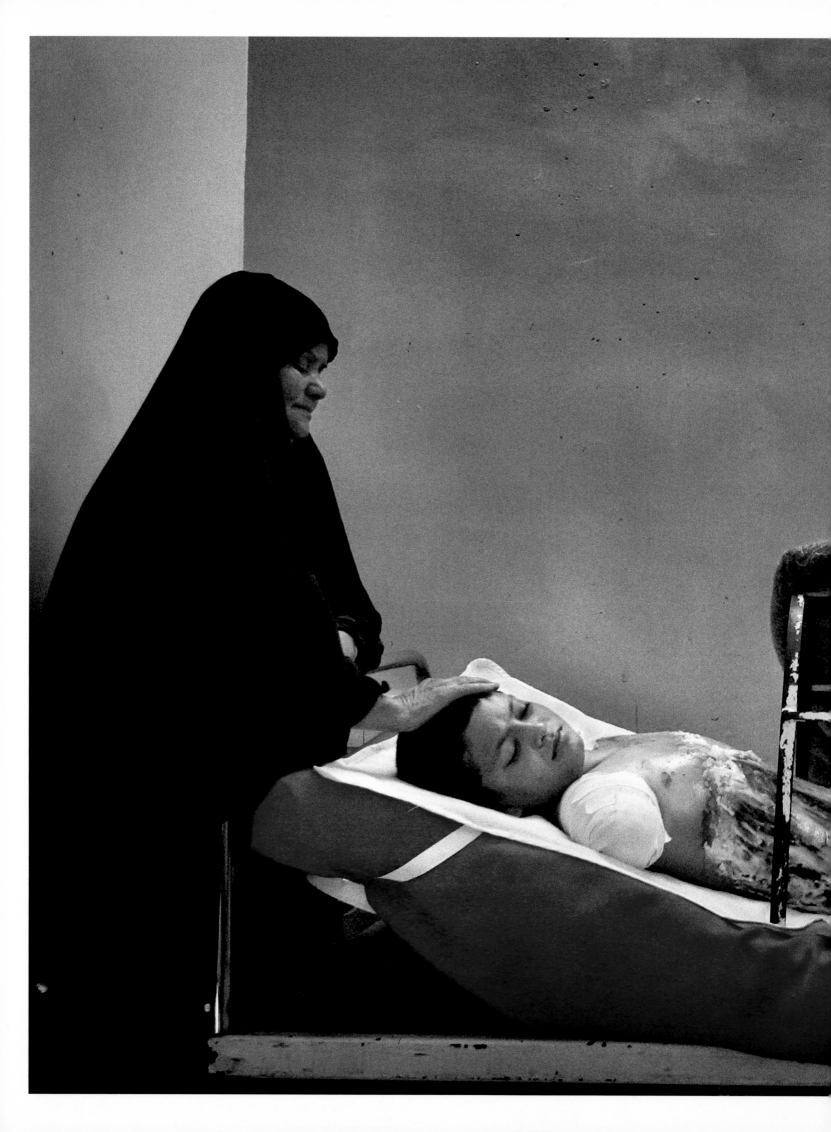

Mariella Furrer wurde in Beirut geboren, hat Schweizer und libanesische Wurzeln und lebt in Kenia. Nach einem Ausbildungsprogramm 1993 am International Center of Photography in New York arbeitete sie in Afrika, im Nahen Osten und in Asien. Unter anderem begleitete sie die UNICEF-Botschafter Harry Belafonte und Lang Lang bei Reisen nach Kenia und Tansania. 2002 begann sie eine Dokumentation über vergewaltigte Kinder in Südafrika. Über zehn Jahre hielt sie das Zusammentreffen mit Opfern, Tätern, Polizisten, Ärzten und Sozialarbeitern fest. Was sie dabei erfuhr, hat sie 2013 in etwas veröffentlicht, was man ihr Lebenswerk nennen kann: *My Piece of Sky.*

Mariella Furrer was born in Beirut, has Swiss and Lebanese roots and lives in Kenia. After completing a training at the International Center of Photography in New York in 1993, she has worked in Africa, in the Middle East and in Asia. Her projects included accompanying UNICEF Ambassadors Harry Belafonte and Lang Lang on travels to Kenia and Tanzania. In 2002 she began a documentary about raped children in South Africa. For ten years she documented meetings with victims, perpetrators, police, doctors and social workers. She published her findings in 2013 in *My Piece of Sky*, a kind of lifetime achievement.

Vergewaltigung bedeutet nicht nur eine massive Verletzung der Selbstbestimmung eines Opfers, sie hat gravierende psychische Folgen, oft lebenslang. Und sie ist häufig nichts anderes als der Mord an verachteten, als minderwertig empfundenen Frauen, wie in Indien zu sehen. Über die Nötigung zum Geschlechtsverkehr oder zu anderen sexuellen Handlungen gibt es naturgemäß keine hinreichenden Statistiken; die Dunkelziffer bleibt hoch. Nach dem, was dennoch öffentlich wird, gehört Südafrika zu den traurigen Rekordhaltern. Etwa 60 000 Vergewaltigungen werden hier jedes Jahr angezeigt, von einer mindestens zehnmal so hohen tatsächlichen Fallzahl gehen Experten aus. Wobei sexuell misshandelte Männer und Jungen kaum erfasst werden. Zur Verurteilung kommt es selten. Kaum vorstellbar, aber wahr: Immer häufiger werden Kinder zu Opfern, sexuell misshandelt sogar auch von anderen Minderjährigen.

Rape is not just a massive violation of the self-determination of the victim, it also has grave psychological consequences, maybe for life. Often it amounts to the murder of despised women, who are seen as worthless, as is happening in India. Of course there are no adequate statistics on coerced intercourse or other sexual activities under duress; the estimated number of unknown cases remains high. Judging by published figures, South Africa ranks high in this sad list. Every year some 60 000 rapes are reported here, experts assume that the actual number of cases is at least ten times that. With sexual abuse of men and boys practically unreported. Sentencing is rare. And, hard to imagine, but true: More and more often the victims are small children, even abused by other minors.

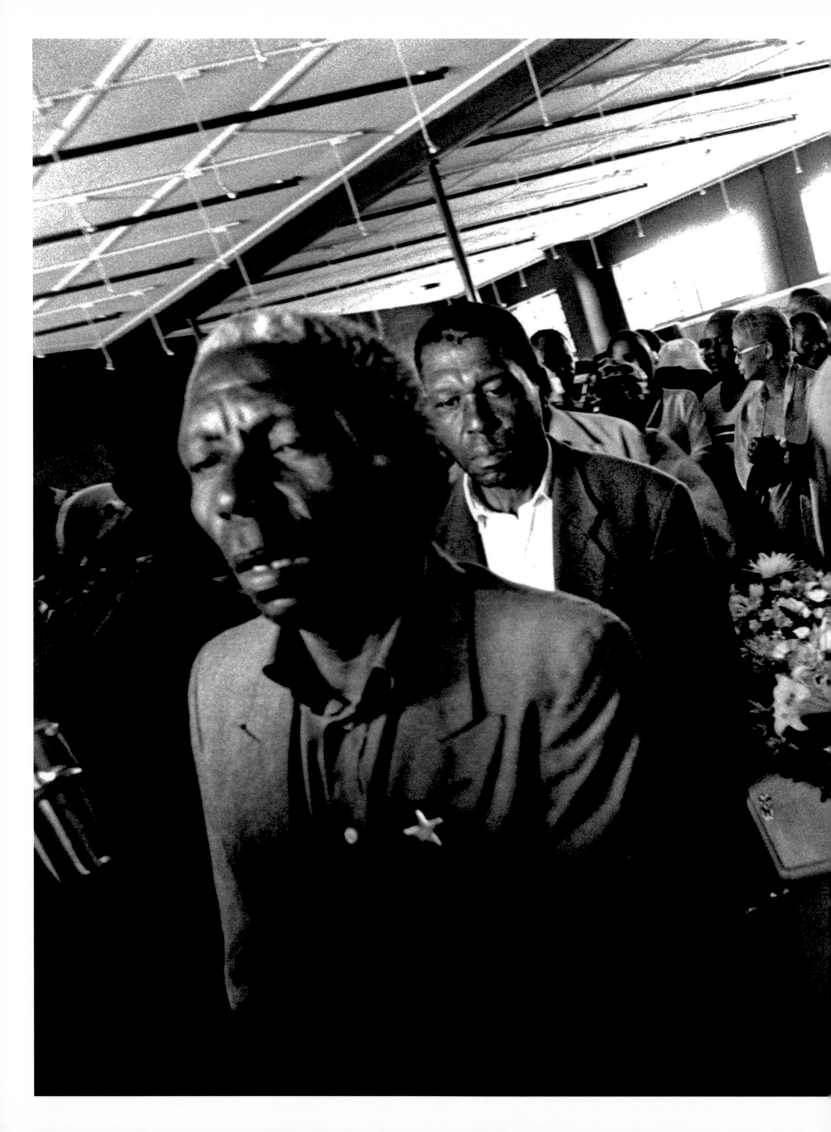

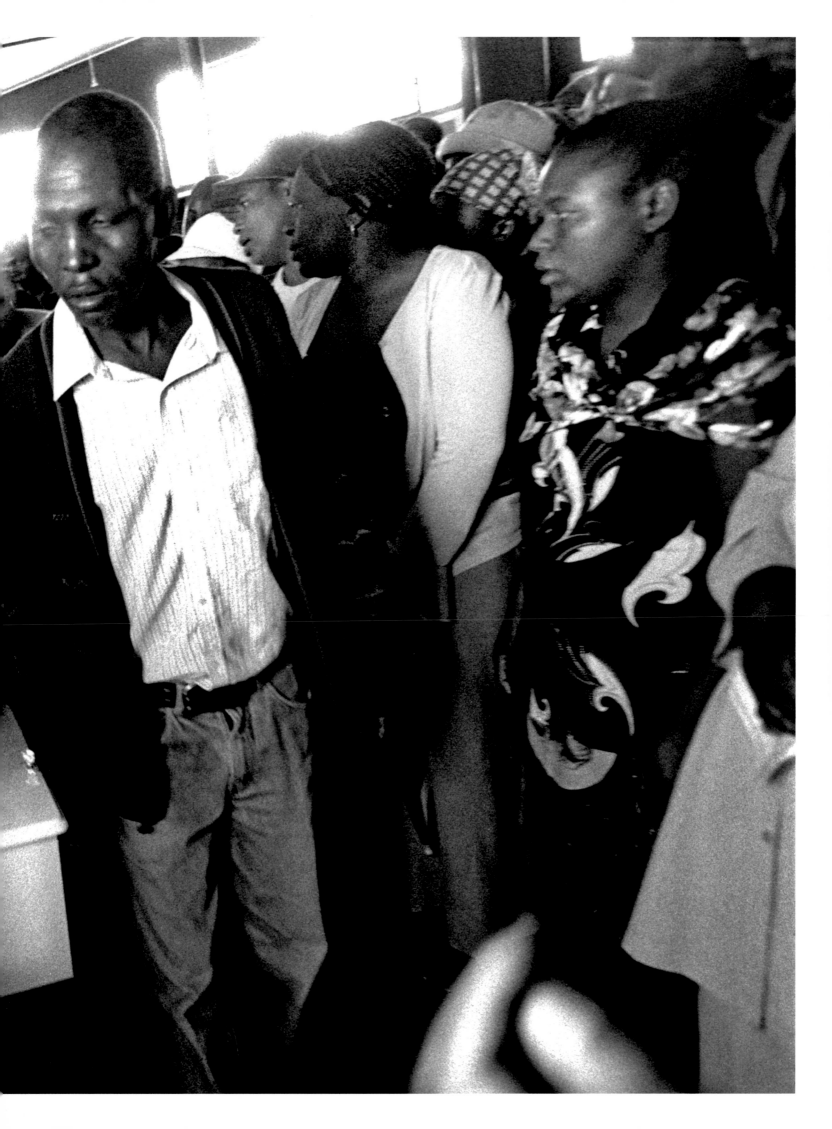

Wolfgang Müller wurde 1958 in Deutschland geboren. Nach einer Ausbildung zum Werkzeugmacher suchte er Zugang zu künstlerischen Ausdrucksmöglichkeiten. 1997 fand er sie in der Fotografie, studierte an der Fachhochschule Dortmund und machte dort sein Diplom als Fotodesigner. In den Jahren 2000 und 2001 erwarb er sich das Vertrauen obdachloser Kinder und Jugendlicher in St. Petersburg, sodass er sie fotografieren durfte. Veröffentlicht wurde die Reportage „Karat. Himmel über St. Petersburg" in vielen Ländern und in einem Buch. Internationale Ausstellungen folgten. Etliche Preise ermöglichen es Wolfgang Müller, Langzeitprojekte in Sibirien und China weiterzuführen.

Wolfgang Müller was born in 1958 in Germany. After training as a toolmaker he started looking for ways of expressing his creativity. In 1997 he found it in photography, studied at the University of Applied Sciences in Dortmund and obtained a diploma in photo design. In 2000 and 2001 he gained the trust of homeless children and young people in St. Petersburg, who let him photograph them. His report was called *Karat. Himmel über St. Petersburg* (Karat. Heaven above St. Petersburg) and shown in many countries, published as a book, followed by international exhibitions. Various grants allow Wolfgang Müller to continue long-term projects in Siberia and China.

Sie heißen Tamara, Lena, Grischa und Borja. Sie verstecken sich wie viele mit anderen Namen und Schicksalen in Kellern und auf Dachböden in St. Petersburg, der schönsten Stadt Russlands, die den Besucher mit Palästen, Prunkbauten und edlen Einkaufszentren beeindruckt. Hinter den glänzenden Fassaden überleben diese Straßenkinder nur mühsam durch Betteln, Stehlen und Prostitution. Es sind Kinder und Jugendliche, die nie ein richtiges Zuhause kannten, um die sich nie jemand gekümmert hat, die verprügelt und verstoßen wurden. „Wenn ich Heroin spritze, dann bin ich frei und habe keine Angst mehr", sagt Tamara, die Drogen nimmt, seit sie 13 Jahre alt ist. Eine billigere Betäubungsmöglichkeit ist das Schnüffeln von „Karat", einer lösungshaltigen Schuhpolitur. Das Einatmen der Duftstoffe lässt diese entwurzelten Kinder für einige Zeit die erbärmliche Wirklichkeit vergessen.

They are called Tamara, Lena, Grisha and Borja. Like many others with other names and fates, they hide in cellars and lofts in St. Petersburg, the most beautiful town in Russia, which impresses visitors with palaces, magnificent buildings and high-end malls. Behind the glittering facades these street children eke out a precarious existence on begging, stealing and prostitution. They are children and young people who have never known a proper home, who have always been neglected, beaten or driven away. "When I shoot heroin then I am free and not afraid anymore," says Tamara, who has been on drugs since she turned 13. A cheaper way to dull your senses is sniffing Karat, a shoe polish that contains solvents. Breathing these in lets these uprooted children forget their wretched reality for a while.

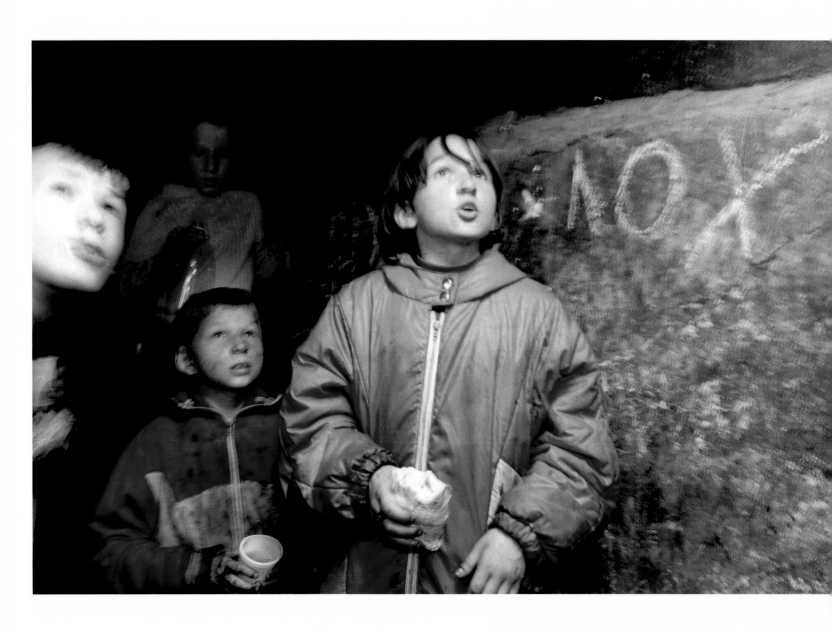

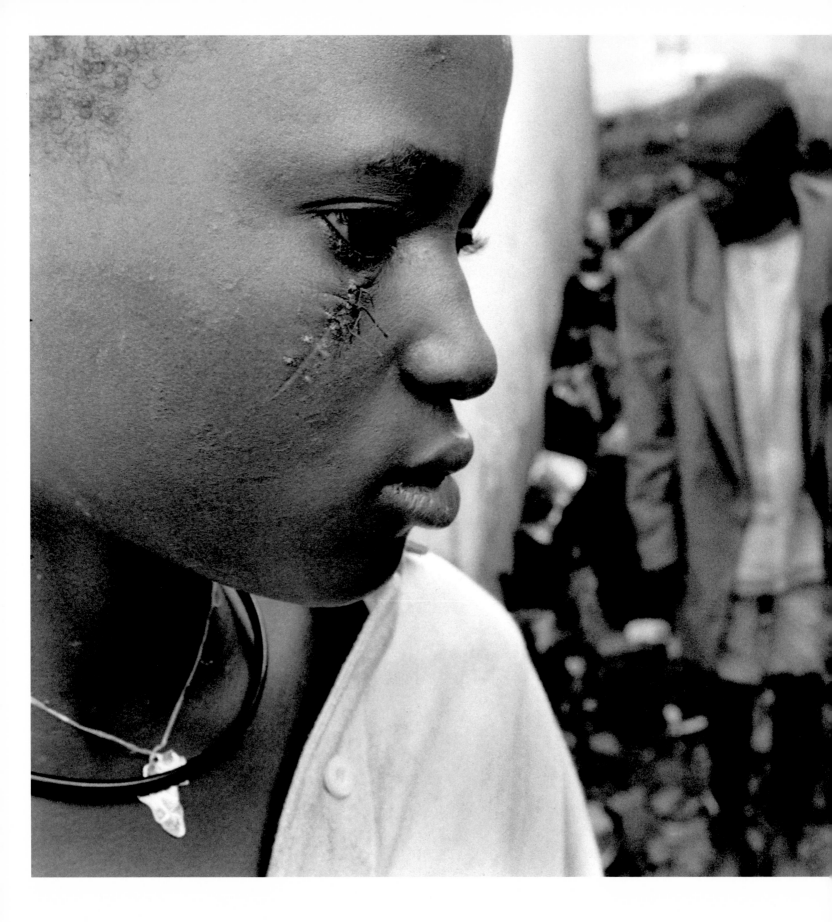

Matías Costa | Panos Pictures wurde 1973 in Buenos Aires geboren und studierte später an der Universität Madrid Journalismus. Von 1994 bis 1998 fotografierte er im Auftrag von *El País* und *El Mundo*. Es folgten Aufträge von europäischen Tageszeitungen und Magazinen. In seinen persönlichen Projekten will Costa Erklärungen für Konflikte und verlorene Identitäten finden. Er wurde mit zwei World Press Photo Awards ausgezeichnet. Eine Unterstützung durch Fondation Hachette und Fundación Fotopress erlaubte es ihm, die Immigration von Illegalen in Europa über den Zeitraum von 2000 bis 2003 zu dokumentieren.

Matías Costa | Panos Pictures was born in Buenos Aires in 1973. He studied journalism at the University of Madrid. From 1994 to 1998 he worked as a photographer for the papers *El País* and *El Mundo*. Commissions from European daily newspapers and magazines followed. In his personal projects Costa wants to find explanations for conflicts and lost identities. He has twice won the World Press Photo Award. A grant from the Fondation Hachette and Fundación Fotopress allowed him to document illegal immigration into Europe from 2000 to 2003.

Der Völkermord in Ruanda begann 1994. In nur einhundert Tagen fielen ihm mindestens 800 000 Tutsi und moderate Hutu zum Opfer. Am 20. Jahrestag sagte Außenministerin Louise Mushikiwabo: „Unser Land fiel in tiefe Gräben voll Dunkelheit." Als der Fotograf Matías Costa im Jahr 2000 das Land bereiste, sah er die deutlich sichtbaren Spuren der finsteren Vergangenheit. Nur in 16 Prozent aller Haushalte lebten Kinder mit Vater und Mutter zusammen. Witwen trugen die größte Last. Wie sollten sie überleben? Die Erträge des Ackerbaus auf Flächen von weniger als einem Hektar halfen nicht, hungernde Kinder satt zu bekommen. Und wie mit den Narben umgehen, die der Bürgerkrieg hinterlassen hatte? Den sichtbaren und den unsichtbaren. Auf dem Land wusste jeder, wer die Opfer waren, wer die Täter. Wer kann sich um 300 000 Waisenkinder kümmern? Viele Fragen, die auch 2014 unbeantwortet sind.

In 1994 a genocide started in Rwanda which, in just one hundred days, cost the lives of at least 800 000 Tutsi and moderate Hutu. On the 20th anniversary, Foreign Minister Louise Mushikiwabo said, "Our land fell into deep abysses of darkness." When photographer Matías Costa travelled through the country in 2000, he saw distinct traces of the sinister past. In only 16 percent of households did children live with their father and mother. The widows carried the biggest burden. How to survive? The yields from fields of less than one hectare were not enough to feed the hungry children. And how to deal with the scars left by the civil war? The visible and the invisible scars. In the country everybody knew who the victims were and who the perpetrators. Who can care for 300 000 orphans? Many questions that remain unanswered in 2014.

DAS RECHT AUF SCHUTZ VOR GEWALT
THE RIGHT TO PROTECTION FROM VIOLENCE [Art. 19]

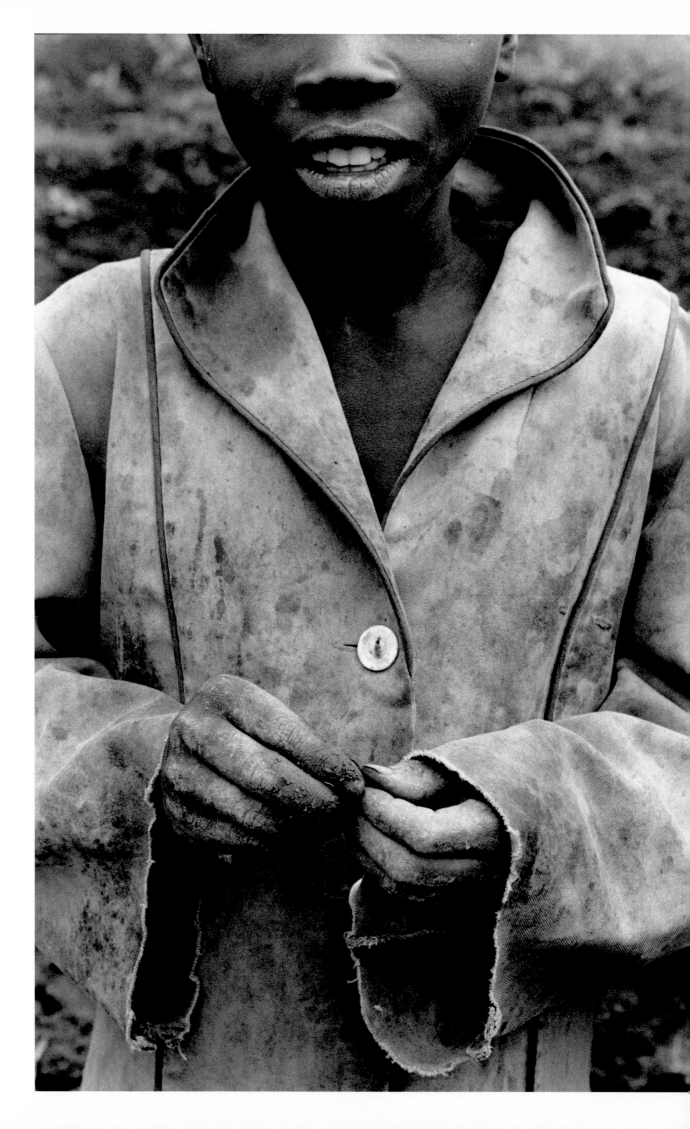

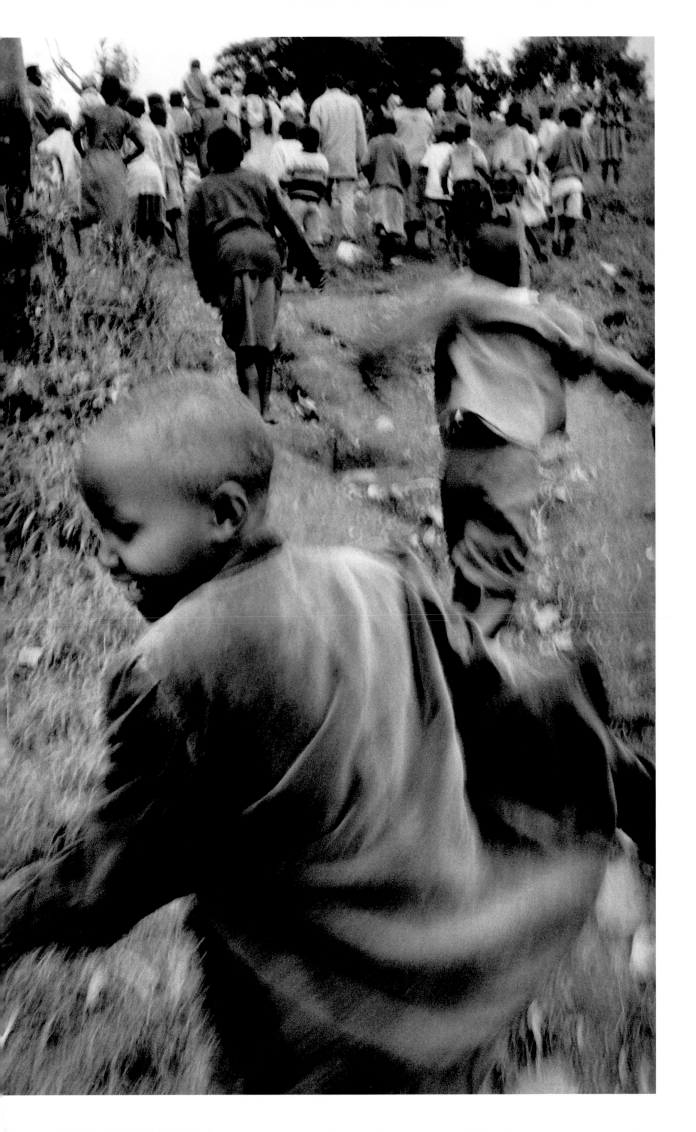

THE CONVENTION ON THE RIGHTS OF THE CHILD

Adopted and opened for signature, ratification and accession by
General Assembly resolution 44/25 of 20 November 1989
entry into force 2 September 1990, in accordance with article 49

Preamble

The States Parties to the present Convention,

Considering that, in accordance with the principles proclaimed in the Charter of the United Nations, recognition of the inherent dignity and of the equal and inalienable rights of all members of the human family is the foundation of freedom, justice and peace in the world,

Bearing in mind that the peoples of the United Nations have, in the Charter, reaffirmed their faith in fundamental human rights and in the dignity and worth of the human person, and have determined to promote social progress and better standards of life in larger freedom,

Recognizing that the United Nations has, in the Universal Declaration of Human Rights and in the International Covenants on Human Rights, proclaimed and agreed that everyone is entitled to all the rights and freedoms set forth therein, without distinction of any kind, such as race, colour, sex, language, religion, political or other opinion, national or social origin, property, birth or other status,

Recalling that, in the Universal Declaration of Human Rights, the United Nations has proclaimed that childhood is entitled to special care and assistance,

Convinced that the family, as the fundamental group of society and the natural environment for the growth and well-being of all its members and particularly children, should be afforded the necessary protection and assistance so that it can fully assume its responsibilities within the community,

Recognizing that the child, for the full and harmonious development of his or her personality, should grow up in a family environment, in an atmosphere of happiness, love and understanding,

Considering that the child should be fully prepared to live an individual life in society, and brought up in the spirit of the ideals proclaimed in the Charter of the United Nations, and in particular in the spirit of peace, dignity, tolerance, freedom, equality and solidarity,

Bearing in mind that the need to extend particular care to the child has been stated in the Geneva Declaration of the Rights of the Child of 1924 and in the Declaration of the Rights of the Child adopted by the General Assembly on 20 November 1959 and recognized in the Universal Declaration of Human Rights, in the International Covenant on Civil and Political Rights (in particular in articles 23 and 24), in the International Covenant on Economic, Social and Cultural Rights (in particular in article 10) and in the statutes and relevant instruments of specialized agencies and international organizations concerned with the welfare of children,

Bearing in mind that, as indicated in the Declaration of the Rights of the Child, „the child, by reason of his physical and mental immaturity, needs special safeguards and care, including appropriate legal protection, before as well as after birth",

Recalling the provisions of the Declaration on Social and Legal Principles relating to the Protection and Welfare of Children, with Special Reference to Foster Placement and Adoption Nationally and Internationally; the United Nations Standard Minimum Rules for the Administration of Juvenile Justice (The Beijing Rules); and the Declaration on the Protection of Women and Children in Emergency and Armed Conflict, Recognizing that, in all countries in the world, there are children living in exceptionally difficult conditions, and that such children need special consideration,

Taking due account of the importance of the traditions and cultural values of each people for the protection and harmonious development of the child, Recognizing the importance of international co-operation for improving the living conditions of children in every country, in particular in the developing countries,

Have agreed as follows:

PART I

Article 1

For the purposes of the present Convention, a child means every human being below the age of eighteen years unless under the law applicable to the child, majority is attained earlier.

Article 2

1. States Parties shall respect and ensure the rights set forth in the present Convention to each child within their jurisdiction without discrimination of any kind, irrespective of the child's or his or her parent's or legal guardian's race, colour, sex, language, religion, political or other opinion, national, ethnic or social origin, property, disability, birth or other status.

2. States Parties shall take all appropriate measures to ensure that the child is protected against all forms of discrimination or punishment on the basis of the status, activities, expressed opinions, or beliefs of the child's parents, legal guardians, or family members.

Article 3

1. In all actions concerning children, whether undertaken by public or private social welfare institutions, courts of law, administrative authorities or legislative bodies, the best interests of the child shall be a primary consideration.

2. States Parties undertake to ensure the child such protection and care as is necessary for his or her well-being, taking into account the rights and duties of his or her parents, legal guardians, or other individuals legally responsible for him or her, and, to this end, shall take all appropriate legislative and administrative measures.

3. States Parties shall ensure that the institutions, services and facilities responsible for the care or protection of children shall conform with the standards established by competent

authorities, particularly in the areas of safety, health, in the number and suitability of their staff, as well as competent supervision.

Article 4

States Parties shall undertake all appropriate legislative, administrative, and other measures for the implementation of the rights recognized in the present Convention. With regard to economic, social and cultural rights, States Parties shall undertake such measures to the maximum extent of their available resources and, where needed, within the framework of international co-operation.

Article 5

States Parties shall respect the responsibilities, rights and duties of parents or, where applicable, the members of the extended family or community as provided for by local custom, legal guardians or other persons legally responsible for the child, to provide, in a manner consistent with the evolving capacities of the child, appropriate direction and guidance in the exercise by the child of the rights recognized in the present Convention.

Article 6

1. States Parties recognize that every child has the inherent right to life.

2. States Parties shall ensure to the maximum extent possible the survival and development of the child.

Article 7

1. The child shall be registered immediately after birth and shall have the right from birth to a name, the right to acquire a nationality and. as far as possible, the right to know and be cared for by his or her parents.

2. States Parties shall ensure the implementation of these rights in accordance with their national law and their obligations under the relevant international instruments in this field, in particular where the child would otherwise be stateless.

Article 8

1. States Parties undertake to respect the right of the child to preserve his or her identity, including nationality, name and family relations as recognized by law without unlawful interference.

2. Where a child is illegally deprived of some or all of the elements of his or her identity, States Parties shall provide appropriate assistance and protection, with a view to re-establishing speedily his or her identity.

Article 9

1. States Parties shall ensure that a child shall not be separated from his or her parents against their will, except when competent authorities subject to judicial review determine, in accordance with applicable law and procedures, that such separation is necessary for the best interests of the child. Such determination may be necessary in a particular case such as one involving abuse or neglect of the child by the parents, or one where the parents are living separately and a decision must be made as to the child's place of residence.

2. In any proceedings pursuant to paragraph 1 of the present article, all interested parties shall be given an opportunity to participate in the proceedings and make their views known.

3. States Parties shall respect the right of the child who is separated from one or both parents to maintain personal relations and direct contact with both parents on a regular basis, except if it is contrary to the child's best interests.

4. Where such separation results from any action initiated by a State Party, such as the detention, imprisonment, exile, deportation or death (including death arising from any cause while the person is in the custody of the State) of one or both parents or of the child, that State Party shall, upon request, provide the parents, the child or, if appropriate, another member of the family with the essential information concerning the whereabouts of the absent member(s) of the family unless the provision of the information would be detrimental to the well-being of the child. States Parties shall further ensure that the submission of such a request shall of itself entail no adverse consequences for the person(s) concerned.

Article 10

1. In accordance with the obligation of States Parties under article 9, paragraph 1, applications by a child or his or her parents to enter or leave a State Party for the purpose of family reunification shall be dealt with by States Parties in a positive, humane and expeditious manner. States Parties shall further ensure that the submission of such a request shall entail no adverse consequences for the applicants and for the members of their family.

2. A child whose parents reside in different States shall have the right to maintain on a regular basis, save in exceptional circumstances personal relations and direct contacts with both parents. Towards that end and in accordance with the obligation of States Parties under article 9, paragraph 1, States Parties shall respect the right of the child and his or her parents to leave any country, including their own, and to enter their own country. The right to leave any country shall be subject only to such restrictions as are prescribed by law and which are necessary to protect the national security, public order (ordre public), public health or morals or the rights and freedoms of others and are consistent with the other rights recognized in the present Convention.

Article 11

1. States Parties shall take measures to combat the illicit transfer and non-return of children abroad.

2. To this end, States Parties shall promote the conclusion of bilateral or multilateral agreements or accession to existing agreements.

Article 12

1. States Parties shall assure to the child who is capable of forming his or her own views the right to express those views freely in all matters affecting the child, the views of the child being given due weight in accordance with the age and maturity of the child.

2. For this purpose, the child shall in particular be provided the opportunity to be heard in any judicial and administrative proceedings affecting the child, either directly, or through a representative or an appropriate body, in a manner consistent with the procedural rules of national law.

Article 13

1. The child shall have the right to freedom of expression; this right shall include freedom to seek, receive and impart information and ideas of all kinds, regardless of frontiers, either orally, in writing or in print, in the form of art, or through any other media of the child's choice.

2. The exercise of this right may be subject to certain restrictions, but these shall only be such as are provided by law and are necessary:

(a) For respect of the rights or reputations of others; or

(b) For the protection of national security or of public order (ordre public), or of public health or morals.

Article 14

1. States Parties shall respect the right of the child to freedom of thought, conscience and religion.

2. States Parties shall respect the rights and duties of the parents and, when applicable, legal guardians, to provide direction to the child in the exercise of his or her right in a manner consistent with the evolving capacities of the child.

3. Freedom to manifest one's religion or beliefs may be subject only to such limitations as are prescribed by law and are necessary to protect public safety, order, health or morals, or the fundamental rights and freedoms of others.

Article 15

1. States Parties recognize the rights of the child to freedom of association and to freedom of peaceful assembly.

2. No restrictions may be placed on the exercise of these rights other than those imposed in conformity with the law and which are necessary in a democratic society in the interests of national security or public safety, public order (ordre public), the protection of public health or morals or the protection of the rights and freedoms of others.

Article 16

1. No child shall be subjected to arbitrary or unlawful interference with his or her privacy, family, or correspondence, nor to unlawful attacks on his or her honour and reputation.

2. The child has the right to the protection of the law against such interference or attacks.

Article 17

States Parties recognize the important function performed by the mass media and shall ensure that the child has access to information and material from a diversity of national and international sources, especially those aimed at the promotion of his or her social, spiritual and moral well-being and physical and mental health.

To this end, States Parties shall:

(a) Encourage the mass media to disseminate information and material of social and cultural benefit to the child and in accordance with the spirit of article 29;

(b) Encourage international co-operation in the production, exchange and dissemination of such information and material from a diversity of cultural, national and international sources;

(c) Encourage the production and dissemination of children's books;

(d) Encourage the mass media to have particular regard to the linguistic needs of the child who belongs to a minority group or who is indigenous;

(e) Encourage the development of appropriate guidelines for the protection of the child from information and material injurious to his or her well-being, bearing in mind the provisions of articles 13 and 18.

Article 18

1. States Parties shall use their best efforts to ensure recognition of the principle that both parents have common responsibilities for the upbringing and development of the child.

Parents or, as the case may be, legal guardians, have the primary responsibility for the upbringing and development of the child. The best interests of the child will be their basic concern.

2. For the purpose of guaranteeing and promoting the rights set forth in the present Convention, States Parties shall render appropriate assistance to parents and legal guardians in the performance of their child-rearing responsibilities and shall ensure the development of institutions, facilities and services for the care of children.

3. States Parties shall take all appropriate measures to ensure that children of working parents have the right to benefit from child-care services and facilities for which they are eligible.

Article 19

1. States Parties shall take all appropriate legislative, administrative, social and educational measures to protect the child from all forms of physical or mental violence, injury or abuse, neglect or negligent treatment, maltreatment or exploitation, including sexual abuse, while in the care of parent(s), legal guardian(s) or any other person who has the care of the child.

2. Such protective measures should, as appropriate, include effective procedures for the establishment of social programmes to provide necessary support for the child and for those who have the care of the child, as well as for other forms of prevention and for identification, reporting, referral, investigation, treatment and follow-up of instances of child maltreatment described heretofore, and, as appropriate, for judicial involvement.

Article 20

1. A child temporarily or permanently deprived of his or her family environment, or in whose own best interests cannot be allowed to remain in that environment, shall be entitled to special protection and assistance provided by the State.

2. States Parties shall in accordance with their national laws ensure alternative care for such a child.

3. Such care could include, inter alia, foster placement, kafalah of Islamic law, adoption or if necessary placement in suitable institutions for the care of children. When considering solutions, due regard shall be paid to the desirability of continuity in a child's upbringing and to the child's ethnic, religious, cultural and linguistic background.

Article 21

States Parties that recognize and/or permit the system of adoption shall ensure that the best interests of the child shall be the paramount consideration and they shall:

(a) Ensure that the adoption of a child is authorized only by competent authorities who determine, in accordance with applicable law and procedures and on the basis of all perti-

nent and reliable information, that the adoption is permissible in view of the child's status concerning parents, relatives and legal guardians and that, if required, the persons concerned have given their informed consent to the adoption on the basis of such counselling as may be necessary;

(b) Recognize that inter-country adoption may be considered as an alternative means of child's care, if the child cannot be placed in a foster or an adoptive family or cannot in any suitable manner be cared for in the child's country of origin;

(c) Ensure that the child concerned by inter-country adoption enjoys safeguards and standards equivalent to those existing in the case of national adoption;

(d) Take all appropriate measures to ensure that, in inter-country adoption, the placement does not result in improper financial gain for those involved in it;

(e) Promote, where appropriate, the objectives of the present article by concluding bilateral or multilateral arrangements or agreements, and endeavour, within this framework, to ensure that the placement of the child in another country is carried out by competent authorities or organs.

Article 22

1. States Parties shall take appropriate measures to ensure that a child who is seeking refugee status or who is considered a refugee in accordance with applicable international or domestic law and procedures shall, whether unaccompanied or accompanied by his or her parents or by any other person, receive appropriate protection and humanitarian assistance in the enjoyment of applicable rights set forth in the present Convention and in other international human rights or humanitarian instruments to which the said States are Parties.

2. For this purpose, States Parties shall provide, as they consider appropriate, co-operation in any efforts by the United Nations and other competent intergovernmental organizations or non-governmental organizations co-operating with the United Nations to protect and assist such a child and to trace the parents or other members of the family of any refugee child in order to obtain information necessary for reunification with his or her family. In cases where no parents or other members of the family can be found, the child shall be accorded the same protection as any other child permanently or temporarily deprived of his or her family environment for any reason , as set forth in the present Convention.

Article 23

1. States Parties recognize that a mentally or physically disabled child should enjoy a full and decent life, in conditions which ensure dignity, promote self-reliance and facilitate the child's active participation in the community.

2. States Parties recognize the right of the disabled child to special care and shall encourage and ensure the extension, subject to available resources, to the eligible child and those

responsible for his or her care, of assistance for which application is made and which is appropriate to the child's condition and to the circumstances of the parents or others caring for the child.

3. Recognizing the special needs of a disabled child, assistance extended in accordance with paragraph 2 of the present article shall be provided free of charge, whenever possible, taking into account the financial resources of the parents or others caring for the child, and shall be designed to ensure that the disabled child has effective access to and receives education, training, health care services, rehabilitation services, preparation for employment and recreation opportunities in a manner conducive to the child's achieving the fullest possible social integration and individual development, including his or her cultural and spiritual development.

4. States Parties shall promote, in the spirit of international cooperation, the exchange of appropriate information in the field of preventive health care and of medical, psychological and functional treatment of disabled children, including dissemination of and access to information concerning methods of rehabilitation, education and vocational services, with the aim of enabling States Parties to improve their capabilities and skills and to widen their experience in these areas. In this regard, particular account shall be taken of the needs of developing countries.

Article 24

1. States Parties recognize the right of the child to the enjoyment of the highest attainable standard of health and to facilities for the treatment of illness and rehabilitation of health. States Parties shall strive to ensure that no child is deprived of his or her right of access to such health care services.

2. States Parties shall pursue full implementation of this right and, in particular, shall take appropriate measures:

(a) To diminish infant and child mortality;

(b) To ensure the provision of necessary medical assistance and health care to all children with emphasis on the development of primary health care;

(c) To combat disease and malnutrition, including within the framework of primary health care, through, inter alia, the application of readily available technology and through the provision of adequate nutritious foods and clean drinking-water, taking into consideration the dangers and risks of environmental pollution;

(d) To ensure appropriate pre-natal and post-natal health care for mothers;

(e) To ensure that all segments of society, in particular parents and children, are informed, have access to education and are supported in the use of basic knowledge of child health and nutrition, the advantages of breastfeeding, hygiene and environmental sanitation and the prevention of accidents;

(f) To develop preventive health care, guidance for parents and family planning education and services.

3. States Parties shall take all effective and appropriate measures with a view to abolishing traditional practices prejudicial to the health of children.

4. States Parties undertake to promote and encourage international co-operation with a view to achieving progressively the full realization of the right recognized in the present article. In this regard, particular account shall be taken of the needs of developing countries.

Article 25

States Parties recognize the right of a child who has been placed by the competent authorities for the purposes of care, protection or treatment of his or her physical or mental health, to a periodic review of the treatment provided to the child and all other circumstances relevant to his or her placement.

Article 26

1. States Parties shall recognize for every child the right to benefit from social security, including social insurance, and shall take the necessary measures to achieve the full realization of this right in accordance with their national law.

2. The benefits should, where appropriate, be granted, taking into account the resources and the circumstances of the child and persons having responsibility for the maintenance of the child, as well as any other consideration relevant to an application for benefits made by or on behalf of the child.

Article 27

1. States Parties recognize the right of every child to a standard of living adequate for the child's physical, mental, spiritual, moral and social development.

2. The parent(s) or others responsible for the child have the primary responsibility to secure, within their abilities and financial capacities, the conditions of living necessary for the child's development.

3. States Parties, in accordance with national conditions and within their means, shall take appropriate measures to assist parents and others responsible for the child to implement this right and shall in case of need provide material assistance and support programmes, particularly with regard to nutrition, clothing and housing.

4. States Parties shall take all appropriate measures to secure the recovery of maintenance for the child from the parents or other persons having financial responsibility for the child, both within the State Party and from abroad. In particular, where the person having financial responsibility for the child lives in a State different from that of the child, States Parties shall

promote the accession to international agreements or the conclusion of such agreements, as well as the making of other appropriate arrangements.

Article 28

1. States Parties recognize the right of the child to education, and with a view to achieving this right progressively and on the basis of equal opportunity, they shall, in particular:

(a) Make primary education compulsory and available free to all;

(b) Encourage the development of different forms of secondary education, including general and vocational education, make them available and accessible to every child, and take appropriate measures such as the introduction of free education and offering financial assistance in case of need;

(c) Make higher education accessible to all on the basis of capacity by every appropriate means;

(d) Make educational and vocational information and guidance available and accessible to all children;

(e) Take measures to encourage regular attendance at schools and the reduction of drop-out rates.

2. States Parties shall take all appropriate measures to ensure that school discipline is administered in a manner consistent with the child's human dignity and in conformity with the present Convention.

3. States Parties shall promote and encourage international cooperation in matters relating to education, in particular with a view to contributing to the elimination of ignorance and illiteracy throughout the world and facilitating access to scientific and technical knowledge and modern teaching methods. In this regard, particular account shall be taken of the needs of developing countries.

Article 29

1. States Parties agree that the education of the child shall be directed to:

(a) The development of the child's personality, talents and mental and physical abilities to their fullest potential;

(b) The development of respect for human rights and fundamental freedoms, and for the principles enshrined in the Charter of the United Nations;

(c) The development of respect for the child's parents, his or her own cultural identity, language and values, for the national values of the country in which the child is living, the country from which he or she may originate, and for civilizations different from his or her own;

(d) The preparation of the child for responsible life in a free society, in the spirit of understanding, peace, tolerance, equality of sexes, and friendship among all peoples, ethnic, national and religious groups and persons of indigenous origin;

(e) The development of respect for the natural environment.

2. No part of the present article or article 28 shall be construed so as to interfere with the liberty of individuals and bodies to establish and direct educational institutions, subject always to the observance of the principle set forth in paragraph 1 of the present article and to the requirements that the education given in such institutions shall conform to such minimum standards as may be laid down by the State.

Article 30

In those States in which ethnic, religious or linguistic minorities or persons of indigenous origin exist, a child belonging to such a minority or who is indigenous shall not be denied the right, in community with other members of his or her group, to enjoy his or her own culture, to profess and practise his or her own religion, or to use his or her own language.

Article 31

1. States Parties recognize the right of the child to rest and leisure, to engage in play and recreational activities appropriate to the age of the child and to participate freely in cultural life and the arts.

2. States Parties shall respect and promote the right of the child to participate fully in cultural and artistic life and shall encourage the provision of appropriate and equal opportunities for cultural, artistic, recreational and leisure activity.

Article 32

1. States Parties recognize the right of the child to be protected from economic exploitation and from performing any work that is likely to be hazardous or to interfere with the child's education, or to be harmful to the child's health or physical, mental, spiritual, moral or social development.

2. States Parties shall take legislative, administrative, social and educational measures to ensure the implementation of the present article. To this end, and having regard to the relevant provisions of other international instruments, States Parties shall in particular:

(a) Provide for a minimum age or minimum ages for admission to employment;

(b) Provide for appropriate regulation of the hours and conditions of employment;

(c) Provide for appropriate penalties or other sanctions to ensure the effective enforcement of the present article.

Article 33

States Parties shall take all appropriate measures, including legislative, administrative, social and educational measures, to protect children from the illicit use of narcotic drugs and psychotropic substances as defined in the relevant international treaties, and to prevent the use of children in the illicit production and trafficking of such substances.

Article 34

States Parties undertake to protect the child from all forms of sexual exploitation and sexual abuse. For these purposes, States Parties shall in particular take all appropriate national, bilateral and multilateral measures to prevent:

(a) The inducement or coercion of a child to engage in any unlawful sexual activity;

(b) The exploitative use of children in prostitution or other unlawful sexual practices;

(c) The exploitative use of children in pornographic performances and materials.

Article 35

States Parties shall take all appropriate national, bilateral and multilateral measures to prevent the abduction of, the sale of or traffic in children for any purpose or in any form.

Article 36

States Parties shall protect the child against all other forms of exploitation prejudicial to any aspects of the child's welfare.

Article 37

States Parties shall ensure that:

(a) No child shall be subjected to torture or other cruel, inhuman or degrading treatment or punishment. Neither capital punishment nor life imprisonment without possibility of release shall be imposed for offences committed by persons below eighteen years of age;

(b) No child shall be deprived of his or her liberty unlawfully or arbitrarily. The arrest, detention or imprisonment of a child shall be in conformity with the law and shall be used only as a measure of last resort and for the shortest appropriate period of time;

(c) Every child deprived of liberty shall be treated with humanity and respect for the inherent dignity of the human person, and in a manner which takes into account the needs of persons of his or her age. In particular, every child deprived of liberty shall be separated from adults unless it is considered in the child's best interest not to do so and shall have the right to maintain contact with his or her family through correspondence and visits, save in exceptional circumstances;

(d) Every child deprived of his or her liberty shall have the right to prompt access to legal and other appropriate assistance, as well as the right to challenge the legality of the deprivation of his or her liberty before a court or other competent, independent and impartial authority, and to a prompt decision on any such action.

Article 38

1. States Parties undertake to respect and to ensure respect for rules of international humanitarian law applicable to them in armed conflicts which are relevant to the child.

2. States Parties shall take all feasible measures to ensure that persons who have not attained the age of fifteen years do not take a direct part in hostilities.

3. States Parties shall refrain from recruiting any person who has not attained the age of fifteen years into their armed forces. In recruiting among those persons who have attained the age of fifteen years but who have not attained the age of eighteen years, States Parties shall endeavour to give priority to those who are oldest.

4. In accordance with their obligations under international humanitarian law to protect the civilian population in armed conflicts, States Parties shall take all feasible measures to ensure protection and care of children who are affected by an armed conflict.

Article 39

States Parties shall take all appropriate measures to promote physical and psychological recovery and social reintegration of a child victim of: any form of neglect, exploitation, or abuse; torture or any other form of cruel, inhuman or degrading treatment or punishment; or armed conflicts. Such recovery and reintegration shall take place in an environment which fosters the health, self-respect and dignity of the child.

Article 40

1. States Parties recognize the right of every child alleged as, accused of, or recognized as having infringed the penal law to be treated in a manner consistent with the promotion of the child's sense of dignity and worth, which reinforces the child's respect for the human rights and fundamental freedoms of others and which takes into account the child's age and the desirability of promoting the child's reintegration and the child's assuming a constructive role in society.

2. To this end, and having regard to the relevant provisions of international instruments, States Parties shall, in particular, ensure that:

(a) No child shall be alleged as, be accused of, or recognized as having infringed the penal law by reason of acts or omissions that were not prohibited by national or international law at the time they were committed;

(b) Every child alleged as or accused of having infringed the penal law has at least the following guarantees:

(i) To be presumed innocent until proven guilty according to law;

(ii) To be informed promptly and directly of the charges against him or her, and, if appropriate, through his or her parents or legal guardians, and to have legal or other appropriate assistance in the preparation and presentation of his or her defence;

(iii) To have the matter determined without delay by a competent, independent and impartial authority or judicial body in a fair hearing according to law, in the presence of legal or other appropriate assistance and, unless it is considered not to be in the best interest of the child, in particular, taking into account his or her age or situation, his or her parents or legal guardians;

(iv) Not to be compelled to give testimony or to confess guilt; to examine or have examined adverse witnesses and to obtain the participation and examination of witnesses on his or her behalf under conditions of equality;

(v) If considered to have infringed the penal law, to have this decision and any measures imposed in consequence thereof reviewed by a higher competent, independent and impartial authority or judicial body according to law;

(vi) To have the free assistance of an interpreter if the child cannot understand or speak the language used;

(vii) To have his or her privacy fully respected at all stages of the proceedings.

3. States Parties shall seek to promote the establishment of laws, procedures, authorities and institutions specifically applicable to children alleged as, accused of, or recognized as having infringed the penal law, and, in particular:

(a) The establishment of a minimum age below which children shall be presumed not to have the capacity to infringe the penal law;

(b) Whenever appropriate and desirable, measures for dealing with such children without resorting to judicial proceedings, providing that human rights and legal safeguards are fully respected. 4. A variety of dispositions, such as care, guidance and supervision orders; counselling; probation; foster care; education and vocational training programmes and other alternatives to institutional care shall be available to ensure that children are dealt with in a manner appropriate to their well-being and proportionate both to their circumstances and the offence.

Article 41

Nothing in the present Convention shall affect any provisions which are more conducive to the realization of the rights of the child and which may be contained in:

(a) The law of a State party; or

(b) International law in force for that State.

PART II

Article 42

States Parties undertake to make the principles and provisions of the Convention widely known, by appropriate and active means, to adults and children alike.

Article 43

1. For the purpose of examining the progress made by States Parties in achieving the realization of the obligations undertaken in the present Convention, there shall be established a Committee on the Rights of the Child, which shall carry out the functions hereinafter provided.

2. The Committee shall consist of eighteen experts of high moral standing and recognized competence in the field covered by this Convention.1/ The members of the Committee shall be elected by States Parties from among their nationals and shall serve in their personal capacity, consideration being given to equitable geographical distribution, as well as to the principal legal systems.

3. The members of the Committee shall be elected by secret ballot from a list of persons nominated by States Parties. Each State Party may nominate one person from among its own nationals.

4. The initial election to the Committee shall be held no later than six months after the date of the entry into force of the present Convention and thereafter every second year. At least four months before the date of each election, the Secretary-General of the United Nations shall address a letter to States Parties inviting them to submit their nominations within two months. The Secretary-General shall subsequently prepare a list in alphabetical order of all persons thus nominated, indicating States Parties which have nominated them, and shall submit it to the States Parties to the present Convention.

5. The elections shall be held at meetings of States Parties convened by the Secretary-General at United Nations Headquarters. At those meetings, for which two thirds of States Parties shall constitute a quorum, the persons elected to the Committee shall be those who obtain the largest number of votes and an absolute majority of the votes of the representatives of States Parties present and voting.

6. The members of the Committee shall be elected for a term of four years. They shall be eligible for re-election if renominated. The term of five of the members elected at the first election shall expire at the end of two years; immediately after the first election, the names of these five members shall be chosen by lot by the Chairman of the meeting.

7. If a member of the Committee dies or resigns or declares that for any other cause he or she can no longer perform the duties of the Committee, the State Party which nominated the member shall appoint another expert from among its nationals to serve for the remainder of the term, subject to the approval of the Committee.

8. The Committee shall establish its own rules of procedure.

9. The Committee shall elect its officers for a period of two years.

10. The meetings of the Committee shall normally be held at United Nations Headquarters or at any other convenient place as determined by the Committee. The Committee shall normally meet annually. The duration of the meetings of the Committee shall be determined, and reviewed, if necessary, by a meeting of the States Parties to the present Convention, subject to the approval of the General Assembly.

11. The Secretary-General of the United Nations shall provide the necessary staff and facilities for the effective performance of the functions of the Committee under the present Convention.

12. With the approval of the General Assembly, the members of the Committee established under the present Convention shall receive emoluments from United Nations resources on such terms and conditions as the Assembly may decide.

Article 44

1. States Parties undertake to submit to the Committee, through the Secretary-General of the United Nations, reports on the measures they have adopted which give effect to the rights recognized herein and on the progress made on the enjoyment of those rights

(a) Within two years of the entry into force of the Convention for the State Party concerned;

(b) Thereafter every five years.

2. Reports made under the present article shall indicate factors and difficulties, if any, affecting the degree of fulfilment of the obligations under the present Convention. Reports shall also contain sufficient information to provide the Committee with a comprehensive understanding of the implementation of the Convention in the country concerned.

3. A State Party which has submitted a comprehensive initial report to the Committee need not, in its subsequent reports submitted in accordance with paragraph 1 (b) of the present article, repeat basic information previously provided.

4. The Committee may request from States Parties further information relevant to the implementation of the Convention.

5. The Committee shall submit to the General Assembly, through the Economic and Social Council, every two years, reports on its activities.

6. States Parties shall make their reports widely available to the public in their own countries.

Article 45

In order to foster the effective implementation of the Convention and to encourage international co-operation in the field covered by the Convention:

(a) The specialized agencies, the United Nations Children's Fund, and other United Nations organs shall be entitled to be represented at the consideration of the implementation of such provisions of the present Convention as fall within the scope of their mandate. The Committee may invite the specialized agencies, the United Nations Children's Fund and other competent bodies as it may consider appropriate to provide expert advice on the implementation of the Convention in areas falling within the scope of their respective mandates. The Committee may invite the specialized agencies, the United Nations Children's Fund, and other United Nations organs to submit reports on the implementation of the Convention in areas falling within the scope of their activities;

(b) The Committee shall transmit, as it may consider appropriate, to the specialized agencies, the United Nations Children's Fund and other competent bodies, any reports from States Parties that contain a request, or indicate a need, for technical advice or assistance, along with the Committee's observations and suggestions, if any, on these requests or indications;

(c) The Committee may recommend to the General Assembly to request the Secretary-General to undertake on its behalf studies on specific issues relating to the rights of the child;

(d) The Committee may make suggestions and general recommendations based on information received pursuant to articles 44 and 45 of the present Convention. Such suggestions and general recommendations shall be transmitted to any State Party concerned and reported to the General Assembly, together with comments, if any, from States Parties.

PART III

Article 46

The present Convention shall be open for signature by all States.

Article 47

The present Convention is subject to ratification. Instruments of ratification shall be deposited with the Secretary-General of the United Nations.

Article 48

The present Convention shall remain open for accession by any State. The instruments of accession shall be deposited with the Secretary-General of the United Nations.

Article 49

1. The present Convention shall enter into force on the thirtieth day following the date of deposit with the Secretary-General of the United Nations of the twentieth instrument of ratification or accession.

2. For each State ratifying or acceding to the Convention after the deposit of the twentieth instrument of ratification or accession, the Convention shall enter into force on the thirtieth day after the deposit by such State of its instrument of ratification or accession.

Article 50

1. Any State Party may propose an amendment and file it with the Secretary-General of the United Nations. The Secretary-General shall thereupon communicate the proposed amendment to States Parties, with a request that they indicate whether they favour a conference of States Parties for the purpose of considering and voting upon the proposals. In the event that, within four months from the date of such communication, at least one third of the States Parties favour such a conference, the Secretary-General shall convene the conference under the auspices of the United Nations. Any amendment adopted by a majority of States Parties present and voting at the conference shall be submitted to the General Assembly for approval.

2. An amendment adopted in accordance with paragraph 1 of the present article shall enter into force when it has been approved by the General Assembly of the United Nations and accepted by a two-thirds majority of States Parties.

3. When an amendment enters into force, it shall be binding on those States Parties which have accepted it, other States Parties still being bound by the provisions of the present Convention and any earlier amendments which they have accepted.

Article 51

1. The Secretary-General of the United Nations shall receive and circulate to all States the text of reservations made by States at the time of ratification or accession.

2. A reservation incompatible with the object and purpose of the present Convention shall not be permitted.

3. Reservations may be withdrawn at any time by notification to that effect addressed to the Secretary-General of the United Nations, who shall then inform all States. Such notification shall take effect on the date on which it is received by the Secretary-General.

Article 52

A State Party may denounce the present Convention by written notification to the Secretary-General of the United Nations. Denunciation becomes effective one year after the date of receipt of the notification by the Secretary-General.

Article 53

The Secretary-General of the United Nations is designated as the depositary of the present Convention.

Article 54

The original of the present Convention, of which the Arabic, Chinese, English, French, Russian and Spanish texts are equally authentic, shall be deposited with the Secretary-General of the United Nations. In witness thereof the undersigned plenipotentiaries, being duly authorized thereto by their respective Governments, have signed the present Convention.

1/ The General Assembly, in its resolution 50/155 of 21 December 1995, approved the amendment to article 43, paragraph 2, of the Convention on the Rights of the Child, replacing the word "ten" with the word "eighteen". The amendment entered into force on 18 November 2002 when it had been accepted by a two-thirds majority of the States parties (128 out of 191).

Nachfolgende Bilder
Following images
Alice Smeets | Out of Focus, 2007
Shannon Jensen | Getty Images, 2012
Alex Masi | Corbis Images, 2012
Mads Nissen | laif, 2008
Shiho Fukada | Panos Pictures, 2008

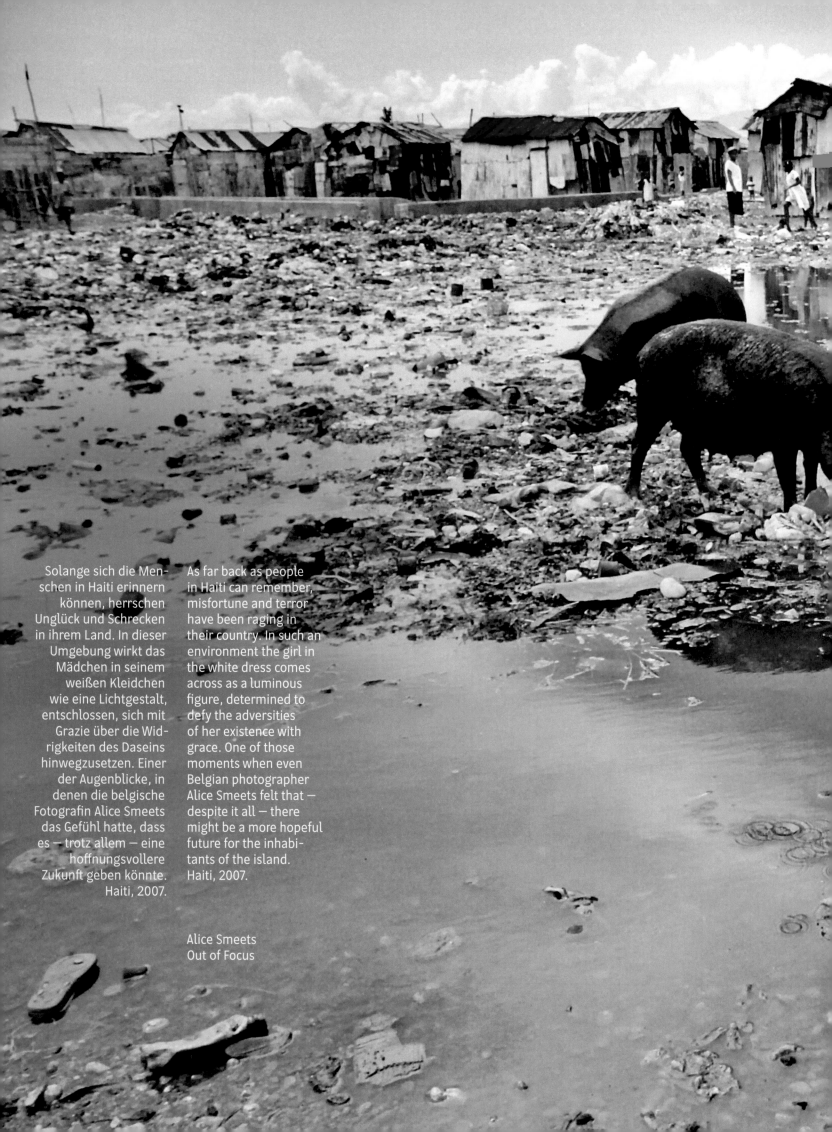

Solange sich die Menschen in Haiti erinnern können, herrschen Unglück und Schrecken in ihrem Land. In dieser Umgebung wirkt das Mädchen in seinem weißen Kleidchen wie eine Lichtgestalt, entschlossen, sich mit Grazie über die Widrigkeiten des Daseins hinwegzusetzen. Einer der Augenblicke, in denen die belgische Fotografin Alice Smeets das Gefühl hatte, dass es — trotz allem — eine hoffnungsvollere Zukunft geben könnte. Haiti, 2007.

As far back as people in Haiti can remember, misfortune and terror have been raging in their country. In such an environment the girl in the white dress comes across as a luminous figure, determined to defy the adversities of her existence with grace. One of those moments when even Belgian photographer Alice Smeets felt that — despite it all — there might be a more hopeful future for the inhabitants of the island. Haiti, 2007.

Alice Smeets
Out of Focus

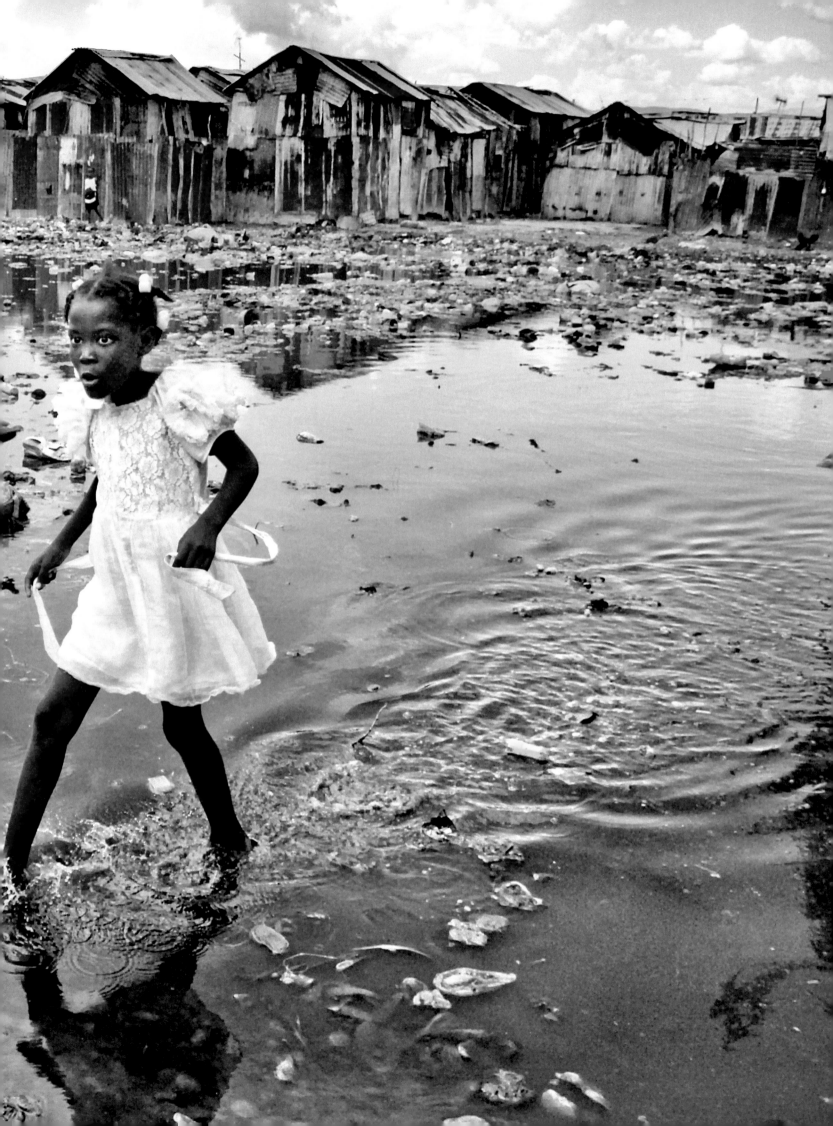

Der Wettbewerb „UNICEF-Foto des Jahres"

Kerstin Bücker
Mitglied der Geschäftsleitung beim Deutschen Komitee für UNICEF e. V.

Die Bilder in diesem Buch haben eine sie vereinende Geschichte bei UNICEF: Sie alle wurden beim „UNICEF-Foto des Jahres" ausgezeichnet, jenem Wettbewerb, mit dem die deutsche Sektion des Kinderhilfswerks Einzelfotos und Fotoreportagen prämiert, welche die Persönlichkeit und die Lebensumstände von Kindern weltweit auf herausragende Weise dokumentieren. Der seit 2000 ausgerichtete Wettbewerb wird von *GEO* unterstützt und richtet sich ausschließlich an professionelle Fotografen. Voraussetzung für eine Teilnahme ist die Empfehlung durch einen international renommierten Fotografie-Experten. Unter dem Titel „Kinder. Die Gegenwart der Zukunft" werden die beim Wettbewerb prämierten Bilder alle zwei Jahre in einer Ausstellung auf der photokina in Köln gezeigt. Seit Beginn des Wettbewerbs wurden Spitzenfotografen und junge Talente aus über 70 Ländern und allen fünf Kontinenten beim „UNICEF-Foto des Jahres" ausgezeichnet. Ihre Arbeiten zeigen die kritische Lebenssituation von Kindern und Jugendlichen im Krieg, in materieller oder seelischer Not und nach Naturkatastrophen, aber auch Momente des Glücks, der Lebensfreude und Facetten unterschiedlicher Alltagswelten.

Über die Preisvergabe für das „UNICEF-Foto des Jahres" entscheidet eine unabhängige Jury unter dem Vorsitz von Klaus Honnef, Kunst- und Fotografiehistoriker und Ausstellungskurator. Die Jury ist von UNICEF und den nominierenden Experten unabhängig. Sie wählt Reportagen und Dokumentationen aus, die sich durch besondere ästhetische und journalistische Qualität sowie durch Sorgfalt, Empathie und Respekt gegenüber Kindern in oft schwierigen Lebensumständen auszeichnen. Die Einsendungen werden für die Jurysitzung anonymisiert. „Die hervorragenden Fotografinnen und Fotografen aus aller Welt teilen eine spezifische ästhetisch-moralische Haltung, die getragen ist von Empathie, Engagement und dem Willen, in prägnanten Bildern und Bildfolgen festzuhalten, was nicht im Lot ist", sagt Klaus Honnef.

Beim Wettbewerb 2013/2014 gehörten der Jury an: Ruth Eichhorn, Leiterin der Bildredaktion *GEO*; Lutz Fischmann, Geschäftsführer Verband Freelens e. V.; Bernd von Jutrczenka, Chefkorrespondent Foto, dpa; Maria Mann, Director of International Relations & Business Development, epa — european pressphoto agency; Rolf Nobel, Leiter Studienrichtung Fotografie, FH für Design und Medien Hannover; Christian Pohlert, Leiter Ressort Bild, *Frankfurter Allgemeine Zeitung*, sowie Reinhard Schlagintweit, Ehrenmitglied des Deutschen Komitees von UNICEF e. V. Zu den nominierenden Experten gehören Vertreter von Nachrichten- und Bildagenturen, von Hochschulen für Fotografie sowie renommierte freie Fotografen. Sie alle zeichnen sich durch internationale Expertise aus sowie ein besonderes Bewusstsein für ethische Standards des Bildjournalismus.

UNICEF Deutschland dankt der Jury, den Fotografen und Agenturen, Angela Rupprecht als Verantwortlicher für Idee, Konzept und Projektleitung von „UNICEF-Foto des Jahres" sowie allen weiteren Unterstützern sehr herzlich für ihren Beitrag zum wachsenden Erfolg des Fotopreises. Ein besonderer Dank gilt den nominierenden Experten Sherri Dougherty, Sheryl Mendez, Patrick Brown, Peter van Agtmael, Teru Kuwayama und James Whitlow Delano, ein weiterer Dank der photokina in Köln.

The UNICEF Photo of the Year Award

Kerstin Bücker
Member of the Management Board of the German Committee for UNICEF

The pictures in this volume are united by their history with UNICEF: All of them have been among the winners of the UNICEF Photo of the Year Award, the competition in which the German section of the children's charity recognizes individual photographs or photo stories that document the personality and circumstances of children across the world in exceptional ways. The competition has been held since 2000 with the support of *GEO magazine* and is only open to professional photographers. Participation is conditional on recommendation by an internationally renowned photography expert. The award-winning pictures are presented every two years under the title *Kinder. Die Gegenwart der Zukunft* (Children. The Presence of the Future) at the Photokina imaging fair in Cologne. Since the first competition, top photographers and young talent from more than 70 countries and all five continents have been honoured at the UNICEF Photo of the Year Award. Their work often shows the critical condition of children and young people in war, in material or emotional need, in the wake of natural disasters, but also moments of happiness, the joy of living, as well as facets of diverse everyday worlds.

An independent jury decides on the prizes of the UNICEF Photo of the Year Award. It is chaired by Klaus Honnef, historian of photography and curator. The jury is independent of UNICEF and of the nominating experts. It selects reportages and documentaries that demonstrate exceptional aesthetic and journalistic quality as well as attention, empathy and respect towards children in often difficult circumstances. The entries are anonymized for the meeting of the jury. "The outstanding photographers from all over the world share a specific aesthetic and moral stance that thrives on empathy, commitment and on the will to record in pictures and photo series what is wrong," explains Klaus Honnef. "They are united in aiming to help change intolerable situations."

In 2013/2014 the jury was made up of: Ruth Eichhorn, Director of Photography *GEO*; Lutz Fischmann, Chief Executive Verband Freelens e.V.; Bernd von Jutrczenka, Head Editor, dpa picture service; Maria Mann, Director of International Relations & Business Development, epa — european pressphoto agency; Rolf Nobel, Head of the Photography Department, Faculty for Media, Information and Design, University of Applied Sciences and Arts Hannover; Christian Pohlert, Director of Photography, *Frankfurter Allgemeine Zeitung*, and Reinhard Schlagintweit, Honorary Member of the German Committee for UNICEF. The nominating experts include representatives of news and photo agencies, schools of photography and well-known freelance photographers. All of them share international expert knowledge and a special awareness of ethical standards in photojournalism.

UNICEF Germany would like to express heartfelt thanks to the jury, the photographers and agencies, to Angela Rupprecht, the person behind the concept of the UNICEF Photo of the Year Award and its project manager, as well as to all other supporters for their contribution to the growing success of the photo award. Special thanks are due to the nominating experts Sherri Dougherty, Sheryl Mendez, Patrick Brown, Peter van Agtmael, Teru Kuwayama and James Whitlow Delano, as well as to photokina in Cologne.

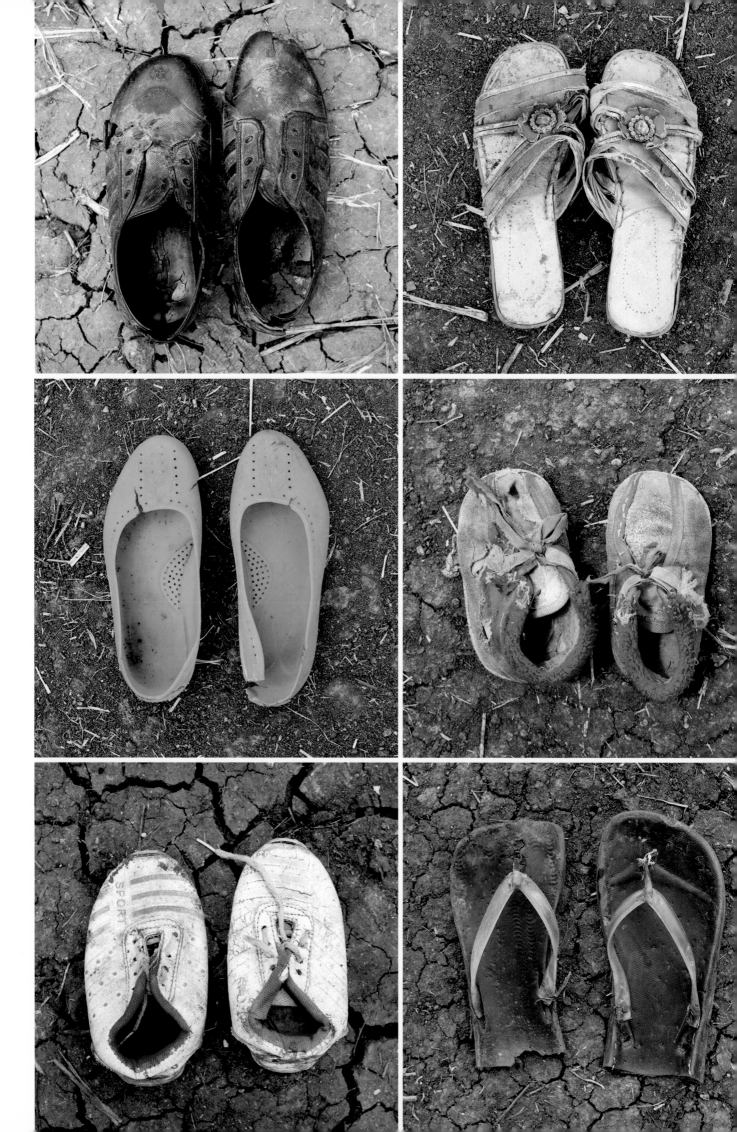

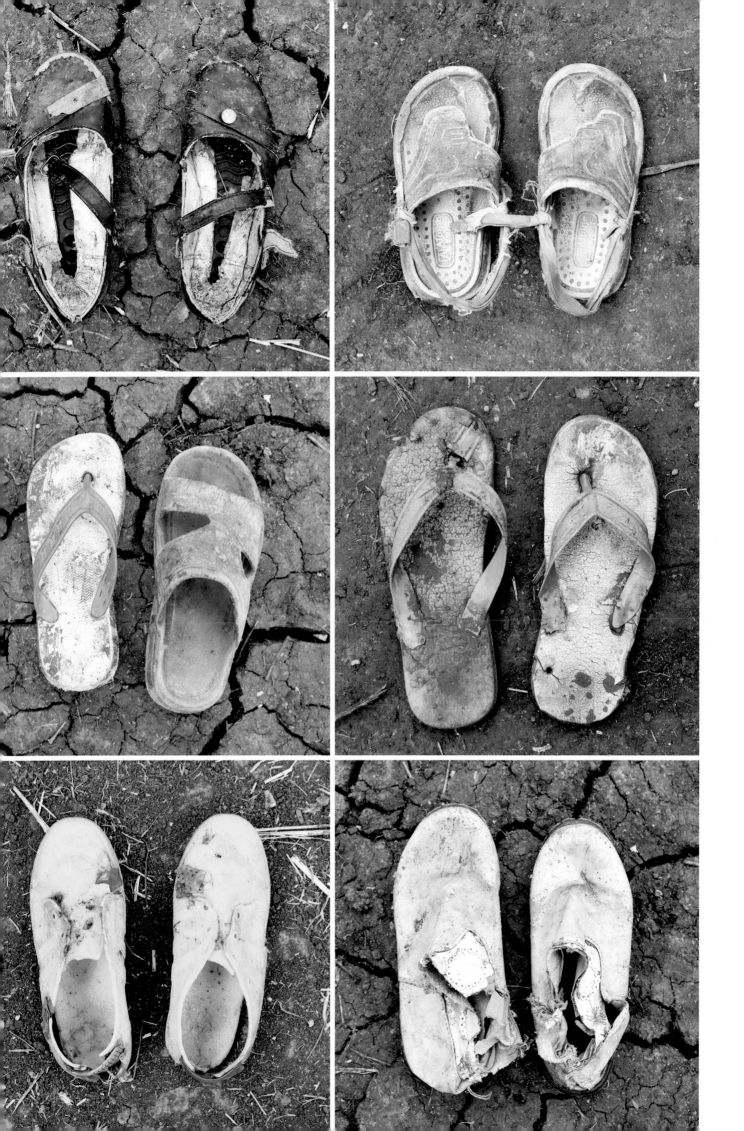

We the Children ist eine Initiative des Deutschen Komitees für UNICEF e.V., *GEO* und der EDITION LAMMERHUBER.
We the Children is an initiative of the German Committee for UNICEF, *GEO* and EDITION LAMMERHUBER.

Project concept **Kerstin Bücker, Peter-Matthias Gaede, Lois Lammerhuber**

Editors **Peter-Matthias Gaede, Jürgen Heraeus**
Book concept **Lois Lammerhuber**
Text **Christiane Breustedt** (captions, photographers' portraits), **Kerstin Bücker, Peter-Matthias Gaede, Jürgen Heraeus**
Photo editing **Kerstin Bücker, Ruth Eichhorn, Lois Lammerhuber, Angela Rupprecht**

Proofreading **Sandra Wilfinger-Bak**
Translation **Brigitte Scott**

Art director **Lois Lammerhuber**
Graphic design **Martin Ackerl, Lois Lammerhuber**
Typographical advisor **Martin Tiefenthaler**
Typeface LAMMERHUBER by **Titus Nemeth**
Digital post production **Birgit Hofbauer**
Project coordination **Kerstin Bücker, Johanna Reithmayer**

Print and binding **Gorenjski tisk storitve, Kranj, Slovenia**
Paper **Printed on GardaPat 13, 170 g/m², made by** LECTA **Group,
exclusively distributed in Austria by PaperlinX — PaperNet.**

Managing director EDITION LAMMERHUBER **Silvia Lammerhuber**
EDITION LAMMERHUBER, **Dumbagasse 9, 2500 Baden, Austria**
edition.lammerhuber.at

Danke | Thank you
Die Herausgeber bedanken sich bei **Save the Children** für die Zusammenarbeit.
The editors would like to thank **Save the Children** for their cooperation.

We the Children wurde vom Auswärtigen Amt der Bundesrepublik Deutschland gefördert.
We the Children was funded by the Foreign Office of the Federal Republic of Germany.

 Auswärtiges Amt

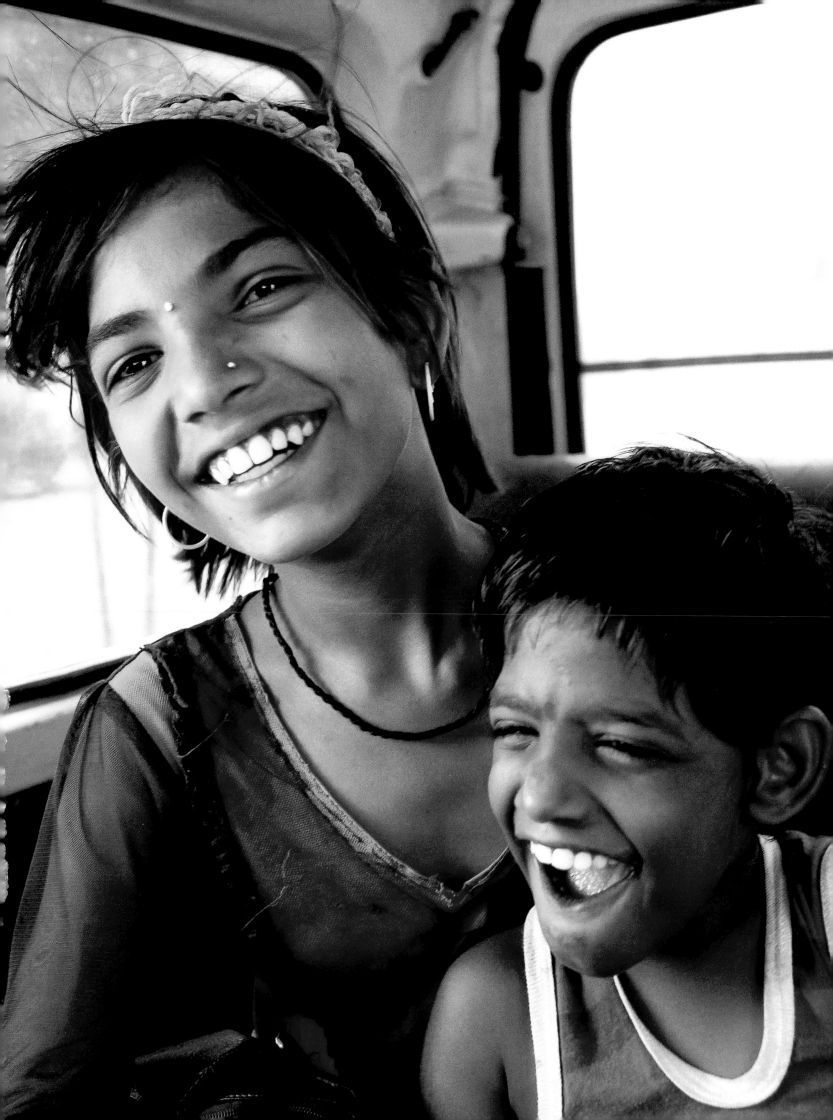

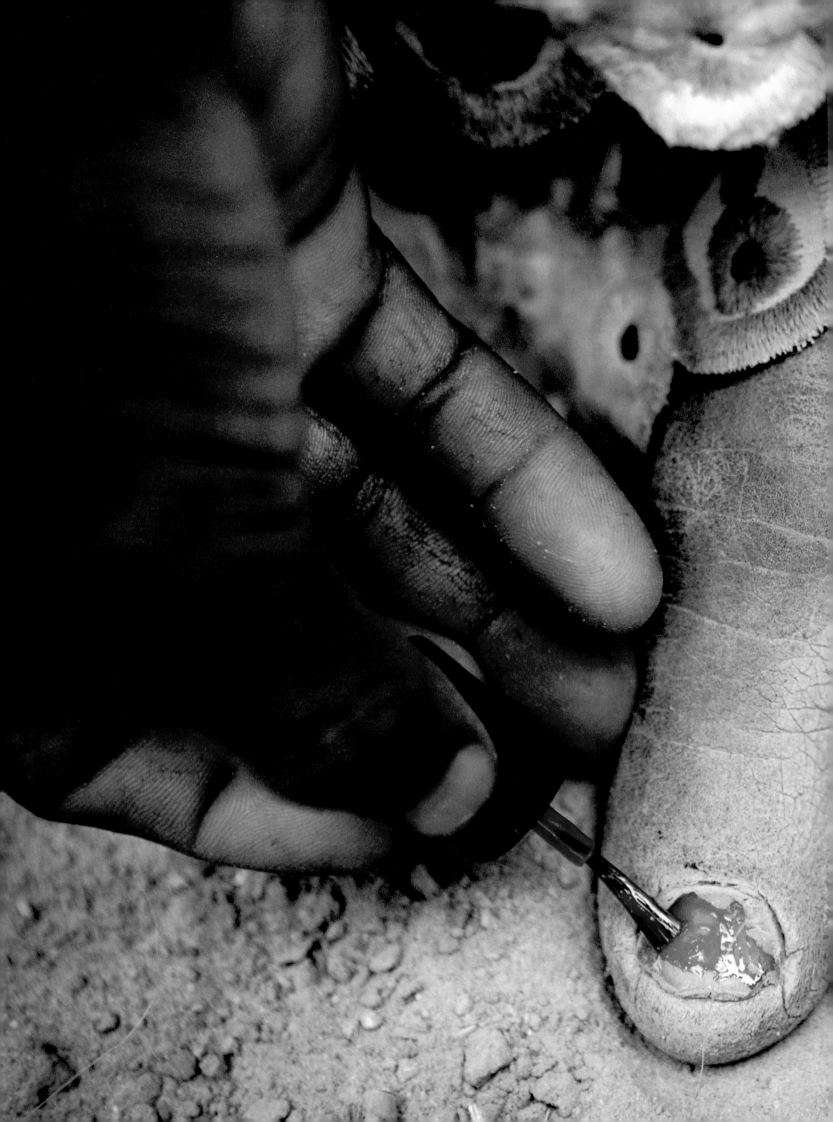